Le Corbusier
The Complete Buildings

Le Corbusier
The Complete Buildings

CEMAL EMDEN

Edited by **Burcu Kütükçüoğlu**

PRESTEL
MUNICH · LONDON · NEW YORK

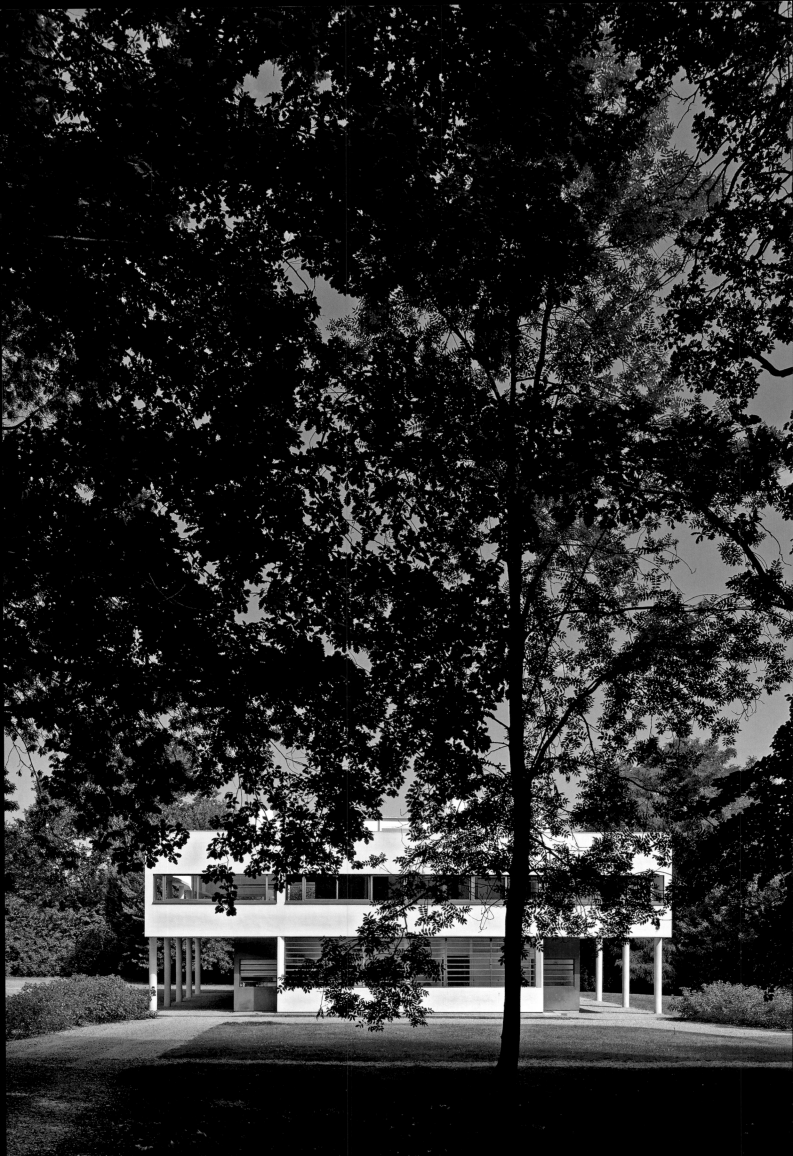

Contents

Preface Burcu Kütükçüoğlu 6

THE BUILDINGS, 1905–1965

Villa Fallet 10
 'Cosy Corbu' Tim Benton 12

Villa Jaquemet 16

Villa Stotzer 20

Villa Jeanneret-Perret 24

Villa Favre-Jacot 28

Villa Schwob 32

Atelier Ozenfant 36
 'Habitable Box' Emre Altürk 36

Villas Lipchitz-Miestchaninoff 40

Maisons La Roche-Jeanneret 44

Villa Le Lac 50
 'An Extraordinary Window' Emiliano Bugatti 50

Quartier Moderne Frugès 54
 'Users' Response' Zeynep Çelik 54

Maison et Cantine 60

Maison Planeix 62
 'Symmetric–Asymmetric Reflections' Atilla Yücel 62

Villa Stein-de-Monzie 68

Maison Cook 72

Maison Guiette 74
 'Inside the Photograph: Matter or Reality?' İhsan Bilgin 76

Houses of the Weissenhofsiedlung 80

Centrosoyuz 86
 'Melancholy in Moscow's Streets' Jean-Louis Cohen 86

Villa Savoye et Loge du Jardinier 92
 'Five Points in Miniature' Pedro Bandeira 100

Armée du Salut, Cité de Refuge 102

Pavillon Suisse 108
 'Courage' Kengo Kuma 108

Immeuble Clarté 114

Immeuble Molitor / Appartement de Le Corbusier 118

Unité d'Habitation, Marseille 122

Usine Duval 130

Maison Curutchet 134

Chapelle Notre Dame du Haut 140
 'Irreligious Ronchamp' Uğur Tanyeli 142

The Monument of the Open Hand 150

Mill Owners' Association 152

Maisons Jaoul 158

Sanskar Kendra City Museum 164

Le Cabanon 168

Villa Sarabhai 172

Villa Shodhan 176
 'When Corbu Met Cemal' Mehmet Kütükçüoğlu 178

Unité d'Habitation, Rezé 180

Museum and Art Gallery 186
 'Memory of the Museum of Unlimited Growth'
 Jacques Sbriglio 186

Palace of Justice 192
 'A Roof for All' Zekiye Abalı 194

Architecture Museum 202
 'Replicating Huts and Trees' Namık Erkal 204

Maison du Brésil 208

Couvent Sainte-Marie de La Tourette 216
 'Architecture as an Artistic Whole' Doğan Kuban 218

Maison de la Culture 224

Palace of Ministries 228

Yacht Club 234

National Museum of Western Art 236
 'How to Photograph the Ineffable' Daniel Naegele 242

Palace of Assembly 246
 'A-morph' Günkut Akın 252

Unité d'Habitation, Briey-en-Forêt 256

The Tower of Shadows 260
 'The "Temple" of Shadows' Reha Günay 262

The Geometric Hill 264

The Monument to the Martyr 266

Unité d'Habitation, Berlin 268

College of Art 272

College of Architecture 276

Unité d'Habitation, Firminy 280

Église Saint-Pierre 284
 'Building Images' Tülay Atak 288

Carpenter Center for the Visual Arts 292

Le Corbusier Centre 300

Stadium 304

CATALOGUE OF BUILDINGS 308

Preface

BURCU KÜTÜKÇÜOĞLU

The Photograph always carries its referent with itself … they are glued together, limb by limb, like the condemned man and the corpse in certain tortures; or even like those pairs of fish … which navigate in convoy, as though united by an eternal coitus.
–Roland Barthes

This book is the end product of a six-year photographic odyssey in pursuit of a holistic and original imagery of Le Corbusier's built work. Architectural photographer Cemal Emden has been shooting the renowned and extensively photographed buildings of the architect since 2011, with a series of professional and personal motives that merged into each other through the course of his journey. Photographing Le Corbusier's buildings when a huge body of images has already been already produced and published since the 1920s is a real challenge in terms of revealing meaning and originality. Yet the 'labyrinthine scope of [Le Corbusier's] production', in Kenneth Frampton's words, not only continues to provide new and interesting architectural knowledge but also makes possible original readings and interpretations through the medium of photography, even today. Emden had a profound belief in this possibility and got involved in the task of producing a comprehensive photographic portfolio of the current state of the architect's buildings in 2011, when it all started with a project realized in Istanbul.

On the centenary of Le Corbusier's *voyage d'Orient* of 1911, Fondation Le Corbusier organized three consecutive conferences in some of the major destinations the self-taught architect visited during his journey: Istanbul, Athens and Naples. Istanbul Bilgi University became the partner institution of the Fondation Le Corbusier in the organization and hosting of the conference, to which a series of parallel events were added. The most significant and attractive of these was an exhibition entitled 'Visual Log: A Gaze at Le Corbusier's Oeuvre', which displayed recent photographs of a number of Le Corbusier's buildings in Europe and India, taken by Cemal Emden over about four months. Following the exhibition, Emden both continued to receive further commissions – from various institutions and scholars – on the topic of Le Corbusier's oeuvre, and carried on filling in the missing parts of his photographic portfolio of the architect's built work. In fact, photographing Le Corbusier's buildings became such a strong interest for him that he personally chose to go through the time-consuming processes of making contacts and obtaining permits – often with the help of the Fondation; he also visited most locations more than once, to ensure he was able to shoot every part of the buildings and to capture the correct light and atmosphere.

After making contributions to various exhibitions and publications on Le Corbusier around the world, Emden opened a second exhibition in Istanbul, in 2016 at Işık Gallery, with a selected group of images from his portfolio. I undertook the curatorial role in the organization of this exhibition, entitled 'Cross Reflections: Architecture, Photography and Text', as I had done for the earlier one in 2011, and together with Emden invited fifteen scholars to shape the content of the show. We asked each participant to choose a single photograph from Emden's extensive portfolio of Le Corbusier's work, give it a title and write a short commentary on it. The idea was to integrate the participants in the curatorial process by letting them select the images to be displayed, and at the same time to pair photographs and texts with the aim of revealing links between architecture, images and words. Needless to say, Roland Barthes was the inspiration behind this curatorial idea. Barthes inspired and directed us to look into the diverse relationships between photographs and their referents – in this case, buildings – and indeed to enhance meaning by creating further links between photographs and texts. In Barthes' words, the participants in the exhibition became 'torn between two languages, one expressive, the other critical' – and maybe even three, for we should surely count architecture as a distinct language as well.

The material from this 2016 exhibition acts as the core of this book, although the scope of the final publication far exceeds its limits. *Le Corbusier: The Complete Buildings* is a

compilation of selected images from Cemal Emden's portfolio, which can be described as the largest and most comprehensive body of photographs of Le Corbusier's buildings produced by a single photographer. For this publication, Emden put in a final effort to complete his portfolio, photographing the buildings he had not been able to shoot before, and accomplished his task of compiling a complete photographic index of the legendary architect's built work, with the exception of a few edifices that have either been demolished or cannot be accessed for privacy or security reasons. As a result, this book presents the reader with 57 up-to-date photographic images of almost all the extant buildings of Le Corbusier, as well as the comments of nineteen authors, including architects, photographers and architectural scholars, most of whom participated in the 2016 exhibition 'Cross Reflections'.

The significance of Emden's work not only lies in the intensity and scope of the task that he passionately accomplished. It also unfolds through his subtle style, which permits the communication of Le Corbusier's intrinsic architectural idea(s) while at the same time putting forward a coherent and identifiable vision of his own. So we might say that in fact Emden elaborates on the standard mission of architectural photography, defined by Ezra Stoller as conveying the architect's idea, and creates an overarching visual narrative connecting the works of Le Corbusier and spanning a period of more than a century. Emden's style is closely associated with his professional training as an architect. He explains that he always has in mind the architectural tools of visualization – two- and three-dimensional drawing techniques – when taking photographs. His photographs are therefore charming hybrids that reveal hints of the abstract realm of ideas and the concrete world of sensual experiences at once. While this book will probably open up a platform for further discussion of the diverse and rich aspects of Cemal Emden's Le Corbusier portfolio, it will surely also cement his indisputable place among the most devoted photographers of the architect, alongside names such as Lucien Hervé and René Burri.

The Buildings

1905–1965

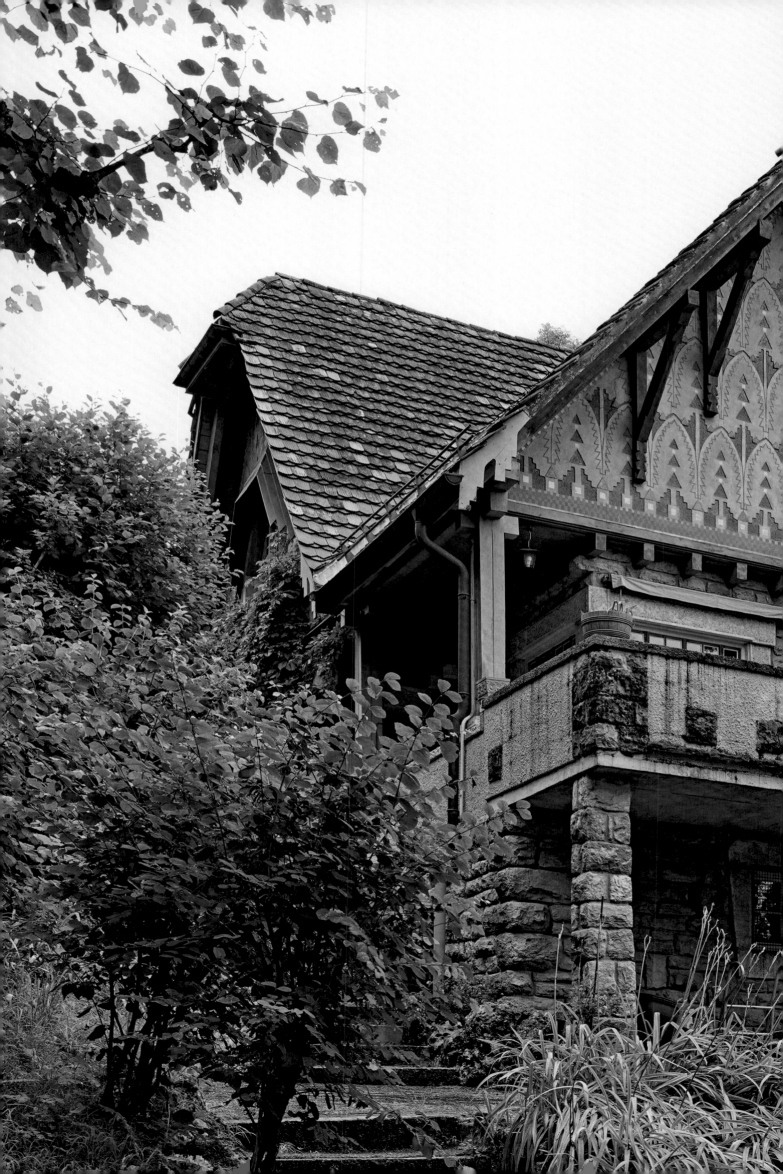

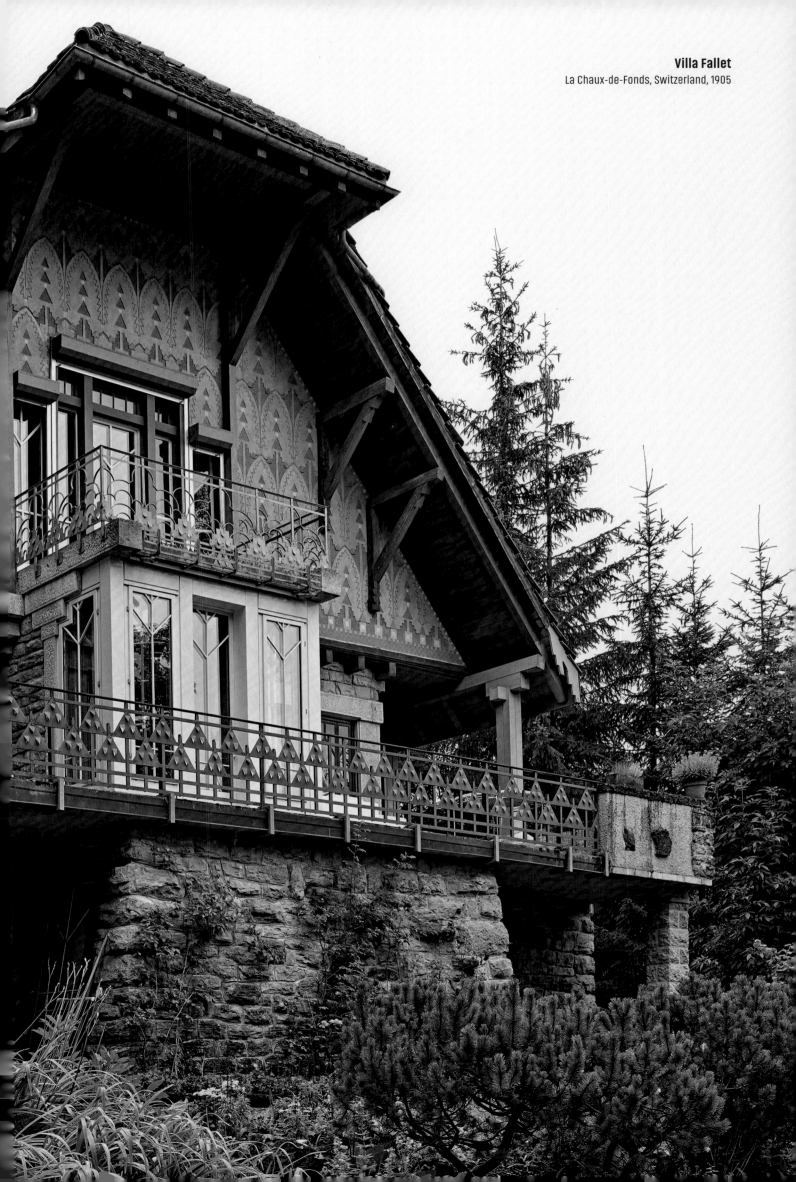

Cosy Corbu

TIM BENTON

You can almost smell the pinewood, cut fresh from the forests high in the Swiss Jura all around La Chaux-de-Fonds. The house is not only made of pine; it embodies the snow-laden pine trees. The triangles and inverted stepped pyramids suggest the clusters of pine needles that the young Charles-Édouard Jeanneret and his fellow students studied so minutely and turned into decorative designs. Elsewhere in the house, the pine branches and snow-covered rocks are represented in stained glass, sheet metal, stone and coloured stucco. But here all is wood and ceramics. The only hints of the *ère machiniste* in this photograph are the Art Nouveau cast-iron radiator and the brass chandelier (probably manufactured in Birmingham, UK), both redolent of the first machine age. Everything else breathes Ruskin's Lamp of Sacrifice – craftsmanship and a loving attention to detail. And the Lamp of Truth dictates each solution: no mendacious veneers or hidden structure. What you see is what you get: sturdy timbers shaped, mortised, dowelled and pegged. Only structural components are decorated, as Pugin demanded. Instead of wallpaper, the grain and texture of wood. How wonderful to live without lies. Isn't this what we all want: the embrace of warm materials, a plan shaped around daily routines and gestures, the pleasure in caressing a well-made thing? But it wasn't enough.

To be an abstract artist you must be able to draw. To invent a modern architecture of pure, concrete 'prisms' in the 1920s, Le Corbusier had to have known what it was to build a warm and comfortable home. From the Villa Fallet to the Maisons Jaoul and Villa Sarabhai, nearly fifty years later, Le Corbusier circled around the idea of domestic comfort, the organic home, the 'foyer' or, as he called it in *Vers une architecture*, the house as a snail's shell.

And this house was a collaborative effort. Jeanneret enlisted his friends to work on the fabric. The merry hammering and plastering, cutting, fitting, painting and varnishing was a picture of medieval collective labour as Viollet-le-Duc would have imagined it. This is the 'other', which helps to define the modernity Le Corbusier discovered thirteen years later in Paris. Replacing the hand with the machine, craft with art, texture with form and ornament with proportion required a struggle which only someone trained in the Arts and Crafts could call his own. And his early experience perhaps explains why Le Corbusier's 'machines à habiter' were invariably hand-crafted by Italian artisans, who alone could achieve the pure and precise surfaces his architecture required. By the 1930s he was back again, with brick and rubble stone walls, wood and a more organic approach to architecture.

So, hats off to the Villa Fallet and the lucky professor for whom it was handcrafted.

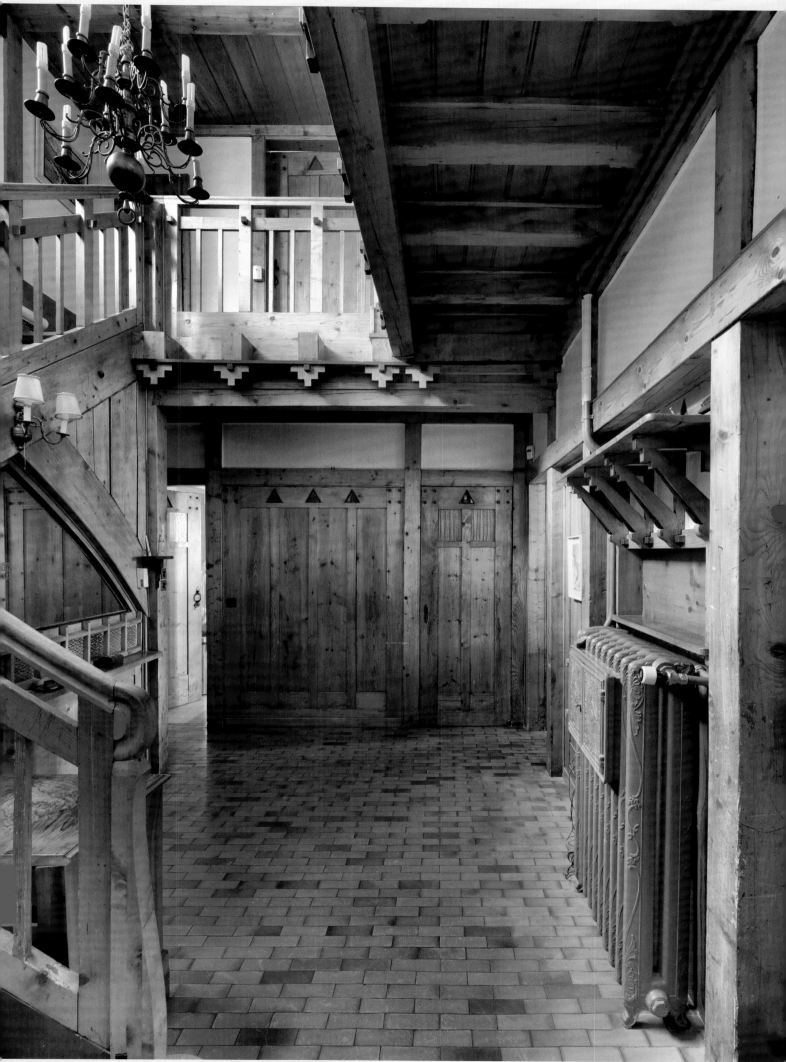

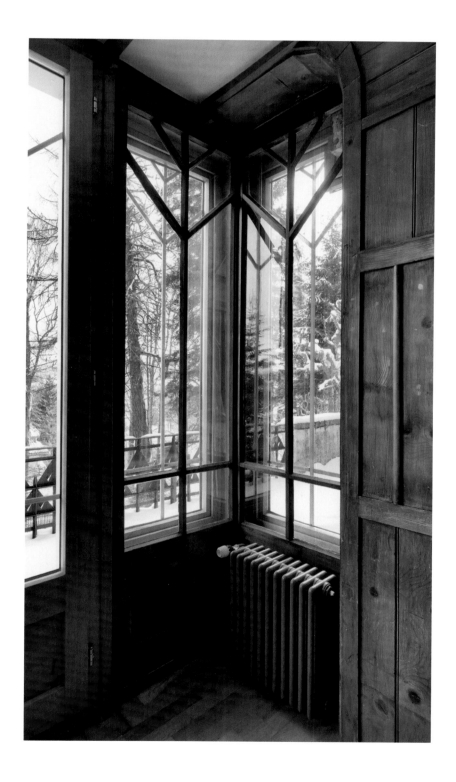

Villa Jaquemet
La Chaux-de-Fonds, Switzerland, 1907

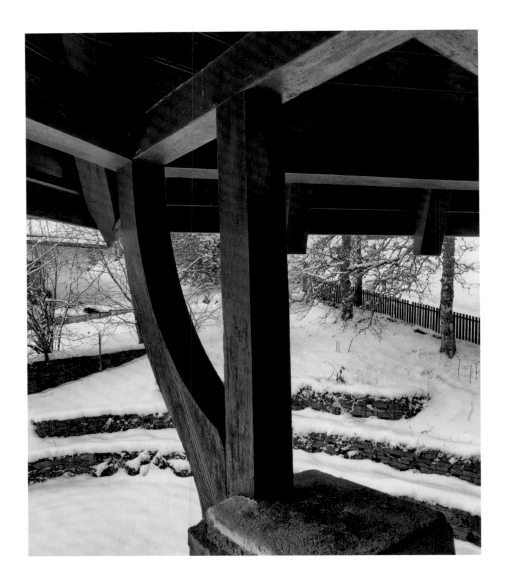

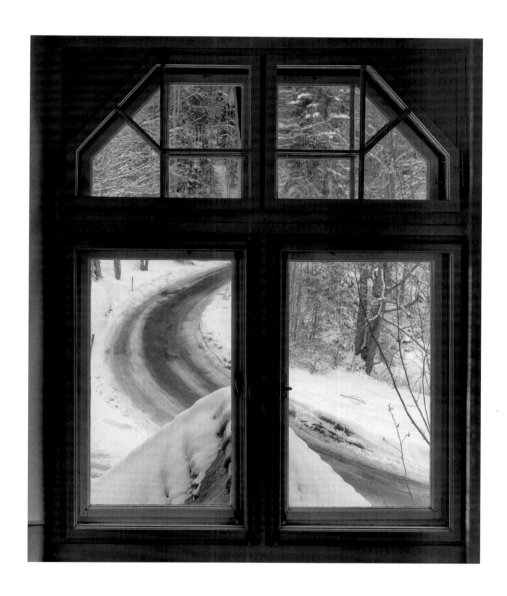

Villa Stotzer
La Chaux-de-Fonds, Switzerland, 1907

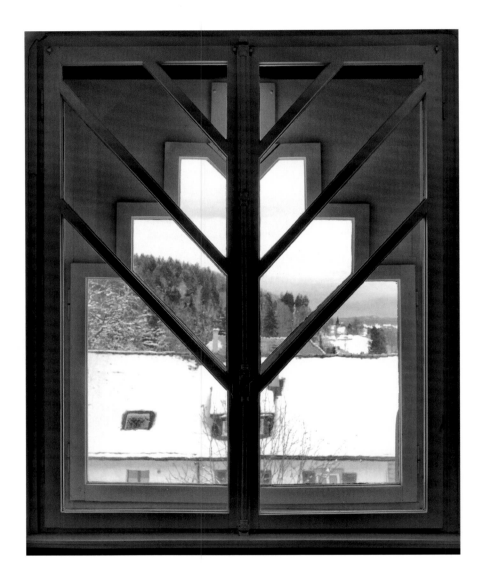

Villa Jeanneret-Perret
La Chaux-de-Fonds, Switzerland, 1912

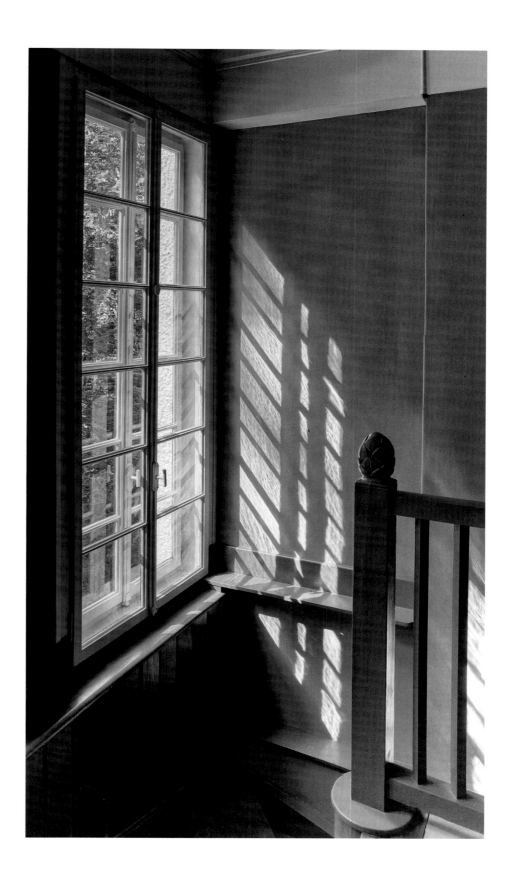

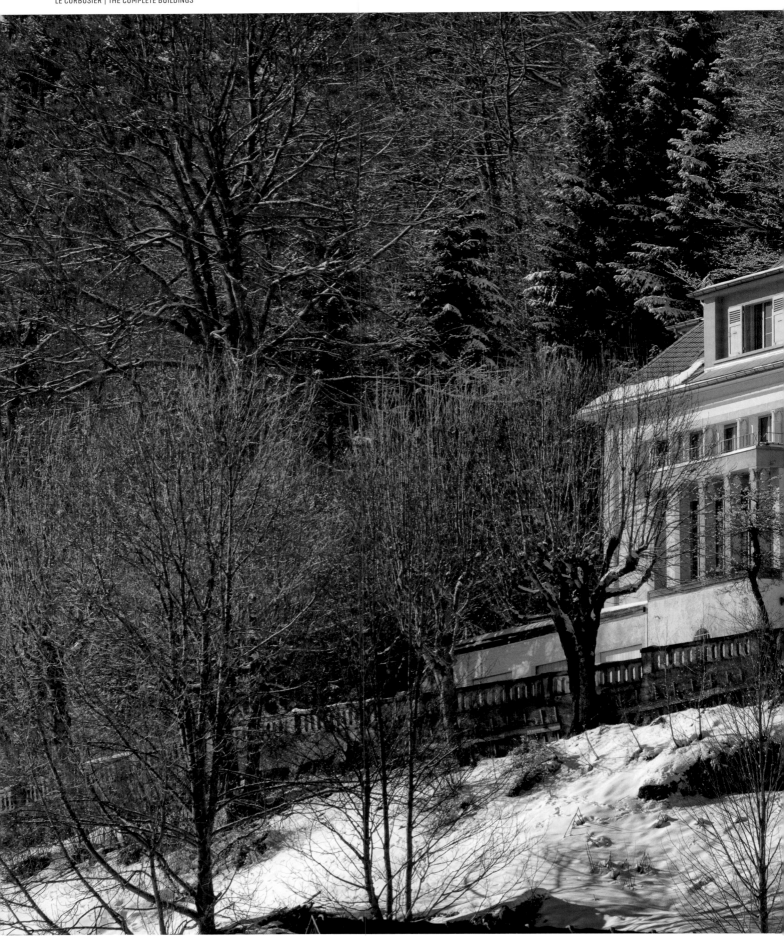

Villa Favre-Jacot
Le Locle, Switzerland, 1912

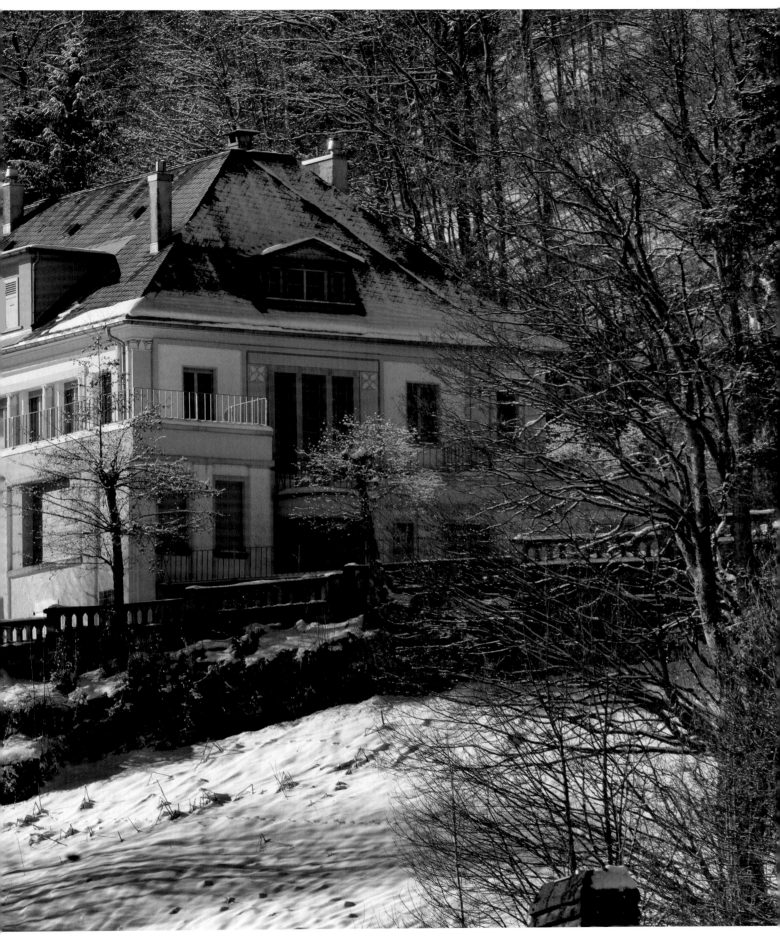

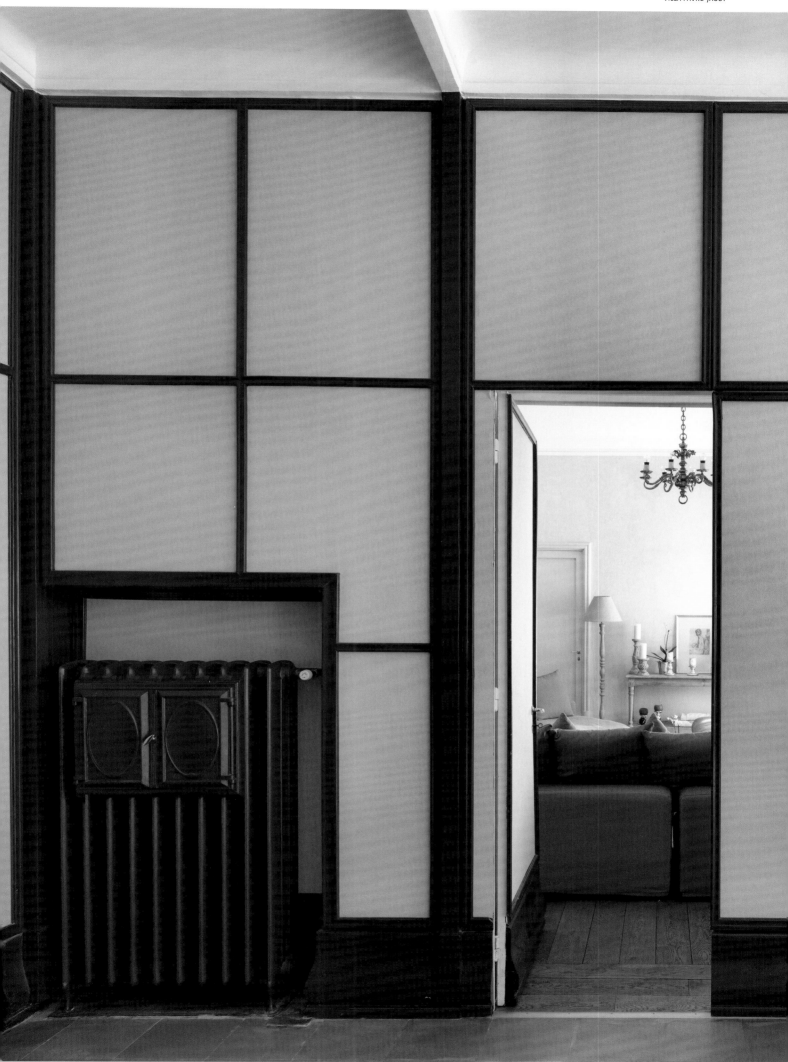

Villa Schwob
La Chaux-de-Fonds, Switzerland, 1916

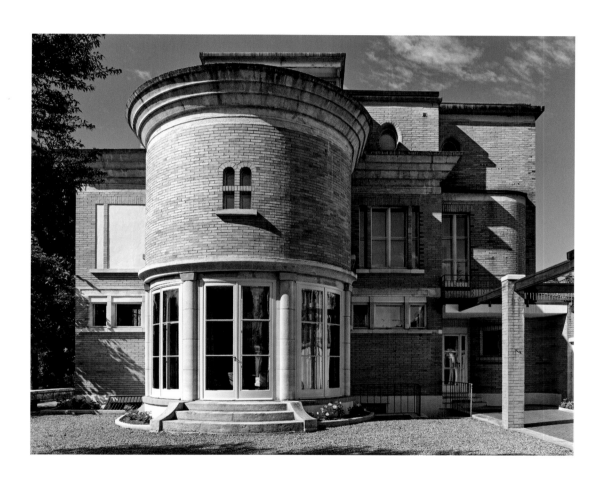

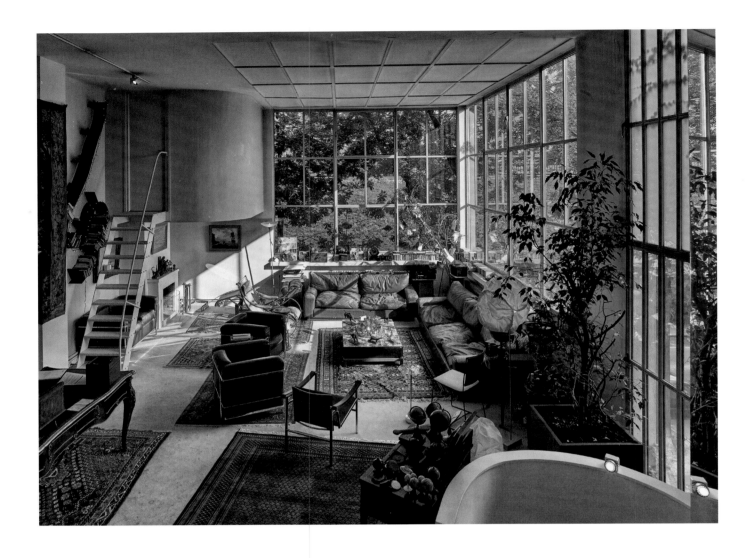

Atelier Ozenfant
Paris, France, 1922

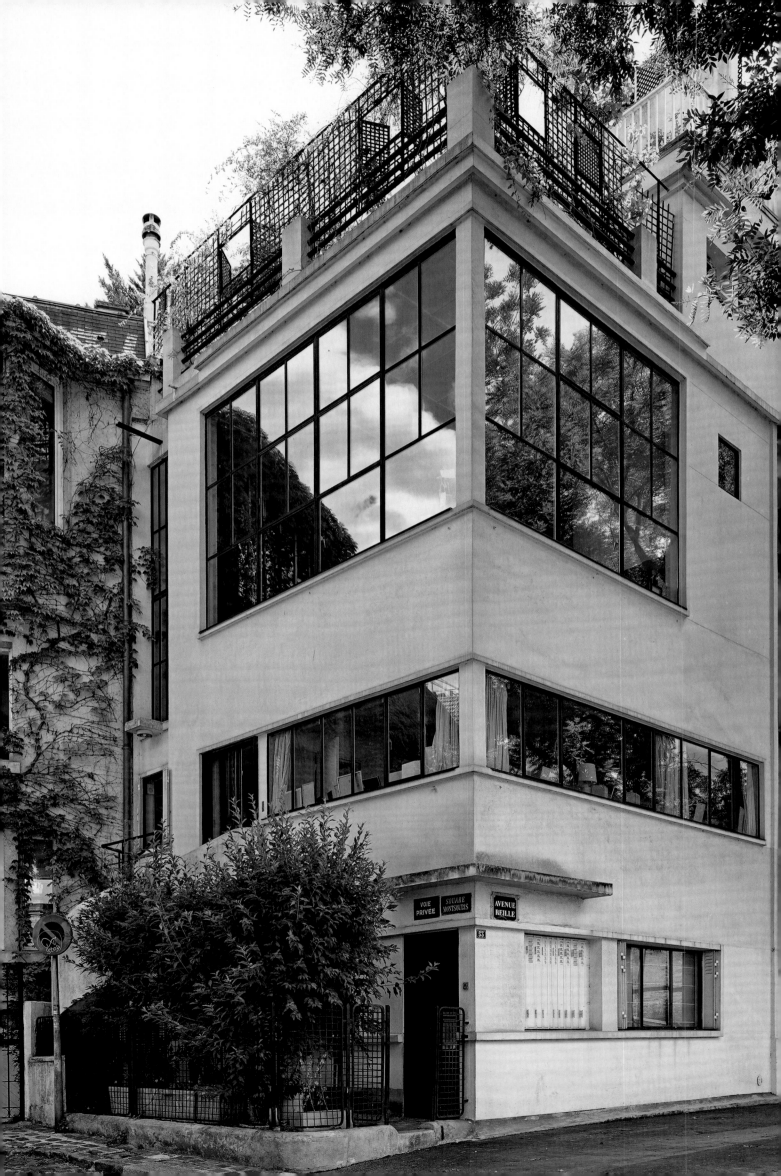

Habitable Box

EMRE ALTÜRK

I have always thought that the powerful spatial effect of a photograph stems from an additional something beyond perspective. Of the possible 'supplements', what I consider to be most powerful is tension. I feel that things that dwell in the same image in a tense relation in terms of form, expression and meaning pull, indeed tug, the space between them, giving the surface of the photograph depth by stretching it, thereby creating an effect that strengthens the spatial feeling produced by perspective.

The reasons this photograph of the Atelier Ozenfant gives a very powerful feeling of space are apparent from the viewpoint of perspective. The wide window profiles and especially the division bars of the closed ceiling window create a superbly geometric space, adding a depth to the photograph reminiscent of the black-and-white tiled flooring in seventeenth-century Dutch paintings. This near-cubical prism has four visible surfaces, three of which are tightly organized geometrically. Looking at this prism from an angle, deviating from the centre line, coupled with the lens distortion towards the edges creates a perspective with three vanishing points.

On the other hand, large and small tensions between various elements in the photograph create a depth beyond perspective. The most obvious is the one between the neat cladding of the windows and the organic disorder of the trees beyond. This tension stretches and increases the distance between the building and the trees. One can argue that these windows and the building in general carry a more latent tension because of the clutter of the room – the diversity of the furniture, the heap of figurines and spheres, piles of books, magazines and CDs. One expects this radically modernist space, or others akin to it, to be empty, or at least sparsely furnished with a certain type of furniture that belongs to the same modernist vocabulary as the building. For example, if the Corbusian chairs – the more expected inhabitants of the house – were to stand in the room on their own instead of being pushed to the corner of the photograph and the space, the photograph would be a step closer to the image of the modernist interior in our minds. As it is, the chairs stand among the clutter and in a tense relation with the brown leather sofas in front of the window, which in particular look like their antitheses. Canonically modernist interiors are often accused of being sterile – unwilling to allow life to leave a trace on them. In a way, these Corbusian chairs are also of this nature: they allow you to sit only in a respectable manner because of their angled form, and their tight leather will not bear your trace once you get up. Conversely, with their loose, crumpled, non-geometric cushions, the brown leather sofas bear the traces of their users, betraying the spots that were last or most often sat on. Looking at these sofas, you realize that in sitting on them you would hear the air blow out of the cushion as it takes your shape, that you would slowly sink into it – even unavoidably lean back a little. This discrepancy between the neat Corbusian chairs and the more comfortable but somewhat dishevelled sofas creates a tension that pulls and stretches the space of the room. Lastly, the morning sun that comes through the window sets up another tension by dividing this space into luminous and gloomy sections. Thankfully, one of the brown sofas is in the sun.

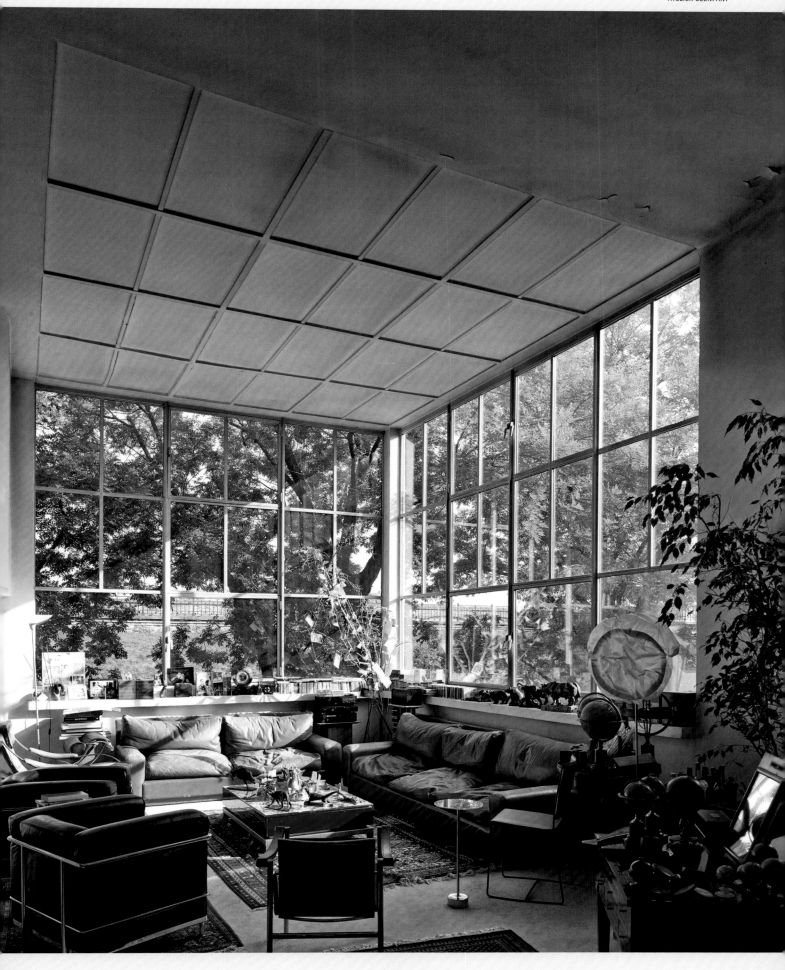

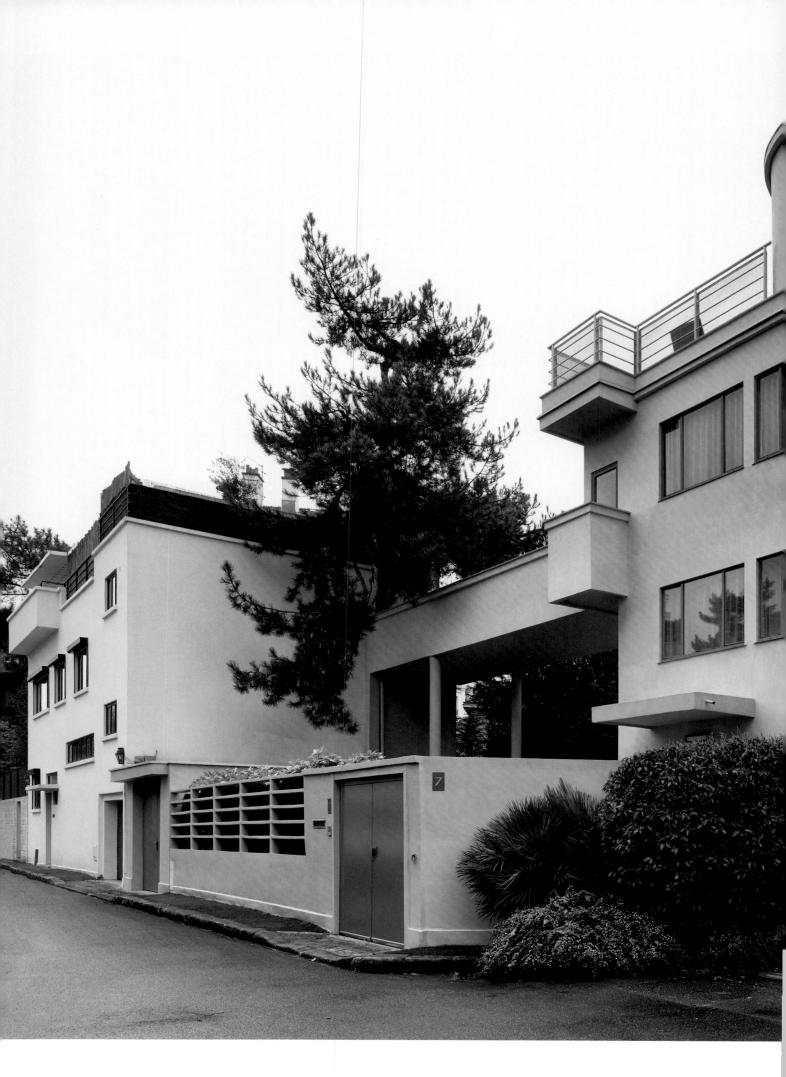

Villas Lipchitz-Miestchaninoff
Boulogne-sur-Seine, France, 1923

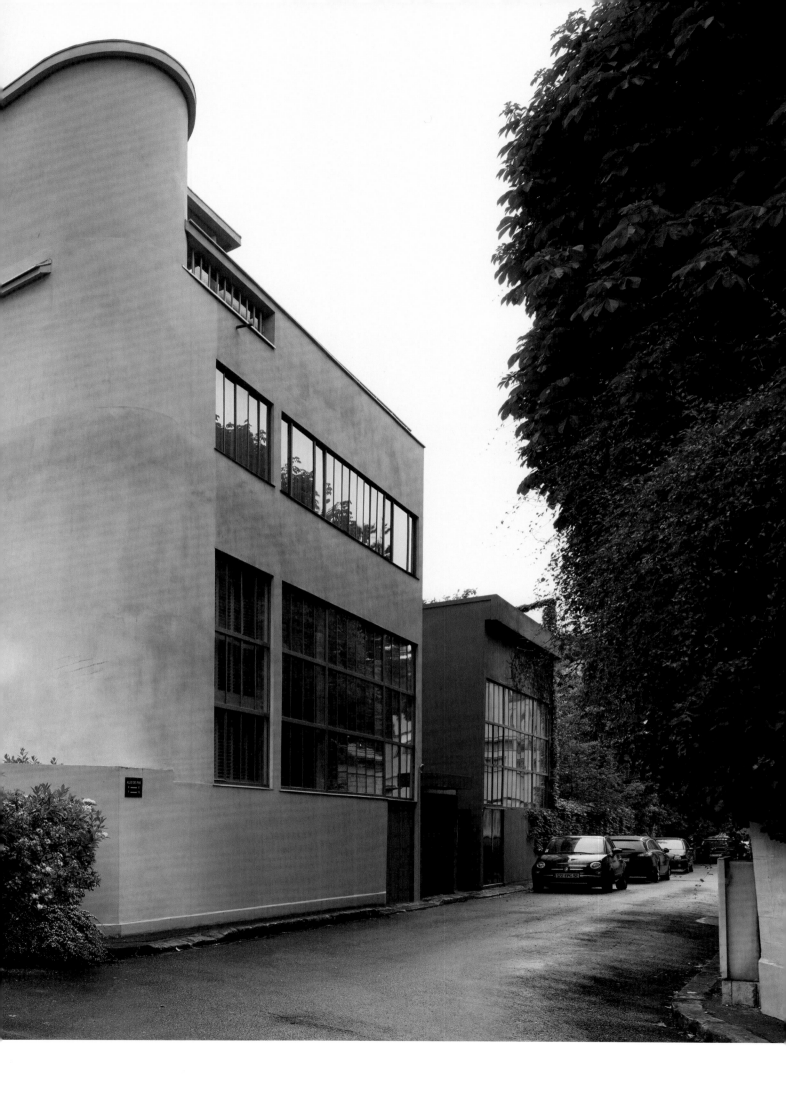

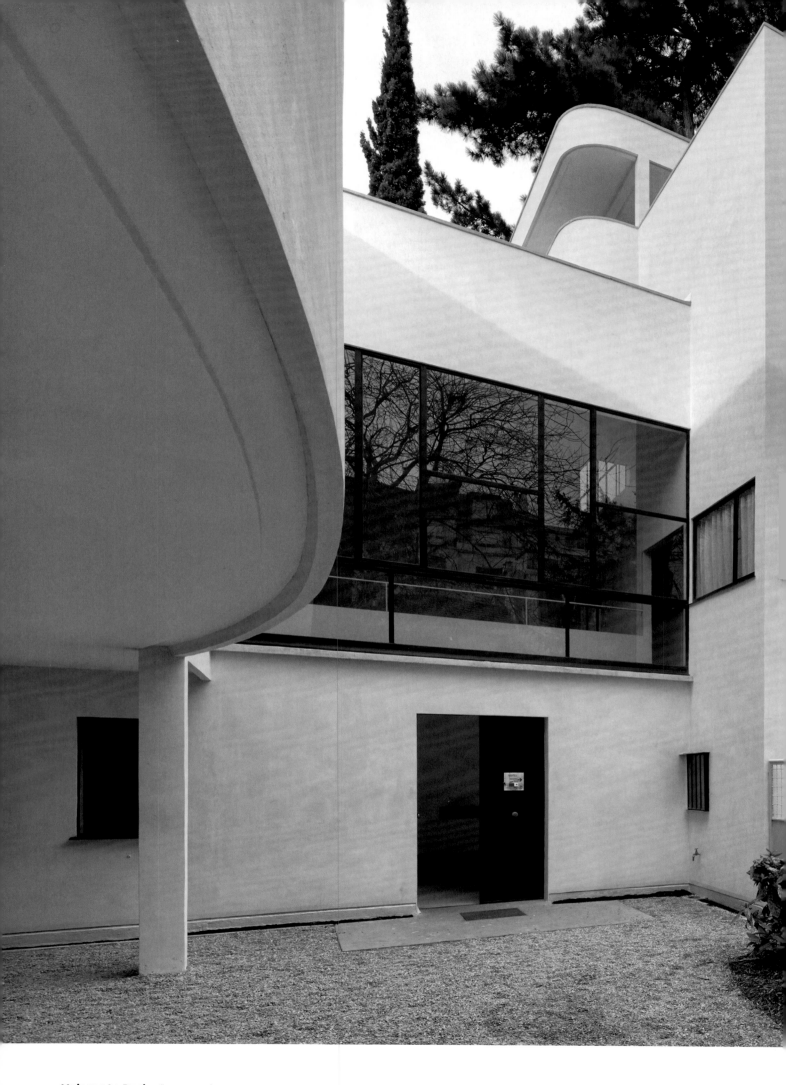

Maisons La Roche-Jeanneret
Paris, France, 1923–25

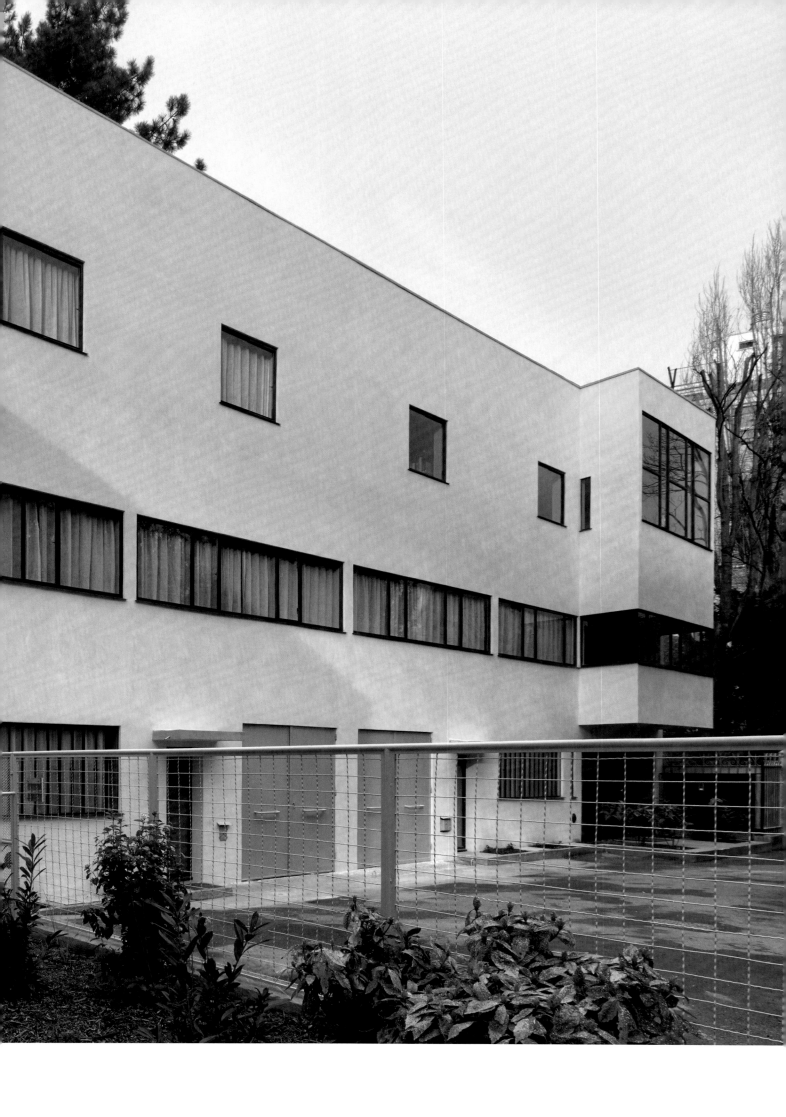

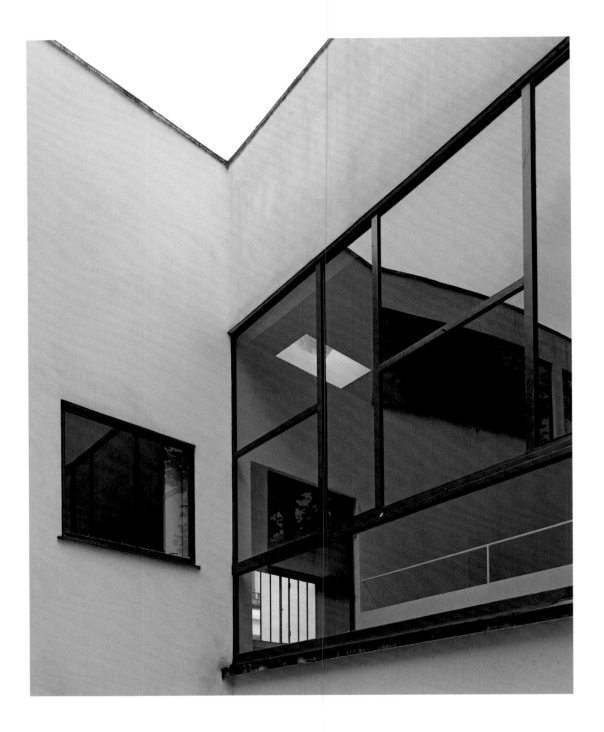

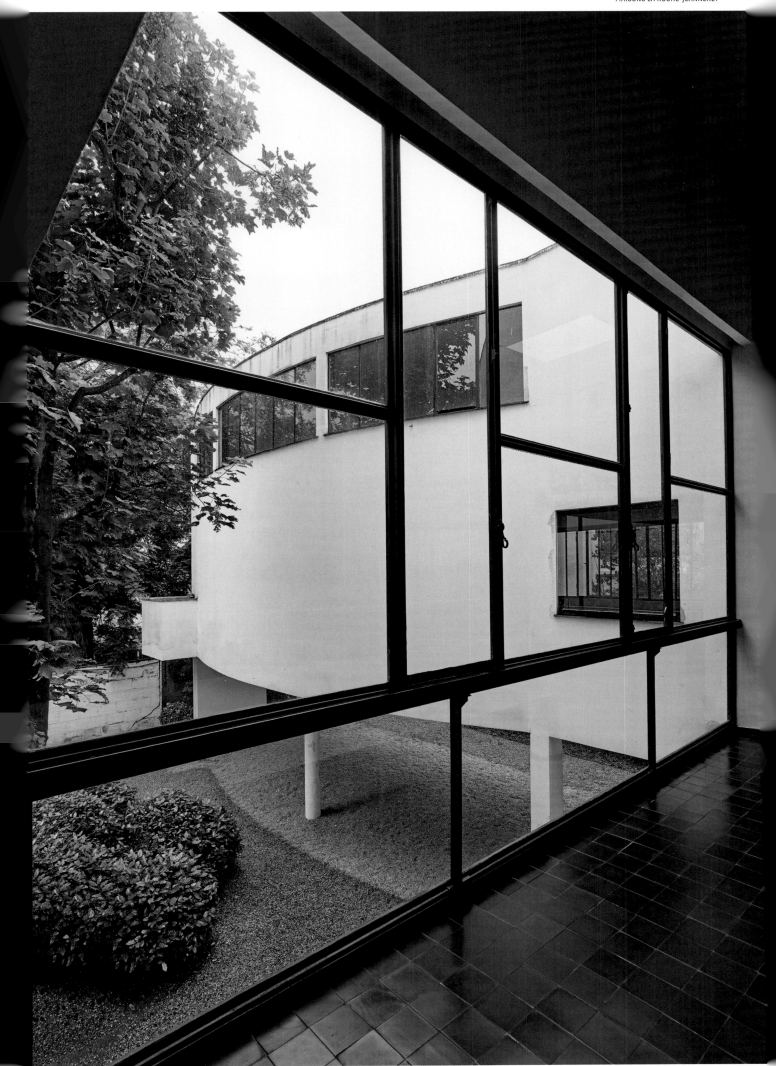

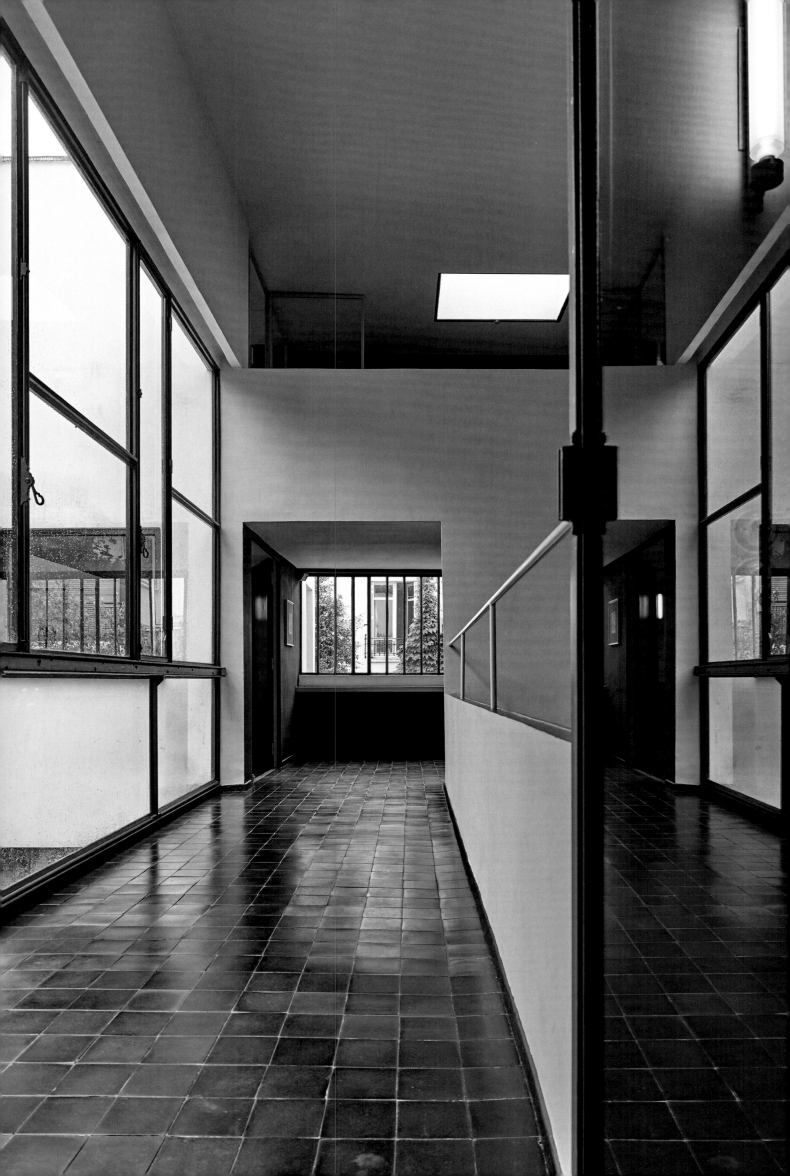

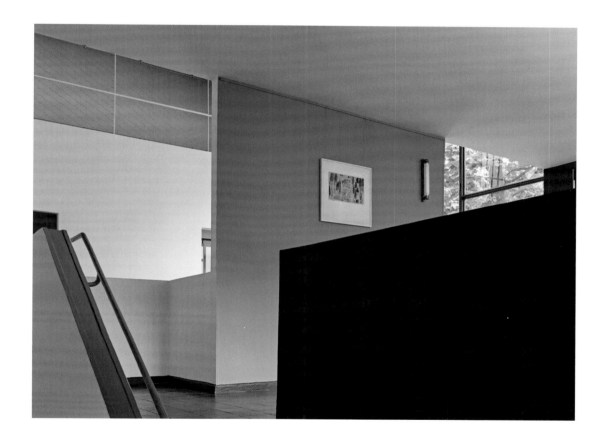

An Extraordinary Window

EMILIANO BUGATTI

In 1923–24, with Pierre Jeanneret at his side, Le Corbusier designed a small house for his parents on the shores of Lake Geneva in Corseaux, Switzerland. The house, known as Villa Le Lac or La Petite Maison, is a single-level building, a simple box of about 60 square metres isolated on a small, narrow plot arranged longitudinally to the lakeside and surrounded by boundary walls that divide and close off the property from the street and nearby plots. The building is tucked to one side of the plot to create space for a proper garden on the empty side, adjacent to the house. Oriented to the south, both the interior spaces and the garden open on to the lake view. Cemal Emden's photographs of La Petite Maison capture the main concept of this small but precious project: its important relationship with the lake view.

At the entrance of the building, a wall obliges either a right turn towards the service spaces or a left turn to reach the living spaces of the house, where there is a spectacular sense of opening on to the lake. Indeed, on the southern side of the house, Le Corbusier incorporated a long window of 11 metres, divided into four parts; this is in fact his first *fenêtre en bandeau*, inspired by his 'Five Points of Architecture', at that time still under elaboration. Along the horizontal window there is no privileged point from which to observe the lake – no specific room was emphasized, nor was symmetry; the window continues through the other spaces of the house: the living room, bedroom and finally the bathroom. Le Corbusier did not design here a typical sequence of rooms, but rather spaces that are fluently disposed on this side of the house, without doors; hence, another point realized: *le plan libre*. With great skill Emden has overturned this idea; he has caught a section of this extensive window, emphasizing, in his usual poetics, a central perspective, a perfect fragment of a complex space.

A beautiful tree and a small wall that partially block the view of the lake characterize the garden. In this part of the plot, where one would have a full, open view of the lake, Le Corbusier does not give the freedom to choose a point of view, but instead offers only a single, special place: a concrete table with an opening that frames the lake, as if in a painting. Memories of the walls of Eyüp precinct, which he visited a decade before, during his *voyage d'Orient*, must have come to his mind. This seemingly simple house represents an important beginning for the poetics of Le Corbusier, as Bruno Reichlin pointed out. In the design of La Petite Maison, he realized some of his Five Points and a first instance of his architectural promenade, later developed in more clearly articulated buildings, as can be appreciated in other images in the book.

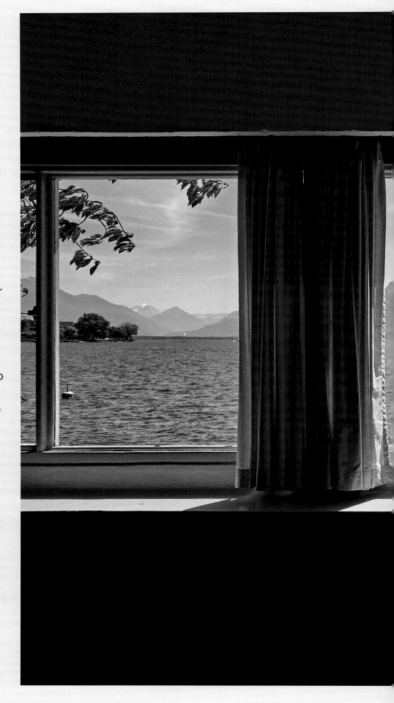

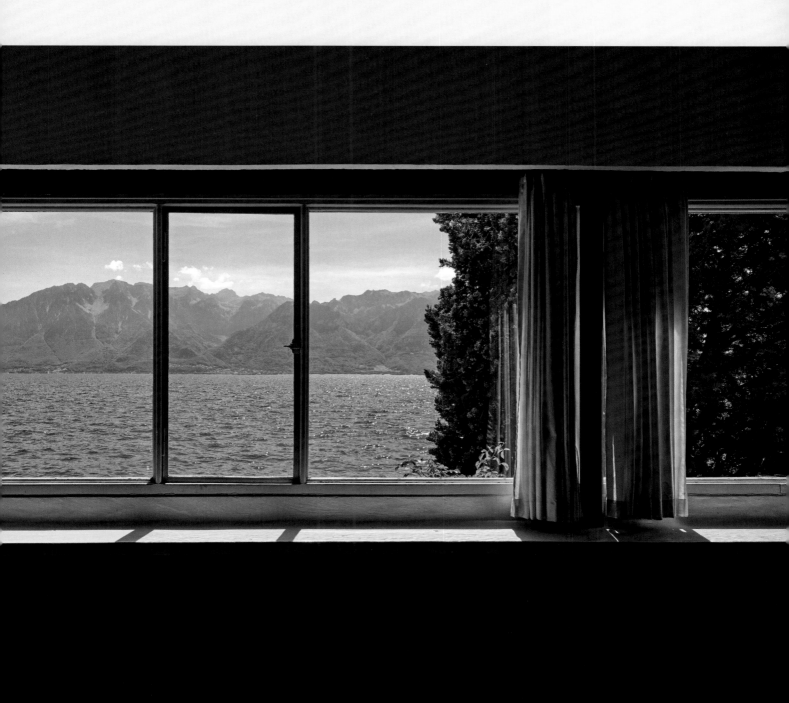

Villa Le Lac
Corseaux, Switzerland, 1923–24

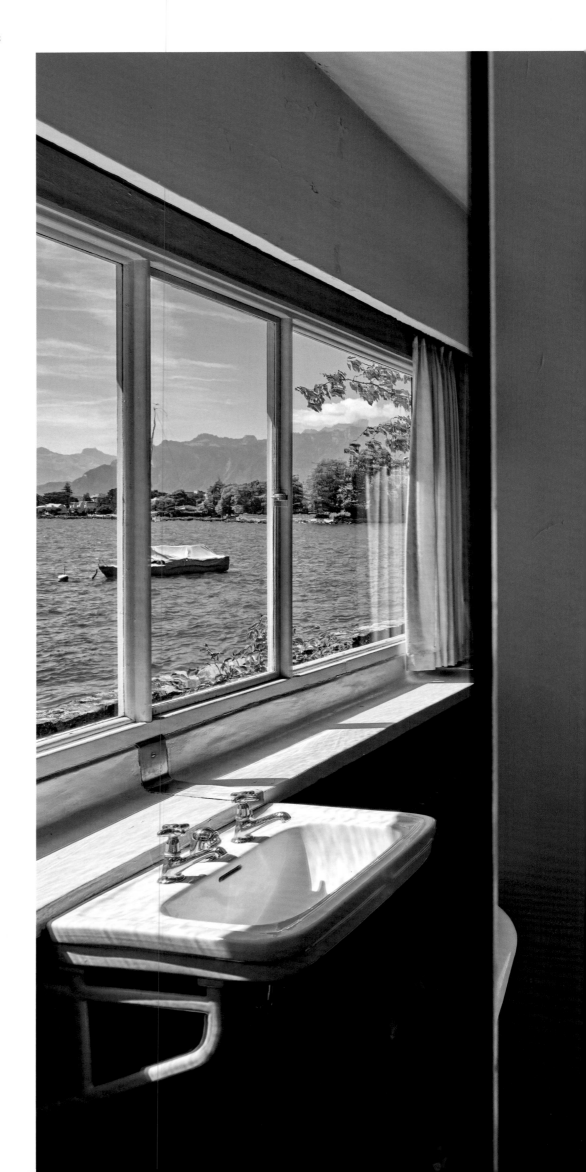

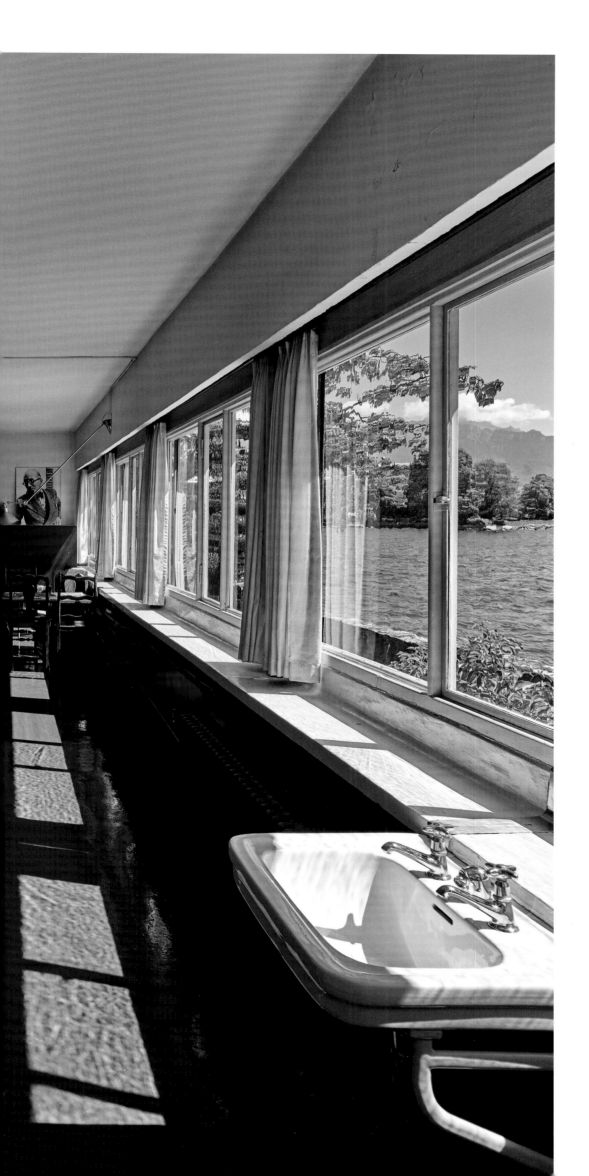

Users' Response

ZEYNEP ÇELİK

The photographer's lens frames the small, intimately scaled houses of Cité Frugès as experiments in pure abstract forms with a dash of colour, deemed representative of Le Corbusier's oeuvre. However, the reality is more complicated. Dating from 1926, this workers' housing complex near Bordeaux was financed by the industrialist Henry Frugès, an owner of sugar refineries, as a company town based on a Taylorism-cum-garden-city model. The ensemble and the units may have embodied the architect's vision of 'machines for living in', but ended up not fully carrying their mission into the future as ideal symbols of modernity. They served instead as a testament to the malleability of the design, providing an excellent case study that underlines the value of situating buildings in their own historic processes.

Having read Philippe Boudon's *Lived-in Architecture: Le Corbusier's Pessac Revisited* (1972)

as an architecture student, I visited Pessac thirty years later to witness the continuation of Boudon's story. Boudon had surveyed in meticulous detail the transformations made to the houses by their users. The visual materials he included in his book did not quite look like the photographs I knew, that is, the classic views of the inauguration day – the black-and-white photographs that punctuated the crispness of the cubic forms. The men in these vintage images (no women were in sight), representing the inhabitants, seemed to be effective artistic devices that complemented the design. Nevertheless, over the course of almost a century, the users turned into active agents and reshaped the original architecture, making the interiors and exteriors fit into their lifestyles and respond to their own tastes. Pursuing an interdisciplinary methodology that relied on ethnography, anthropology and sociology, Boudon's

Quartier Moderne Frugès
Pessac, France, 1924

analysis did not remain focused on forms alone but also investigated the reasons for the changes with the help of interviews. Not always happy with the openness and the flow of the original rooms, the residents had divided spaces and enclosed the terraces to accommodate the needs of their families. The band windows were turned into smaller ones, corresponding to the new arrangements inside, and shutters were added, giving the outside appearance a 'traditional' veneer. Thus the users revised the signature features of the famous architect.

The resulting image may have betrayed the aesthetic integrity of the original design, but personalization had endowed the settlement with another life. No longer monolithic, it reflected the individuality of its inhabitants. Many of the units made idiosyncratic statements; those that did not served as signs of memory, albeit in their rundown glory.

Together, they coalesced into an alluring collage. The transformation was not an erasure of Le Corbusier's architecture; it should rather be understood as an acknowledgement of the flexibility of his design to respond to change, as a salute to his creativity.

More recent developments call for the restitution of Le Corbusier's architecture to its original forms and for the declaration of the site as a historic monument. I see this move as neither good nor bad, but simply as a reflection of another set of changing values, another episode in the history of Cité Frugès. And, if it gets cleaned up, architectural photographers will no longer seek ways to edit out the impingements to the master's work.

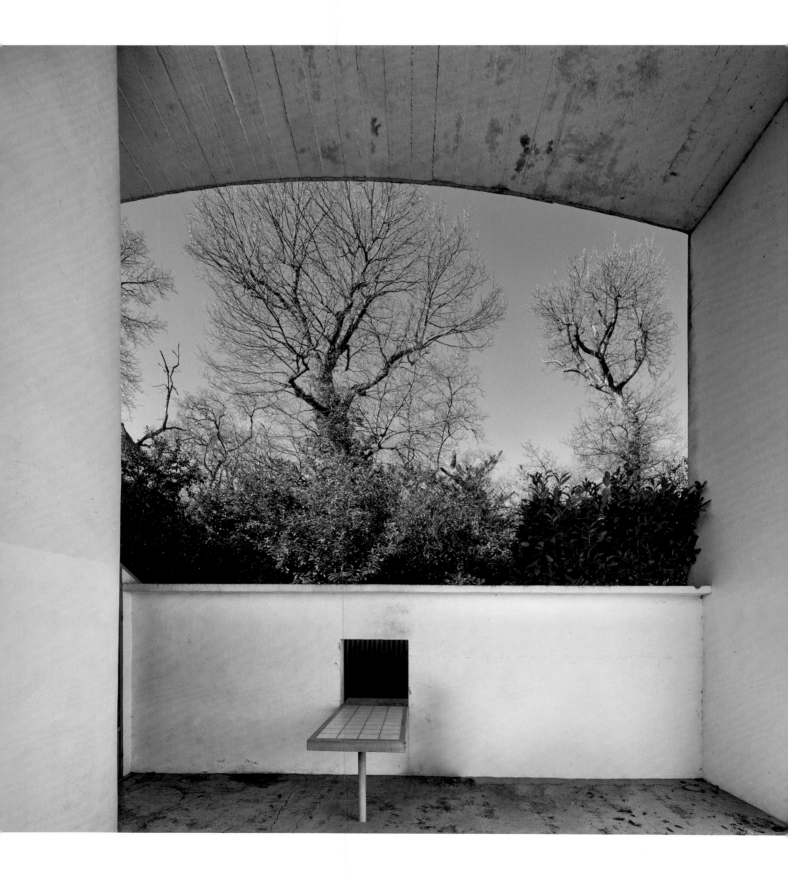

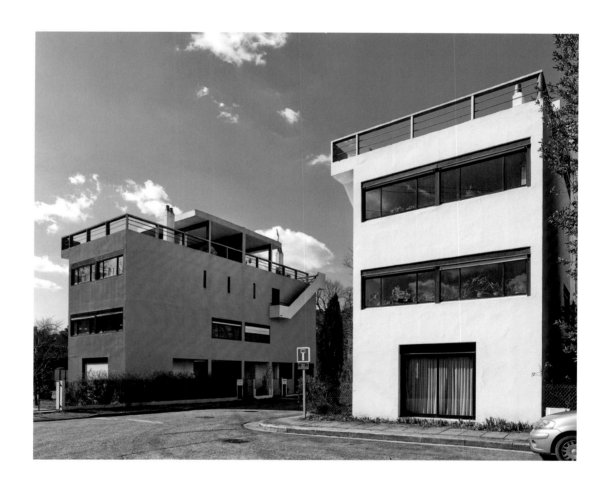

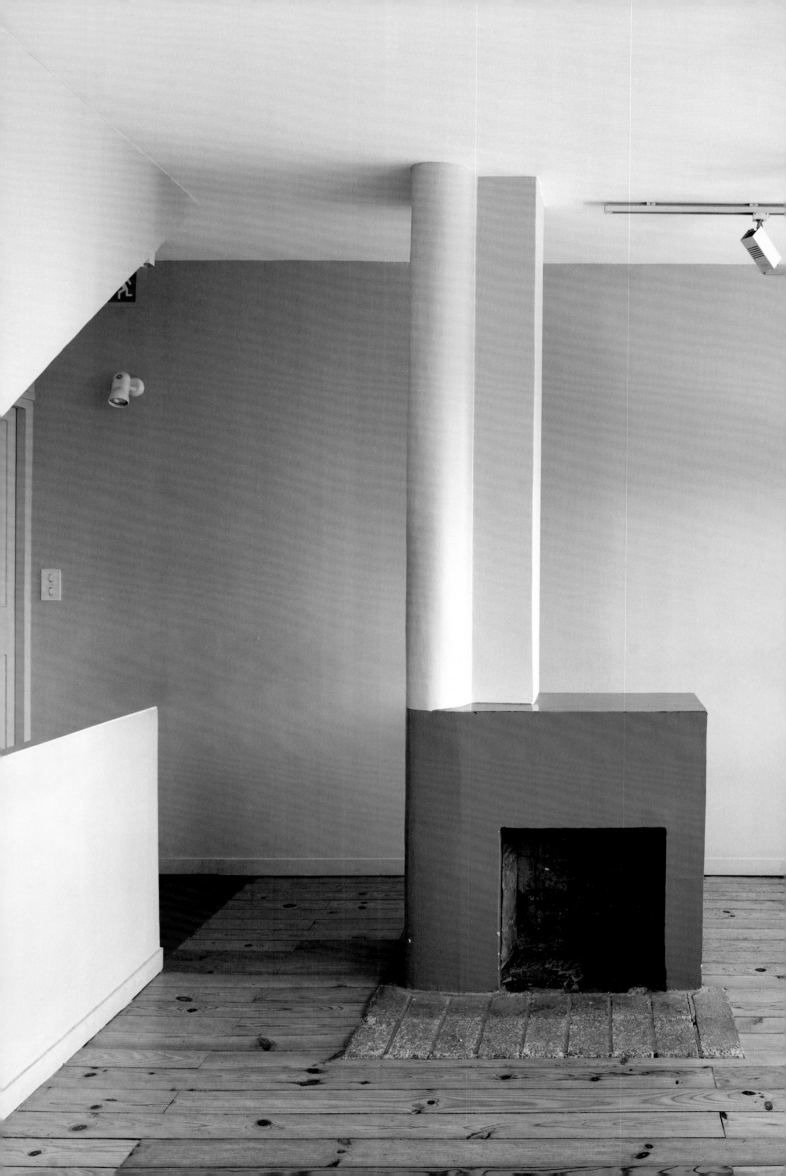

Maison et Cantine
Lège, France, 1924

Symmetric–Asymmetric Reflections

ATİLLA YÜCEL

As it appears in Cemal Emden's frame, Le Corbusier's Maison Planeix is a building situated in the south of Paris, on boulevard Masséna. It is part of a building row and, like its neighbours, it consists of a single facade. Because the photograph was taken perpendicular to the facade, it seems that the profiles of the projection at the front have been thoroughly erased and the planar effect of the only surface has been further emphasized. The photograph frames the facade laterally between the minimal borders of the neighbouring buildings, underneath by the pavement and above by the roof parapet. If it had been shot from further away, the planar effect would have been enhanced.

In fact, there are two planes that are not perceived in this facade photograph, for lack of an angle: the surface that stretches from the pavement line of the main facade and includes the glass case and window bays, and the surface generated by the large and blind projection in the middle. The balcony eaves that end level with the second surface help complete the surface in one's mind; this allows those in the know to construct the plane that is flush with the building on the right as a virtual screen that presents the main facade. The glazed metal surface that starts at the frontage line of the adjacent building (and continues along neighbouring buildings) is already a tangible part of this screen. Since the photograph was taken facing the building, the differentiation of the two planes is not fully perceptible and the screen up front becomes more of an image.

Because this photograph was taken from a point directly facing the house, centred and perpendicular to the facade, it erases the details and represents the facade in its ideal form as depicted in projected elevation drawings; the points of connection of the projection to the main facade, with horizontal window niches, are also not included in the photographic frame. In fact, the architect has used a series of articulation elements, such as horizontal band windows, horizontal balcony and terrace guard rail profiles, a vertical window that detaches the console from the facade, and thin vertical cuts that separate the building from its neighbours. The photograph erases all this as much as possible and reduces the facade to an ideal composition.

As it idealizes the building as a surface composition, the photograph erases the scale that differentiates it in relation to its environment. In fact, the floor heights of the house are different from those of the neighbouring buildings: they are higher. This gives the building a different scale from the rest of the buildings in the row with the same number of floors. This difference is much more apparent in the rich and vibrant back facade that overlooks the garden but which is hidden in this photograph. What we have here is a facade composition whose scale becomes undefined. In my opinion, this is the magic of photography and a deformation belonging to the photographer's sphere of creativity.

When one looks carefully, it becomes apparent that the symmetry of the building deteriorates on the second floor; that the single square window without a symmetric counterpart on this floor brings an unexpected dynamism to the facade. Had the frame been wider, we would have perceived the integrative role of this asymmetric layout in the building row that includes Maison Planeix. Since the floor heights of the surrounding buildings vary – one higher and the other lower – there is a musical rhythm from the higher building on the right towards the left, a decrescendo. The photograph erases this possibility and squarely places this Palladio-like building within the concept of an 'ideal villa'. At this point, we relate by association the architectural set-up of this relatively small house to the text that Le Corbusier wrote on his house designs of the time and his design for the League of Nations building in Geneva, *Une maison – un palais* (A House – A Palace). We know of the architect's other Palladio-like designs, especially in his early period, whose symmetry became distorted: examples are Villa Stein and Villa Savoye. The distortion in the Maison Planeix is at a minimum compared to Villa Stein.

Mental associations link the building to other designs as well: the white, symmetric, purist facade is reminiscent of Adolf Loos's Moller House, and to some extent the same architect's Tristan Tzara House. It is possible to read the relation between Loos's perfectly symmetric Moller House design and his later, asymmetric Villa Müller as being similar to the relation between the Maison Planeix and Villa Stein. These two almost contemporaneous Le Corbusier buildings are also similar in the importance of the facade, their centrality, their use of a band window and of projections or balconies, and their references to Palladio villas.

Built between 1924 and 1928, Maison Planeix was designed for a sculptor. There is a garage in the central opening on the ground floor; to the right and left are the sculptor's studios. Initially, however, the architect had thought that the ground floor would be empty and stand on a three-bay pilotis system, as in his ideal conception of a house. Nevertheless this version, with a glass case on the ground floor, allows a comparison with other house-studios: the two-storey-high, glazed ground-floor studio is reminiscent of the upper-floor studios in other houses by the same architect, built according to a similar programme, such

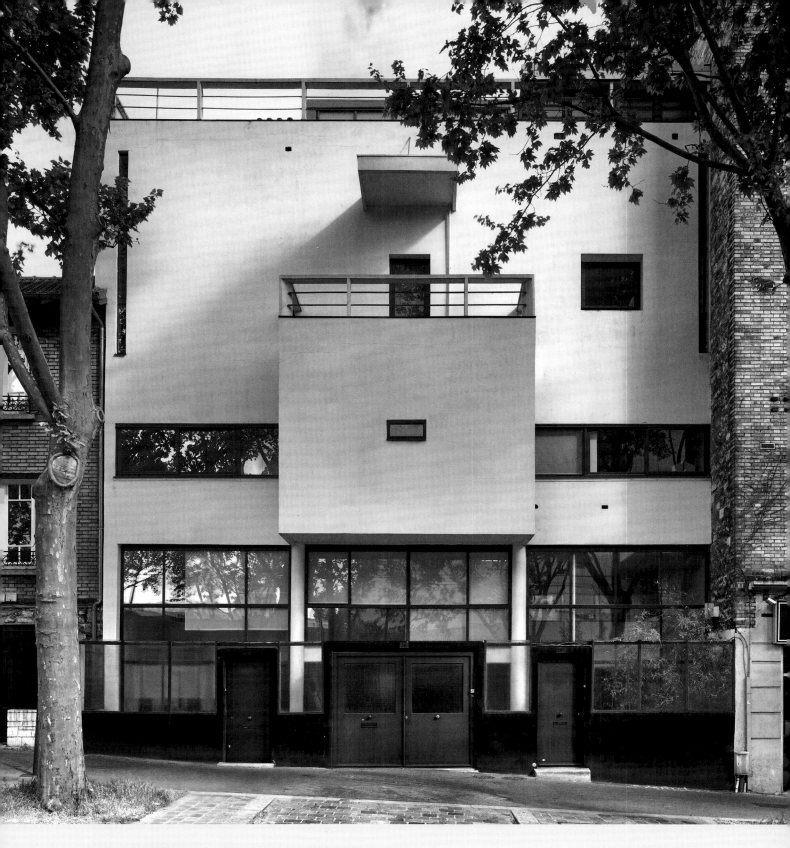

as the Atelier Ozenfant in Paris and Maison Guiette in Antwerp. We find the same solutions in the Braque house, a Perret design of the period that has a similar functional programme. The buildings carry the same functional essence: the house-studio couplet led two different architects to two symmetric solutions in their designs for buildings during this period.

When a design that swerves between symmetry and asymmetry, modesty and excess of scale, being part of a series and standing on its own, is frozen via photography, it is reduced to an idealized visual concept. We read it between the lines, deconstructing it every time using our memory and imagination, only to reconstruct it again with different cognitive reflections.

Maison Planeix
Paris, France, 1924

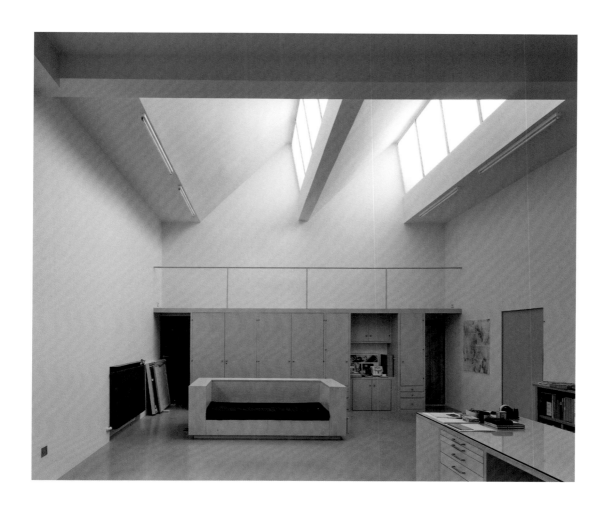

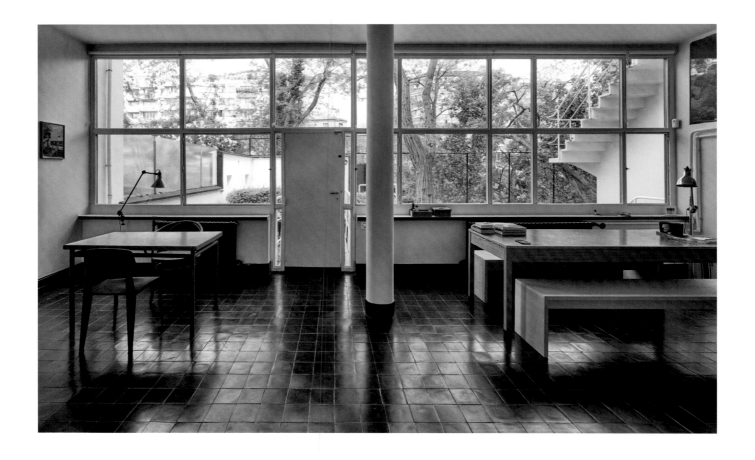

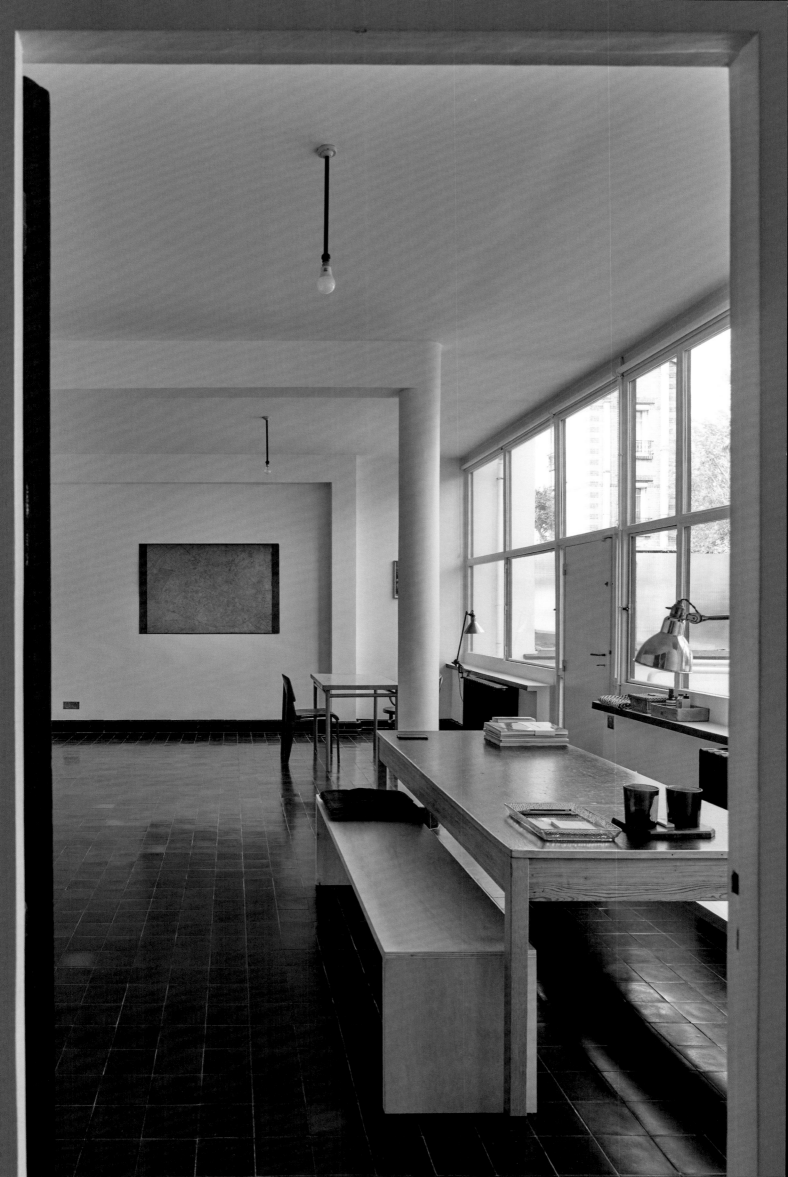

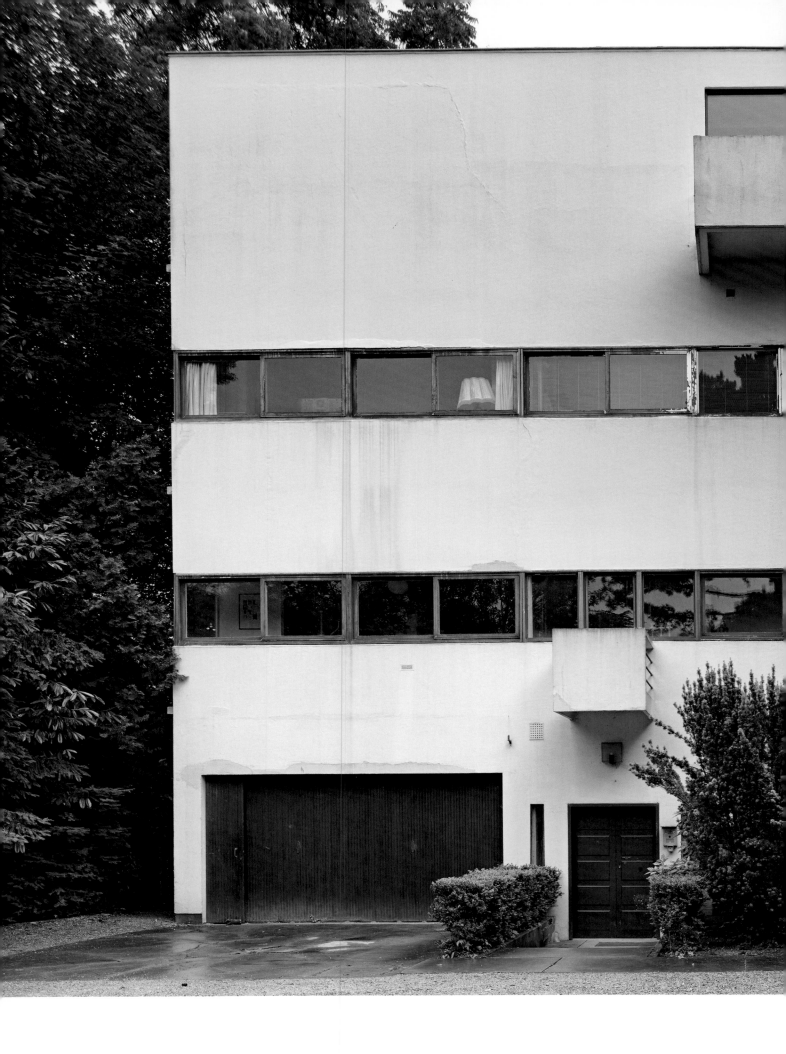

Villa Stein-de-Monzie
Garches (Vaucresson), France, 1926

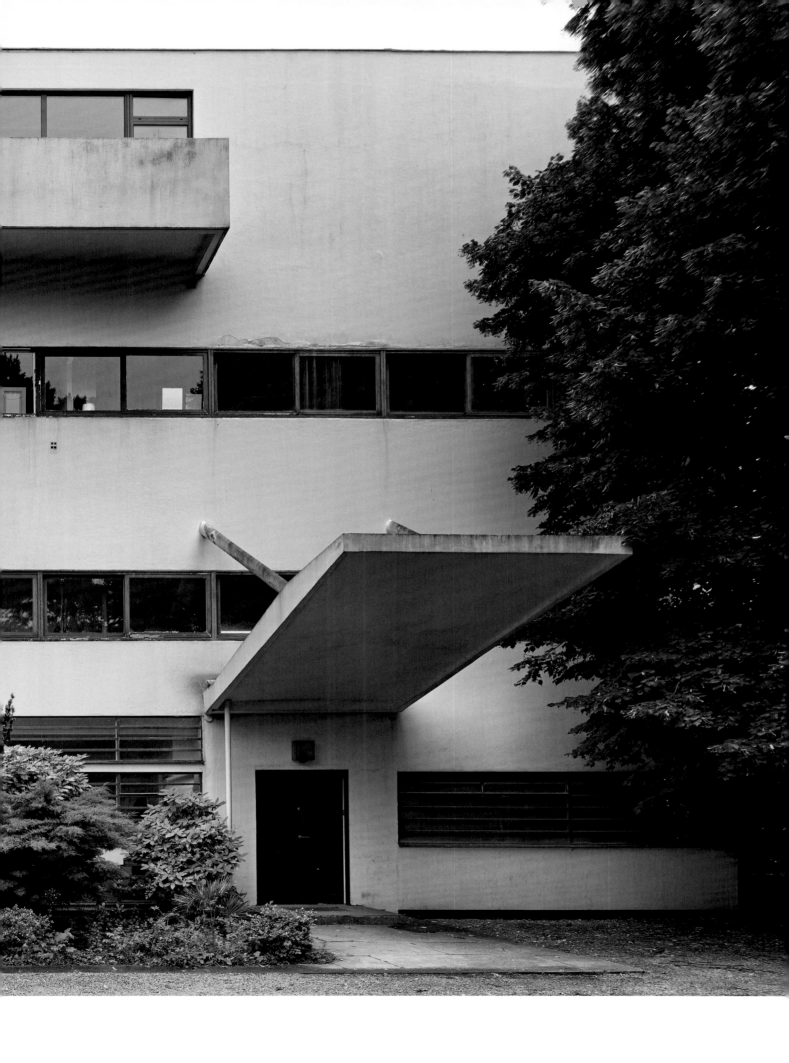

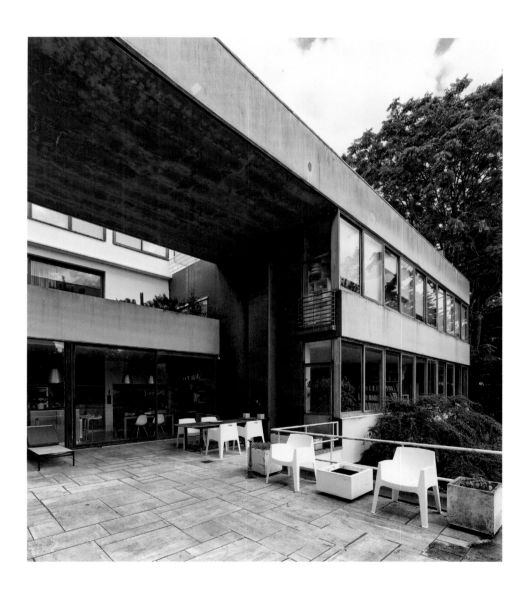

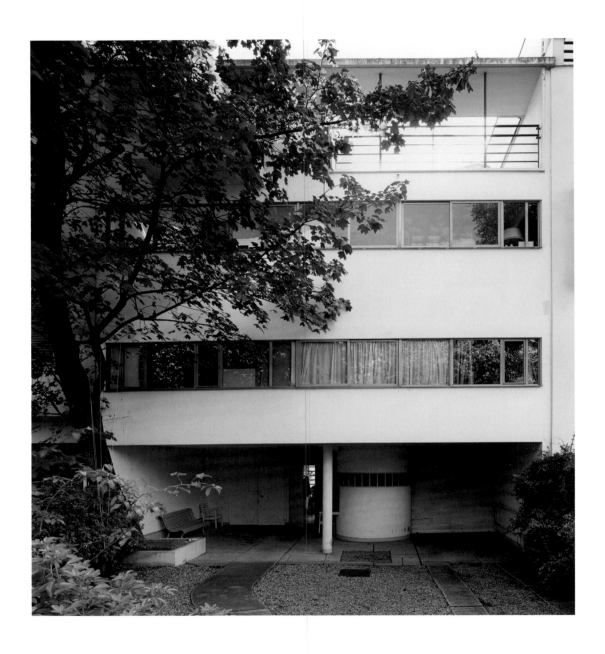

Maison Cook
Boulogne-sur-Seine, Paris, France, 1926

Maison Guiette
Antwerp, Belgium, 1926

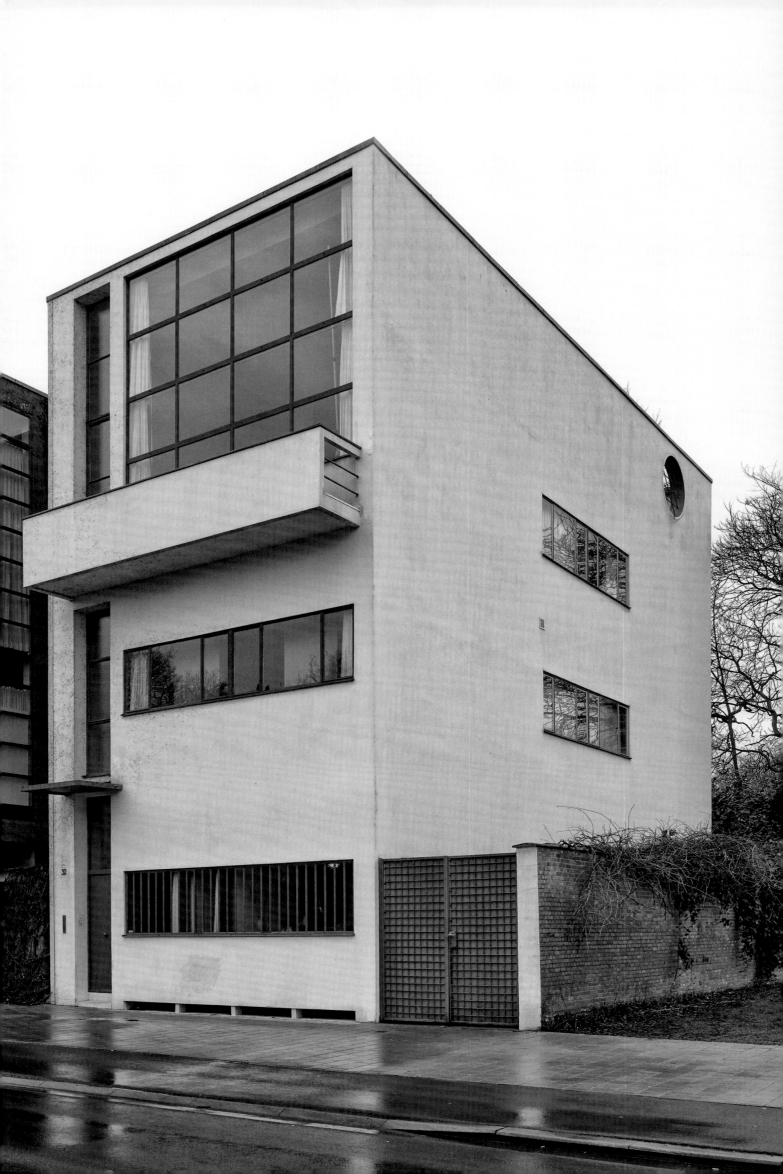

Inside the Photograph: Matter or Reality?

İHSAN BİLGİN

Here we have a generic Le Corbusier photograph. Can a photograph show everything? Up to a point … but not even all of the architecture … All right, it's an angle that an eye unaware of what to expect from free plan architecture would not see; but are we seeing the architecture, the photographer, or the house? We cannot know which one would excite Roland Barthes, whose words we used for the exhibition that occasioned this piece. But even those much attached to writing, who like me prefer to ask 'what' instead of 'who' and put the object in the place of the subject, are not lacking for words: what makes the upstairs and the ground where the photographer stood so refreshingly spacious is not the planimetric plane representation – nothing more than an abstraction – of the two elevations, which the architect insistently underlined from Maison Citrohan on, but the continuity of the cross-section, which represents the perspective of a person standing up. The two elevations flow into each another by way of an uninterrupted, obviously not constructive staircase. Thus what actually unites, refreshes, enlarges and makes both elevations so spacious is the equivalent brightness of the sunlight also washing the shared beige wall facing us. Or it could be the curved wall under the column of the upper elevation, or the concrete curtain wall buried inside the column downstairs, or the plaster wall covering the service areas behind it.

That those who pay close attention to the photograph understand I have begun to use 'free plan' knowledge indicates not only their attentiveness but also that they may be architects. The exhibition's curator, photographer and other writers share with them Le Corbusier – a fellowship of imagery first with his early generic drawings, Dom-ino and Maison Citrohan, and beyond, to the humble types within the installation 'unit' from Weissenhof and even Pessac's optimal workers' housing. Is solidarity a closed chain of subjectivities that begins and ends in intersubjectivity? Or does it also require material mediation? Thus once again we come back to Faust's question: what was there first, action or words? What will bring the world to an end – global warming, fate? That endless quarrel between materialism and idealism … If Roland Barthes is self-evidently a theoretician of words, I must from words arrive again at material (the space shown in the photograph) and not leave materialism, whose side I take in that quarrel, bereft of its partner dialectic, lest I lose philosophical, social or political allies. I will even take this opportunity to send humble regards to Werner Öchslin, whom I call my esteemed colleague and friend although we have met only a few times, for his kind intention to dedicate to me his study, Sinan-Palladio by way of Le Corbusier.[1]

We are familiar with that beige tending to grey of the facing wall, because it exists in the colour chart. But it is impossible not to wonder what that prismatic flowerpot is doing under the stairs, and the unnecessary contrast of the sunlight illuminating the point under the stairs likewise bothers the eye.

It was a work of his I did not know; on my trip to Antwerp I will find the same angle and test it out …

Istanbul, 17 January 2016[2]

1 Werner Öchslin, 'Proportion: A Modern Myth and a Dynamic Concept in the Process of Form Giving', paper delivered at the Sinan-Palladio Conference held at Istanbul Bilgi University on the occasion of the publication of the Turkish translation of Gülrü Necipoğlu's The Age of Sinan.

2 I went and saw it because of the closing panel of Murat Tabanlıoğlu's 'Port City Talks: Antwerp-Istanbul' exhibition at Antwerp's MAS museum. I and my friend Korhan Gümüş, who visited the house with me, decided that since the family who bought the 1925 house in 1993 had sensitively restored it in a way faithful to the original and enjoyed living there with their children, a Great Dane and other animals, the prismatic box in the photograph I thought a flowerpot under the stairs, illuminated by florescent lighting – invented in 1936 – must have been put there by a professional who occupied the house some time in the intervening years. On the other hand, considering that the other object bothering my eyes, the wall lamp (seen in other photographs in the living room of the house), was the same, it might well be a misguided attempt to reproduce one original to the house. Antwerp, 22 January 2016

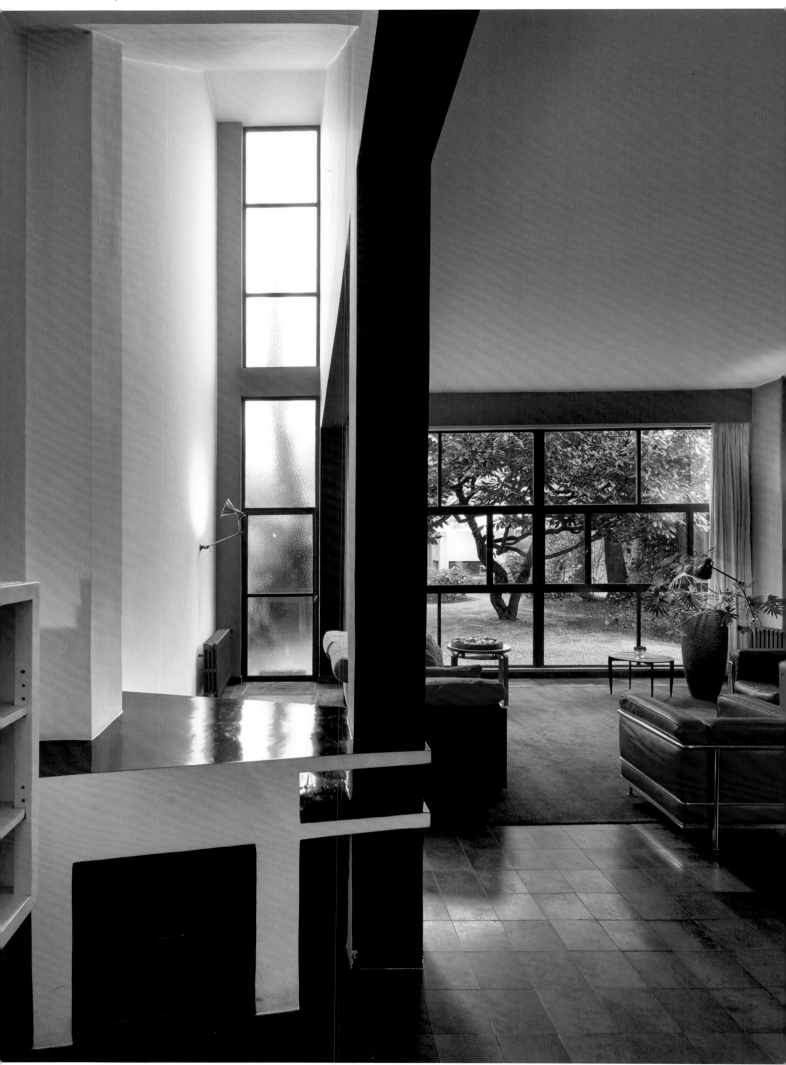

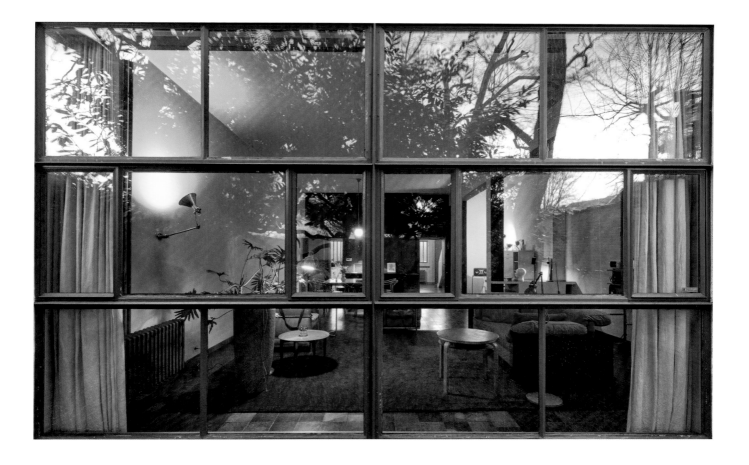

Houses of the Weissenhofsiedlung
Stuttgart, Germany, 1927

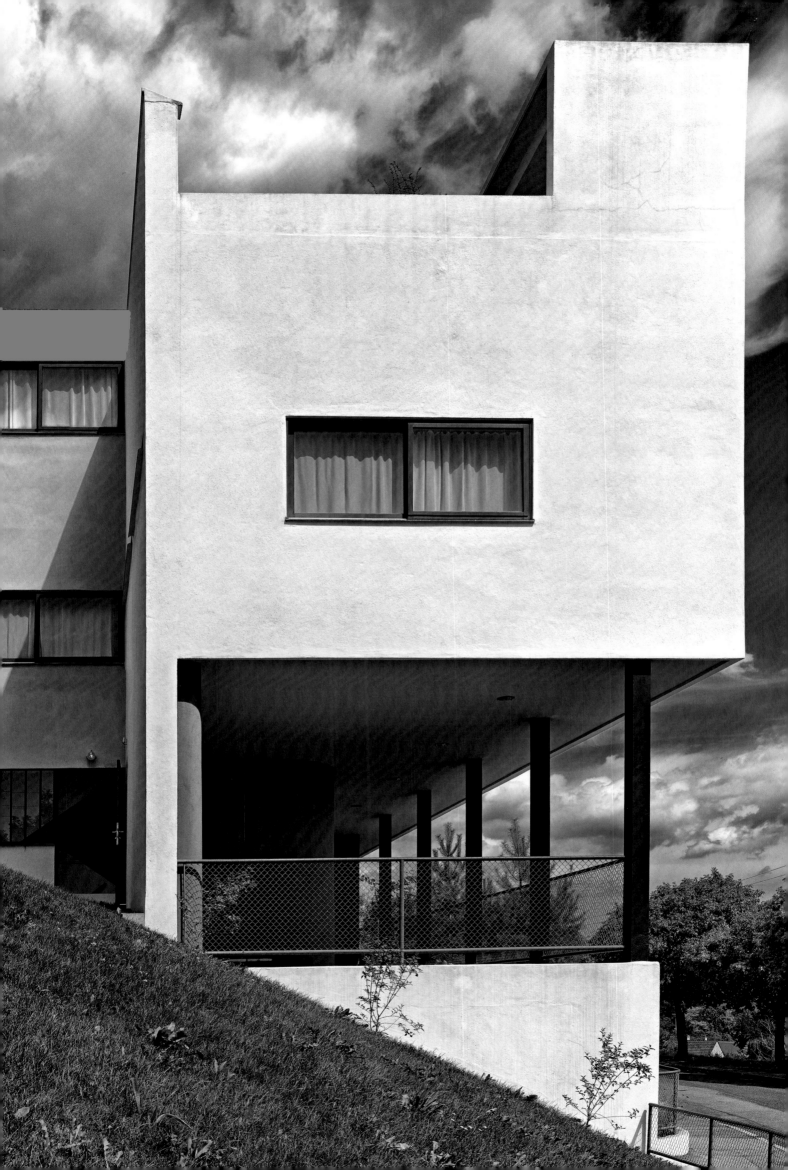

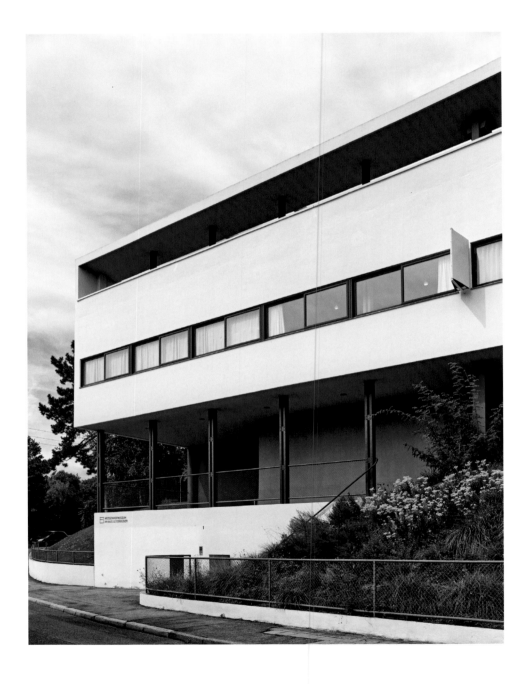

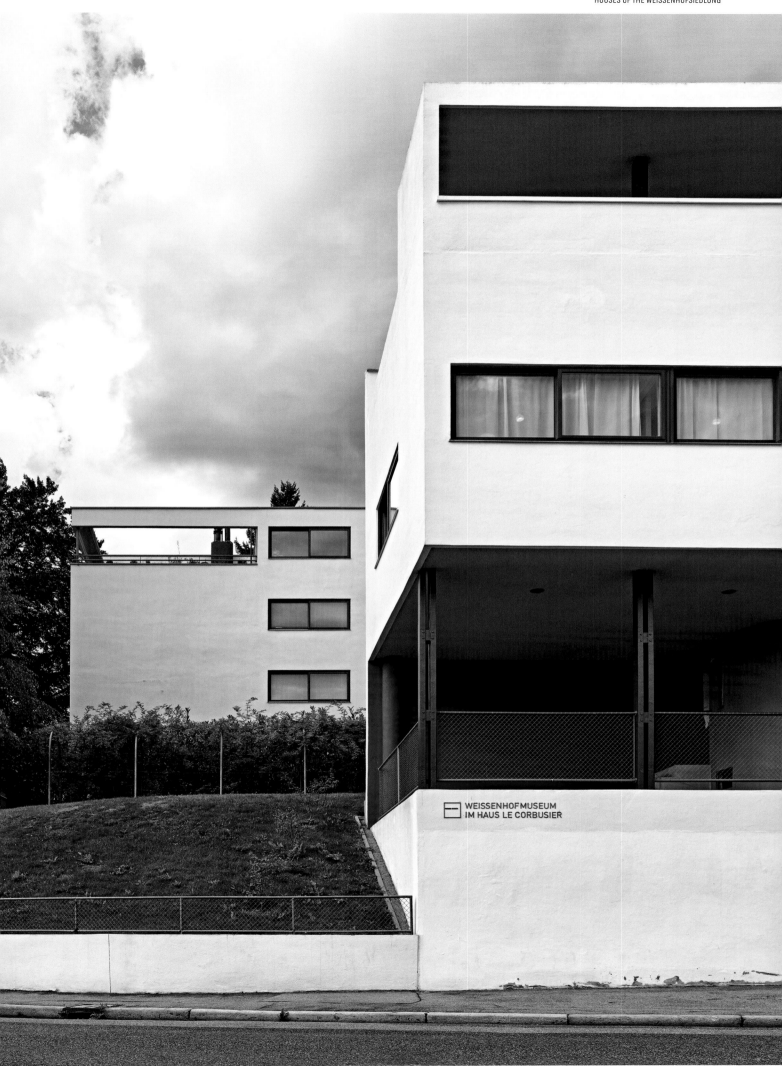

WEISSENHOFMUSEUM
IM HAUS LE CORBUSIER

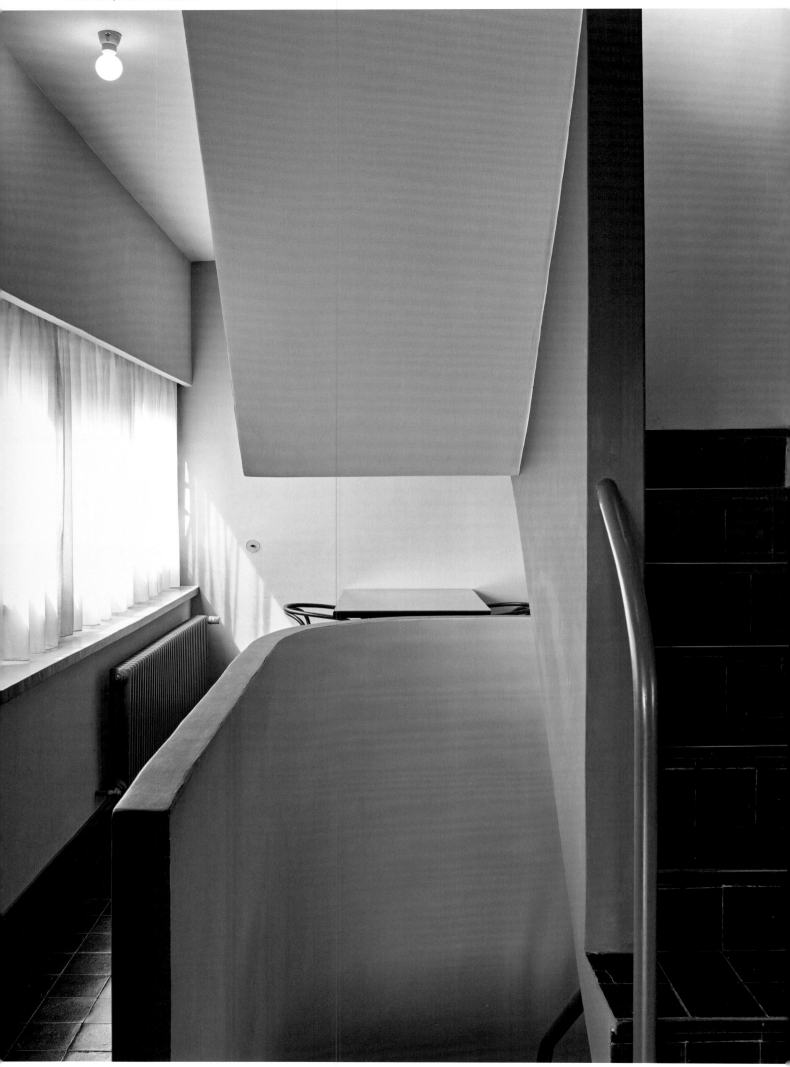

Melancholy in Moscow's Streets

JEAN-LOUIS COHEN

When Le Corbusier started designing the headquarters of the Central Union of Consumer Cooperatives of the USSR, or Centrosoyuz, upon the invitation of the Soviet government, he conceived in 1928 a number of possible combinations of its diverse components. Much more than the flat glass facade on Myasnitskaya Street, which was to house the main entrance, the rear facade on Akademika Sakharova Avenue, which was invisible until the opening of this wide thoroughfare in the 1970s, conveys the drama of a design that took the Paris office more than three years to complete.

The first feature of the building captured by this photograph, shot on a grey winter's morning, is the suspension of its volumes in the air, which resulted from the extensive use of pilotis, a device Le Corbusier had started using in his Paris villas. He wrote in one of the lectures he held in Buenos Aires in 1929, 'Circulation is a term I used all the time in Moscow. Architecture is circulation. Think about what this means. It condemns academic methods and sanctions the principle of pilotis.' Furthermore, if this view does not reveal the most sinuous of the ramps used for the interior circulation of Centrosoyuz employees, as other photographs by Emden do, one sees on the right side of the curved volume of the auditorium the white stucco cylinder of one of the ramps leading to the uppermost floor.

Beside this ramp, the four units arranged by Le Corbusier and a team that included the Russian architect Nikolai Kolli are clearly perceived, with their specific features and in the syntax of their assembly. In the same 1929 lecture, Le Corbusier described the thicker block on Myasnitskaya Street, the less visible on the photograph (barely a chunk on the left of the white ramp), saying it 'contains large areas for collective work and is enclosed within plate-glass facades at either end'. The two other office blocks feature 'a glass facade on one side, and a mixed (glass and stone) wall for the corridors; at the ends, completely opaque walls of the same stone'.[1] One of these walls projects onto the street at the right of the photograph.

The central block housing the auditorium is not only 'a storey lower than the two flanking buildings', it is also wrapped in a curved stone envelope. In order to describe the assembly of the four blocks, Le Corbusier used a landscape-related metaphor, affirming that 'they are disposed in plan and section so as to create specific impressions, here a vertical cliff-wall there a welcoming basin.' As a consequence of the use of the pilotis, 'the building resembles an object in a window-display, and it is perfectly legible.' He adds, 'on the skyline, the impeccable lines of this crystal prism [are] circled with a band of volcanic stone that mark

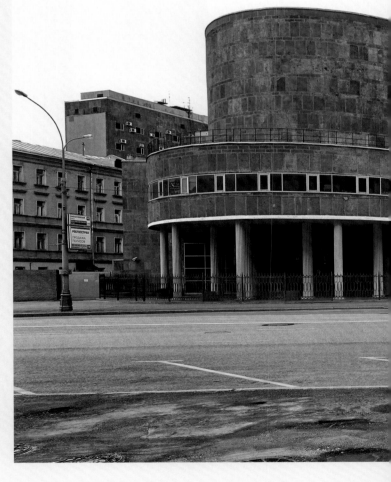

the parapet of the terraces,' producing a 'sharp break with the sky'.

Despite the thick aluminium frames installed during the last restoration campaign in 2011, which break unfortunately the continuity of the facade, the building still carries with it the heroism of its initial intentions, as well as the treason of Kolli, who under the pressure of Stalin's socialist realism transformed the pilotis carrying the auditorium into fluted columns.

1 Le Corbusier, *Précisions sur un état présent de l'architecture et de l'urbanisme* (Paris, 1930), pp. 59-60.

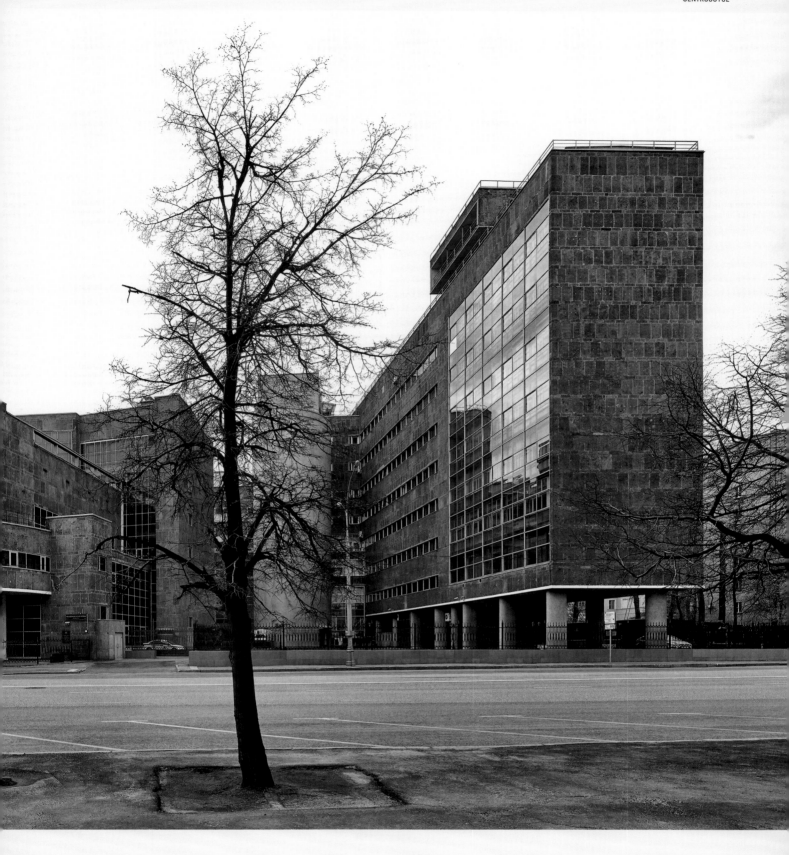

Centrosoyuz
Moscow, Russia, 1928

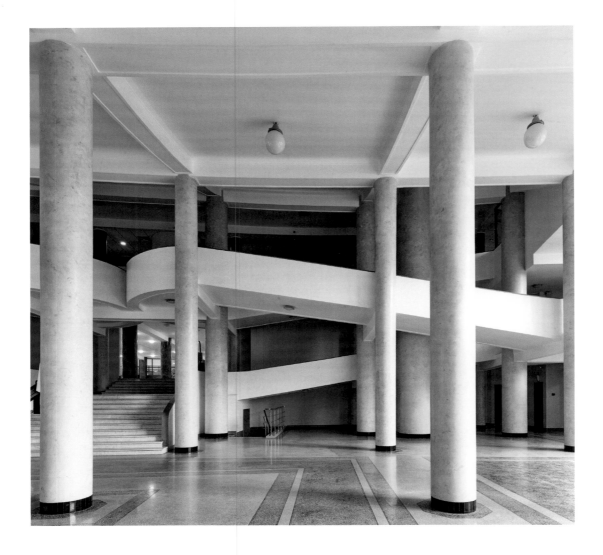

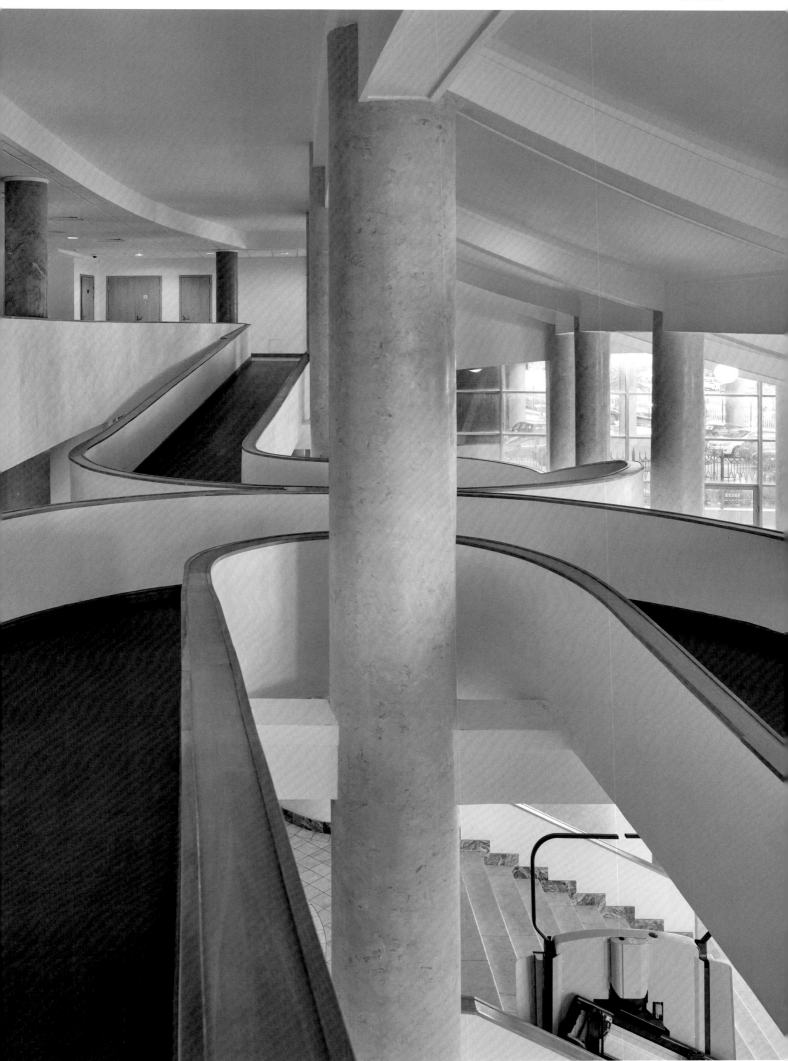

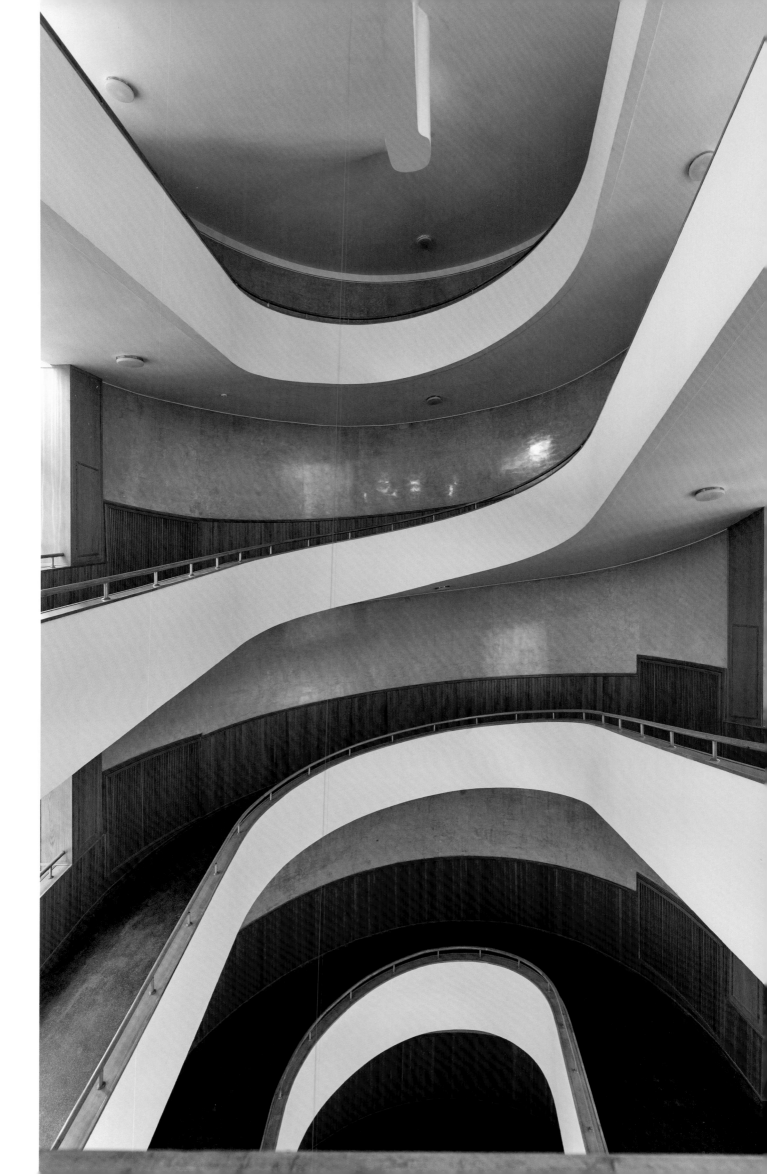

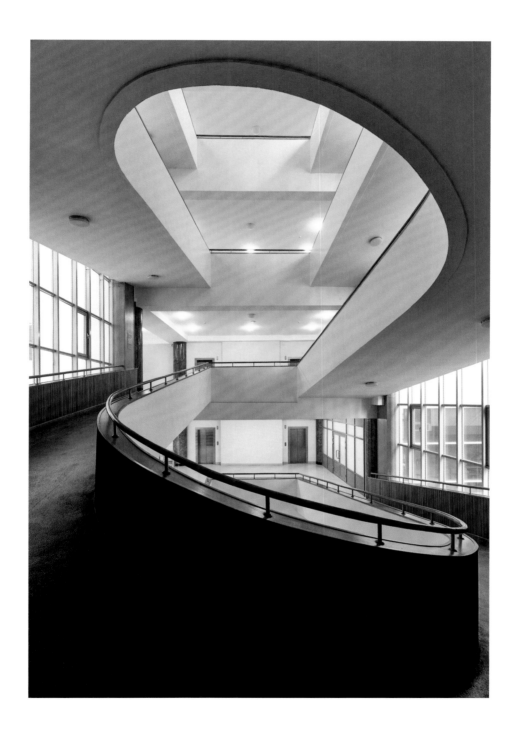

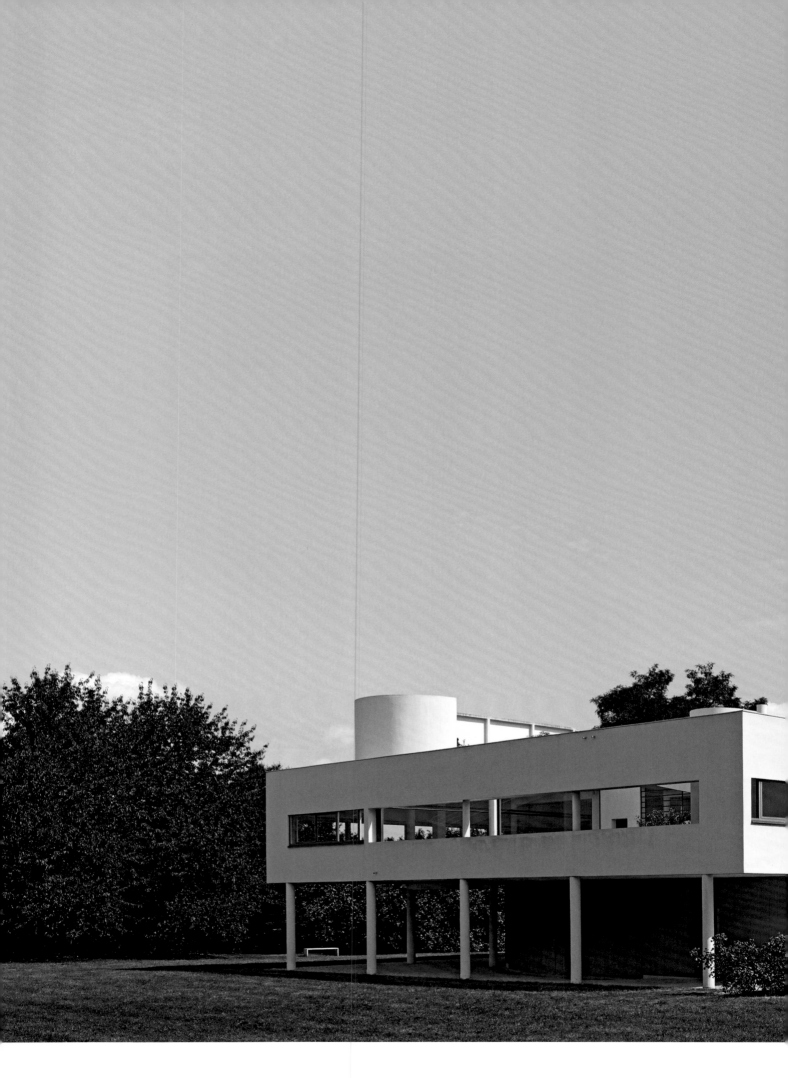

Villa Savoye et Loge du Jardinier
Poissy, France, 1928

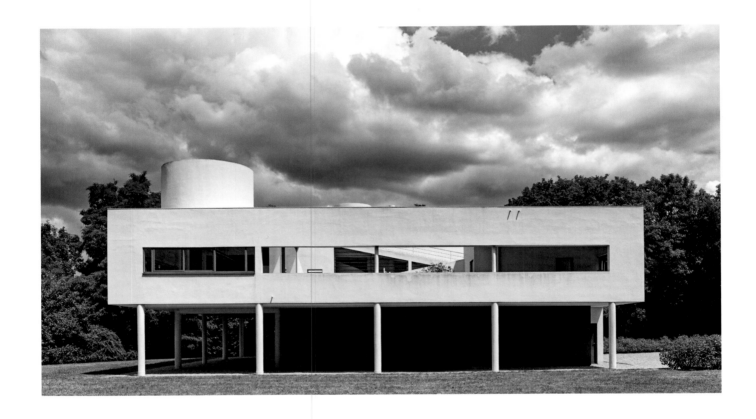

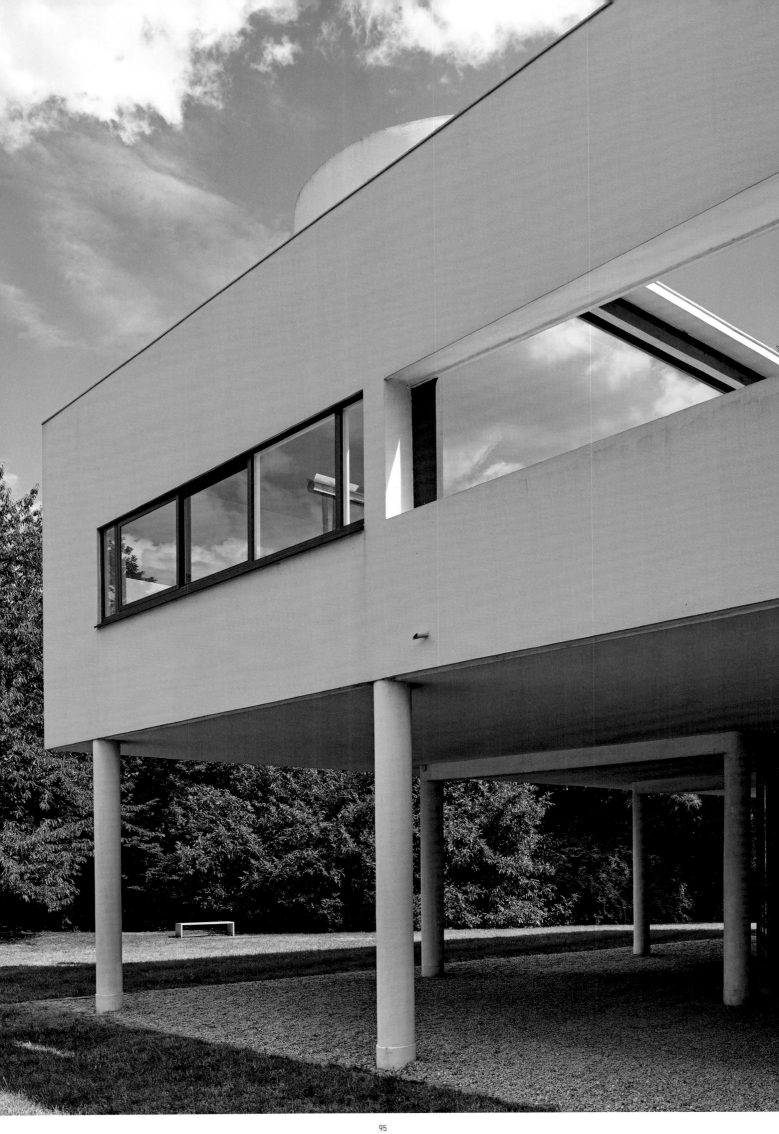

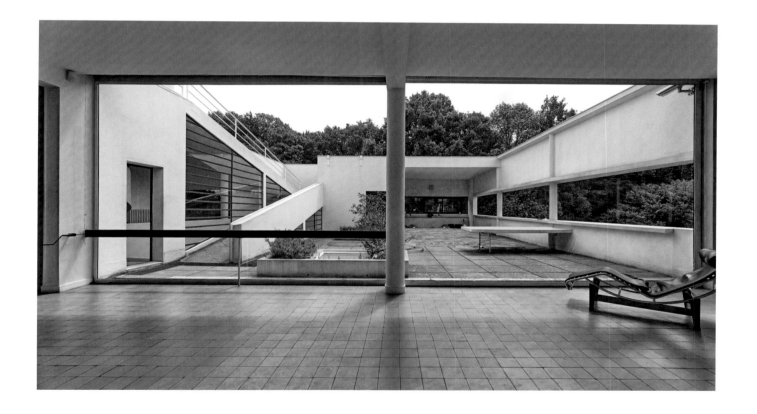

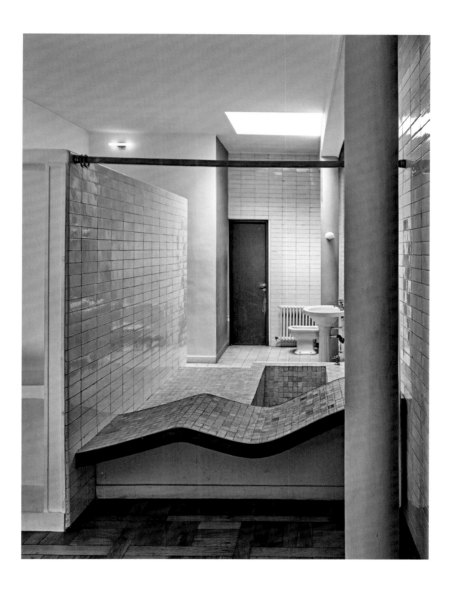

Five Points in Miniature

PEDRO BANDEIRA

It is very rare to see this little modernist object designed by Le Corbusier, from the entrance of Villa Savoye, photographed or published. With a surface area of about 35 square metres, the so-called Gardener's House (Loge du Jardinier) is almost always ignored, overshadowed by the exuberance and appeal of the villa.

With an unquestionable formal coherence, Le Corbusier applied in this small home four of the Five Points that he advocated for modern architecture: the pilotis, the free plan, the free facade and the horizontal window, leaving out only the roof garden – a leisure that the gardener was, ironically, denied.

The commonality of principles between the two houses mirrors a willingness of modern architecture to be accessible and transversal from an economic and social point of view. However, in the particular case of this villa, the contrast between the scale and programme of the houses is abysmal. This comparison would be totally unnecessary if Le Corbusier had not designed this object as a small replica of Villa Savoye.

This formal dependency on the main house relegates the Gardener's House to the background, to a level of mere representation or image. The Gardener's House is not a house but an image of a house. And indeed, the plan is too small to be free, the columns too close to the walls to be released or to release the facade, and its horizontal window, although generous, is nonetheless single.

The two things that interest me in Cemal Emden's photograph of the Gardener's House are almost contradictory. The first is the fact that this house does not look inhabited or attempt to appear so. The opaque glass surface of the window betrays nothing. There are no curtains, potted flowers or light inside. The only thing that seems alive in this house is a surveillance camera, pointed in an uncertain direction (one wonders if it is looking for an owner, or perhaps some affection). The second is the dignity that the photograph attaches to this subject. The correction of perspective, ensuring vertical alignments, makes a higher volume of a lighter house, suggesting a willingness to rise and perhaps leave.

I am interested in the brief attention and exclusivity that the Gardener's House received in this image. It compels me to think of this house as an autonomous and detached gesture of the architect. I wonder if it is possible to look at this house without knowing that it is a part of the Villa Savoye; to look at this object as if there were not also another, privileged object that gives it meaning. Probably it is not; there is no place for an innocent, naive gaze. Yet another irony emerges. In disrepair or recovery, Villa Savoye has become an archetype of modernism, occupying the minds of all architects. In fact it looks as if these two houses were constructed to be archetypes, whose existence takes on a meaning beyond the question of habitability. Ultimately, everything is image, everything is architecture, a house is not a home.

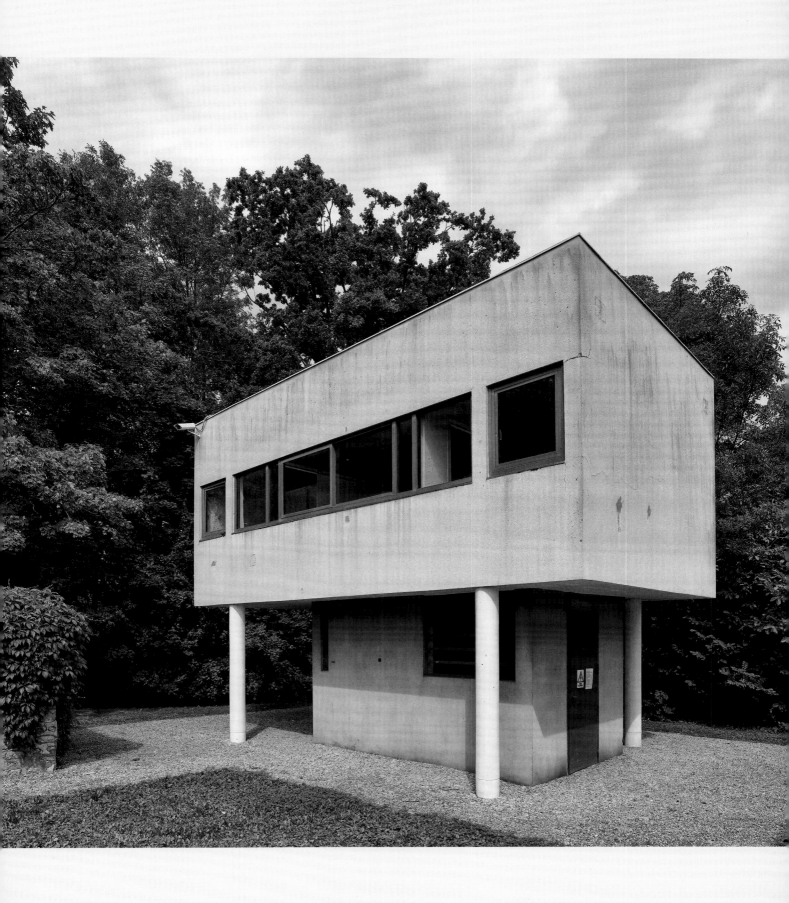

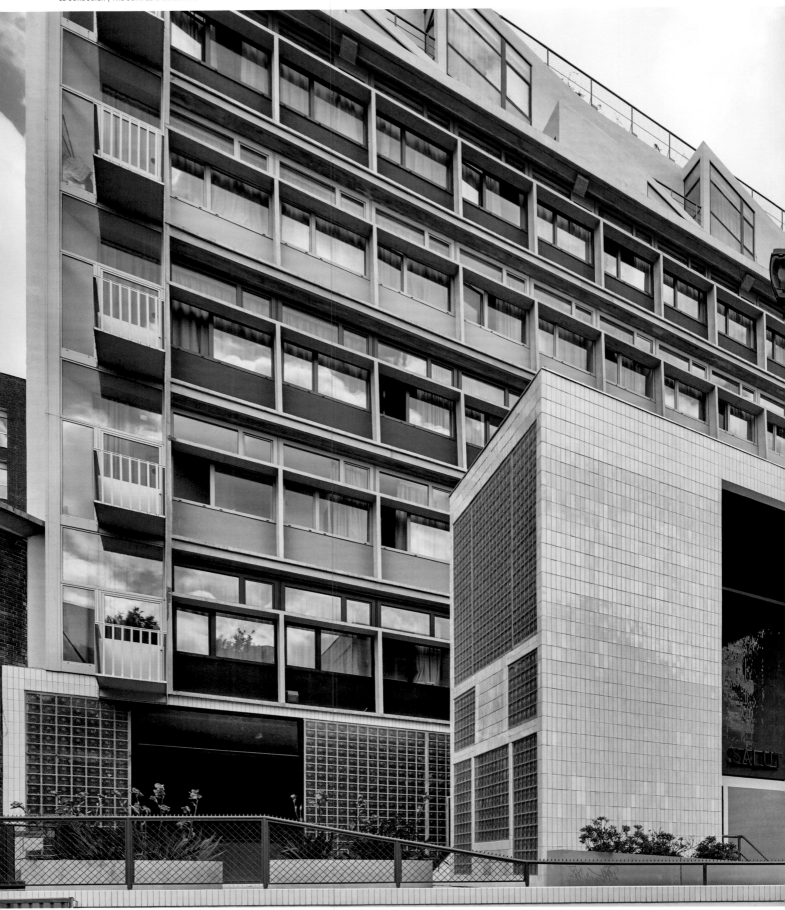

Armée du Salut, Cité de Refuge
Paris, France, 1929–33

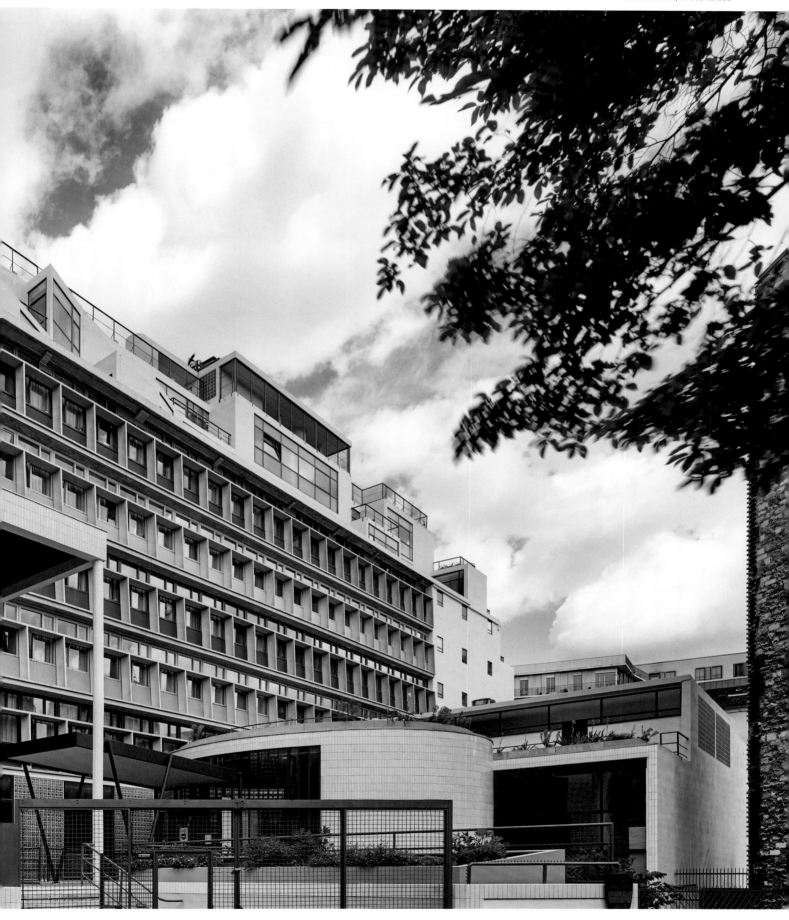

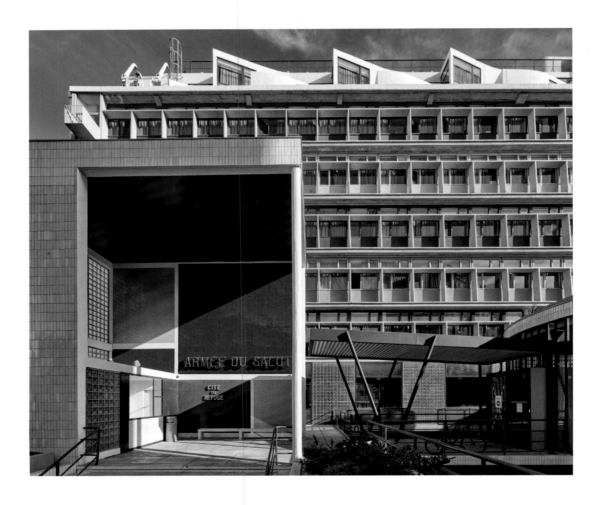

Le Corbusier

KENGO KUMA

My opinion of Le Corbusier changed when I saw the Swiss Pavilion. I clearly understood from the very rough and uneven stone cladding and concrete floor in the lobby, which made it appear as if the workers had failed to do their job properly, that Le Corbusier was striving to achieve the same effect as I do, and this made me very happy. The essence of Le Corbusier, which lies in this roughness and sensitivity, was something that directly touched my heart.

The thing that architecture needs most in the age of post-industrial society is this type of tarnished unevenness. The Villa Savoye is a building that appears to flirt with industrial society, and I was very disheartened when I saw it. I thought that the so-called architectural experts who call the building a masterpiece of the twentieth century were a group of useless, closed-off people, and wanted to get away from that place as quickly as possible.

Le Corbusier had the courage to break away from the part of himself that designed Villa Savoye and create the Swiss Pavilion. There was a period of only one year between the completion of Villa Savoye and the Swiss Pavilion. I think that this courage was Le Corbusier's driving force: he had the courage to liberate himself from his own designs in order to continually change and evolve. The latter half of Ronchamp has that overwhelming level of roughness, but from the perspective of courage, I was truly impressed by that shown by Le Corbusier in the Swiss Pavilion and the realistic sensation one gets of the architect groping to seek out and create new versions of himself. I also strive to have this type of courage: to break down and break away from the 'nice-looking' buildings of industrial society and create architecture that appears uneven and tarnished.

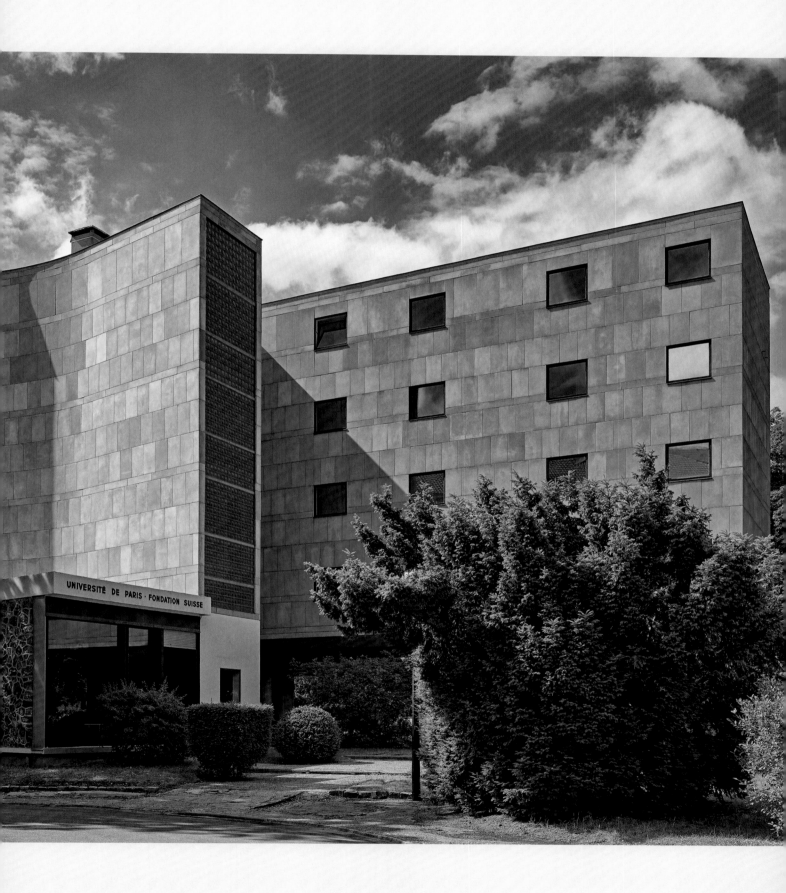

UNIVERSITÉ DE PARIS · FONDATION SUISSE

Pavillon Suisse
Paris, France, 1930

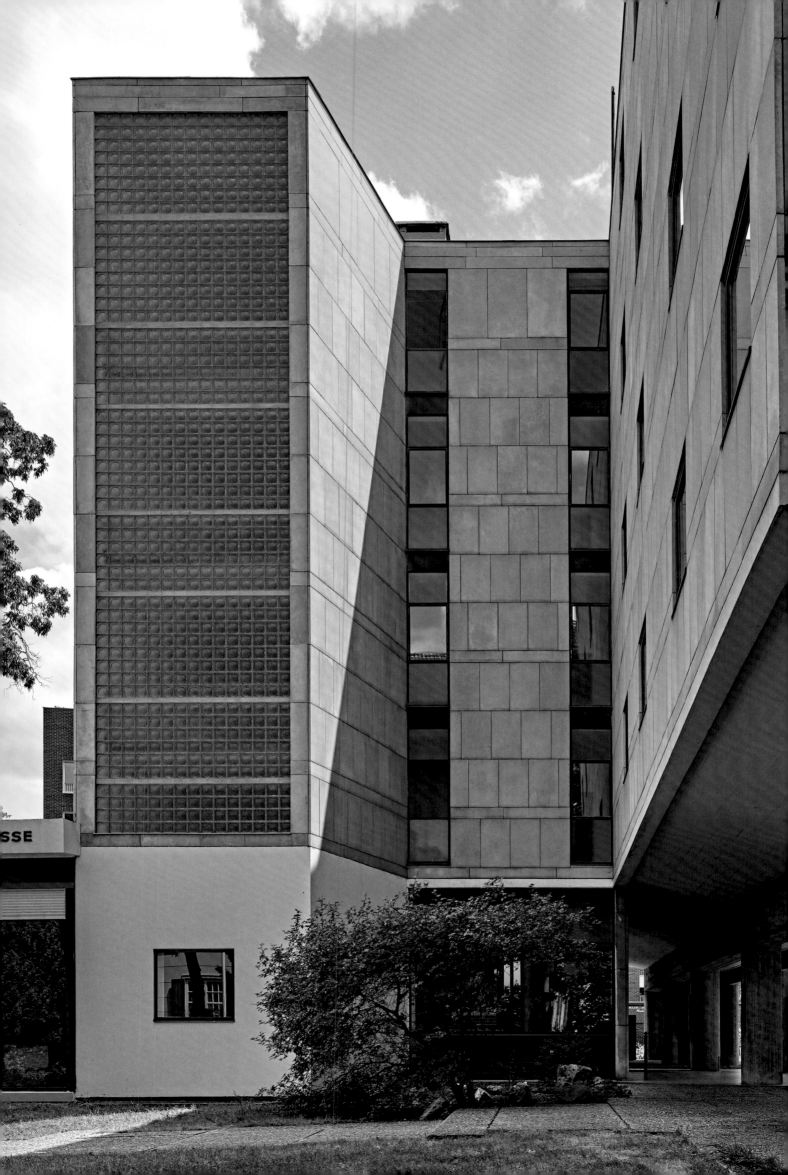

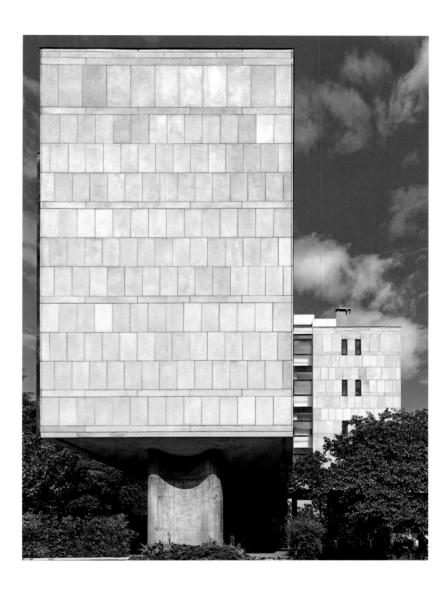

Immeuble Clarté
Geneva, Switzerland, 1930

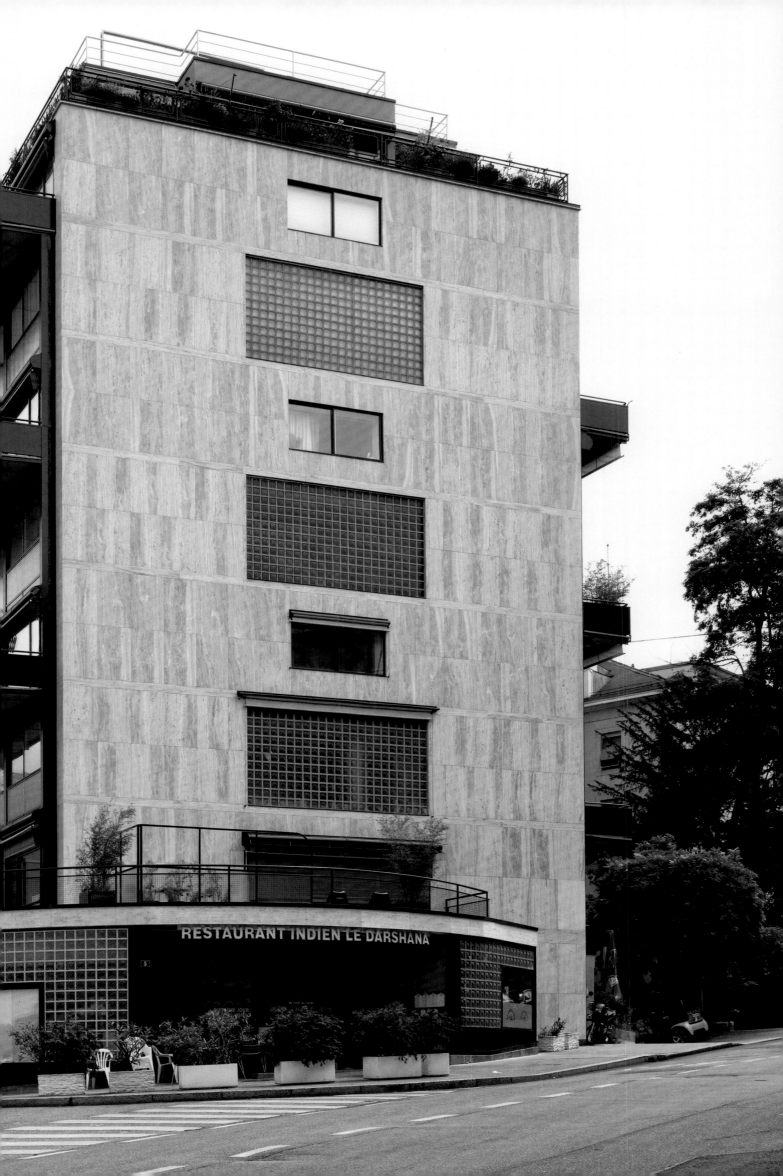

RESTAURANT INDIEN LE DARSHANA

Immeuble Molitor / Appartement de Le Corbusier
Paris, France, 1931–34

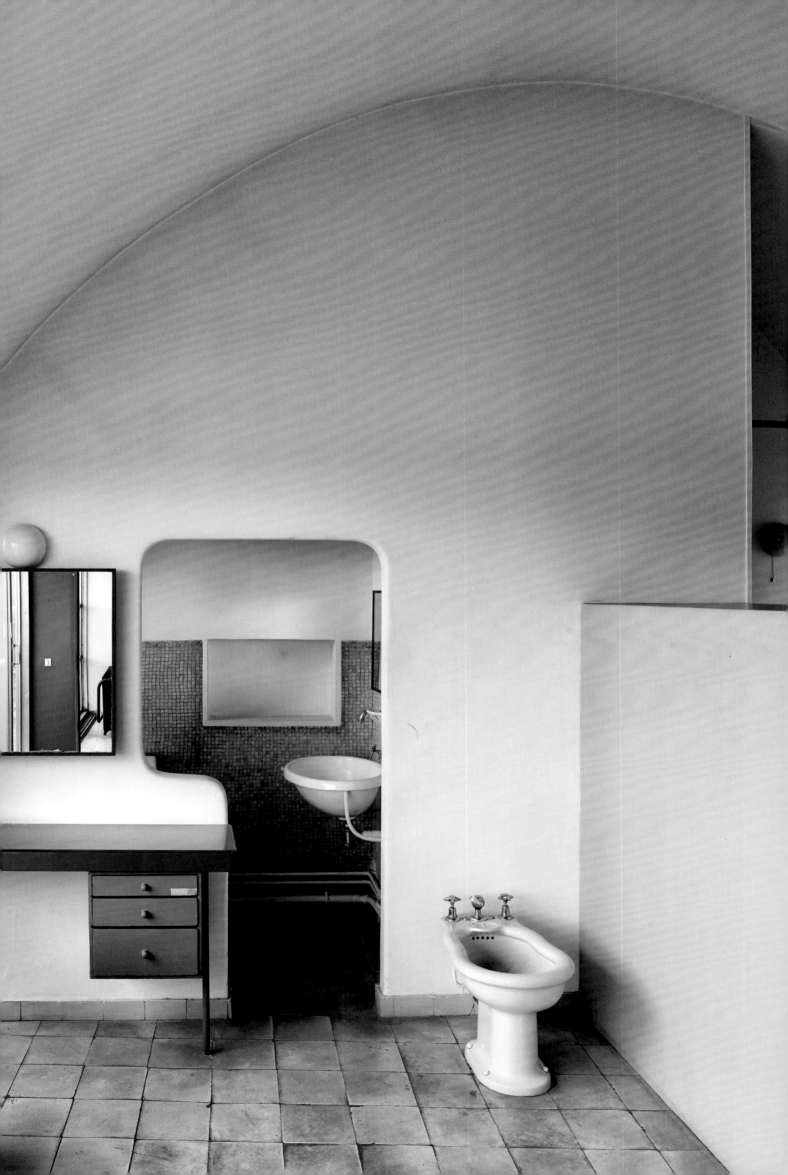

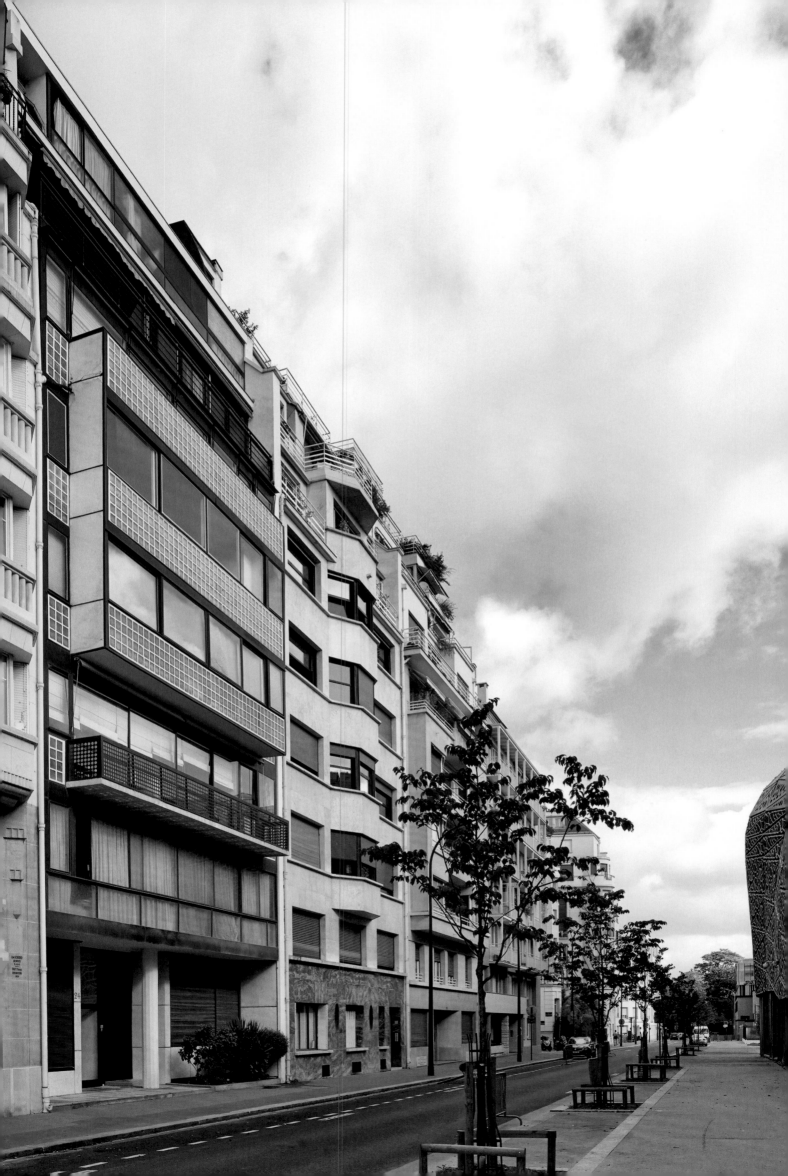

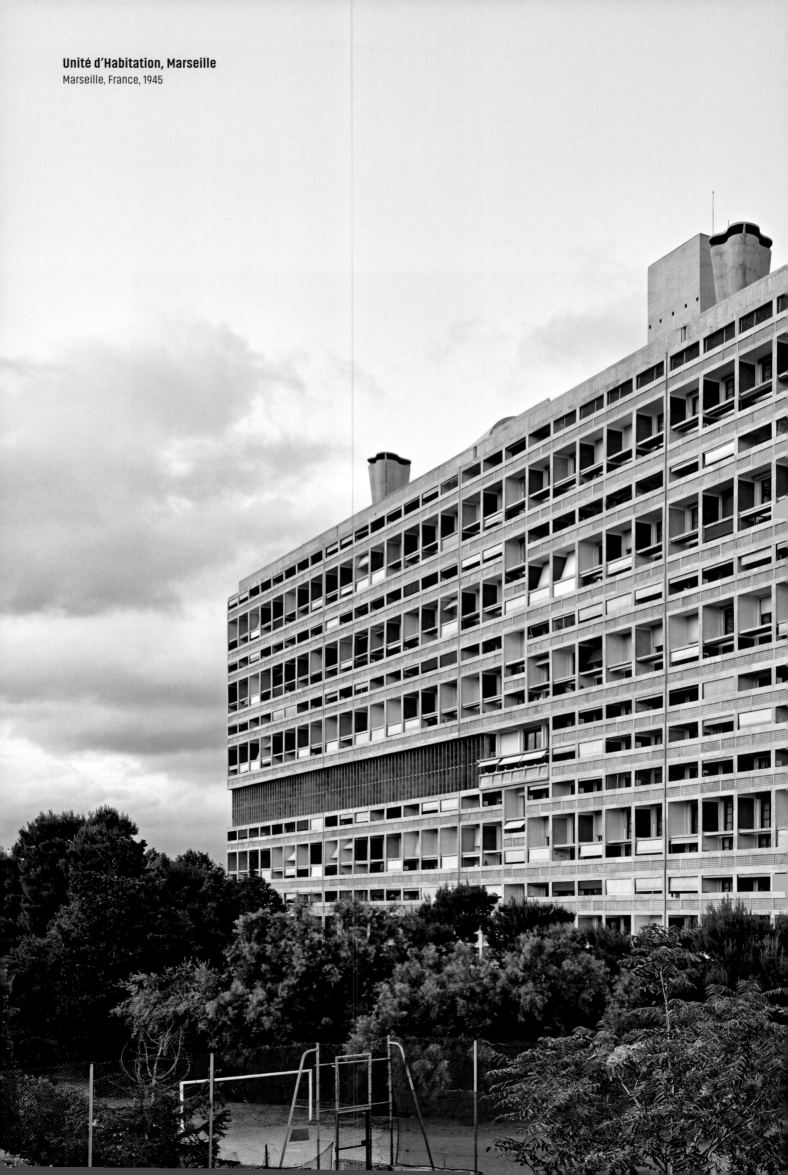

Unité d'Habitation, Marseille
Marseille, France, 1945

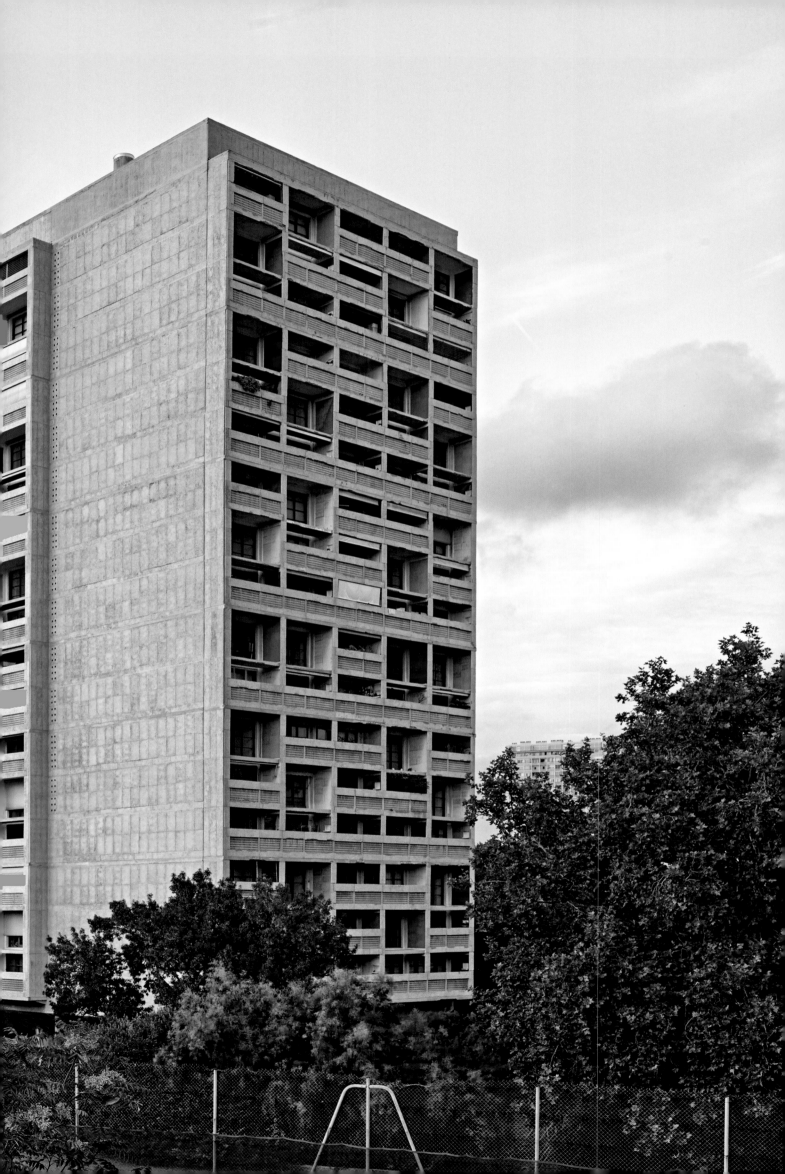

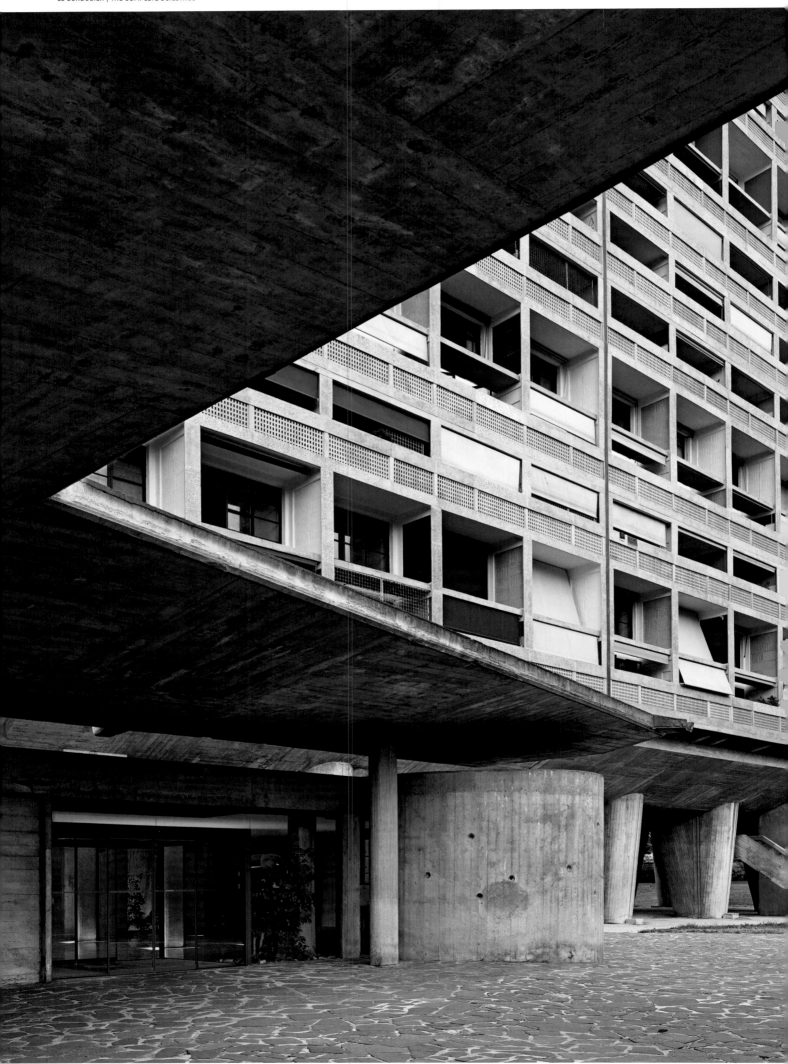

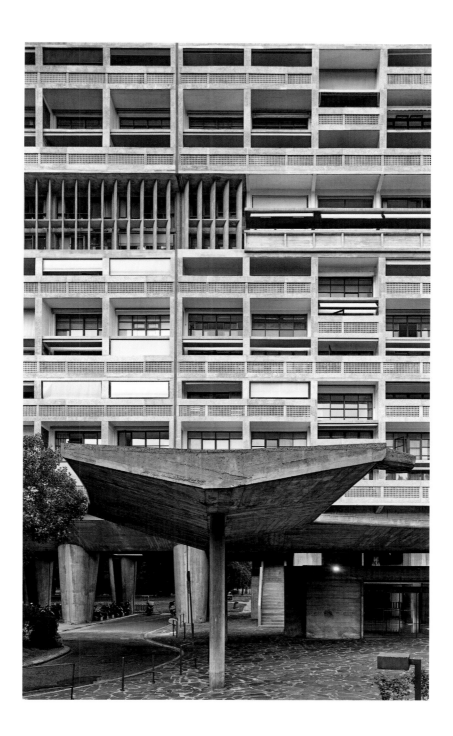

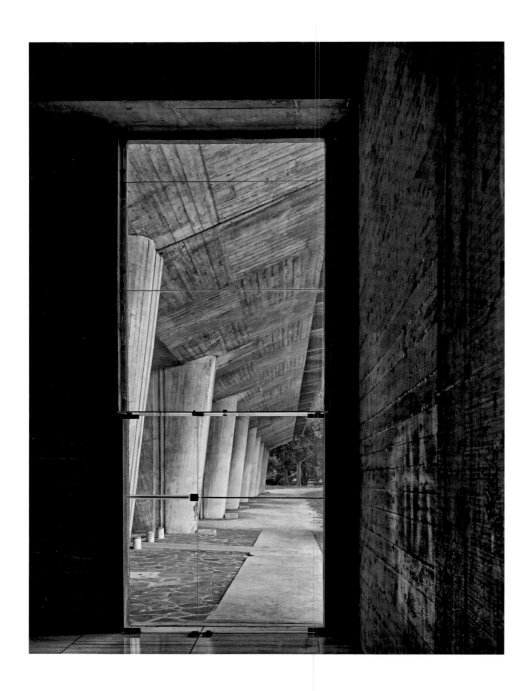

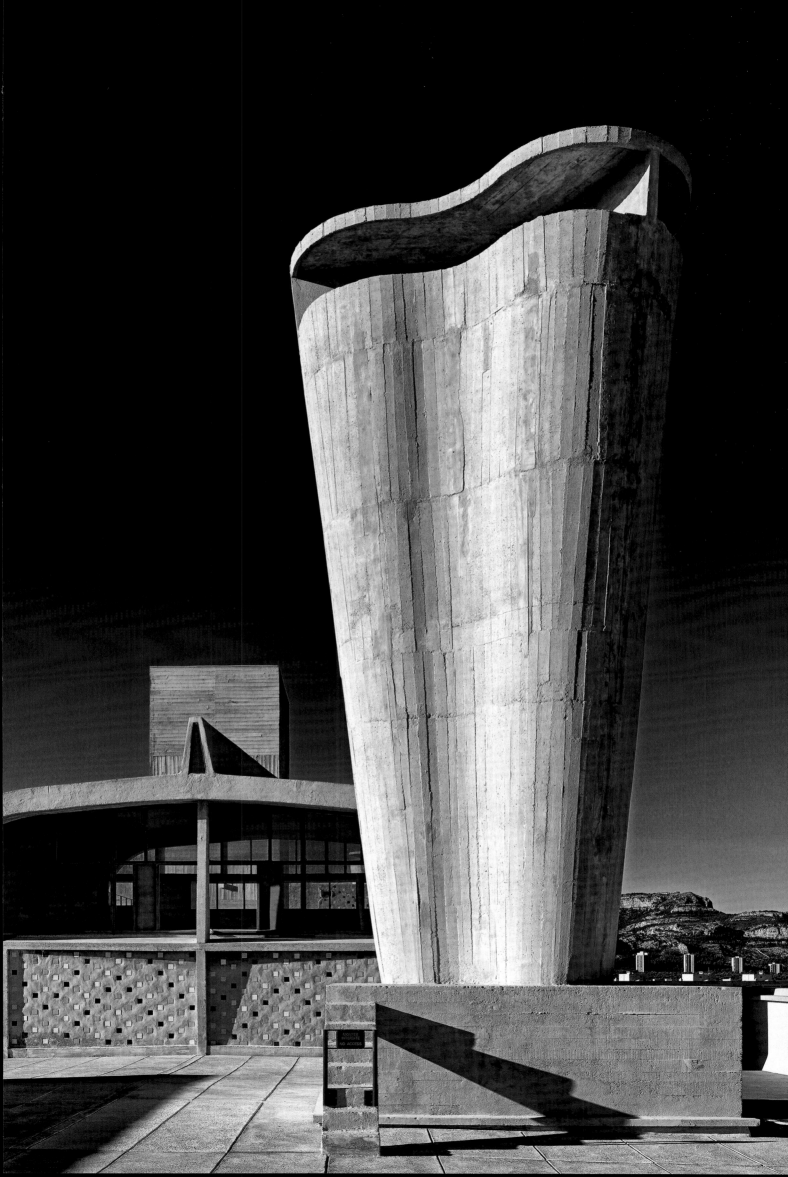

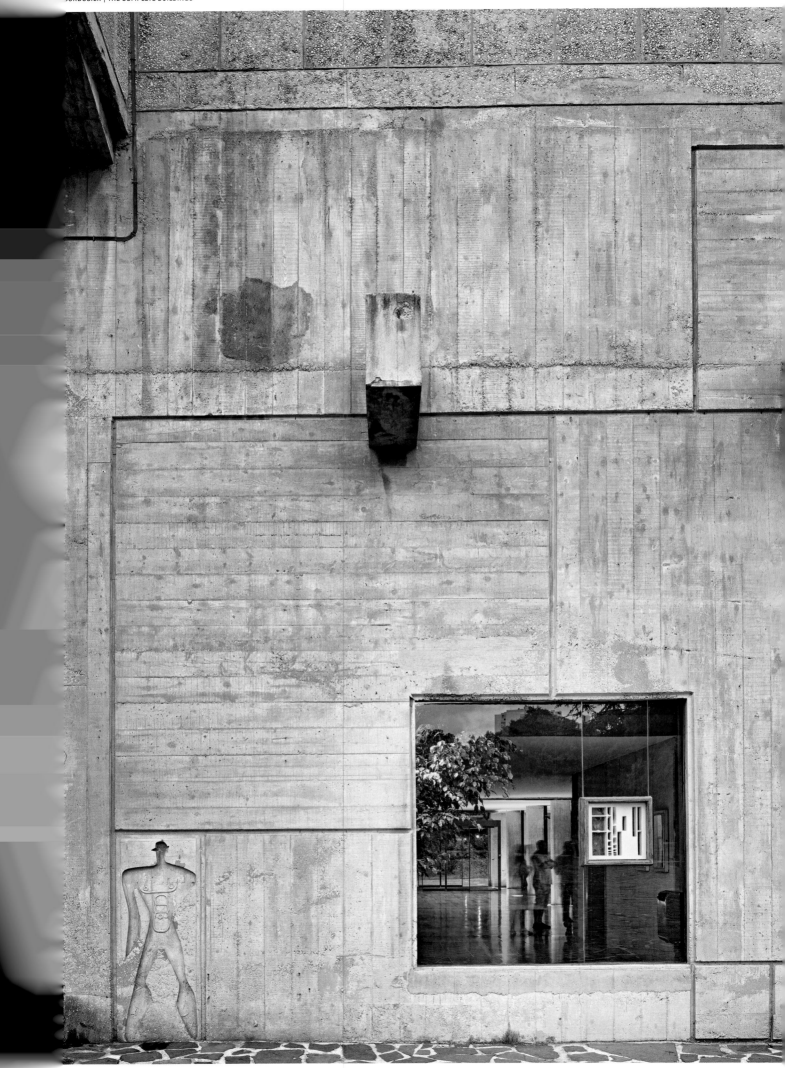

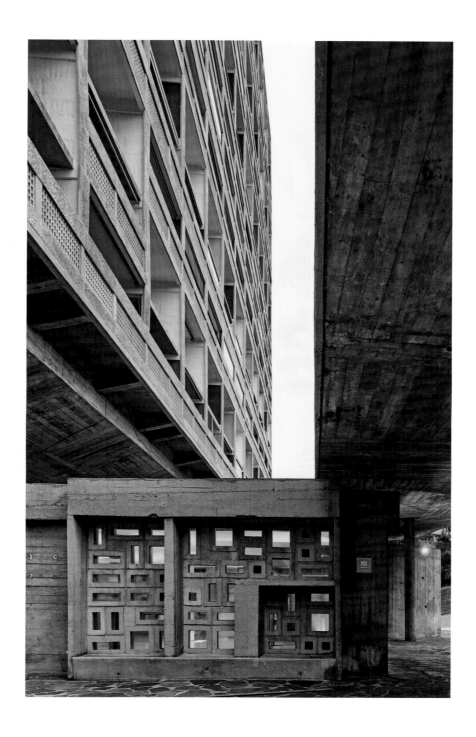

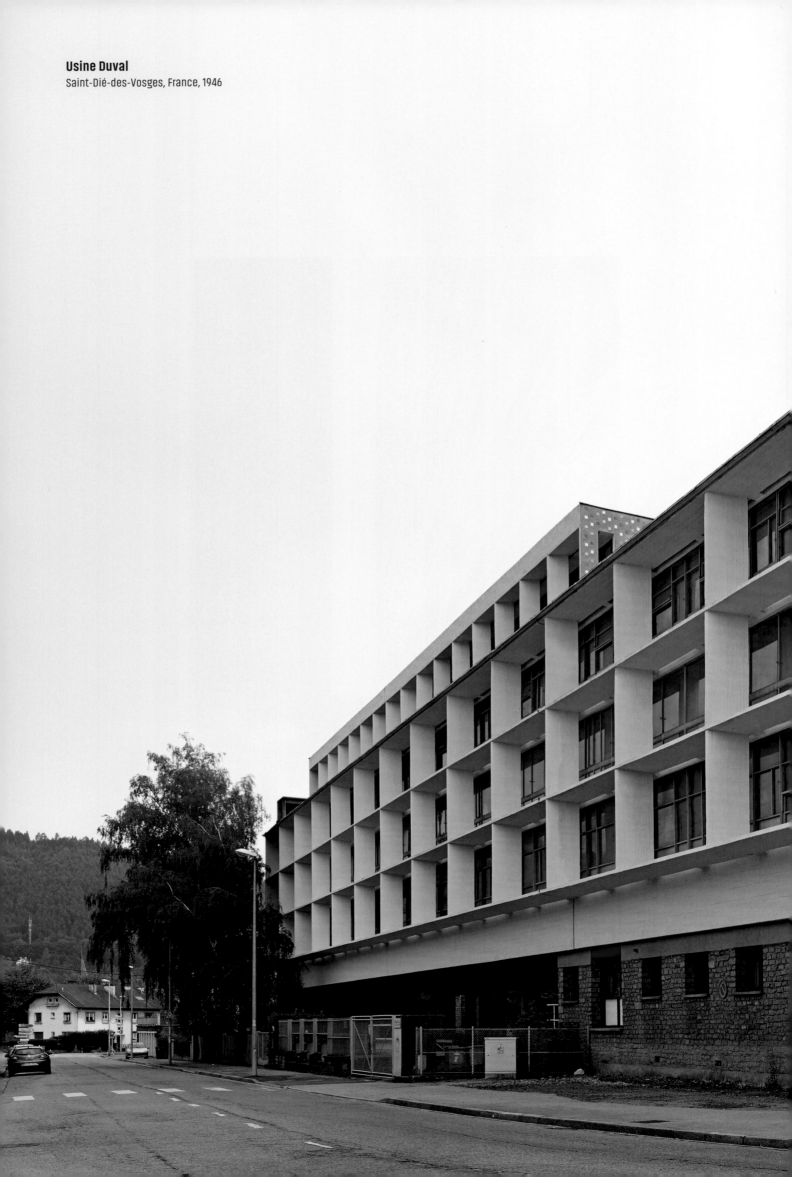

Usine Duval
Saint-Dié-des-Vosges, France, 1946

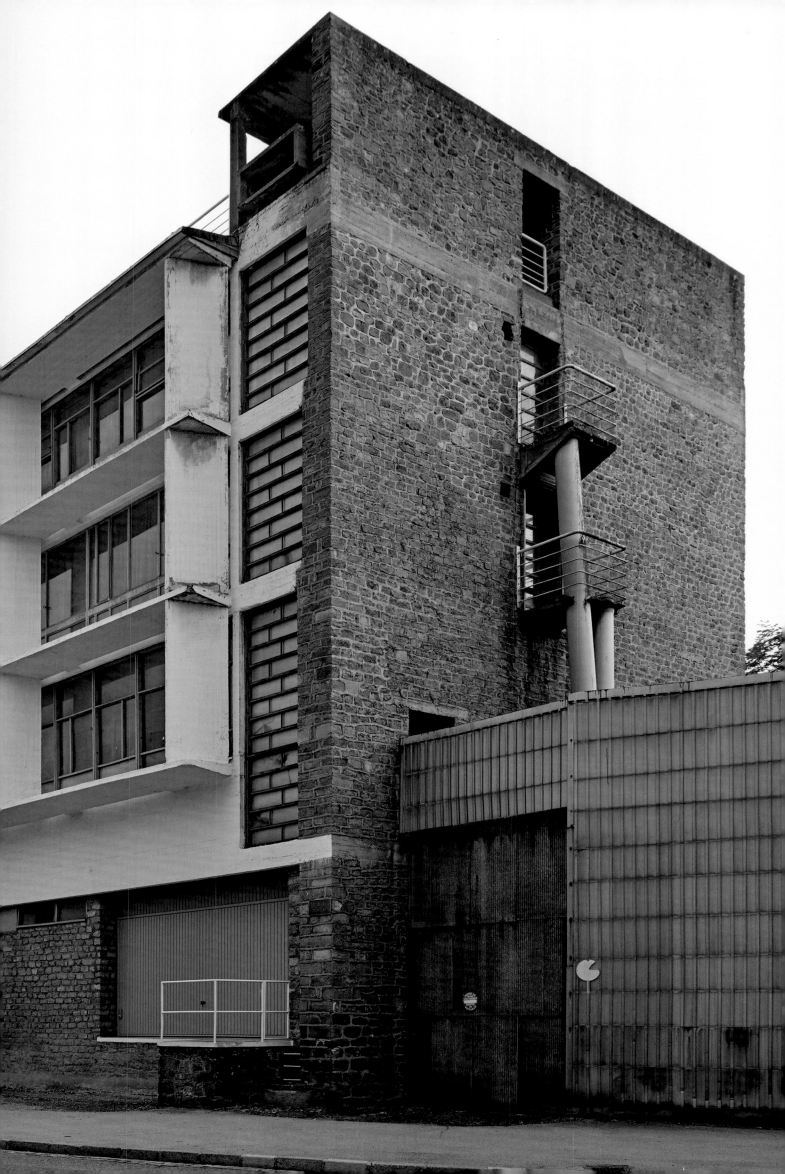

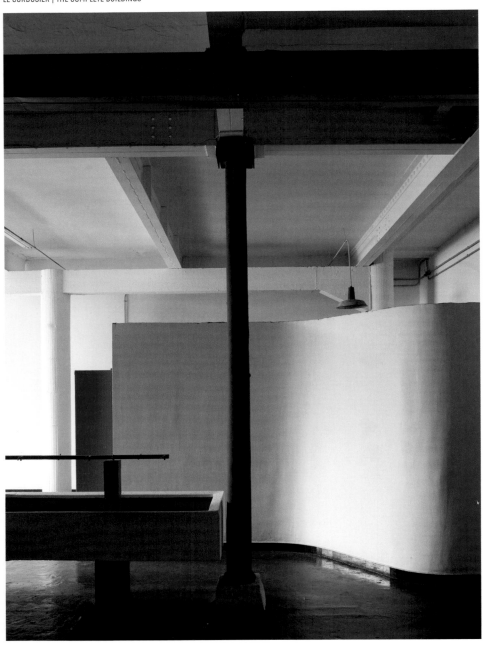

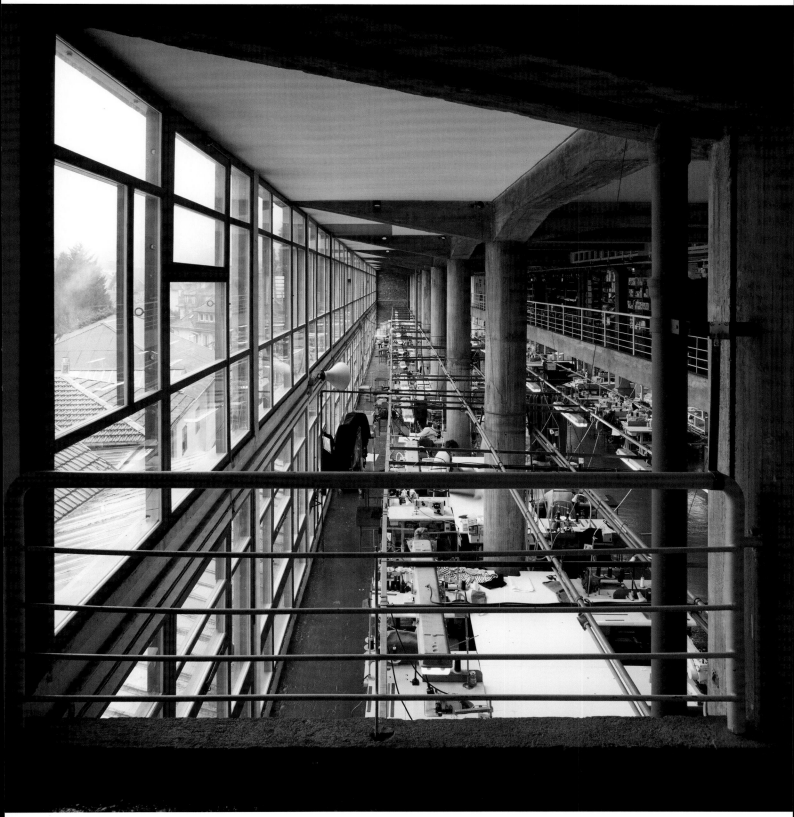

Maison Curutchet
La Plata, Argentina, 1949

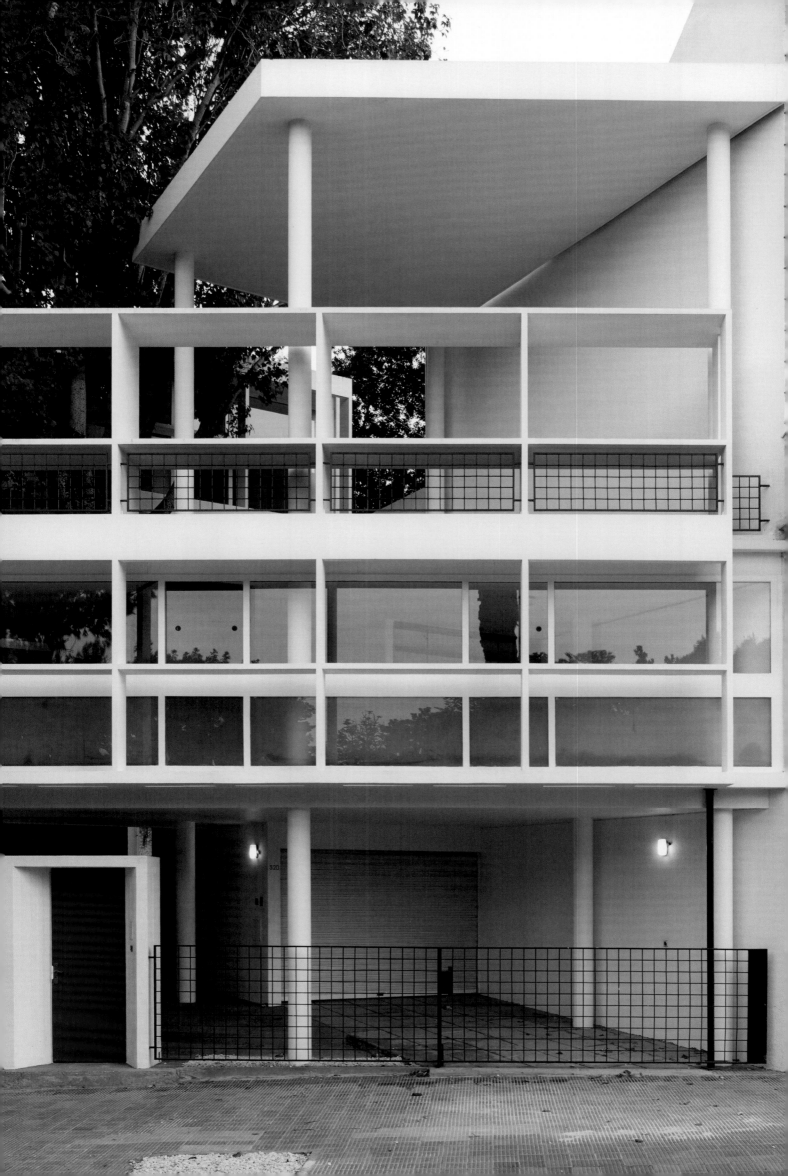

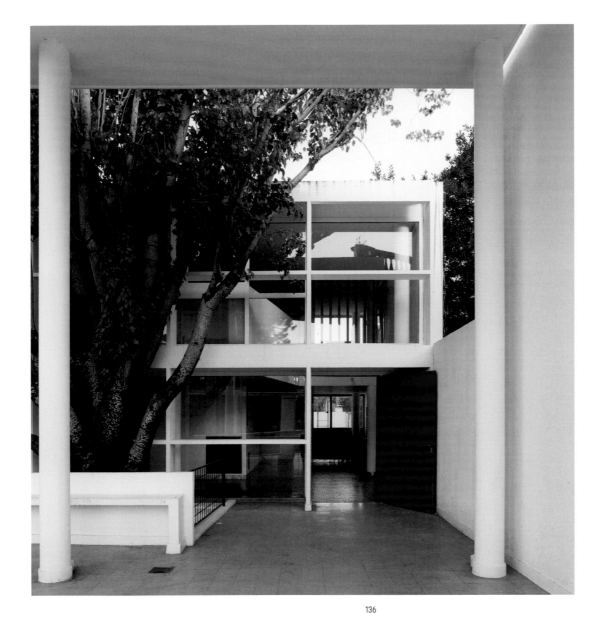

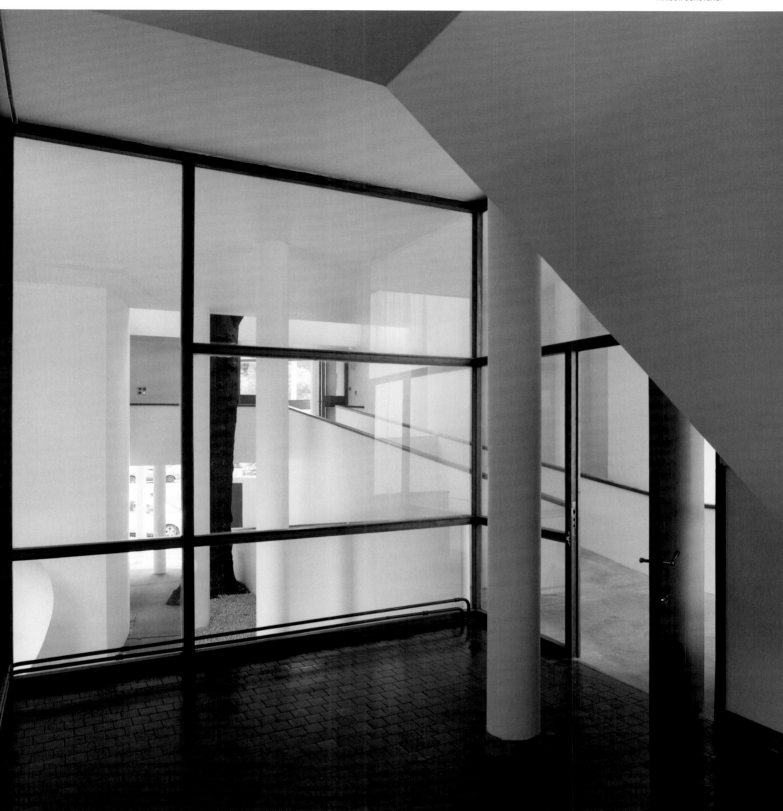

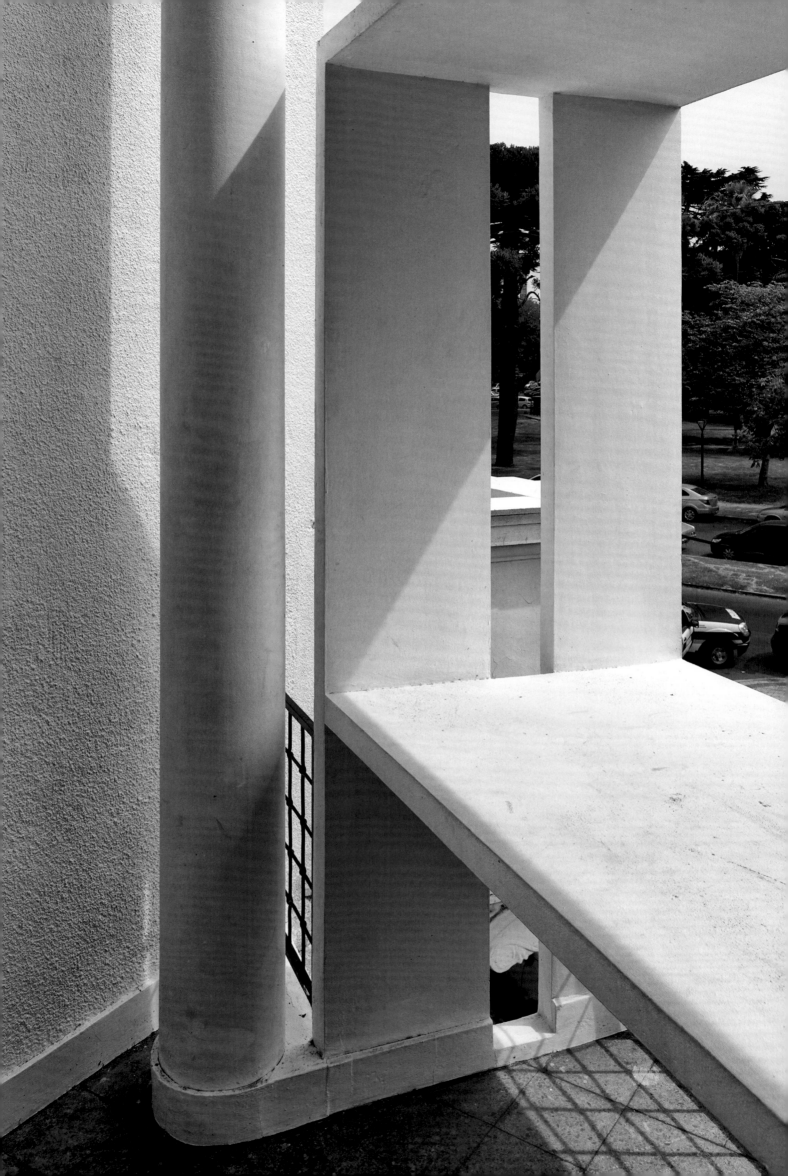

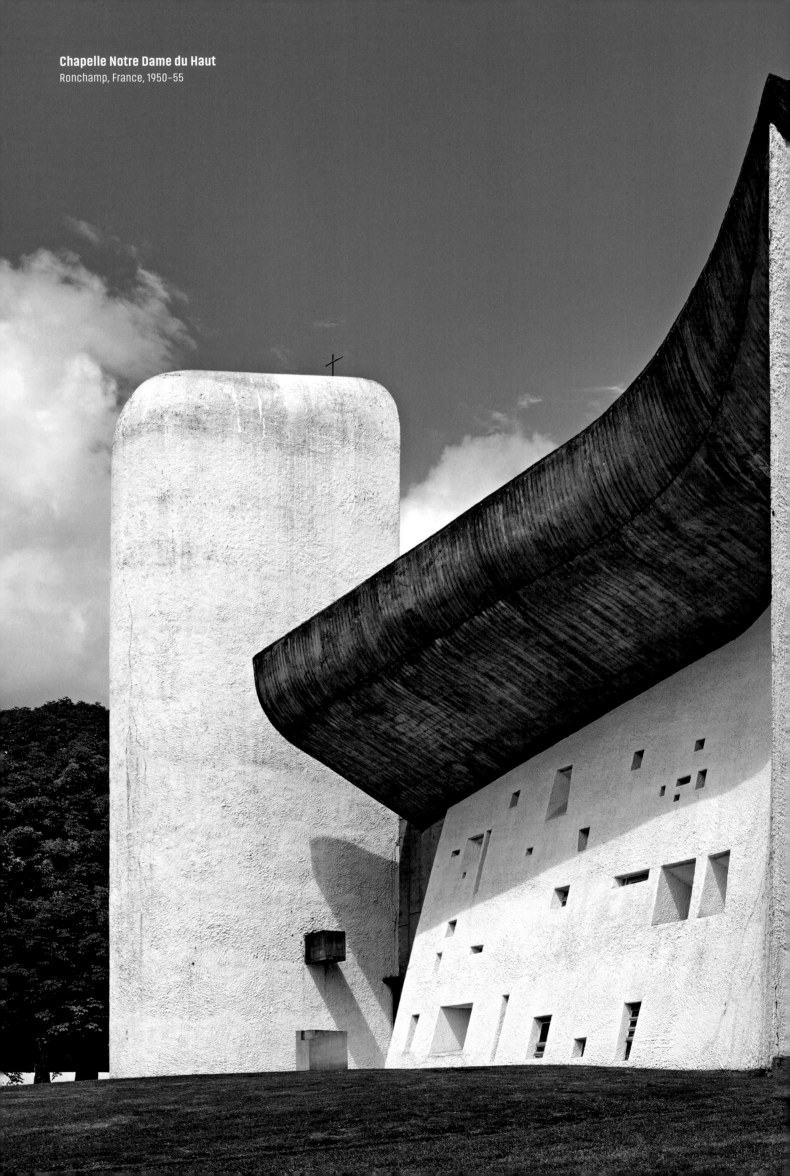

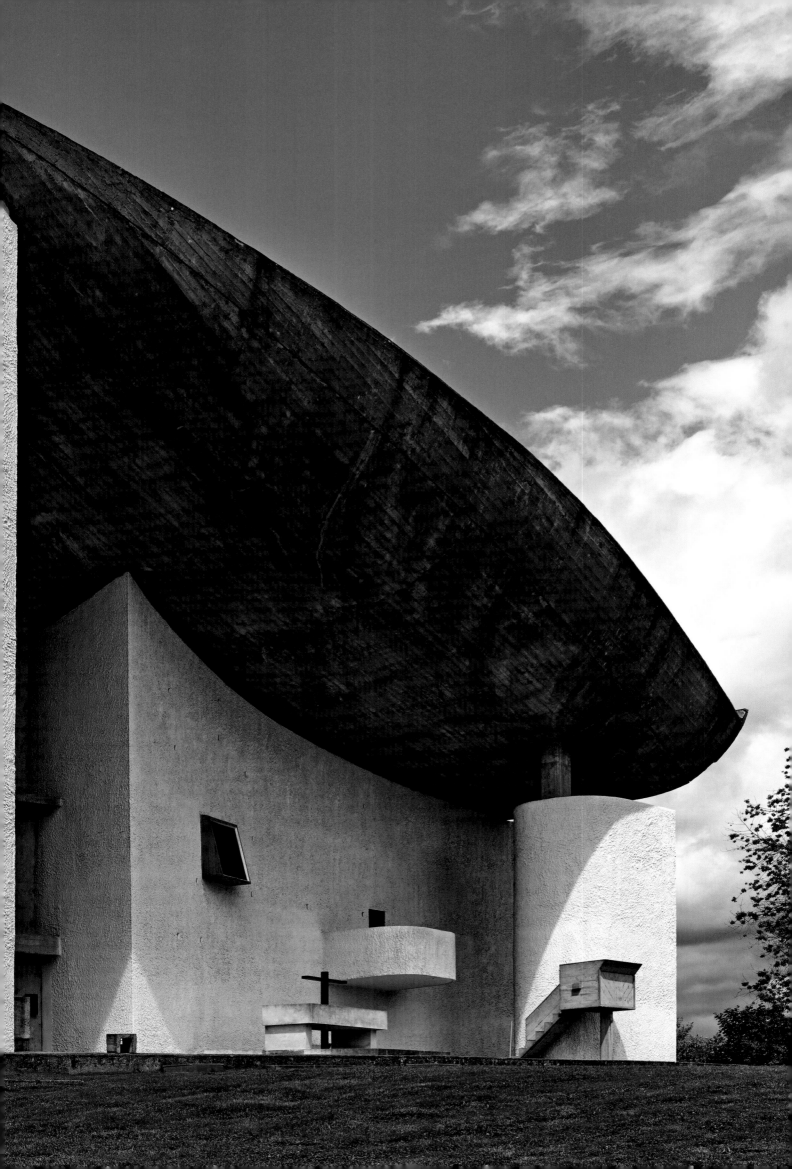

Irreligious Ronchamp

UĞUR TANYELİ

What meaning would I find in this photograph if I did not know that it represented Ronchamp chapel? Probably very little, other than that it depicts a sculptural building. Images are troublesome objects because we recognize them. We grasp what they are. This leaves us in an ambivalent position when it comes to talking about them. Do we interpret a known, familiar fact only through the premise of the image that we see? Or is it possible to speak of a visual image while forgetting the 'thing' it depicts and our prior knowledge of it? Or, specifying the question a little further, can we isolate an architectural image from the architectural product it depicts? Is it possible to grasp that image independently of what has been said and written about the building, or independently of the ideas about it that may not have crossed its producer's mind but have been suggested by others? Moreover, can we forget what we know about its designer, the occasional myths spun around him, or the cult that places his personality at its centre?

Architectural images do not possess a purely visual existence. In short, as I talk about this photograph I will not be able to put aside the knowledge I have acquired about Le Corbusier and Ronchamp, what comes to my mind within a set of associations that goes beyond Ronchamp, or my everyday concerns, most of which belong only to the environment I live in. For example, knowing that Le Corbusier designed a church despite being an atheist (or indifferent towards religion) is vitally important for me. Even though his religious identity and the pro-modern art objectives of the clergyman and institution that commissioned him cannot be discerned in this photograph, they remain at the core of my perceptions of Ronchamp. And I care about the fact that devout Catholics embrace this chapel, which is visited by 80,000 pilgrims every year, more even than I do about the dramatic architecture of the church or the magnificence of the photograph that portrays it. This is because my perception of the photograph does not come into being in a direct confrontation between 'me' and the photograph.

On the contrary, there is an encounter between the sociality that also encompasses – indeed generates – me, and what I know about Ronchamp and Le Corbusier. This is why I speak as one Uğur Tanyeli who looks at this photograph in Turkey in the year 2016.

I therefore remember that Le Corbusier never asked, as he was designing Ronchamp, questions such as: what is a church? What should a church be, and how should a place of worship be designed according to Catholic belief and liturgy? This loquacious architect does not discuss religion or religious architecture in any of his texts. He does not describe how the two form a harmonious whole; nor does he try to prove this. In doing so he leaves aside the subjects that nearly every designer, every client, every power holder in Turkey cannot talk enough about when it comes to building a mosque. Le Corbusier takes religion and religiosity as pure data. He does not describe Catholicism to Catholics, or claim that he designed the church according to the basic tenets of that belief. He, as Le Corbusier, designed according to his own architectural approaches and ideas. After all, it is because his clients were willing to accept this subjectivity – even specifically demanding it – that they commissioned him to design Ronchamp. They did not imagine a connection between the architecture that generates Ronchamp and the Catholic religion. Believers who attend this church do not ask themselves, in doubt, whether a Catholic church should be built like this. They are aware that they are worshipping not just in any church, but in one designed by Le Corbusier. This is what conscience does: when a religious building of Ronchamp's stature is built, it does something to the creed it was built for; the latter is no longer what it was before. Of course, it does not alter religious principles, but Catholicism with Ronchamp is different from Catholicism without Ronchamp. Seen from present-day Turkey, this is supremely important, because here, contemporary religious architecture tailgates religiosity and is merely dragged along by the latter.

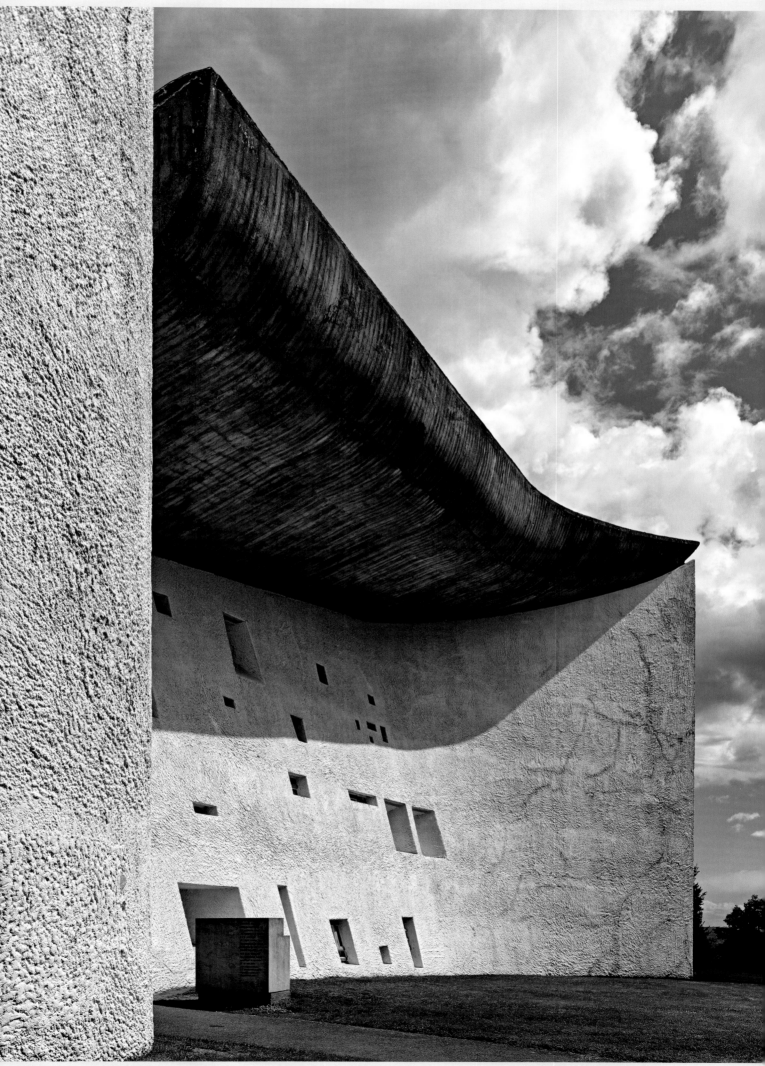

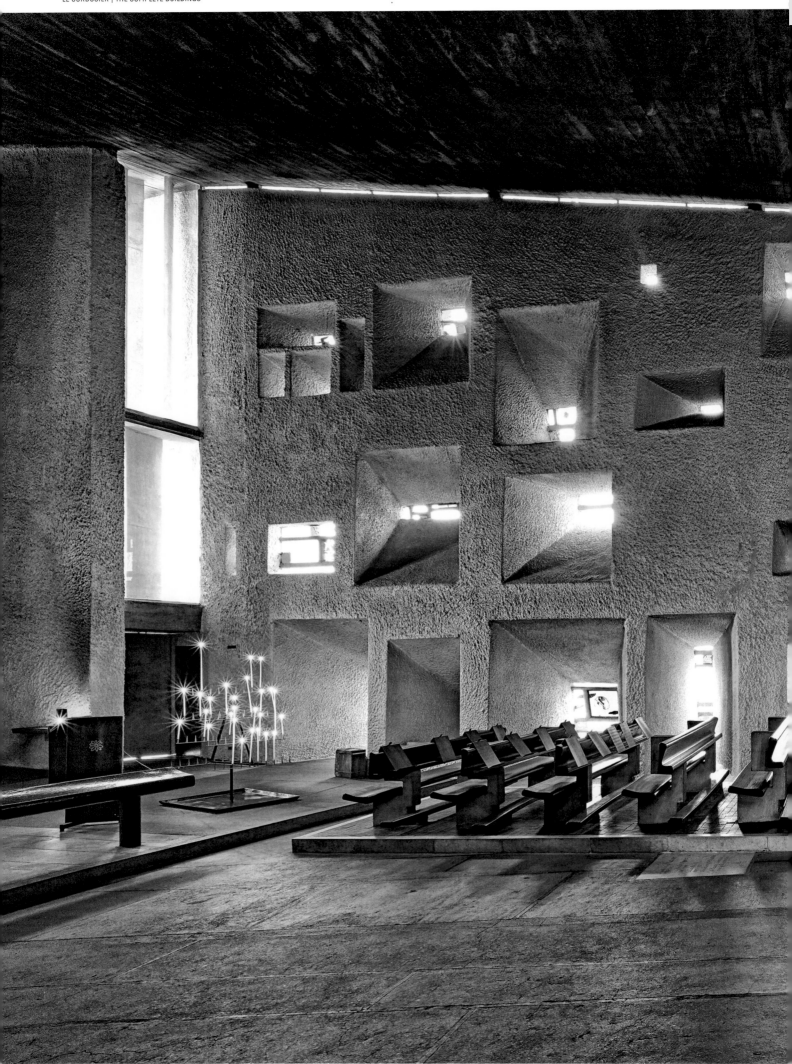

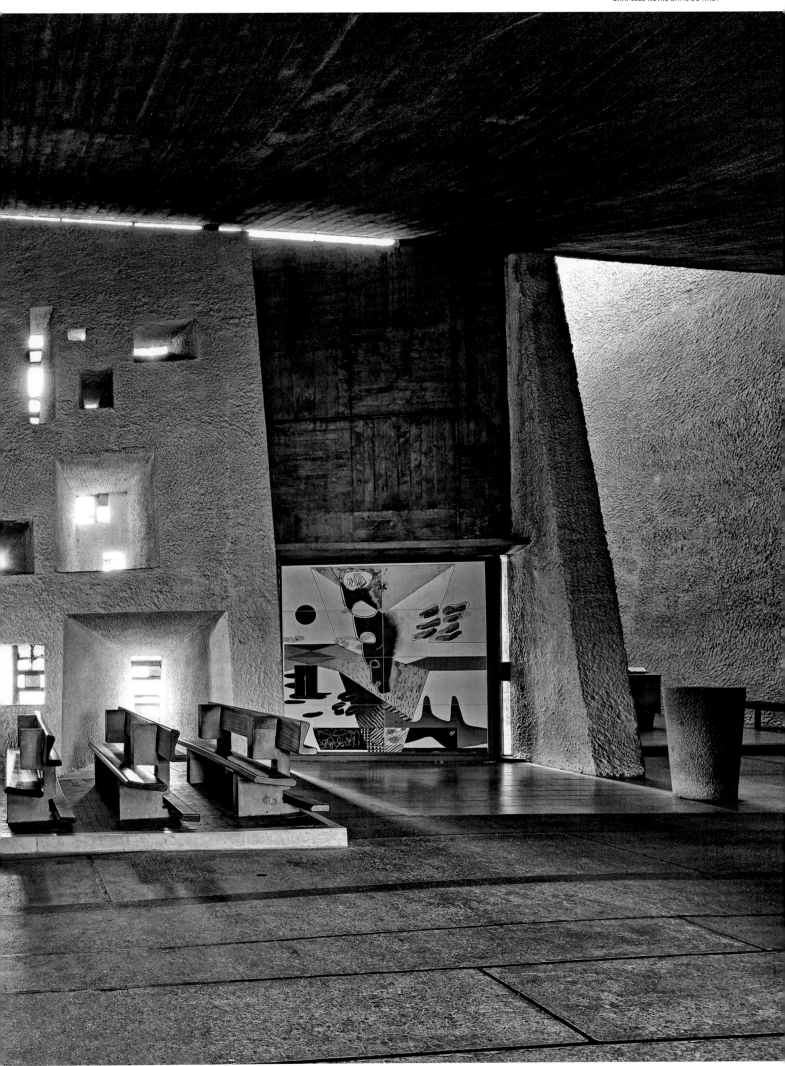

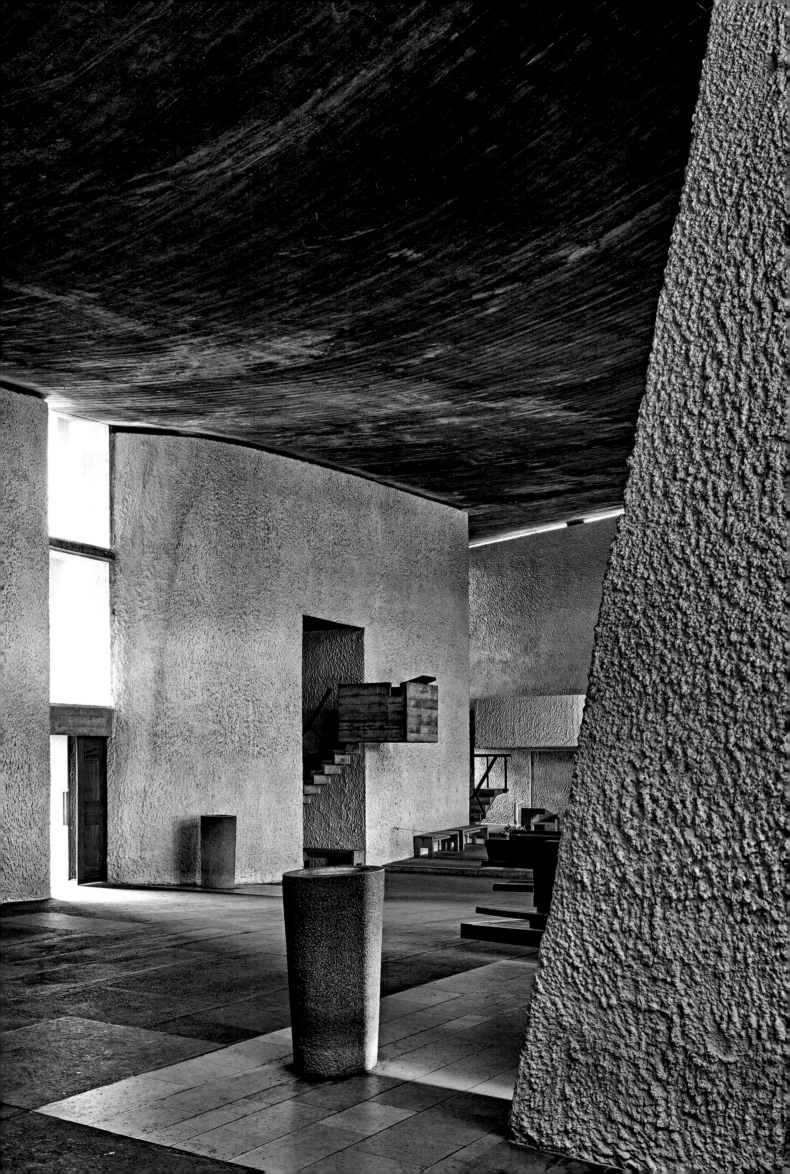

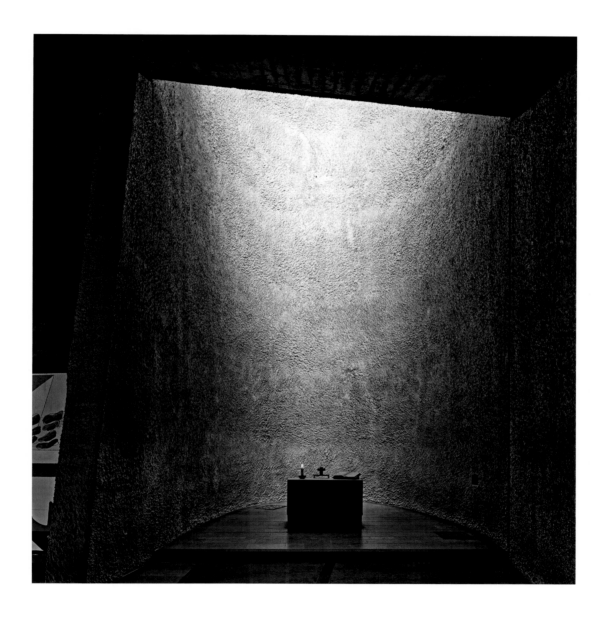

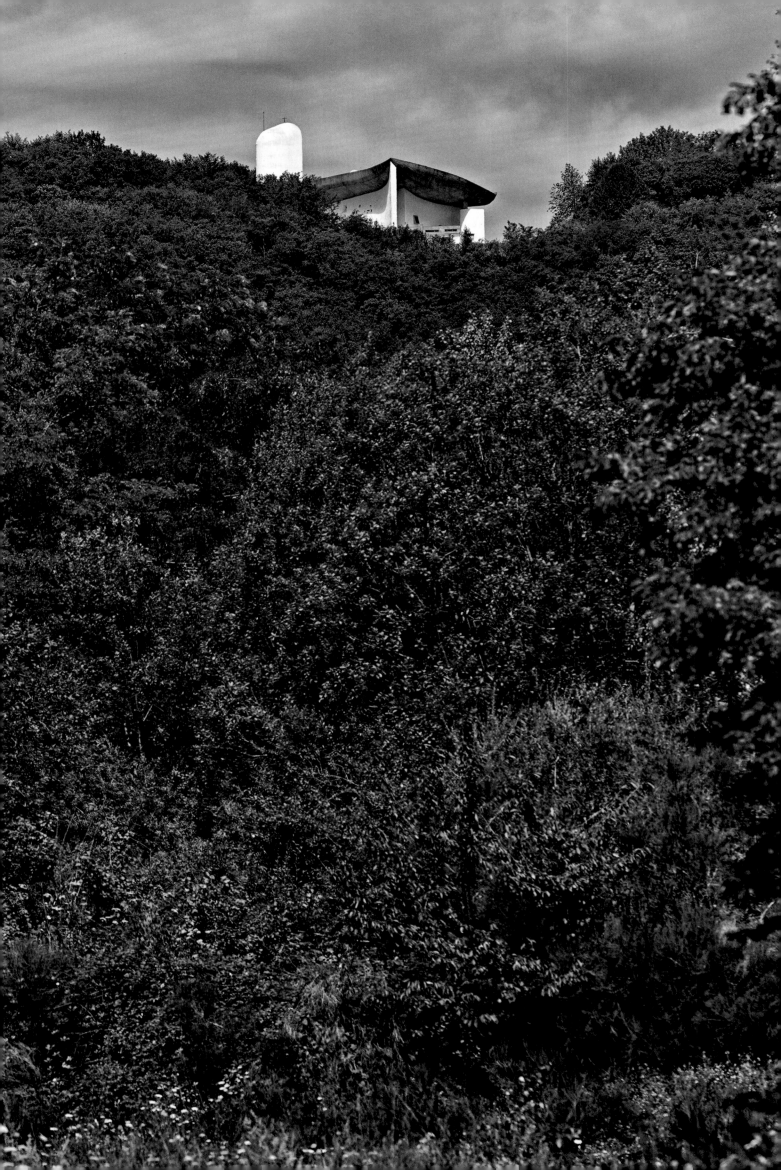

The Monument of the Open Hand
Chandigarh, India, 1950–65

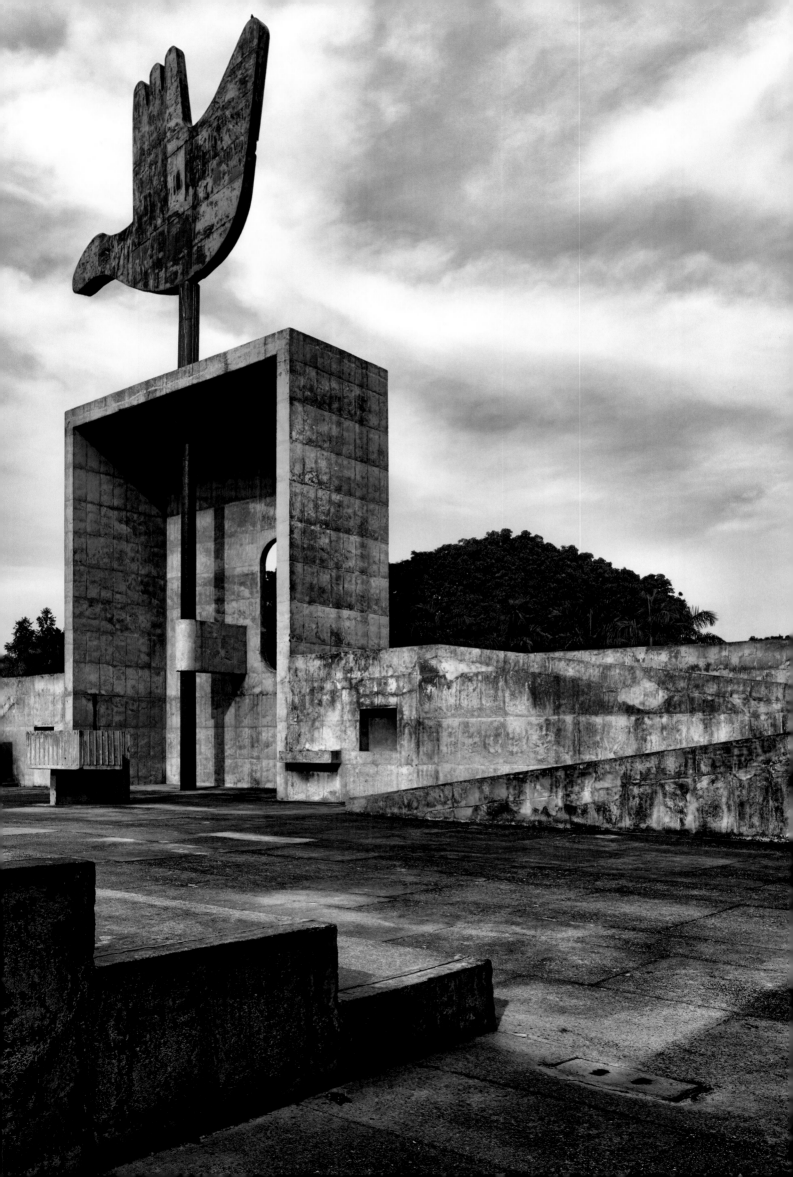

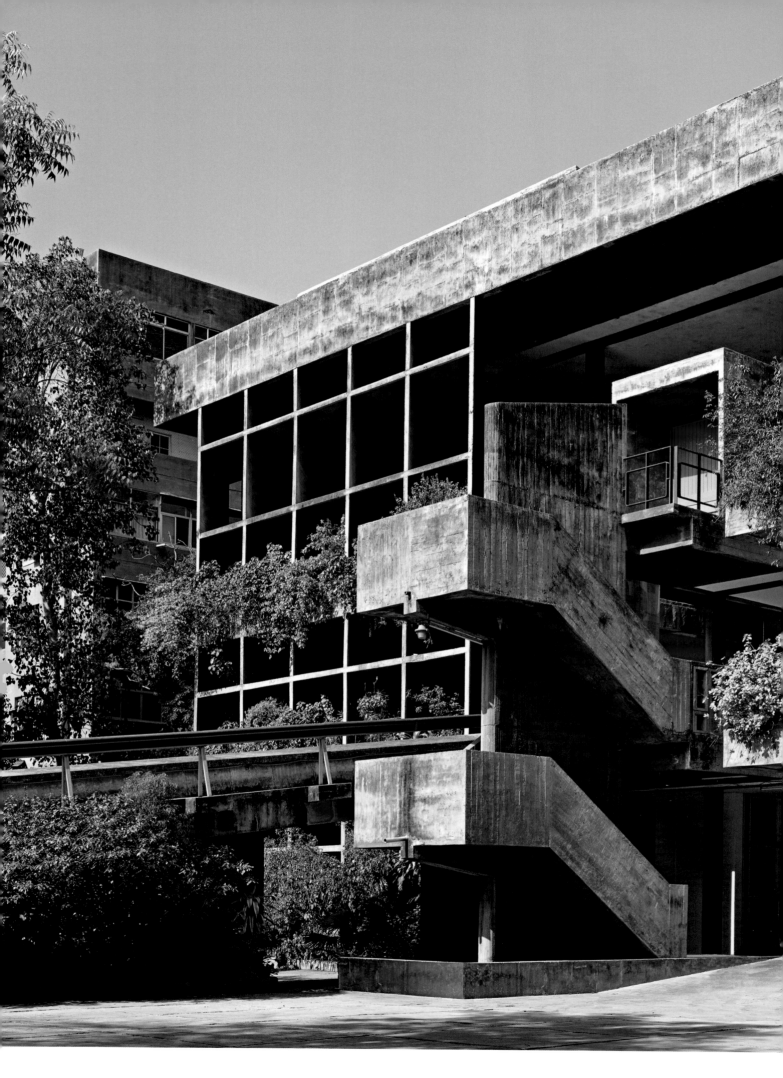

Mill Owners' Association
Ahmedabad, India, 1951

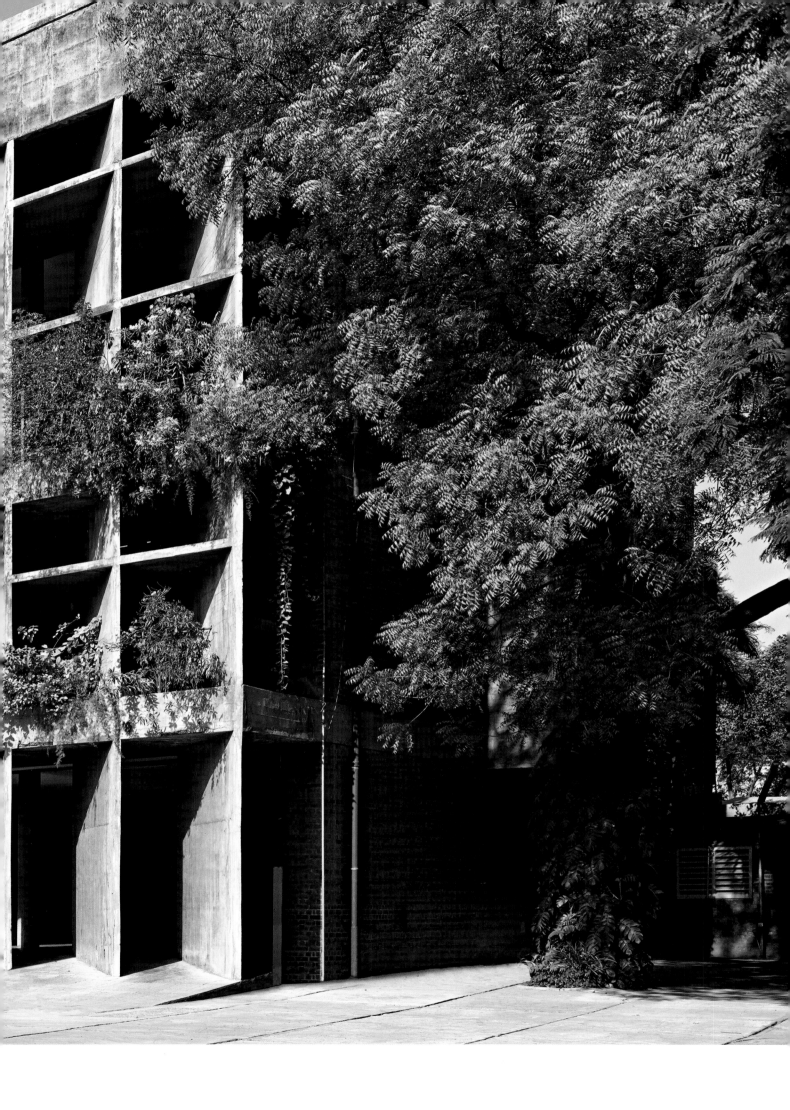

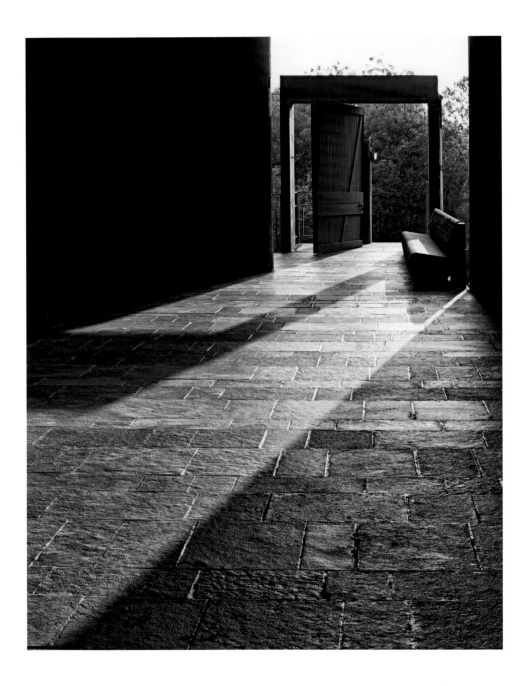

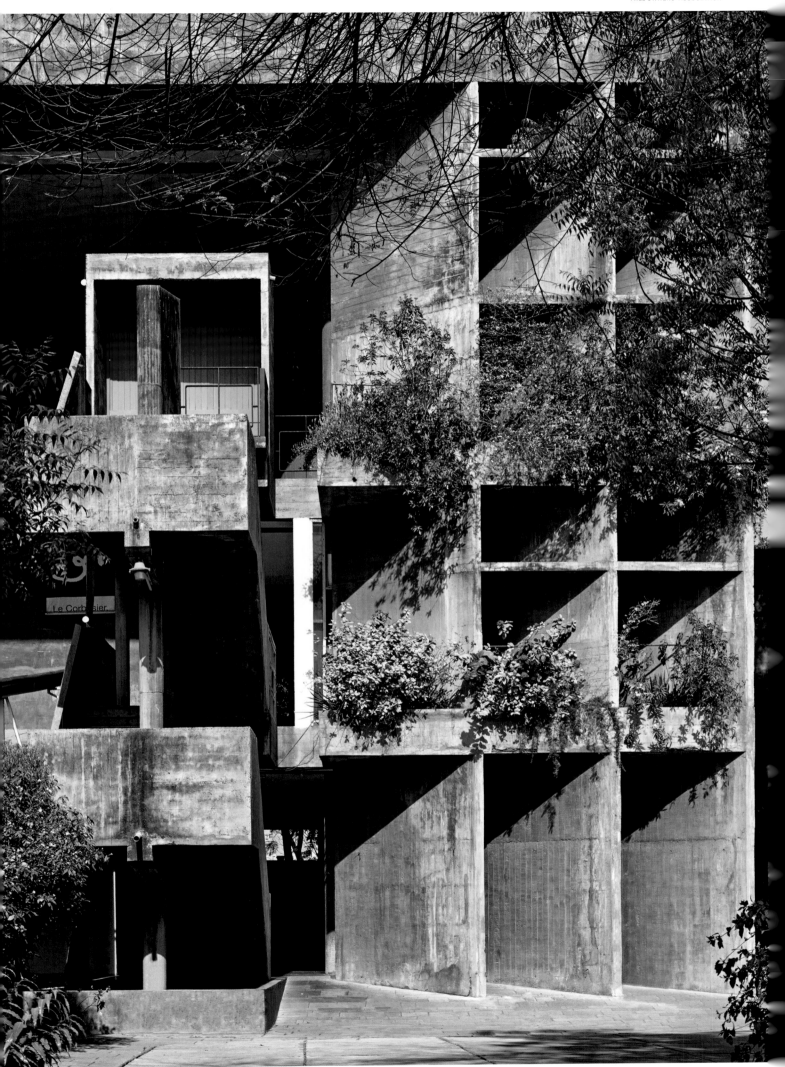

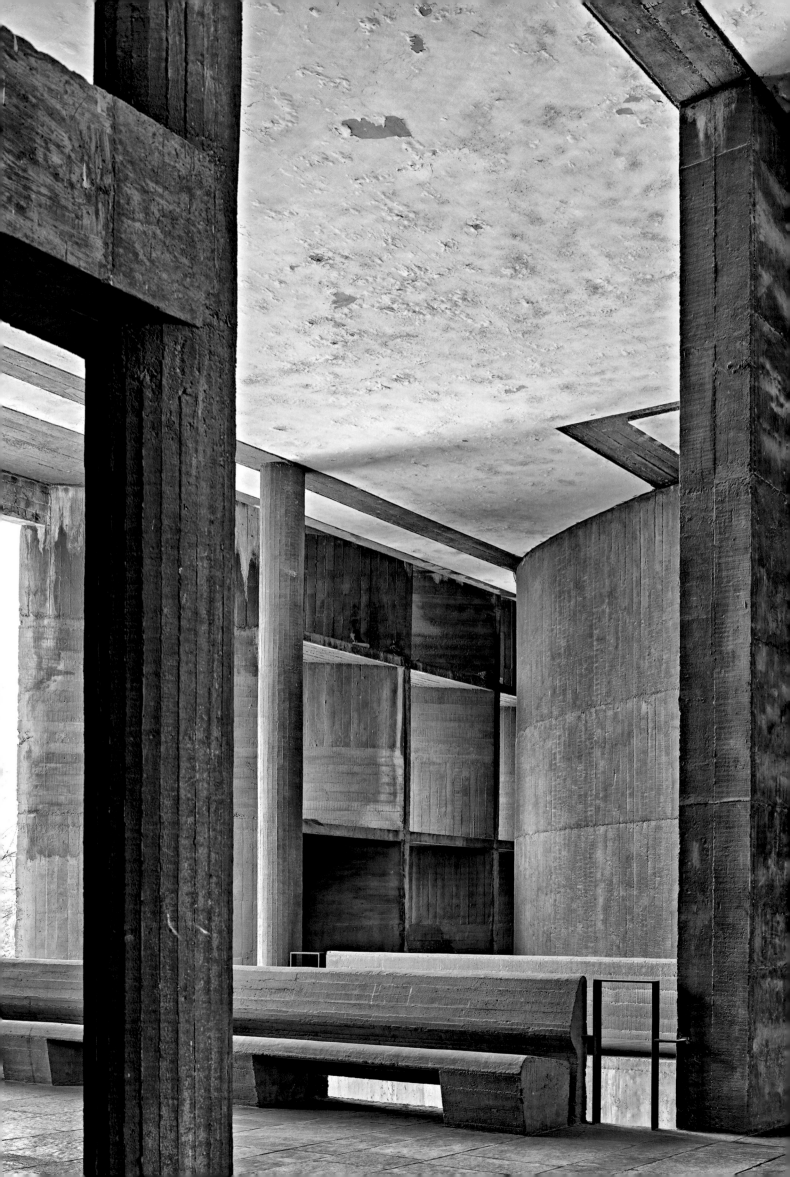

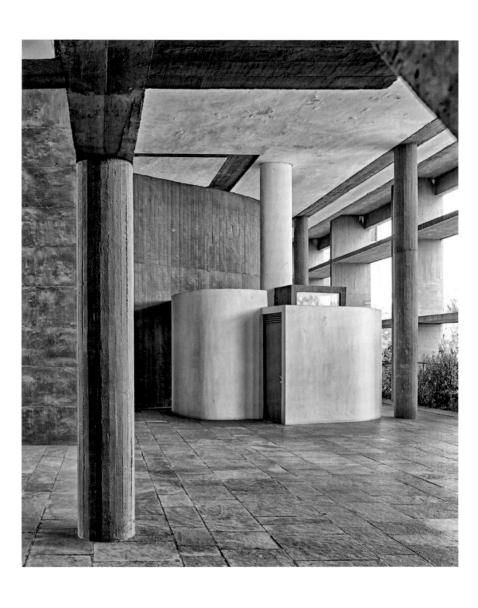

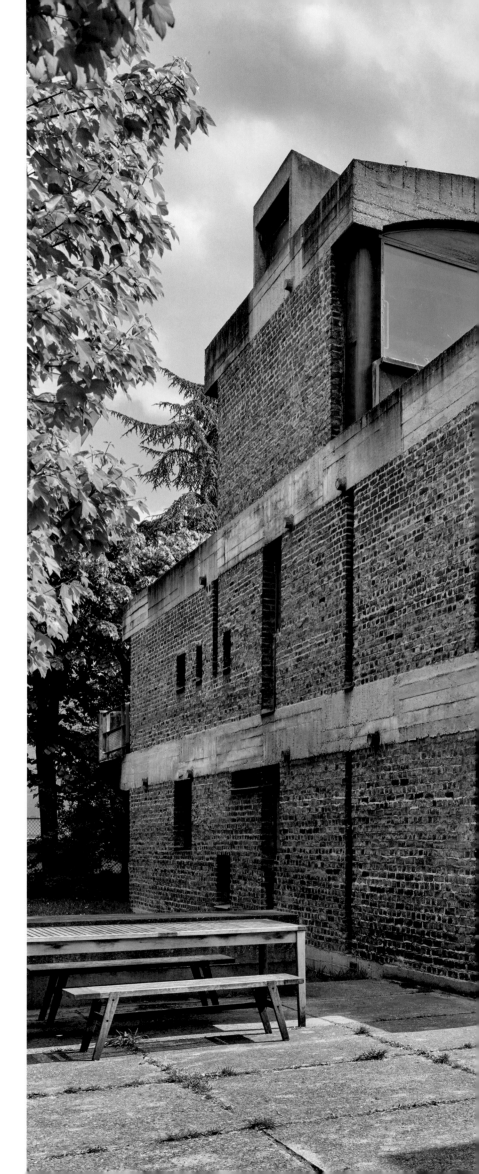

Maisons Jaoul
Neuilly-sur-Seine, Paris, France, 1951

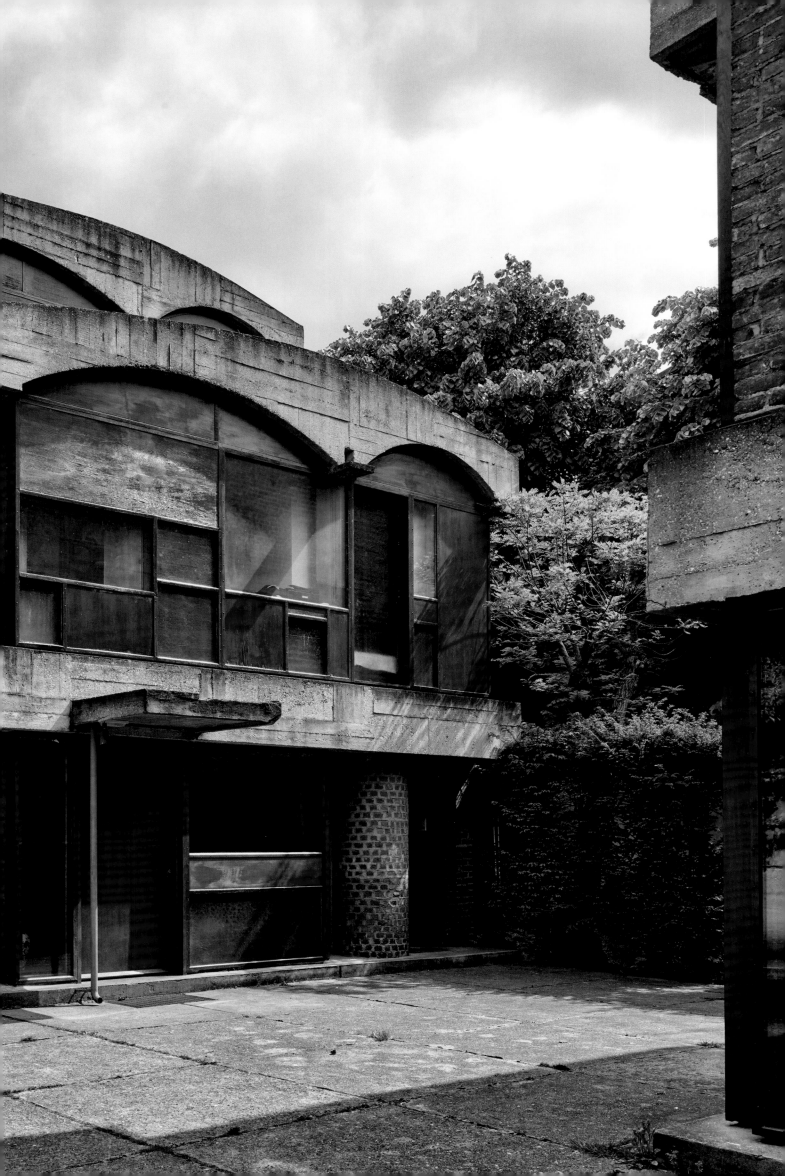

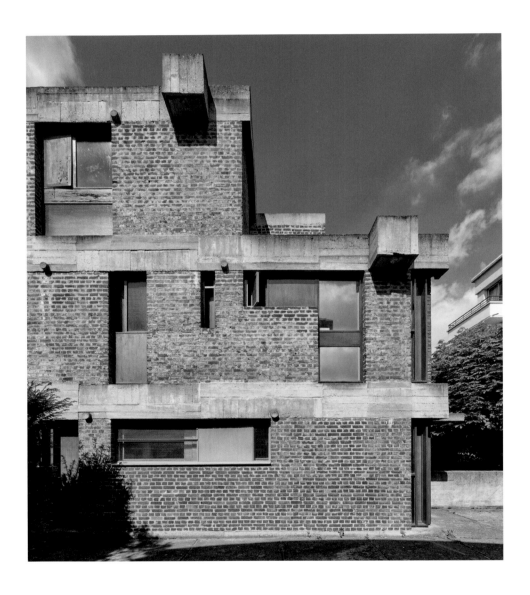

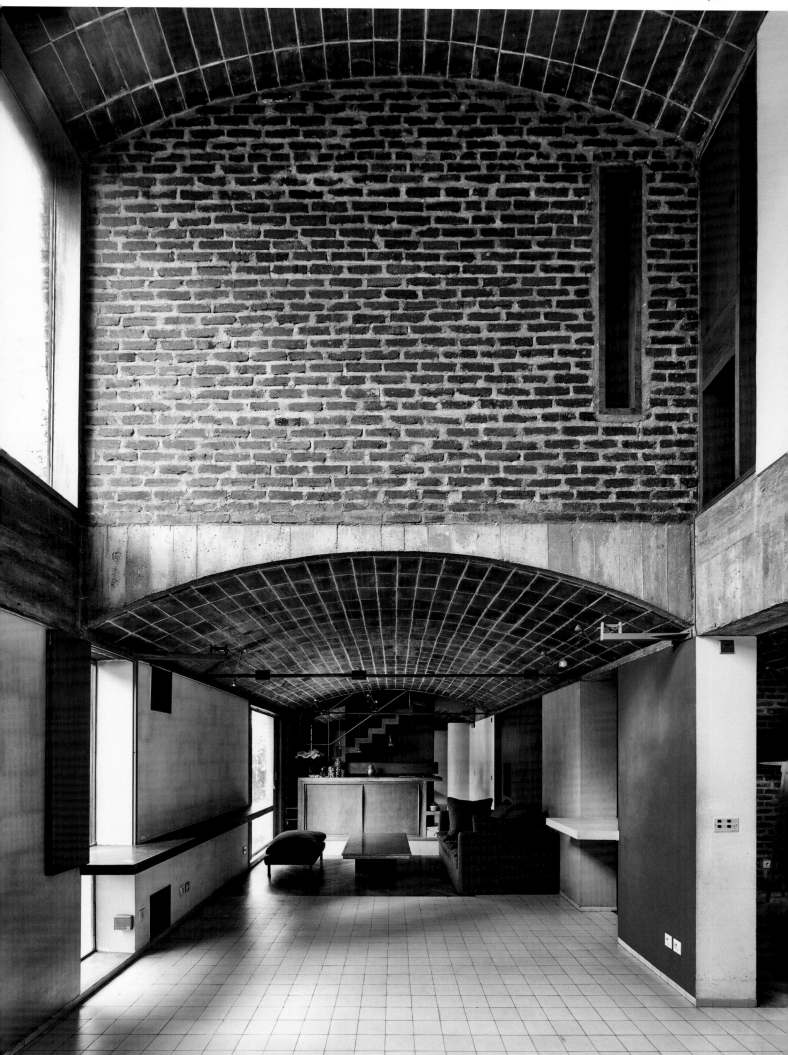

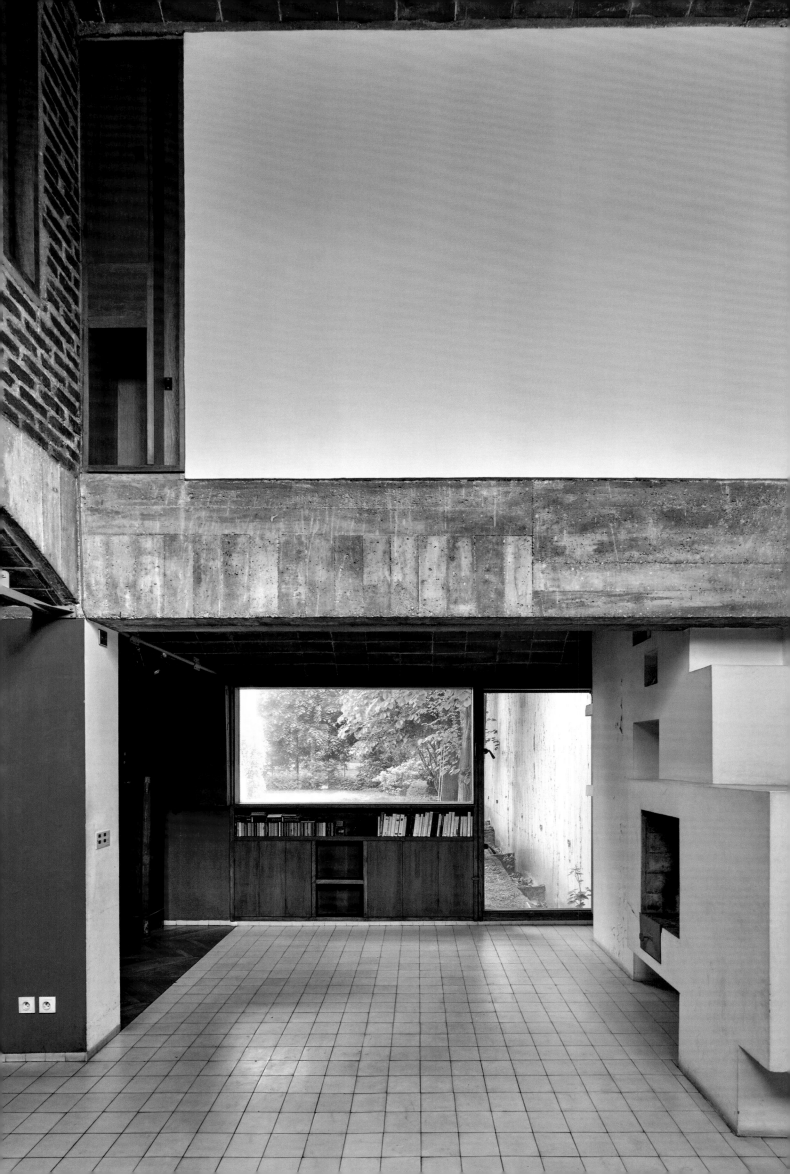

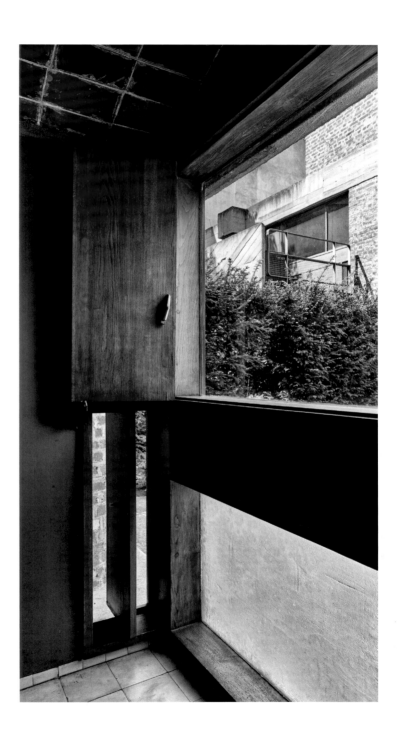

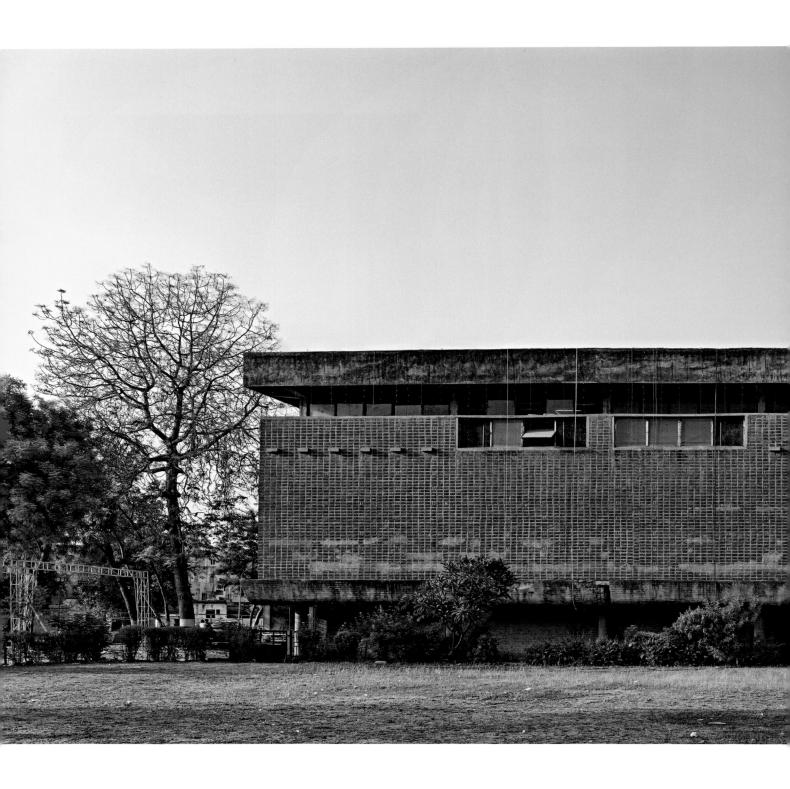

Sanskar Kendra City Museum
Ahmedabad, India, 1951

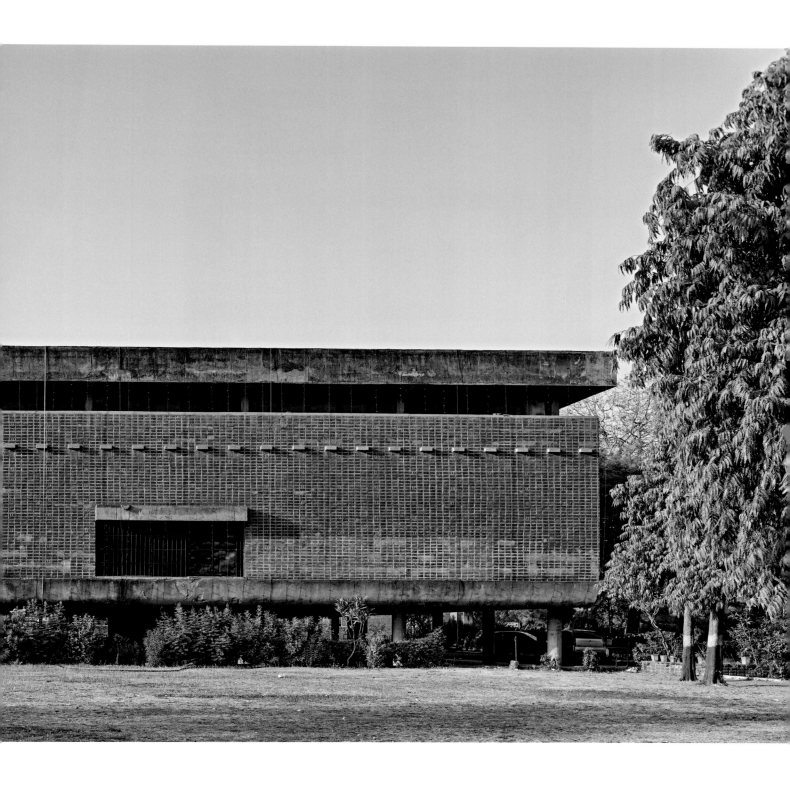

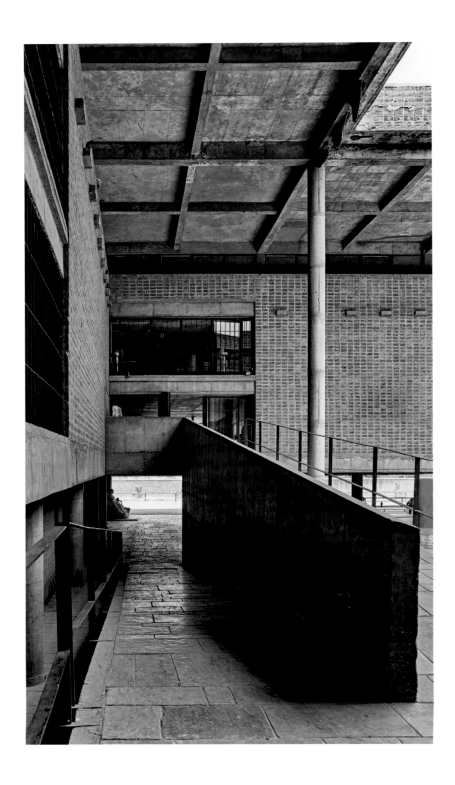

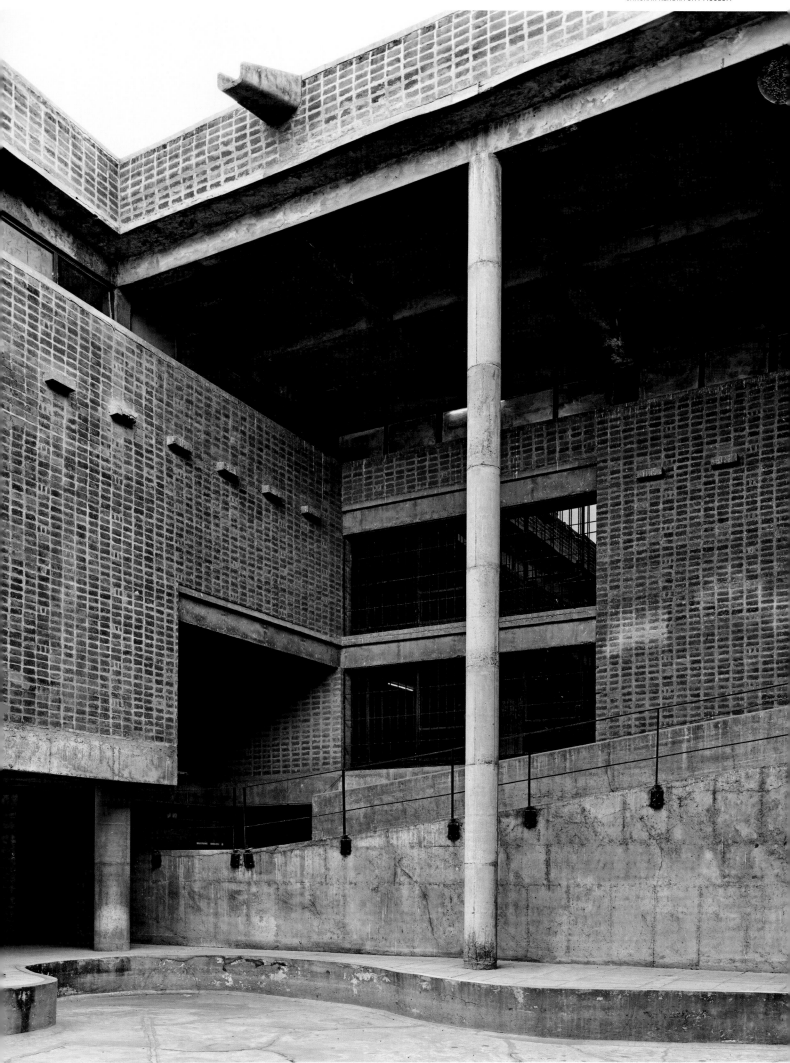

Le Cabanon
Roquebrune-Cap-Martin, France, 1951

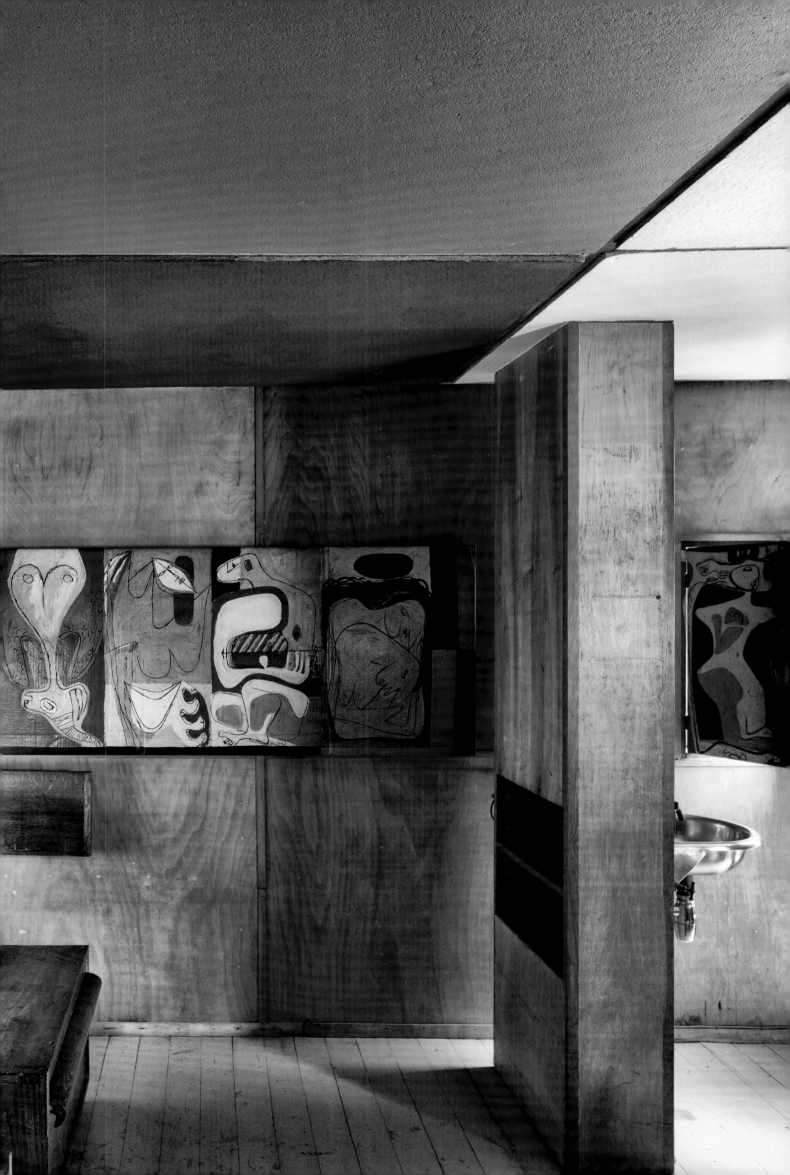

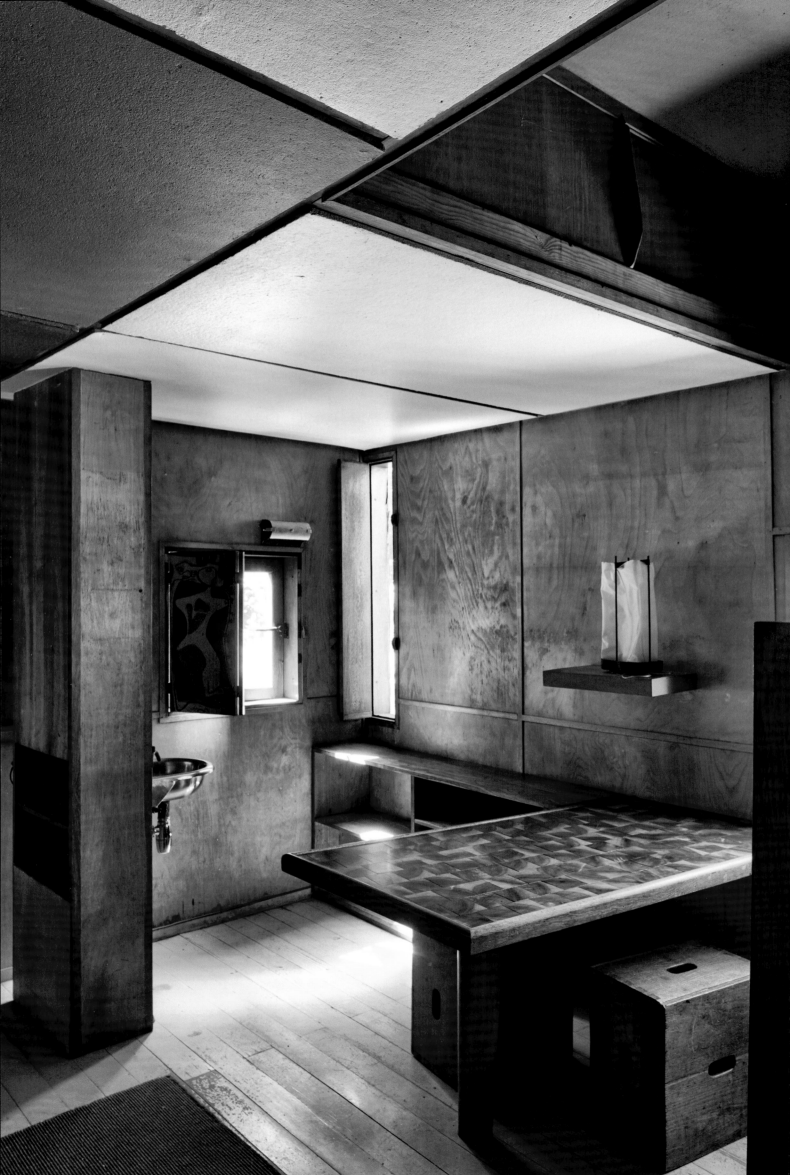

Villa Sarabhai
Ahmedabad, India, 1951

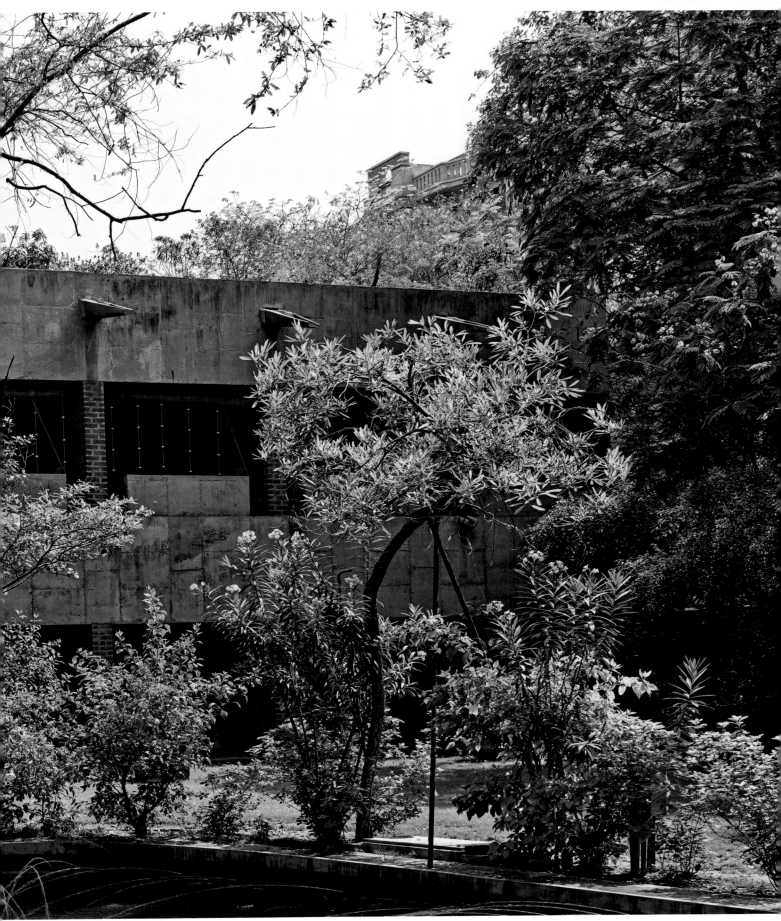

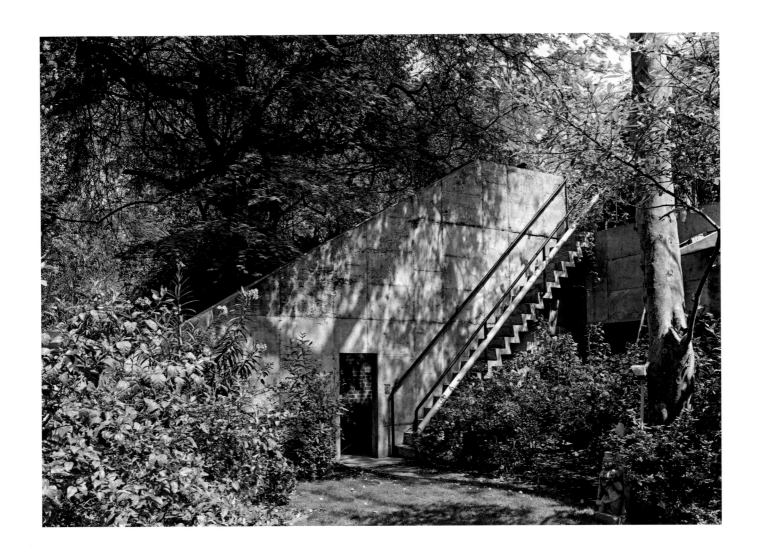

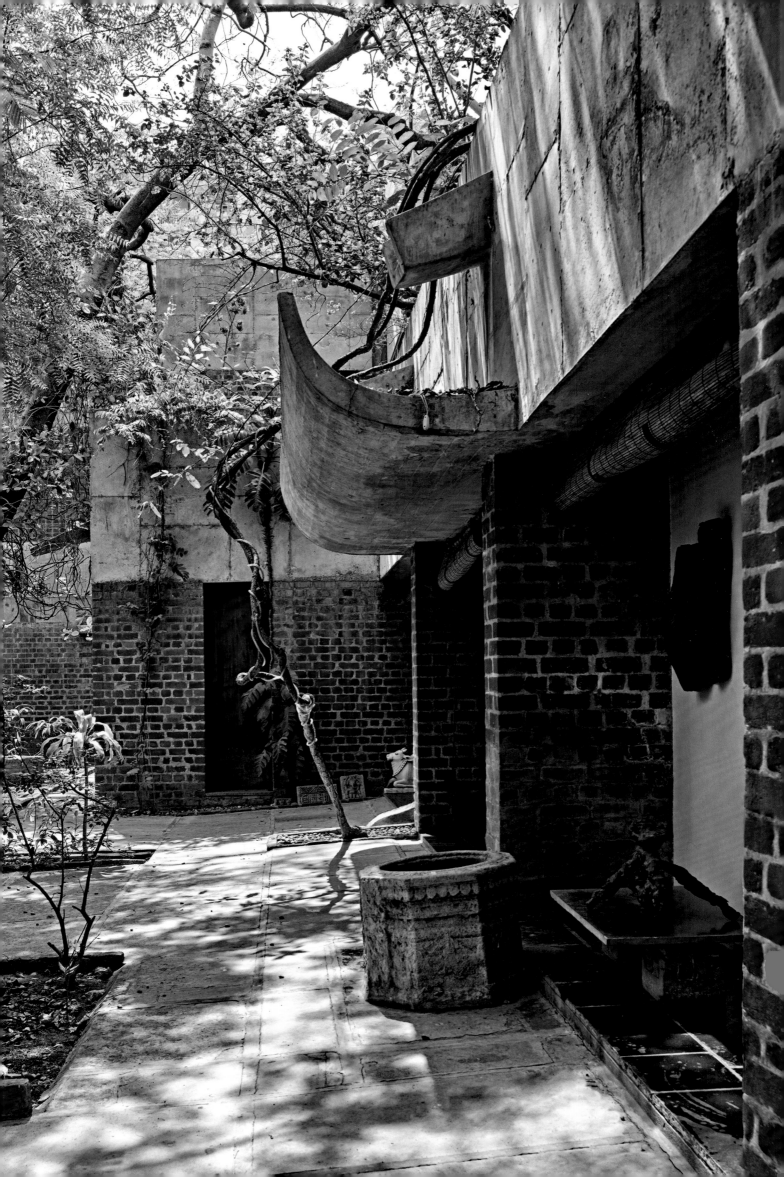

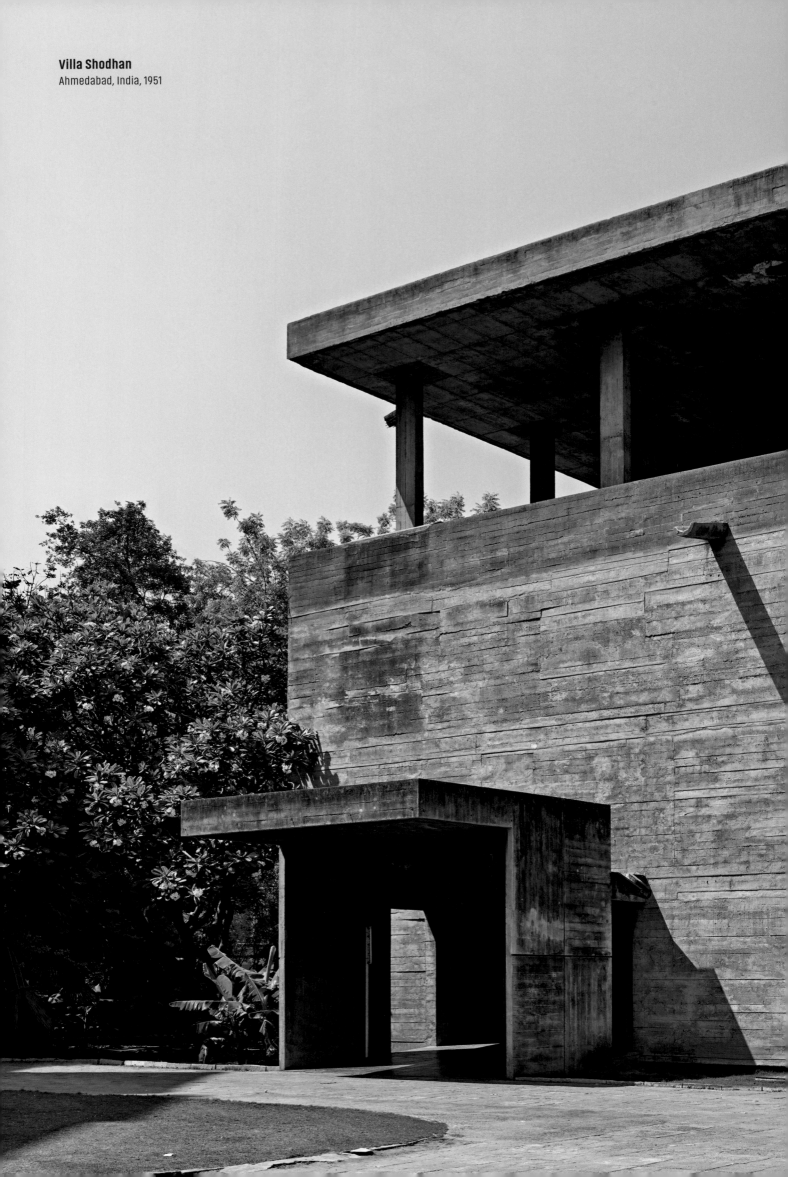

Villa Shodhan
Ahmedabad, India, 1951

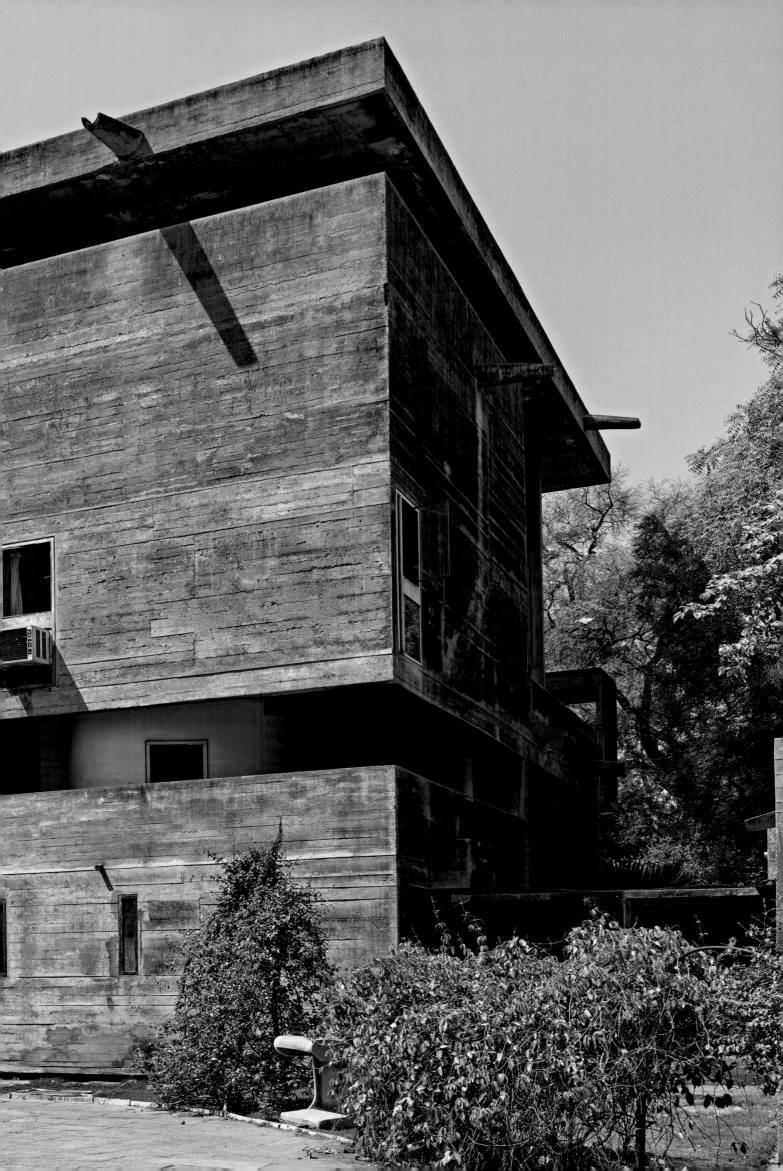

When Corbu Met Cemal

MEHMET KÜTÜKÇÜOĞLU

From a crude but still viable point of view, Corbu and Cemal hardly make a good match. It can be said that the photographer (Cemal) treats photographs like architectural drawings, adapting the latter's abstraction and projection techniques to his media – thanks to advanced lens technologies – creating drawing-like frozen representations of buildings. This is no coincidence when we consider Cemal's formal education as an architect. Corbu, on the other hand, like many other modernist architects, is said to have been trying to break free from the classical frontal, static architecture towards a more asymmetrical, sequential perception that unfolds in movement and time. This is to say that a cinematographic series of oblique snapshots would serve him better than two-dimensional architectural projections. But, as often, it is highly probable that Corbu defies such clichés, even those uttered by himself. Villa Shodhan, in Ahmedabad, is in some sense his take on a classical type – a Palladian free-standing *palazzetto*. The parasol slab, apart from being merely a sun protection, is deliberately employed to encapsulate the mass within a Palladian cube. In contrast to many other Corbu buildings, the treatment of the ground floor does not differ much from the upper floors, thus rendering the mass susceptible to flatter representations. Cemal takes it a step further. His frame is vertical, accentuating the verticality of the section by cropping the squarish facade. The building now occupies almost the entire frame, as an orthogonal projection parallel to the edges. What we see is a section rather than a facade, with the cut slabs and walls flattened onto the two-dimensional surface of the photograph. In fact, it is a section perspective, very common in modern architectural practice, with a single vanishing point combining two-dimensional composition with depth, named both by architects and photographers as 'cavalier perspective'. Here, we clearly read Corbu's intention of removing the surface to create a facade out of a section. It is his celebration of the untameable ensemble of brutal sun, brutal green and brutal concrete. His experiments with open-air rooms and brise-soleil culminated in the removal of all that is not spatial or structural, his epitome of Brutalism.

Cemal, in his odyssey chasing Corbu, has captured this instant in his own style, provoking reciprocity, inviting Corbu to meet him this time.

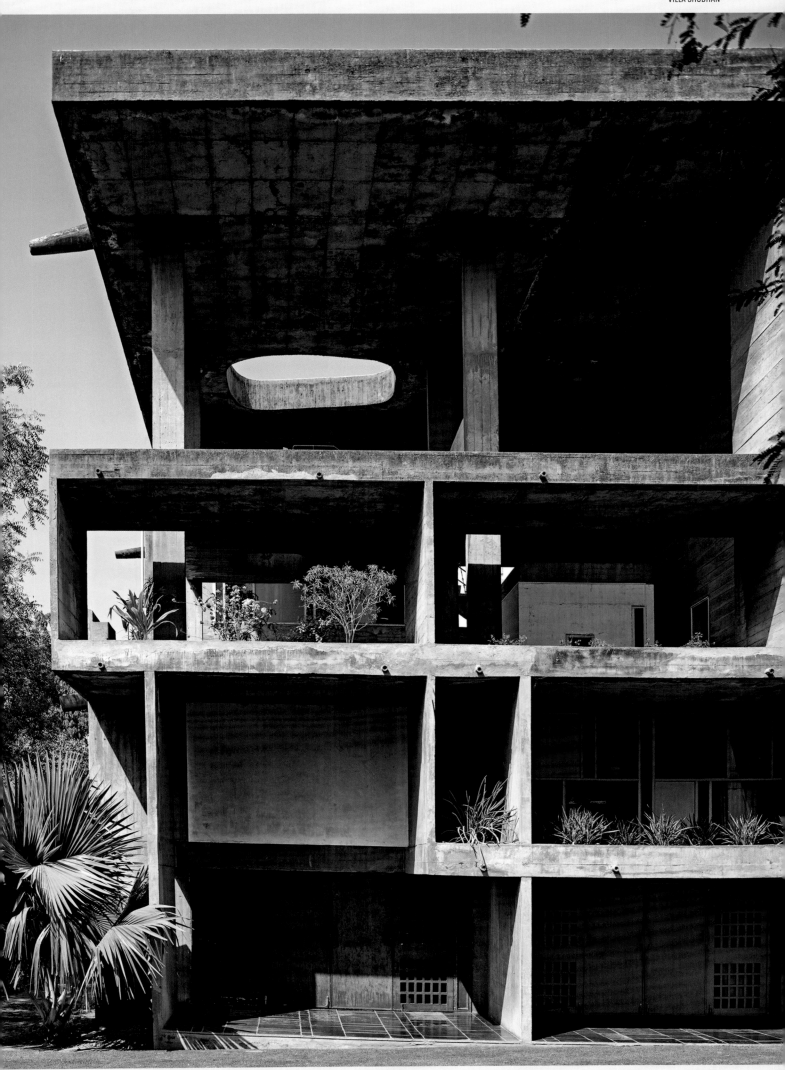

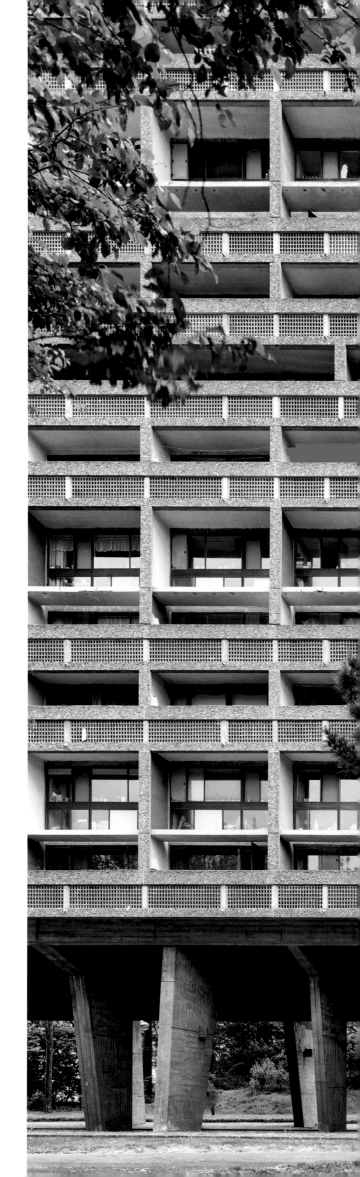

Unité d'Habitation, Rezé
Rezé, France, 1952

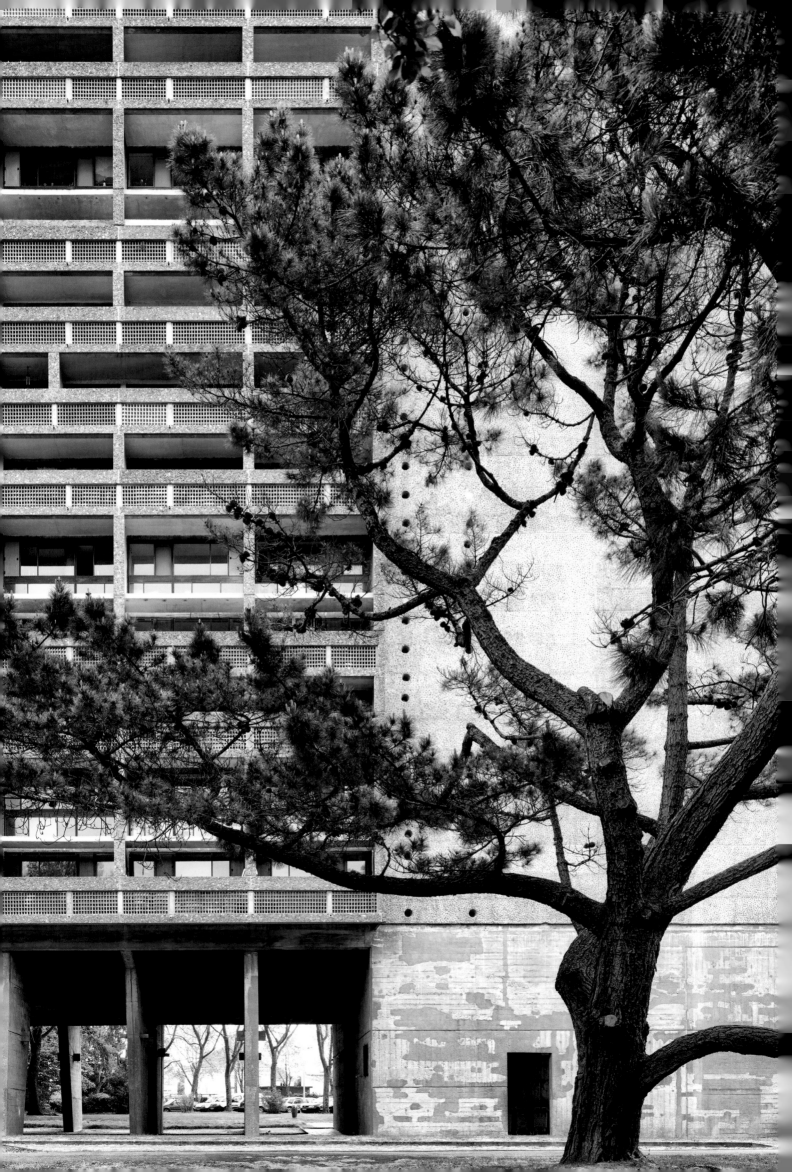

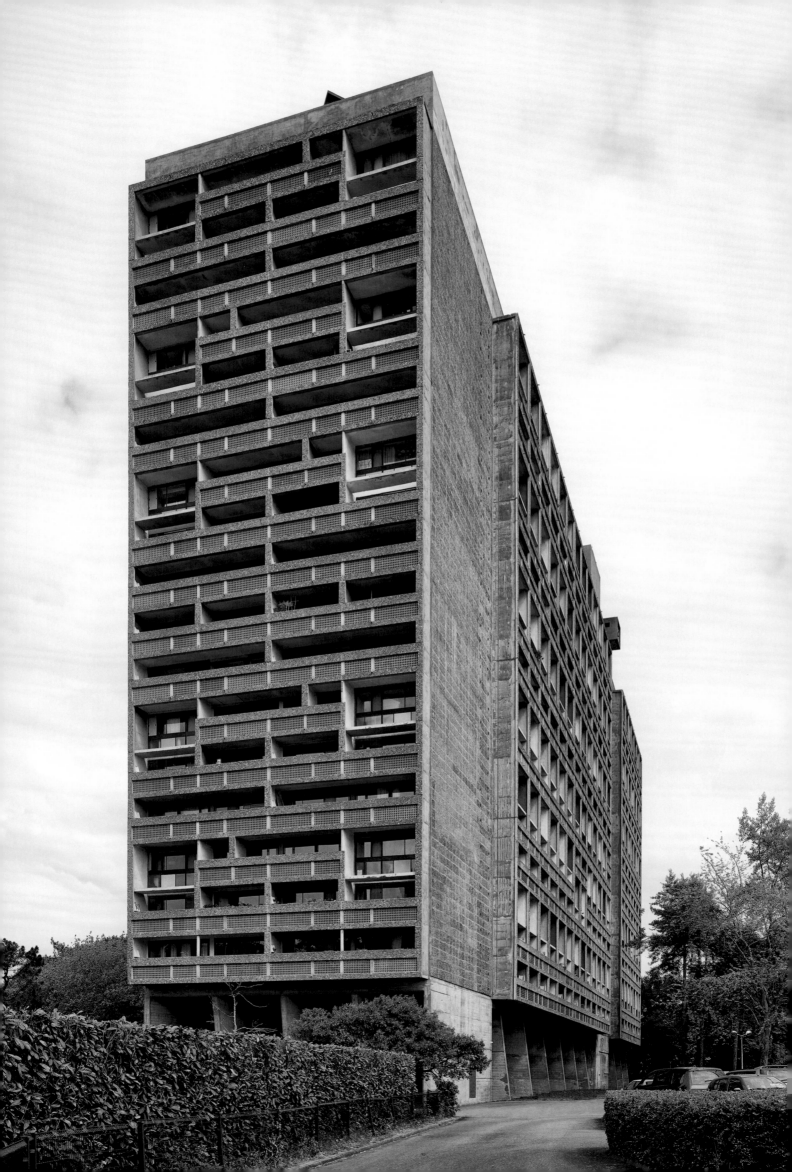

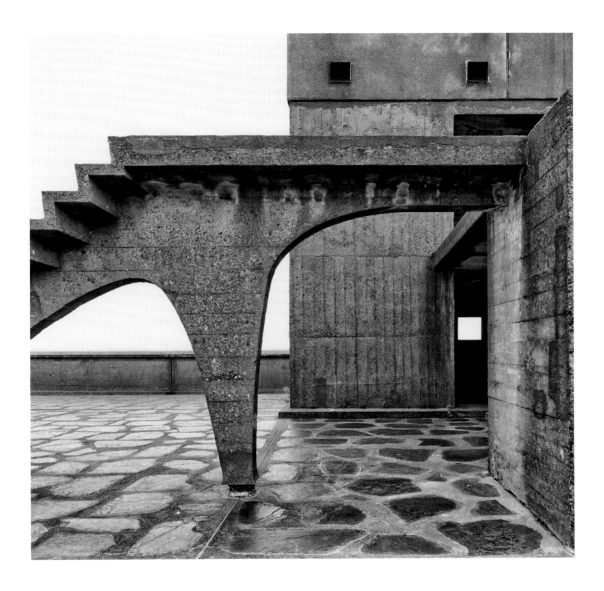

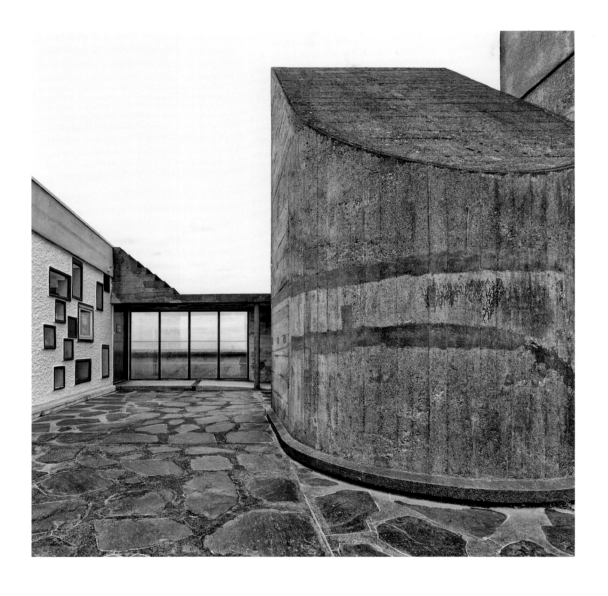

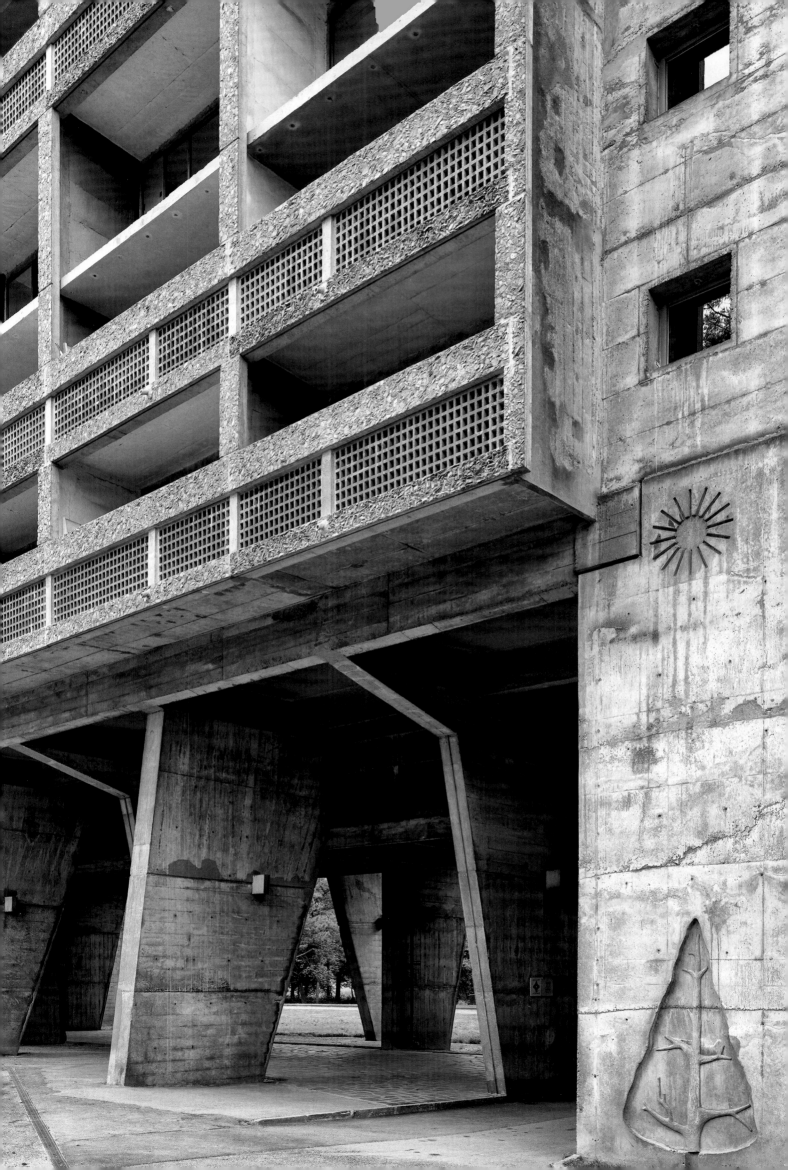

Memory of the Museum of Unlimited Growth

JACQUES SBRIGLIO

Different reasons motivated the choice of this photo. The first has to do with its subject, in that the theme of the museum and particularly that of the 'museum of unlimited growth' spans the entirety of Le Corbusier's work from the early 1930s until his death in 1965. This idea of the museum of unlimited growth, totally revolutionary for its time and highly relevant today, prefigured the construction of a museum in stages, the development of which would have followed the development of its collections. From this point of view, the plan of the Chandigarh museum, like that of Ahmedabad and to a lesser degree that of Tokyo, takes up the spiral figure of this 'museum of unlimited growth', and its principle of access 'from below' allows the visitor to penetrate directly to the heart of the building.

The second reason is that this building, which is less of a 'star' than the Capitol Complex, perfectly represents the Brutalist aesthetic, this 'romanticism of the ill-made', as Le Corbusier liked to joke, which permeates the mature work (1945–65) of the famous architect. Its Brutalism is here a unicum of simplicity of form, as austere in appearance as it is enigmatic. It is Brutalist in its economy of means, readable in the choice of materials – raw concrete and brick – bringing the architecture of this building close to that of the most ordinary buildings in Chandigarh. Finally, it is Brutalist in its treatment of the opaque walls, which harbour introverted spaces lit only by an ingenious system of sheds located on the roof terrace. Here we have Brutalist architecture but also a modern architecture, and its expression is paradoxically based on the canons of classical architecture. This is what is revealed in particular by the building's tripartite facades, consisting of a basement, a main facade with a large gallery, surmounted by a crown that is cadenced by the repetition of the visible beam ends of the structure.

The third reason relates to the manner in which Le Corbusier inscribed the questions of the local and of nature in his architecture. From this point of view, this building's DNA unmistakably issues from the climatic characteristics of India and especially the Punjab region, with its harsh winters, hot summers and rainy season with abundant showers. Hence the presence of the portico, whose depth provides pleasant shade for visitors, as well as of those immense gutters that run along the lateral facades before dumping their rainwater through a large gargoyle into a huge freeform pool that plays counterpoint to the orthogonal architecture of this museum.

All this and much more is shown in this photograph, which uses unexpected framing, since it was taken from the terrace of the art gallery that was built near

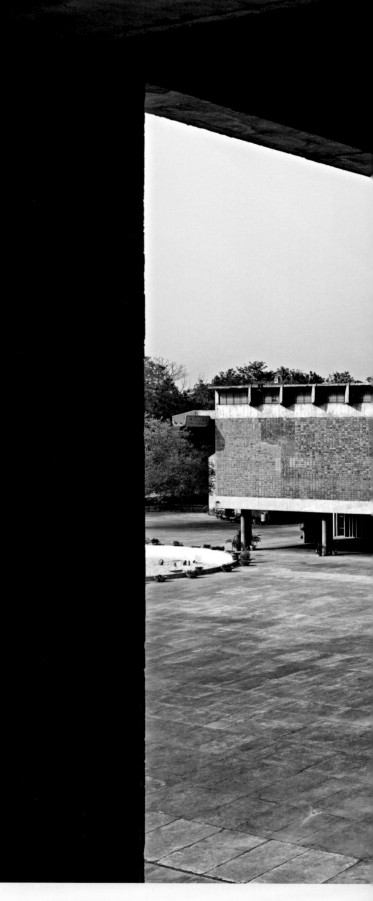

the museum and which is a concrete replica of the metal art gallery that was built on the banks of Lake Zurich in Switzerland after the death of Le Corbusier. Oblique lines, the play of shadow and light, contrasts, textures – everything here expresses the essentiality of the museum architecture, destined to transmit the ideals of modernity throughout a country whose ancient traditions are still at the heart of its culture.

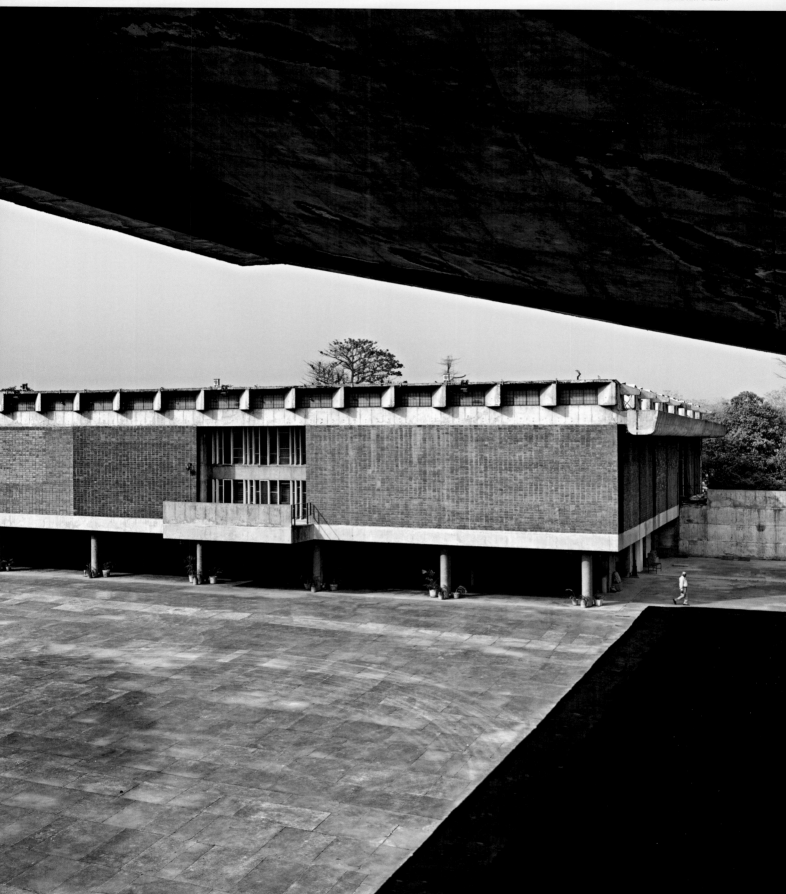

Museum and Art Gallery
Chandigarh, India, 1952

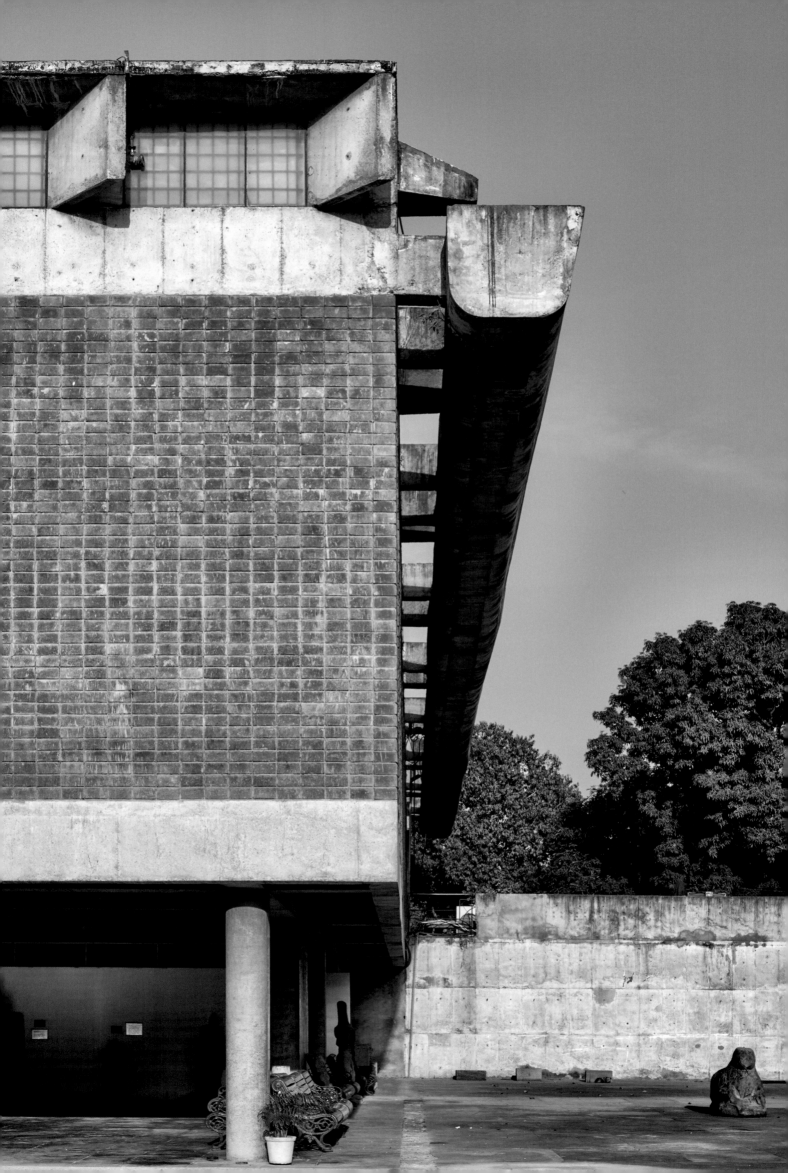

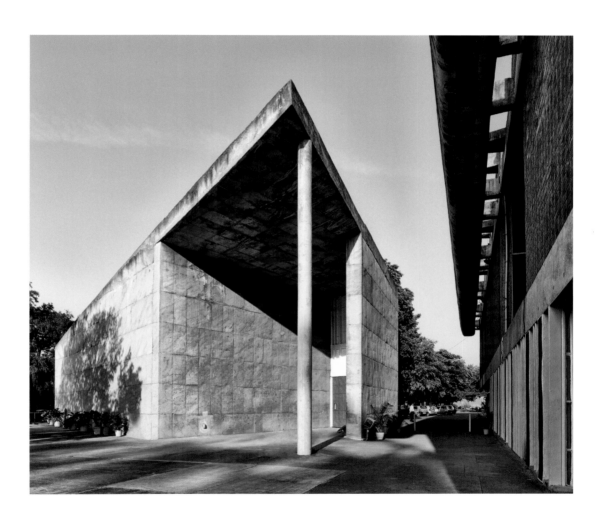

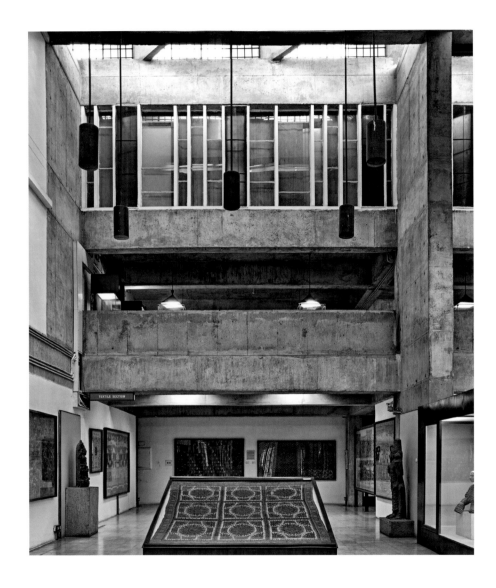

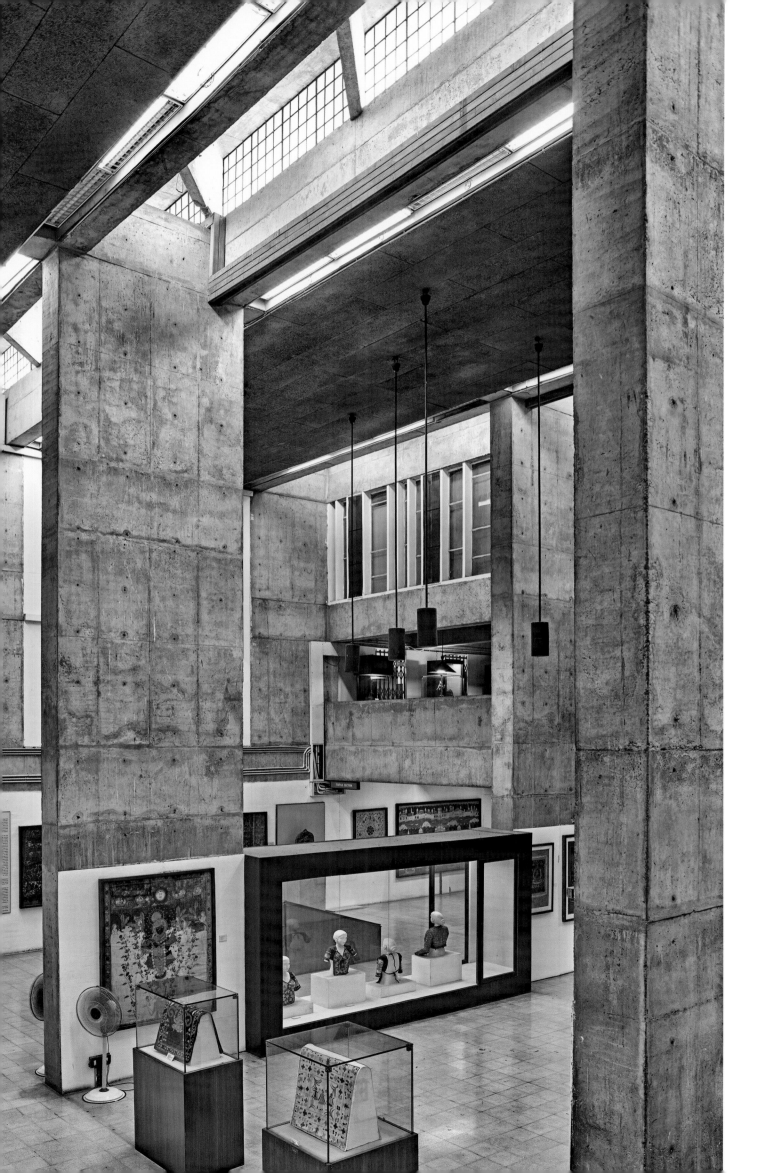

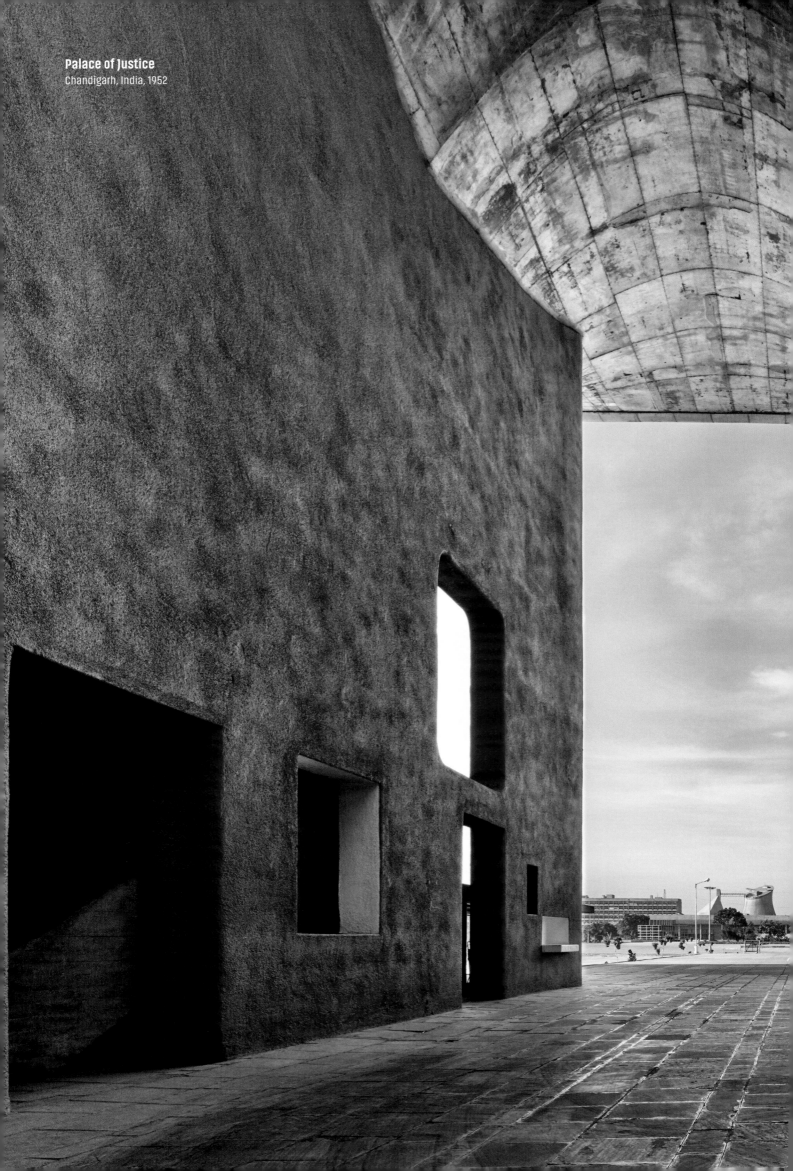

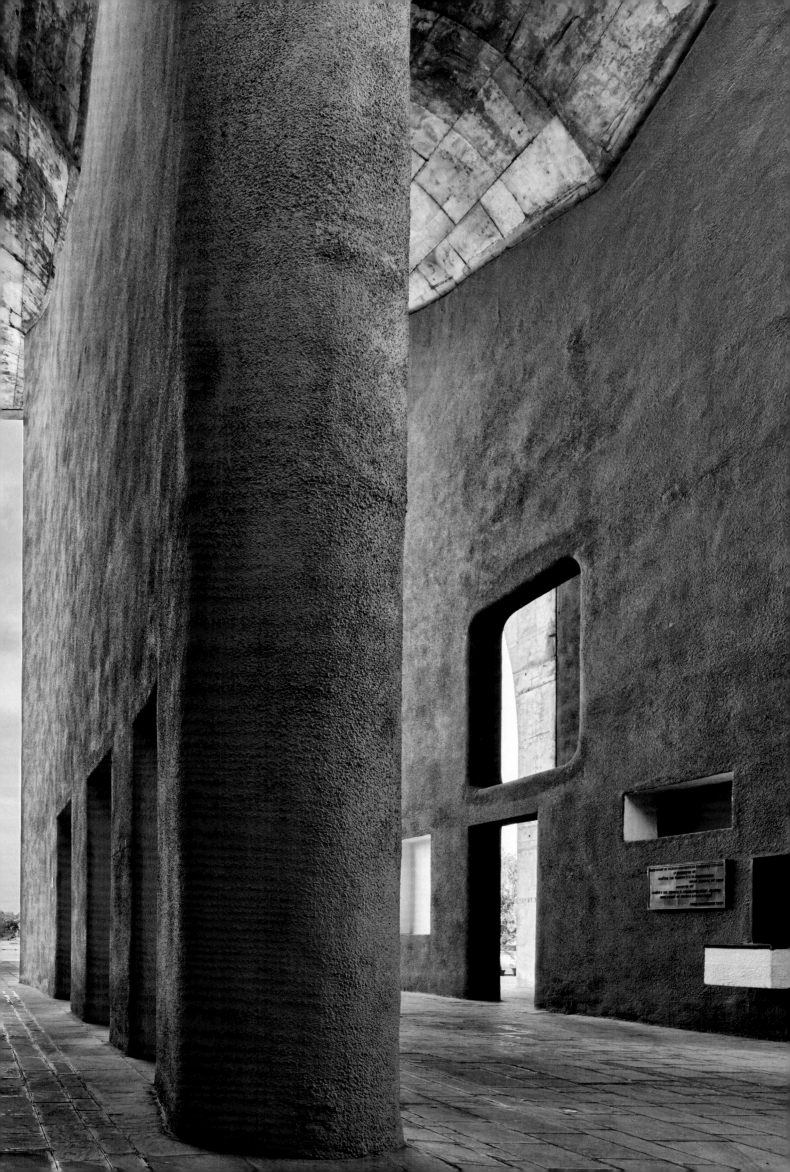

A Roof for All

ZEKİYE ABALI

Situated in the foothills of the Himalayas, the 'five rivers' region – the Punjab – gained independence from British colonial rule in 1947 and was concurrently divided on the basis of religious faith. Muslim-majority West Punjab became part of Pakistan, and Hindu-majority East Punjab became part of India. The Indian Punjab, along with Haryana, gained the status of a province. This new administrative unit needed a new city and a new administrative structure. Even though his functionalist urbanization has been amply criticized, Le Corbusier's original architectural approach in the Capitol Complex – consisting of the Assembly, the Secretariat and the High Court buildings – left a deep imprint. The architect knew well that he was designing buildings for a newly liberated society living in a subtropical environment – that is, at the same time poor and ridden with religious and ethnic differences. The new identity should not be construed above old differences but constructed around the framework of newly crafted partnerships, and modernist architecture was very suitable for this.

A contemporary but primitive concrete technology; a controlled indoor climate created without the use of mechanical air conditioning, a multi-storey public building using ramps instead of elevators; the love of colour embedded in Indian culture; categories of space that are not reminiscent of British or Mughal architecture but still familiar: this is how the architectural language of the administrative buildings was constructed.

The High Court building can be described as an office building set within a rectangular box. This picture shows only one third of the block, yet it is a summary of the whole. Here we can see the certain details that render this simple structure original: the rectangular prism, which was wrapped with a grid that is permeable at the front and back; deep brise-soleil at the front facade, constituting a building curtain that creates shading and allows the breeze to flow through.

The most striking element is the top cover above the roof of the box, expressed in this picture in all its large and magnificent character. It is essentially a second roof that starts way out and high up at the front, descending towards the back. The first layer, which we do not see in the picture, is the roof of the box and constitutes a functional ceiling for the office units; the second, monumental roof is a huge, high concrete shell that stretches wide to cover the entire building. This single element undoubtedly carries a symbolic meaning besides offering protection against the burning sun and monsoon showers: it represents the physical structure of the new polity that unified deeply suffered differences by guaranteeing a single, egalitarian justice system. This building accommodates under its roof not the historical differences based on religious belief and cultural tradition but the constitutional rights framework under which everyone is equal.

The thick vertical green line framing the picture at the right is a wall, a column or a pilotis defining the entrance hall together with its red and yellow siblings, which are not in the picture. The high-ceilinged entrance hall without front or back walls, nor a precise door, can be seen as the flowing of the outdoor plaza into the building. The rough concrete surfaces with marks of poor moulding are clearly visible in the photograph. This is not only an expression of the building's Brutalist architecture but also a sign of scarce resources and inadequate labour. On the other hand, the architect created a subtropical warmth over the cold, grey concrete surfaces by applying a few of the bright colours that are popular in India. Coloured architectural elements stand out like brushstrokes here and there on the front of the building. The artist who shot this image focused on only a small portion of the main facade, yet in doing so presents us with an encapsulation of everything that makes this building unique.

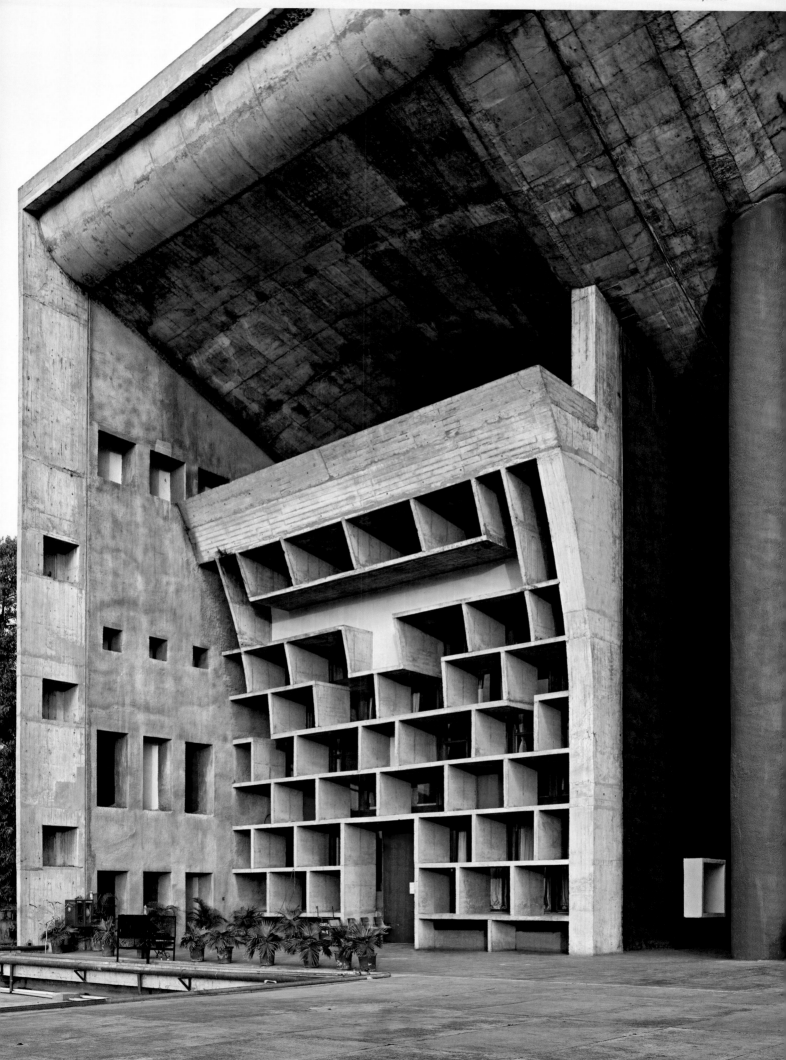

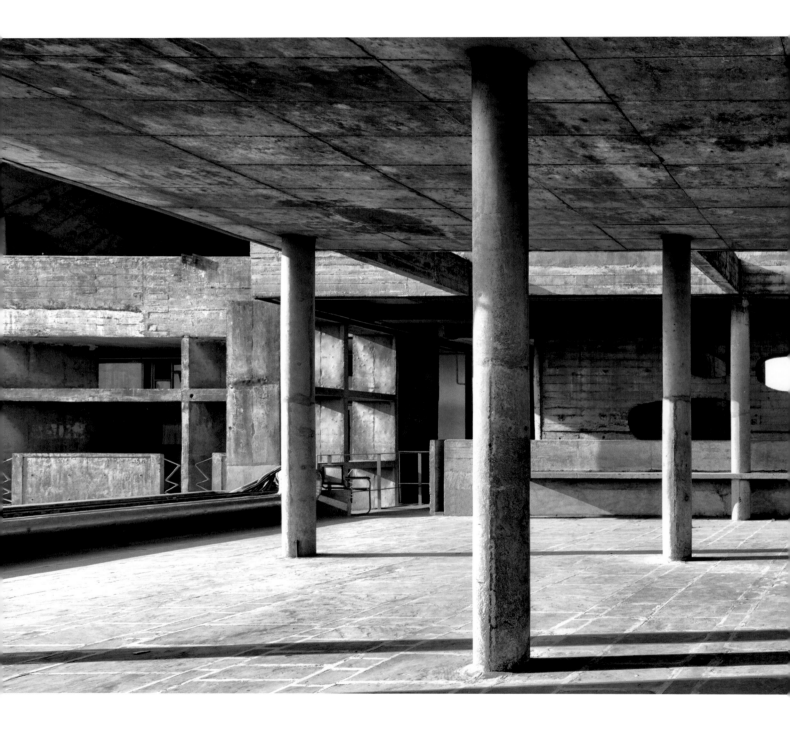

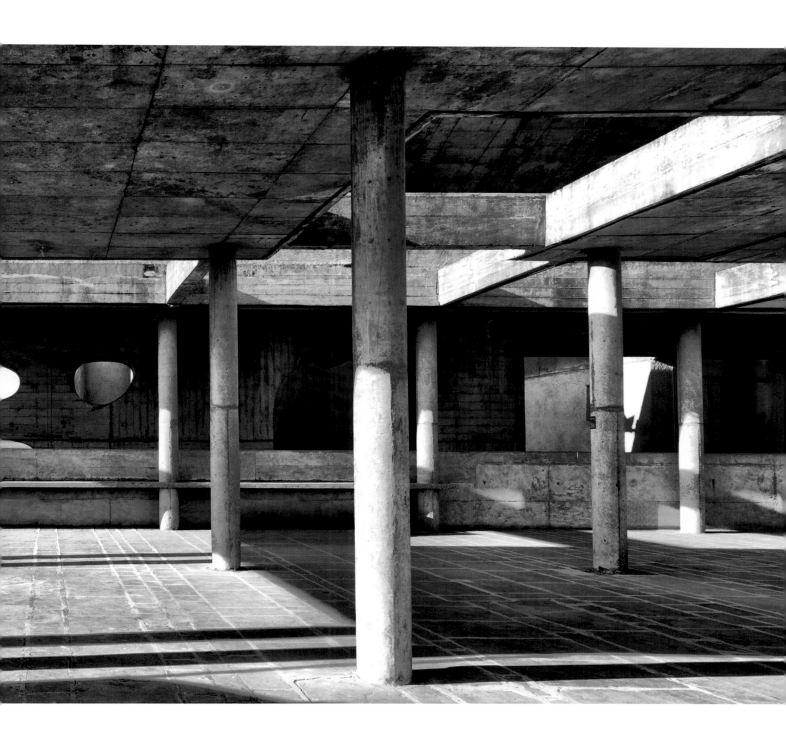

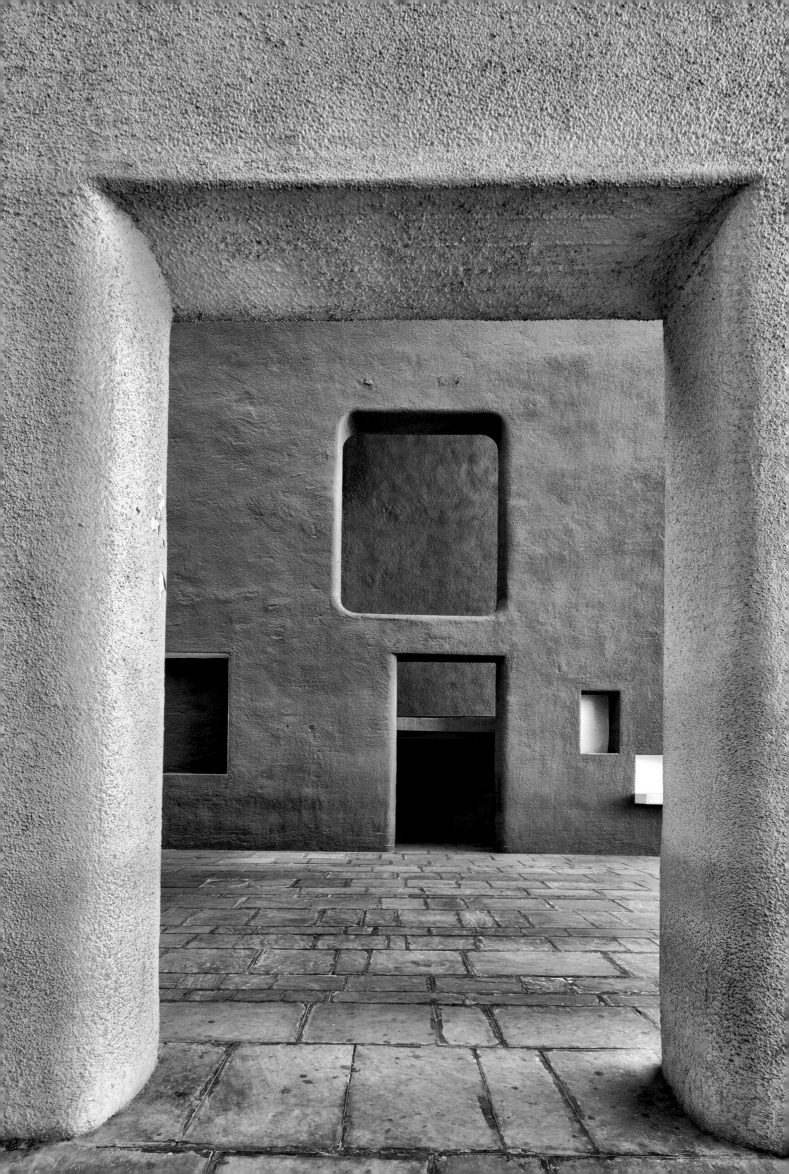

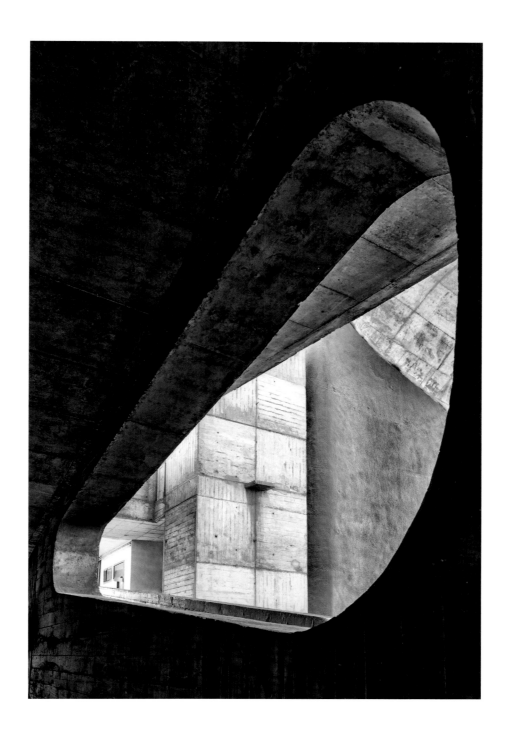

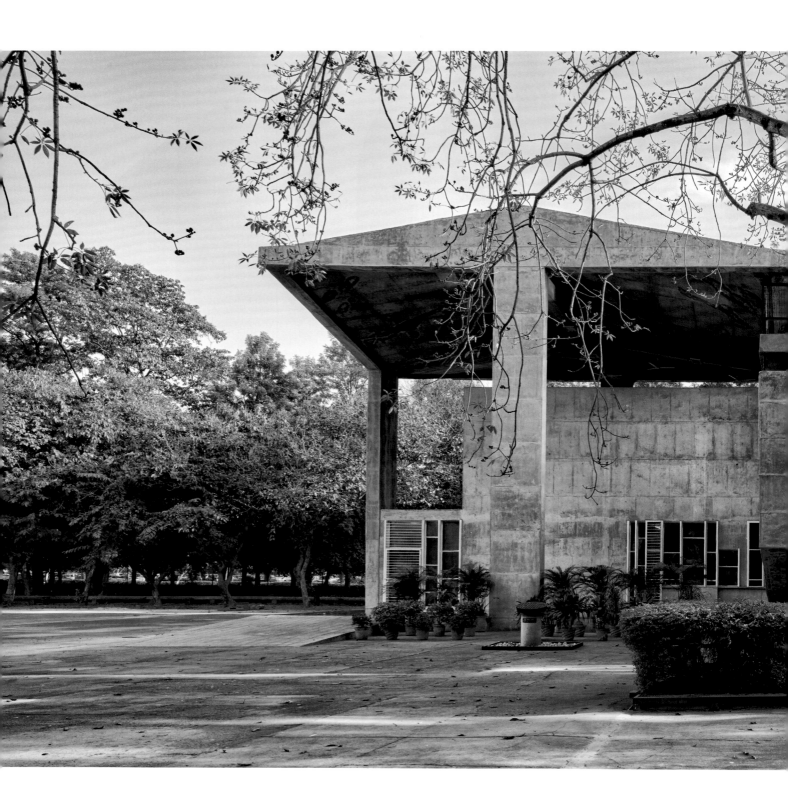

Architecture Museum
Chandigarh, India, 1952

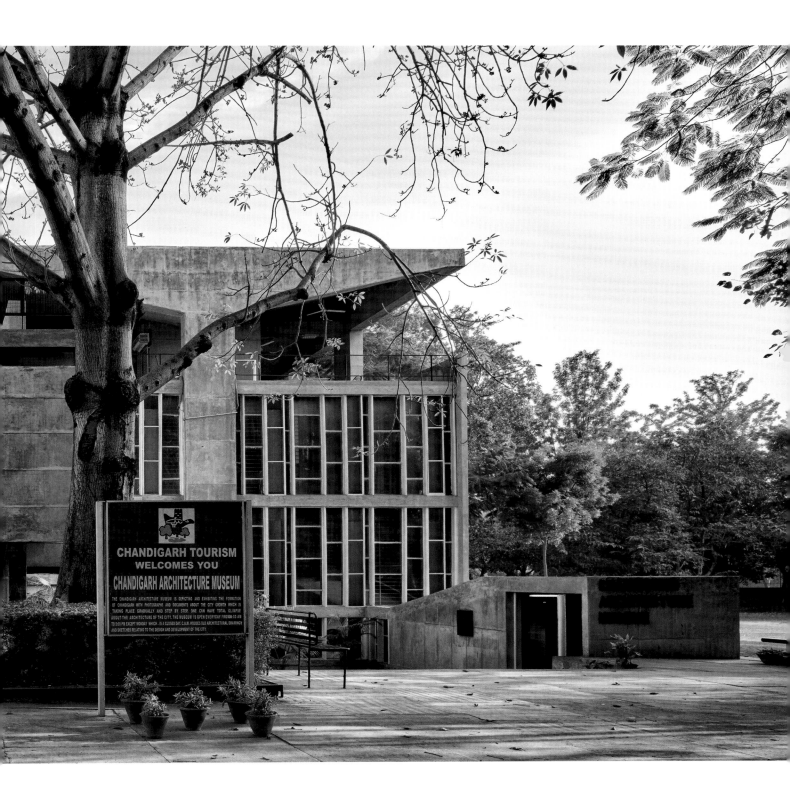

Replicating Huts and Trees

NAMIK ERKAL

For those like myself who have not been to Chandigarh, the building in this photograph may first catch their eye with its resemblance to the iconic Pavillon Le Corbusier (formerly Centre Le Corbusier – Heidi Weber Museum) in Zurich. This is the Chandigarh Architecture Museum, a gallery dedicated to the planned city and its architects. Since we are dealing with a master like Le Corbusier, for whom replication rarely eventuated in replicas, how did these duplicates emerge? Le Corbusier initially proposed the idea of a shelter formed of two adjacent but reverse-pitched canopies for a pavilion at Liège, Belgium, in 1926, but the design never left the drawing board. In the 1950s, the same idea was reincarnated in sketches for a gallery near the Chandigarh Museum, but was not immediately realized. Eventually, Le Corbusier proposed the same pavilion design for the Heidi Weber Centre.[1] In its initial stages, this building was conceived in concrete; it was subsequently reworked in steel as an artefact of the modular system. In Chandigarh, Le Corbusier's former assistant architect Shivdatt Sharma realized the sketch for the gallery after the architect's death; the pavilion, completely sculpted of concrete, was inaugurated as the Chandigarh Architecture Museum in 1997. As such there are two buildings, in Chandigarh and Zurich, that translate the same design diagram in two different materials and two different contexts. Certainly the Zurich pavilion represents the modular aspects of Corbusian architecture in its canopy and the parties beneath. But, as this photograph by Emden reveals, it is in fact the Chandigarh gallery and its locus that singularly display the idea of these projects: the primitive hut.

Marc-Antoine Laugier's theory of the 'primitive hut' is known to have been a key reference for Le Corbusier. As a conceptual building the primitive hut represents core architectural necessities with five main articles: column, entablature, pediment, slabs and fenestrations, all of which are embedded in nature. Recall here the frontispiece illustration in which a reclining muse points to a hut formed beneath four sheltering trees. The idea of the primitive hut might have influenced Le Corbusier in diverse ways; however, it is in the canopies of the Chandigarh and Zurich pavilions that Laugier's first three items find literal formal expression, in a likeness to the well-known illustration. These sections of Le Corbusier's project consist of side columns that carry the upper structure from the middle of the modules in an analogous way to a tree. The canopy is shaped of alternative pitches that may be interpreted as projected entablatures and pediments or simply as branches. For more, let us look to the photograph.

The left half of the picture is occupied by the museum, while the right half is respectfully reserved for a single crowning tree. The correspondence between the building and the tree is obvious; however, the answer to which came first may be obscure. The landscape of Chandigarh is planned like the city itself, which is attributed to Mohinder Singh Randhawa, the landscape planner and chairman of the capital's foundation committee. There are over ninety types of tree planted in the city, and all are catalogued and registered, including the tree near the Architecture Museum. Here to inexpert eyes we

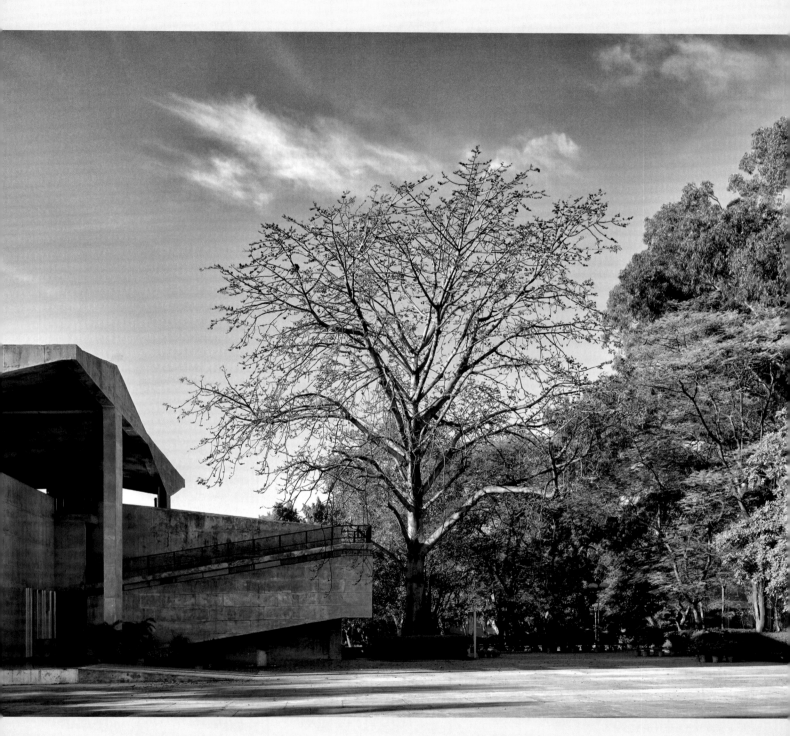

have a plane tree, though this may rather be a more distinct species. In the photograph, the symmetrically placed building and tree display two different perspectives: at the left, the single-point perspective of architecture; at the right, a free landscape view – that of nature. The vanishing point of the picture, the ramp, being the sole element of the building excluded from the canopy, unites the two. The open ramp is reached from the second floor of the building. It climbs up towards the shade of the tree, arrives at the landing, where the branches can be touched, and continues in the other direction to reach the space

beneath the shed. It is with this ramp that the tree becomes another canopy: the primordial sheltering tree. Furthermore, the ramp unifies the idea with its illustration, and the abstract reference to the primitive hut in the canopy becomes phenomenal. Cemal Emden captures this assemblage and accommodates the viewer at its centre. It is an assemblage whose authors are multiple: the master, the assistant and the landscape architect.

1 Recently renamed Pavillon Le Corbusier.

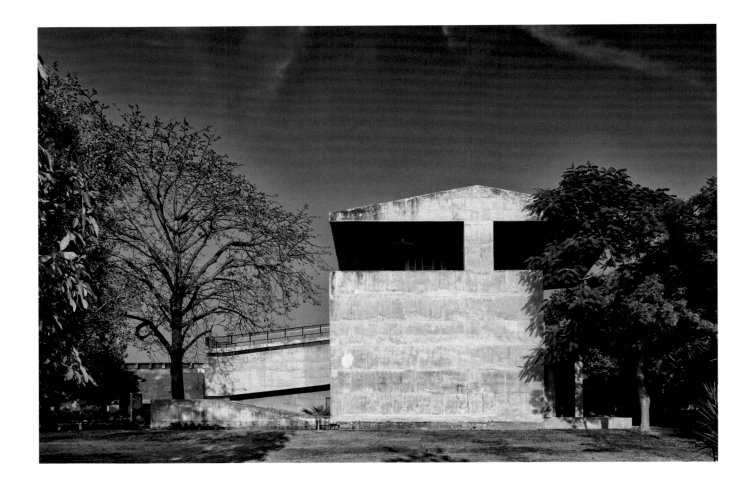

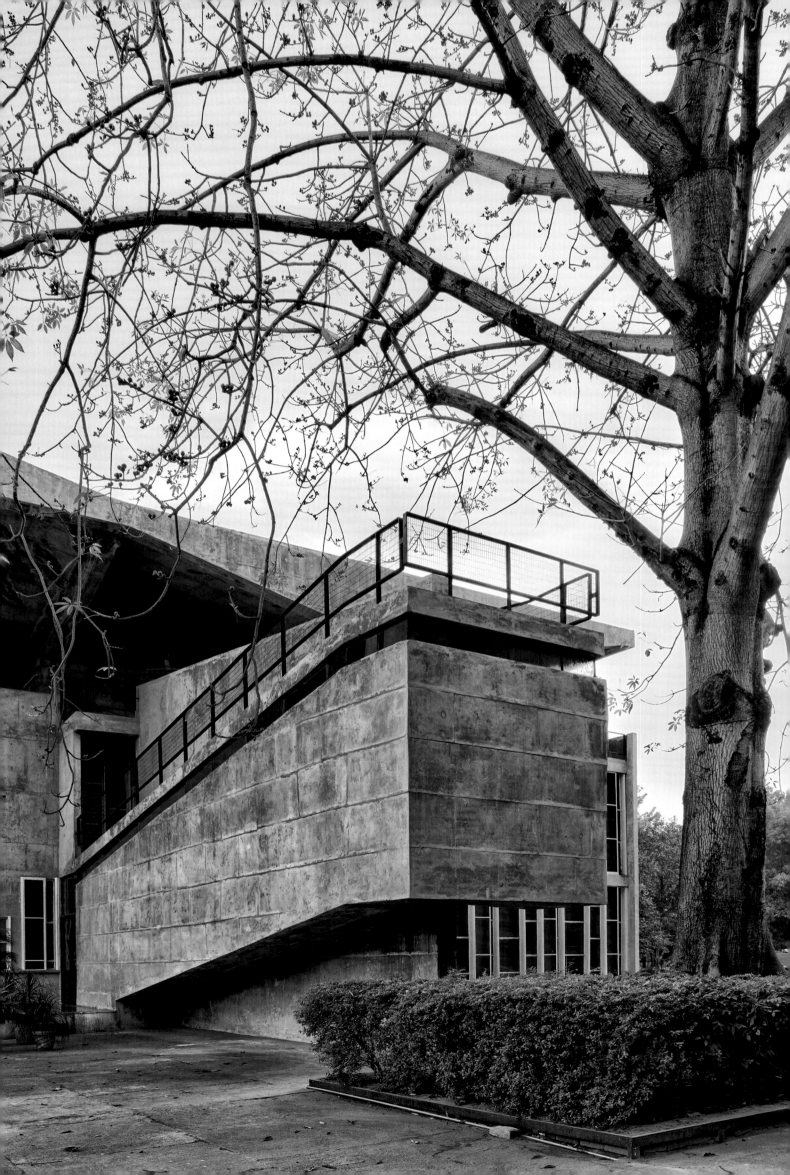

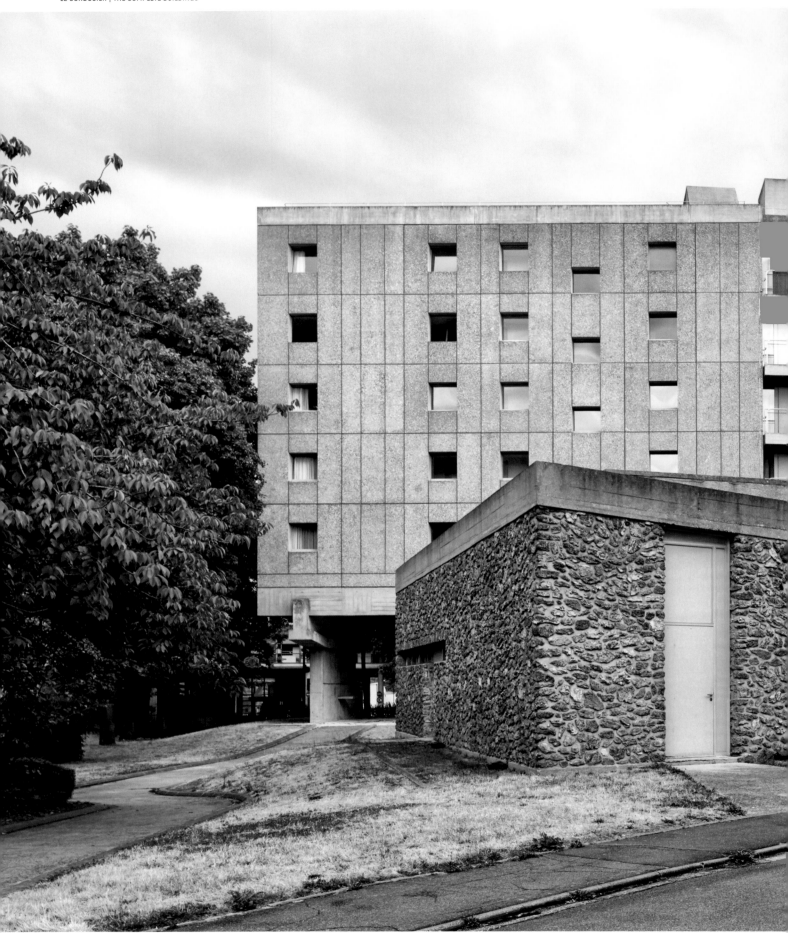

Maison du Brésil
Paris, France, 1953

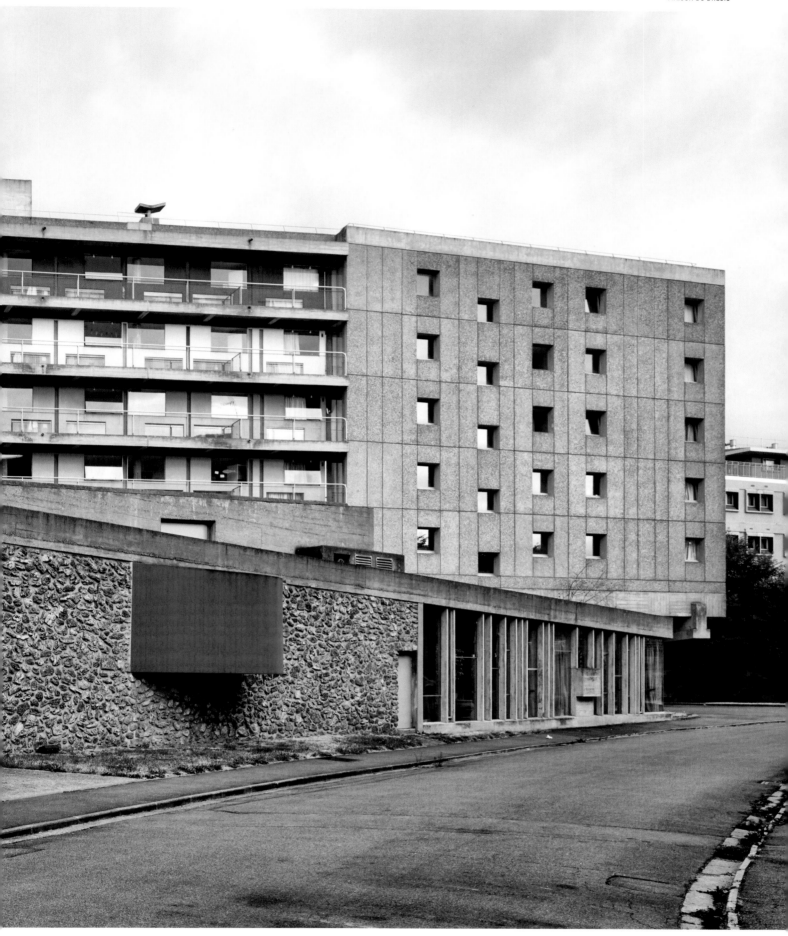

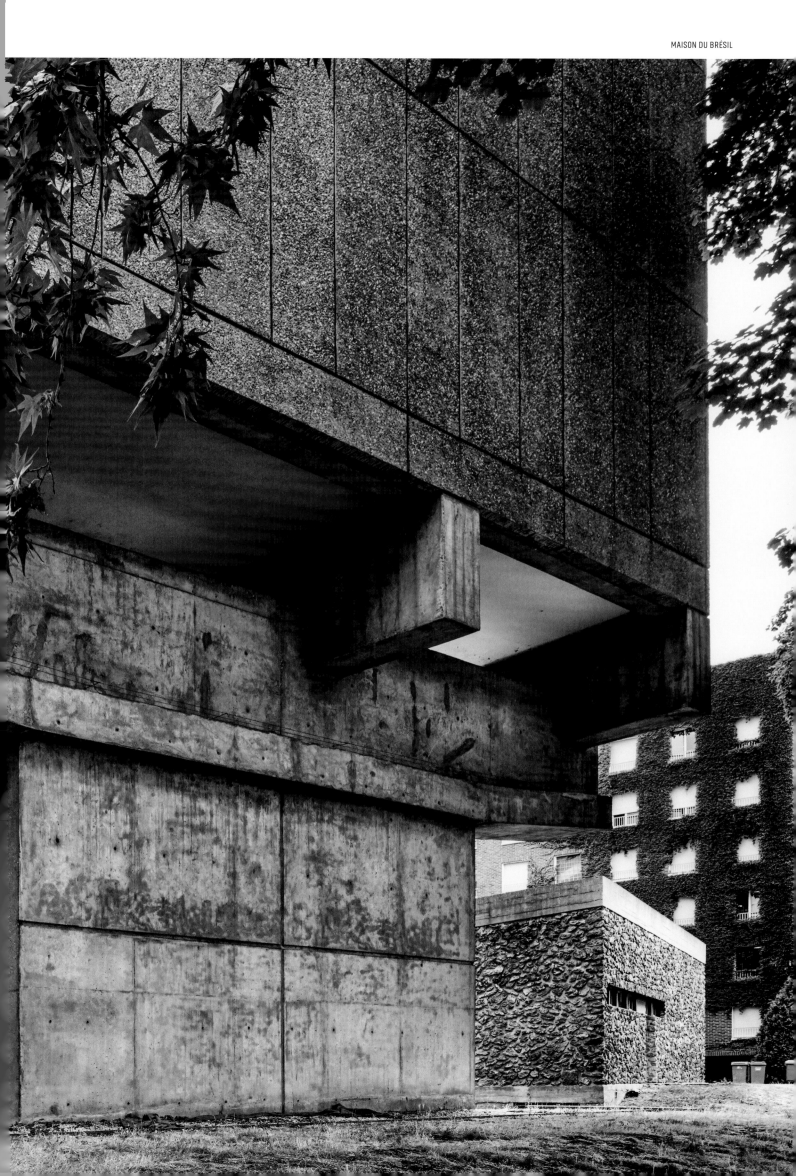

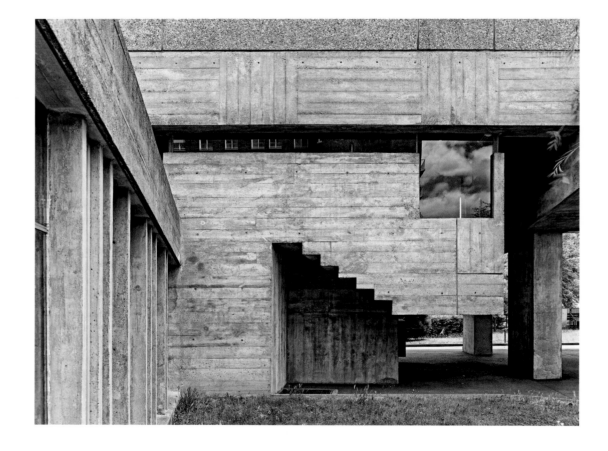

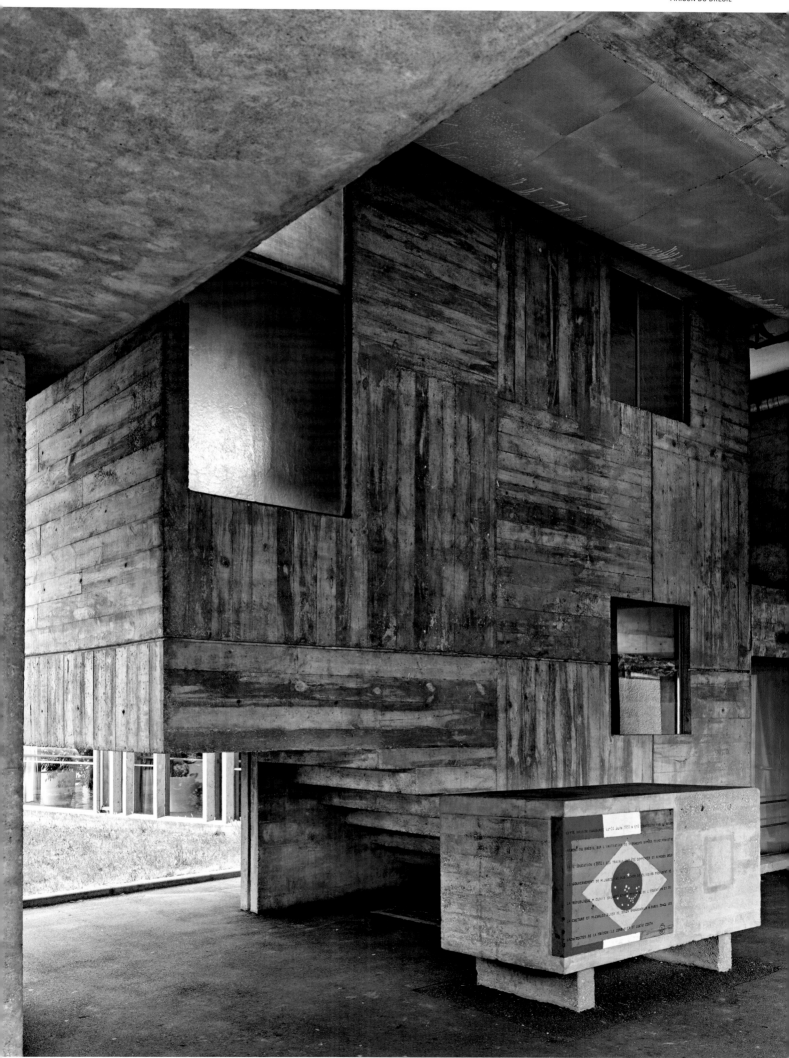

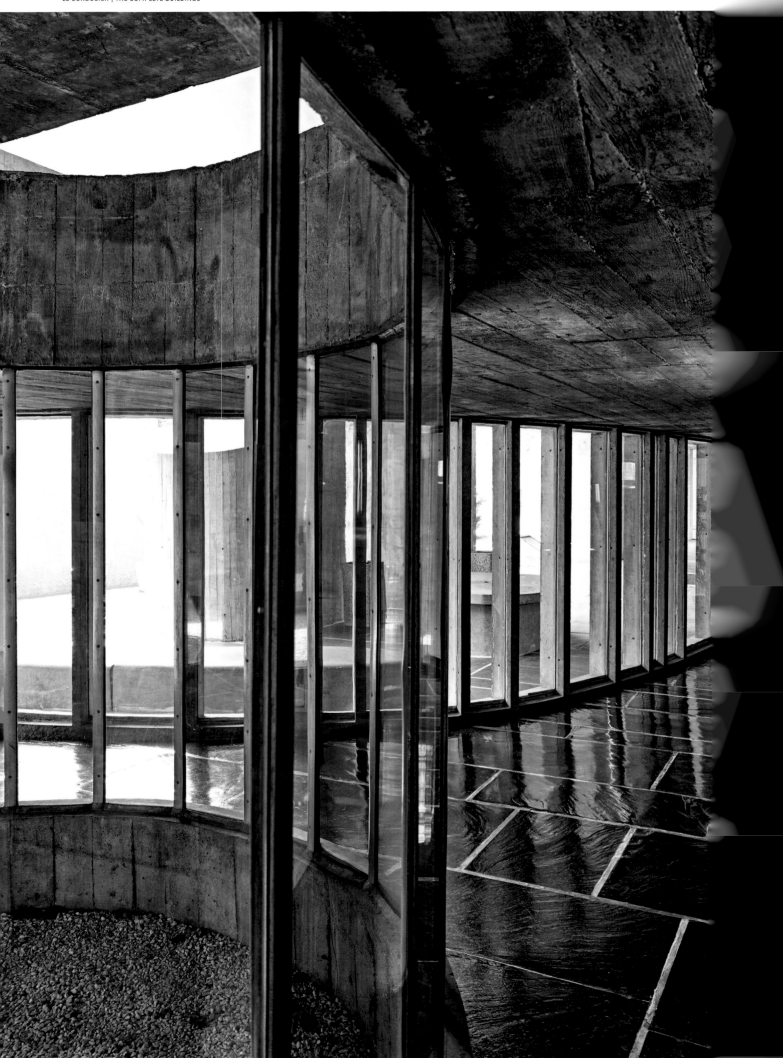

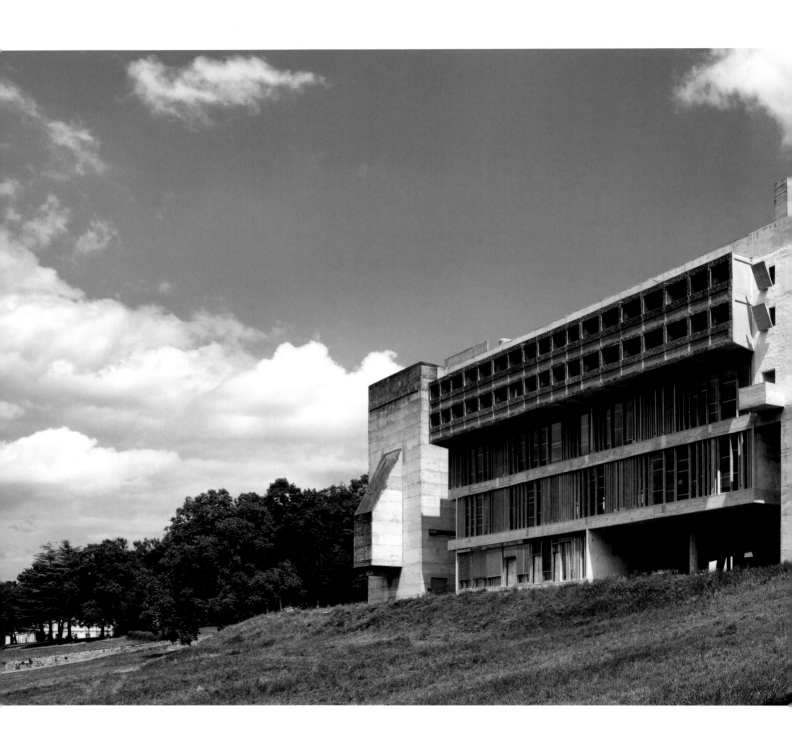

Couvent Sainte-Marie de La Tourette
Éveux-sur-l'Arbresle, France, 1953

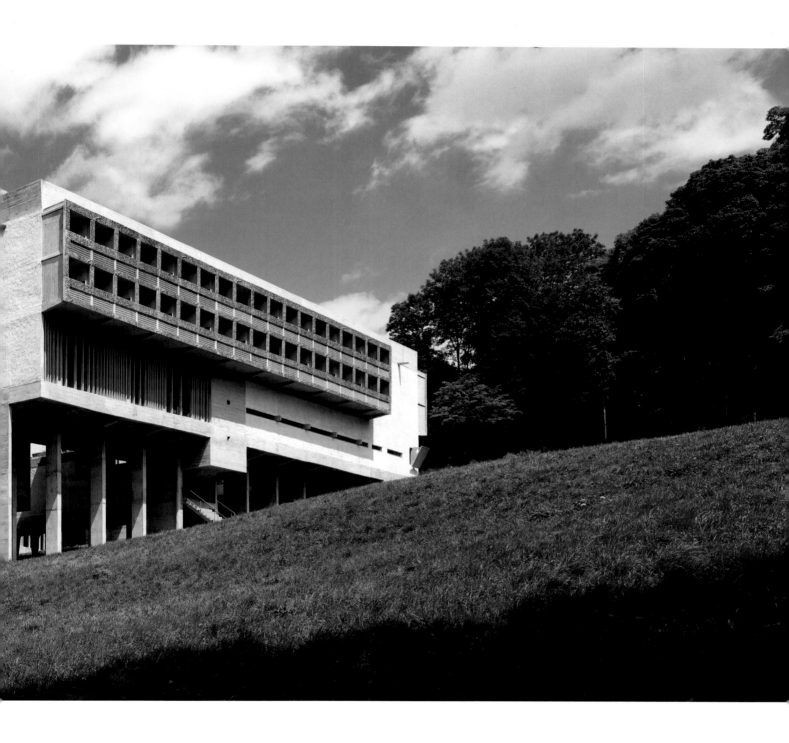

Architecture as an Artistic Whole

DOĞAN KUBAN

I think Le Corbusier was the greatest creative architect of the twentieth century and one of its leading creative minds. The Dominican monastery of La Tourette is one of his great works. It shows, however, the split tendency that dominates his design.

I tried to view the building in the photograph as the work of an unknown architect. It is the work of a man who does not share the rules or prejudices of architects about architecture. The courtyard refers to no past model. There is no geometrically well-defined space, no regular stoa, no dominating shade. The square building in raw concrete in the middle of the courtyard has no windows but a diagonal cut at the corner that lets in light. Its pyramidal top is asymmetric. The building is supported by two thin stone walls that intersect to form a cross. This is a support form that antagonizes all the structural rules of architecture. The walls surrounding the courtyard have no formal relationship to each other. In the background of the photograph, there is a concrete wall with no window openings. In front of it, the cubical room is illuminated from the top through chimney-like sculptural forms. The long building on the right has a band of horizontal windows, like a ribbon. At the level of the courtyard, window bays have irregular divisions. The facade design of the surrounding walls has no regularity. This building seems to refuse regular architectural forms and tends to dress them with sculptural form. It suggests that the designer's purpose was to destroy the common architectural concept. Le Corbusier consciously defies the common rules of architectural practice. One cannot understand Le Corbusier's style by looking at any single building. Le Corbusier was a man of energy and different talents. He was simultaneously a designer, sculptor, architect, city planner and thinker: an architect working in the vein of the *Gesamtkunstwerk*, a Bauhaus concern. But his tireless search for new forms and perfection does not represent a stylistic unity.

Le Corbusier was already a well-known architect when he designed the monastery of La Tourette. The single photo used here does not provide enough insight into the complexity of his design and its other painterly and sculptural details. These indicate that a double personality – a revolutionary artist and a business-minded Swiss watchmaker – controls his design.

Le Corbusier was expressing an early form of postmodernism. He became one of the leaders of modern architecture. A sculptural and painterly imagination was ever active in his thought and practice, allowing him to put the final touches to any architectural design. Although he was one of the precursors of functionalism, for him the main function of practising architecture was to create his own idea of the beautiful. This was realized, at least to my understanding and taste, at the chapel at Ronchamp. But from a progressive architectural perspective, Chandigarh must be considered his mature, path-breaking work.

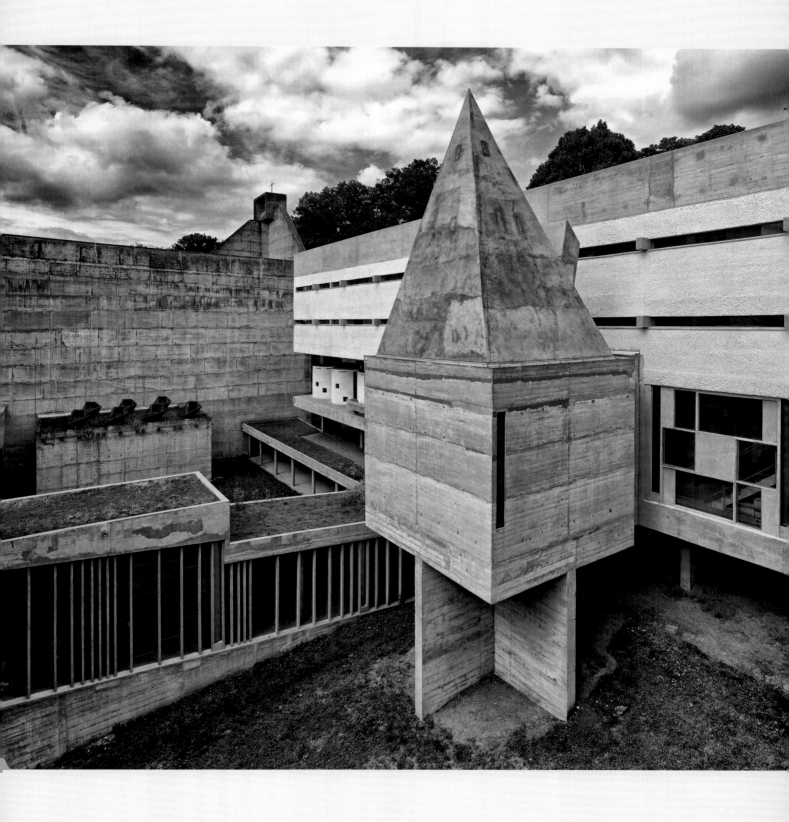

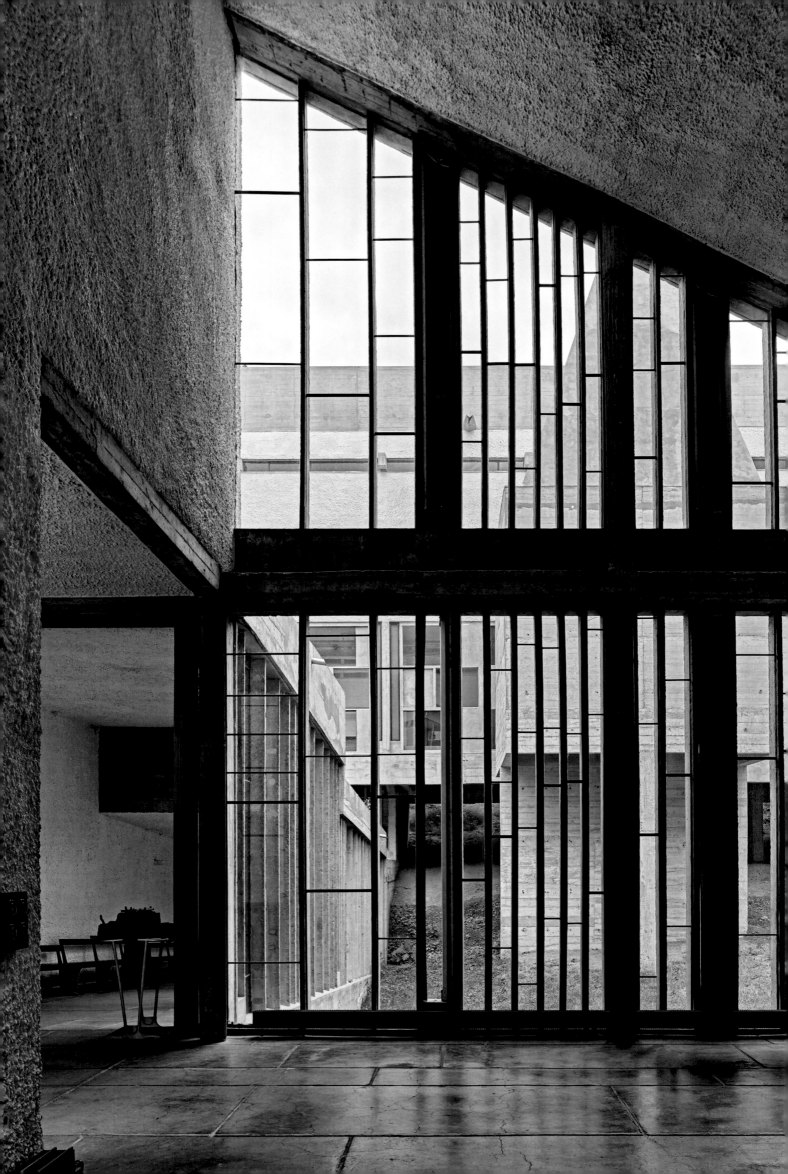

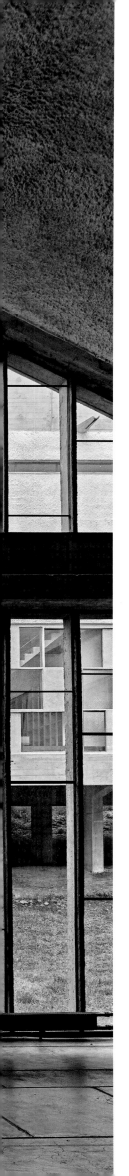

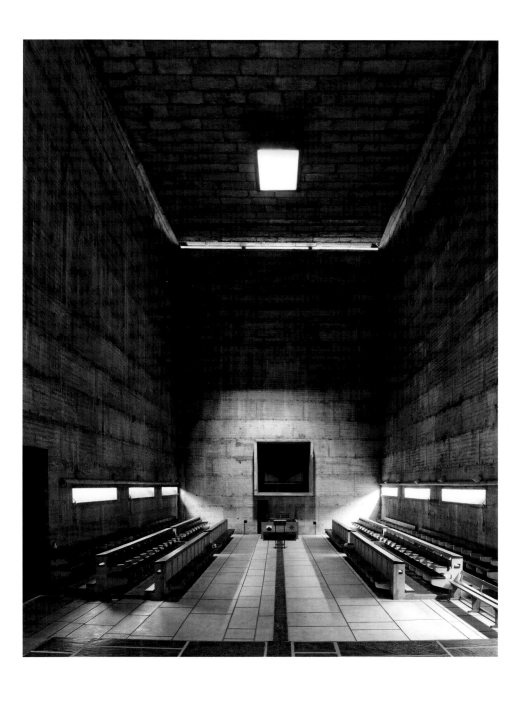

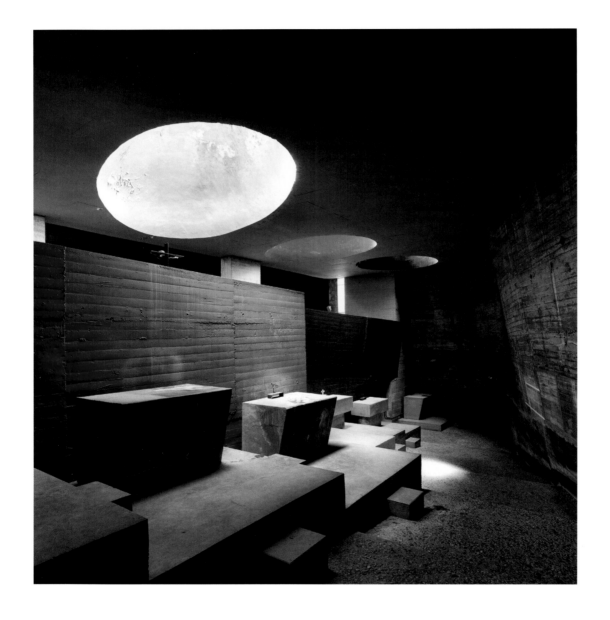

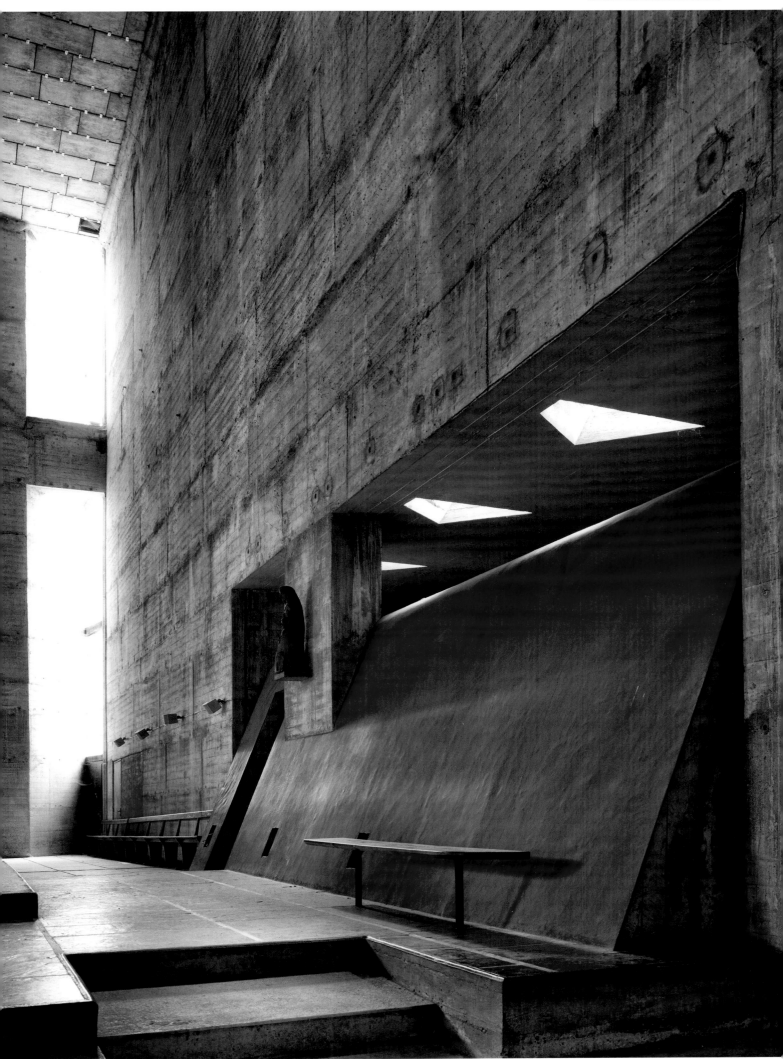

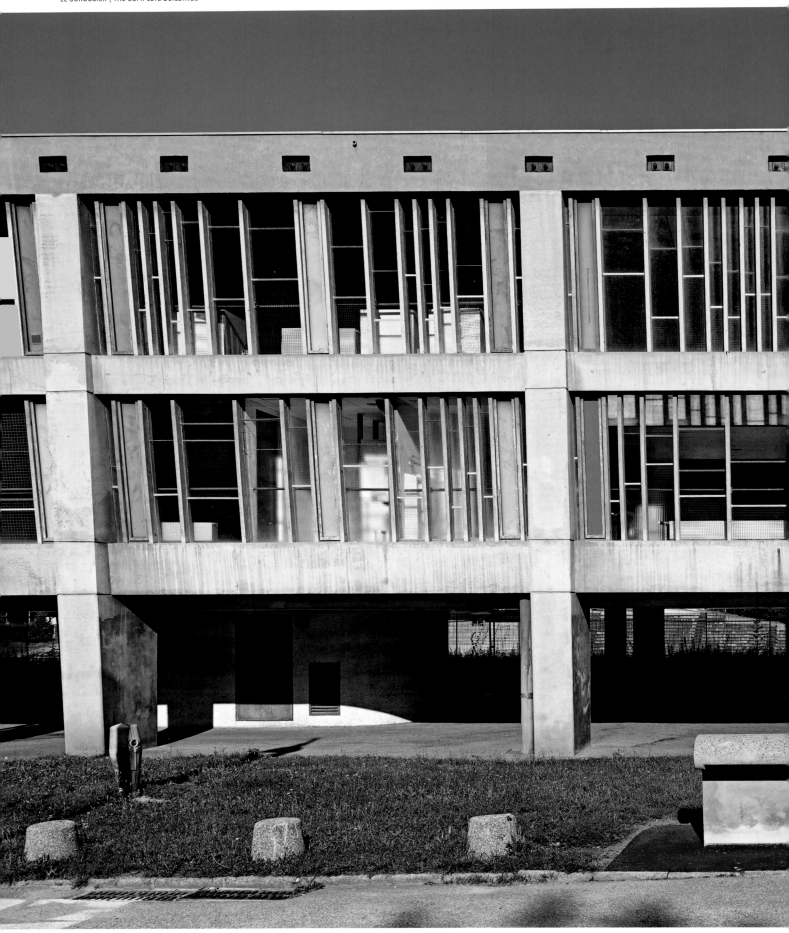

Maison de la Culture
Firminy, France, 1953

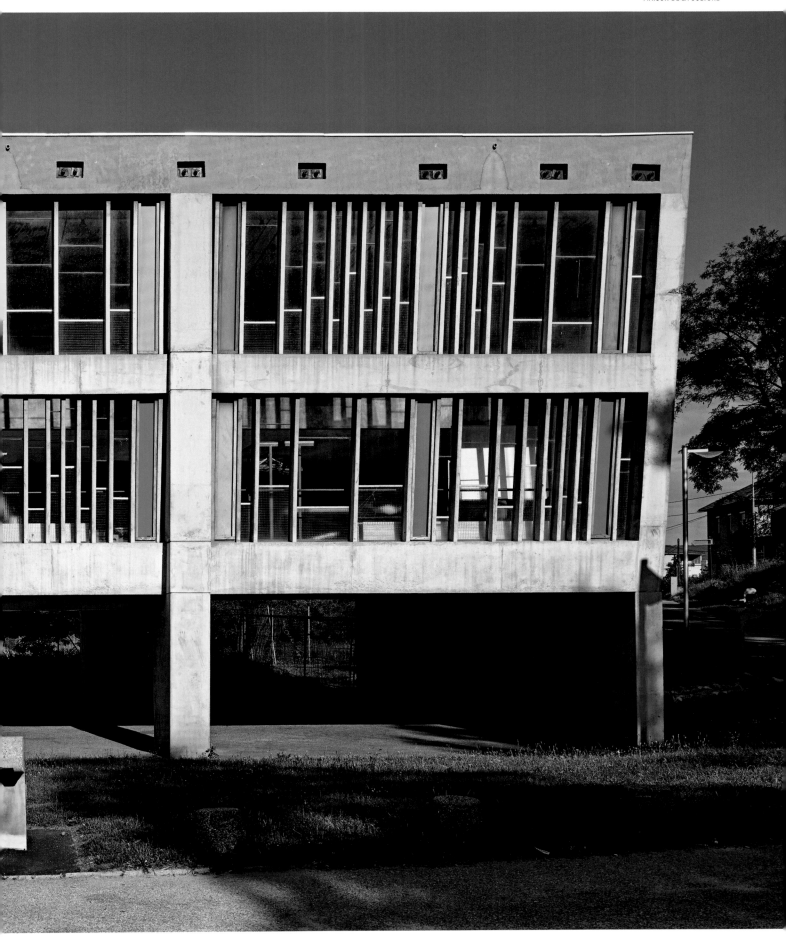

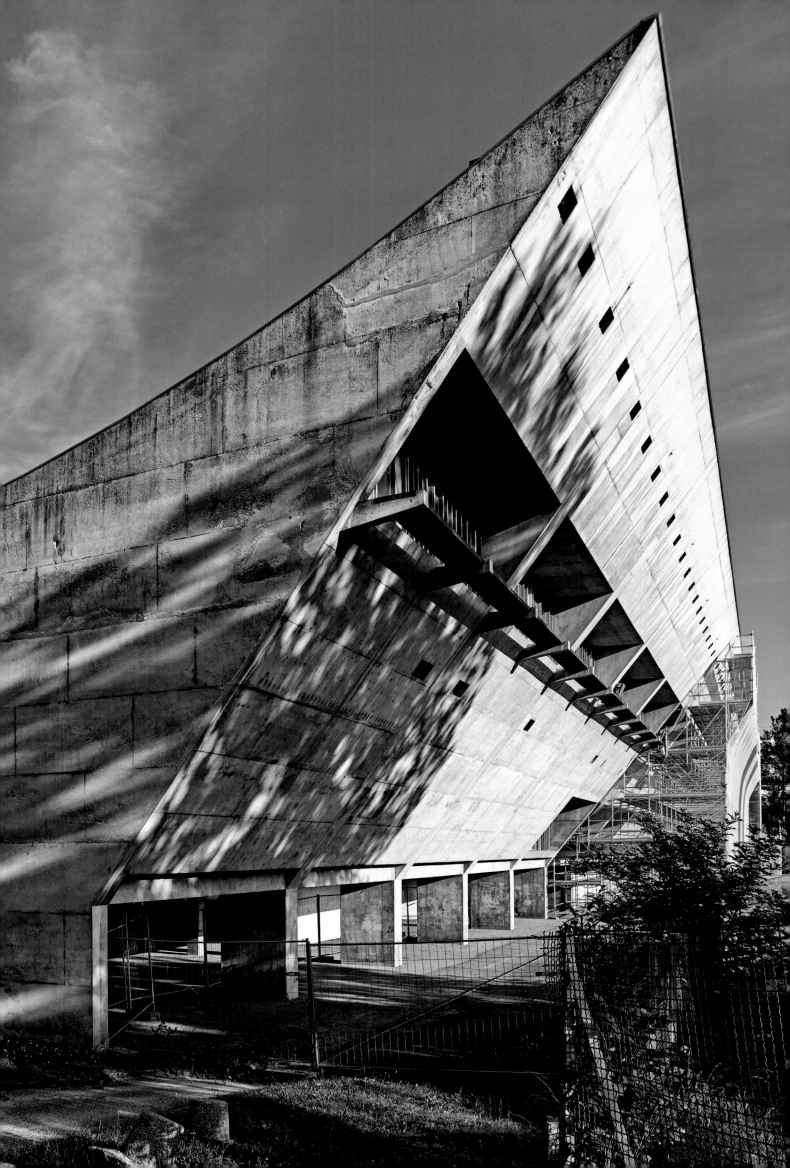

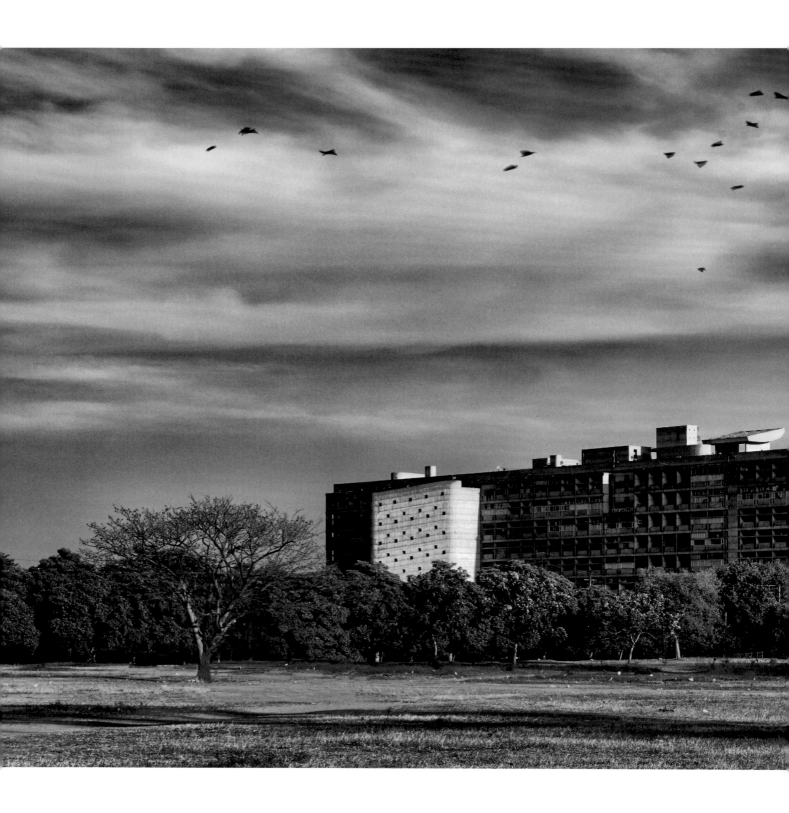

Palace of Ministries
Chandigarh, India, 1953

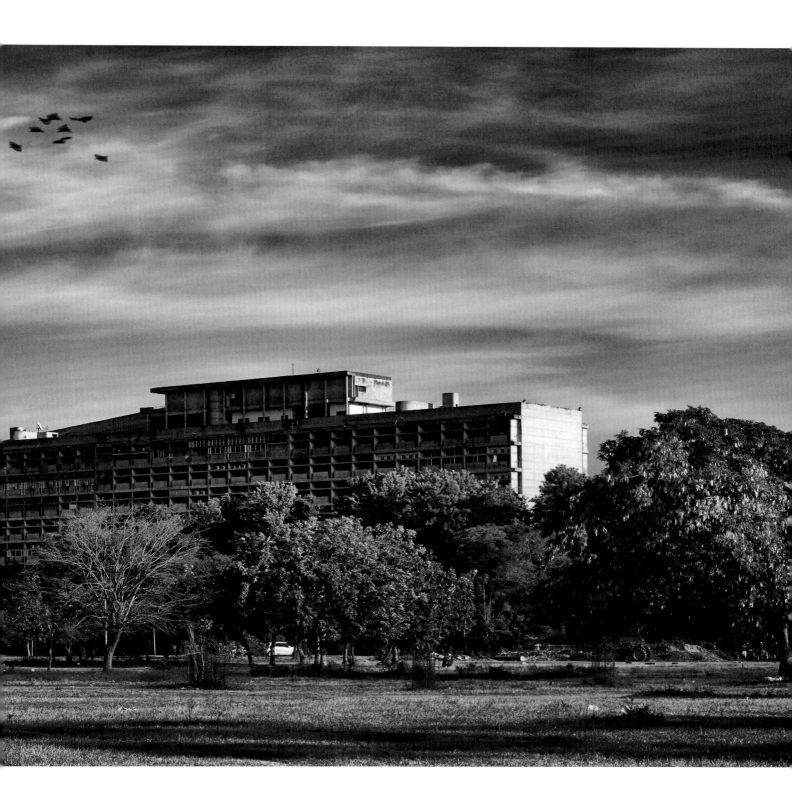

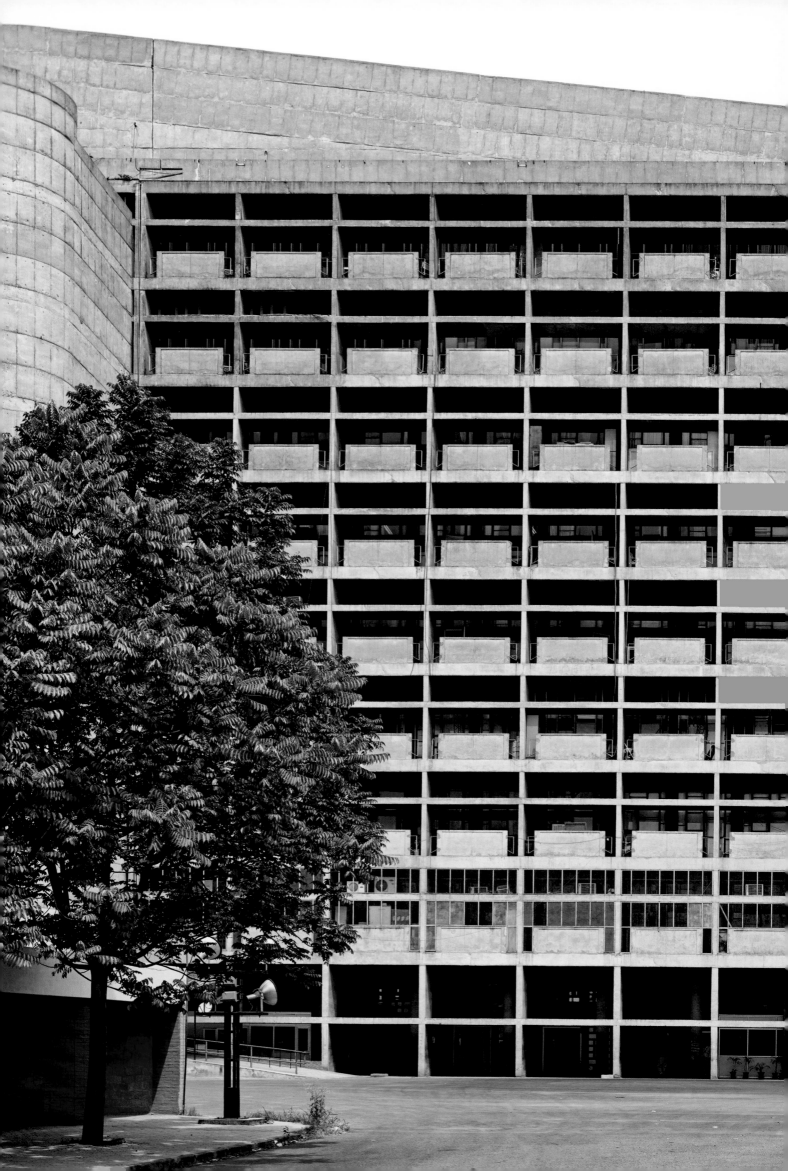

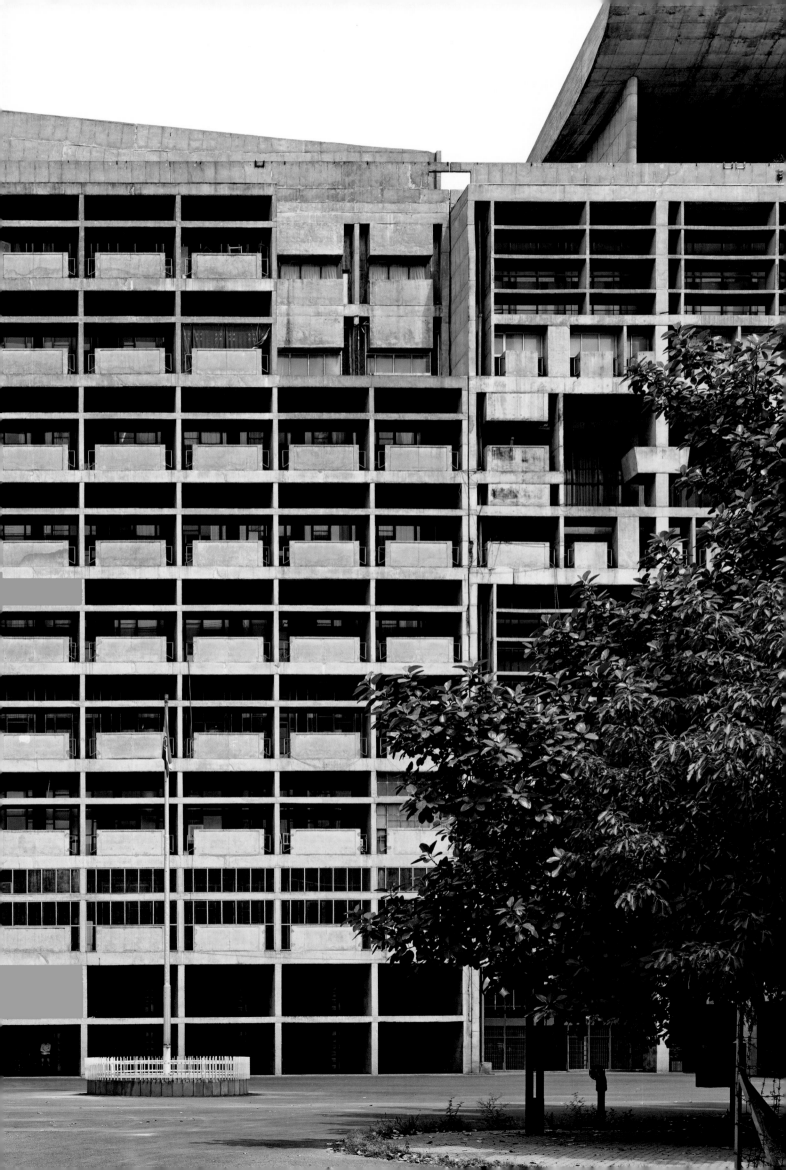

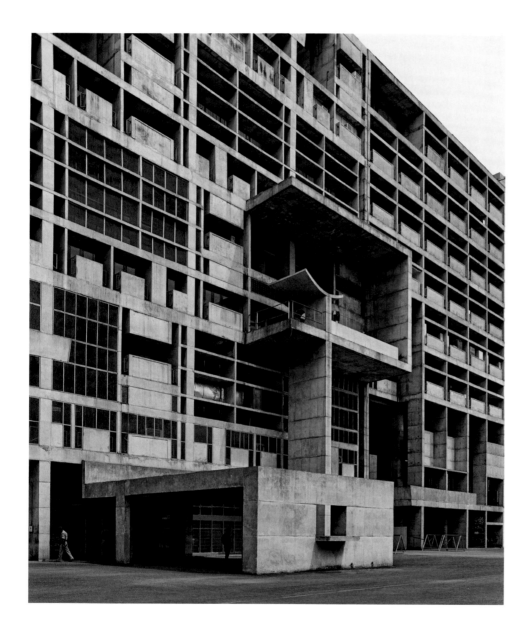

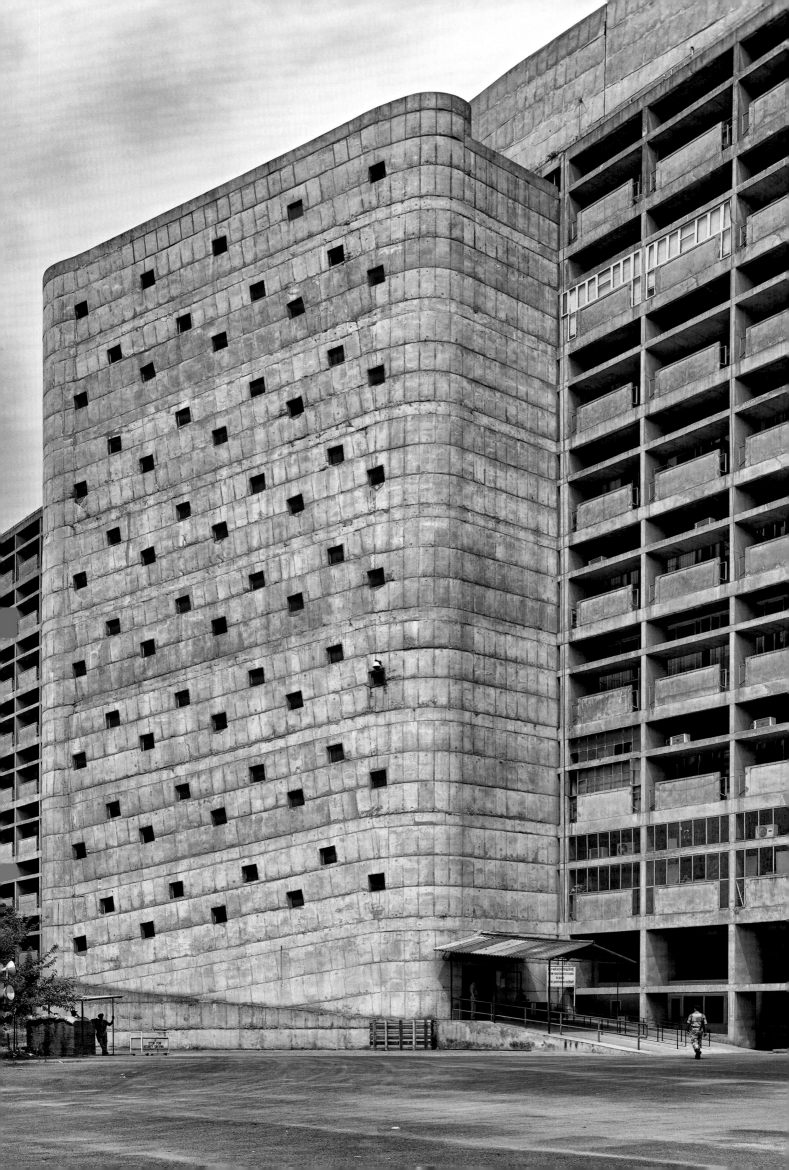

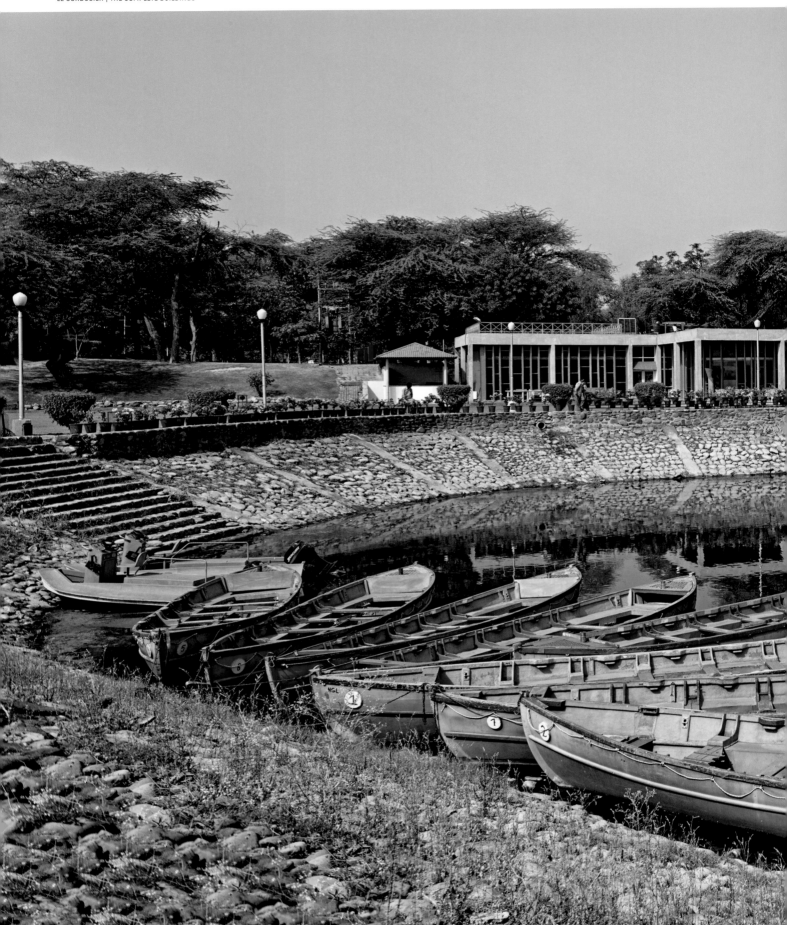

Yacht Club
Chandigarh, India, 1953

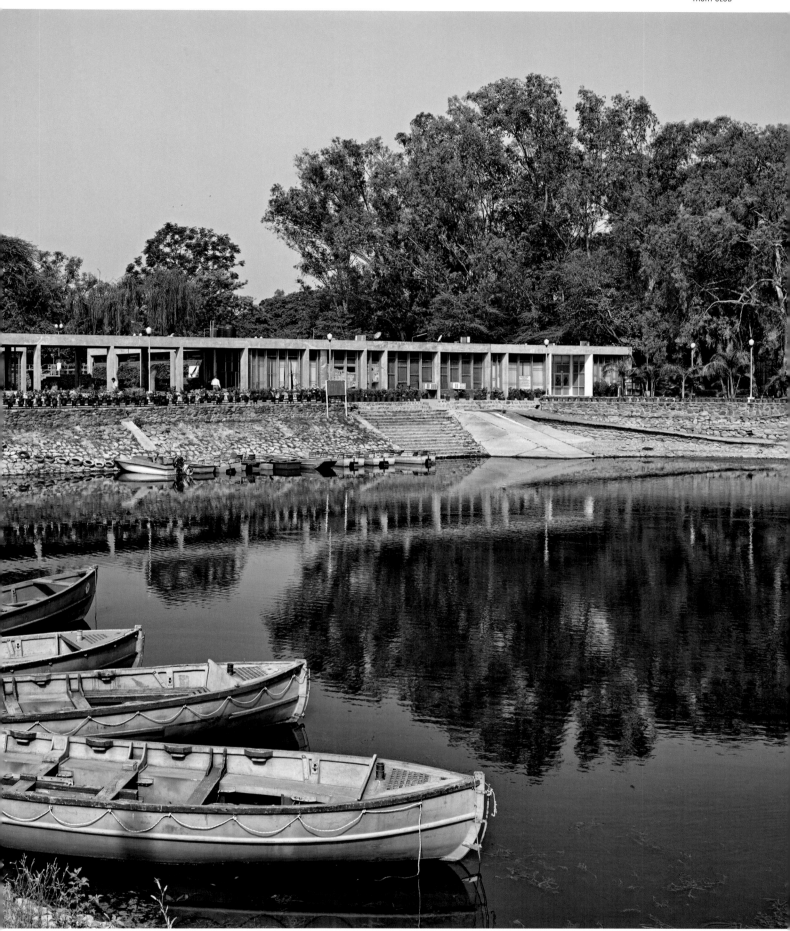

National Museum of Western Art
Tokyo, Japan, 1955

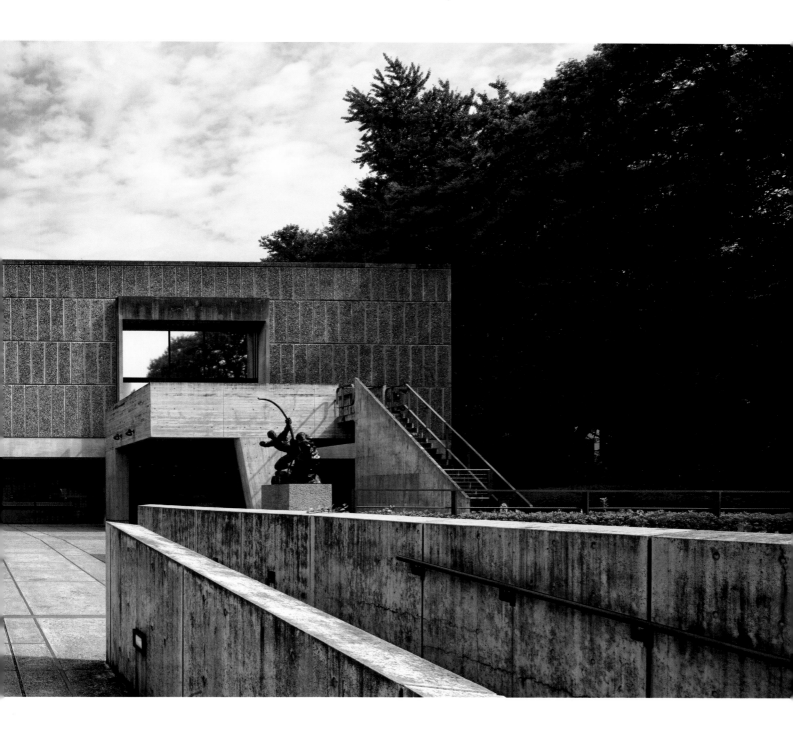

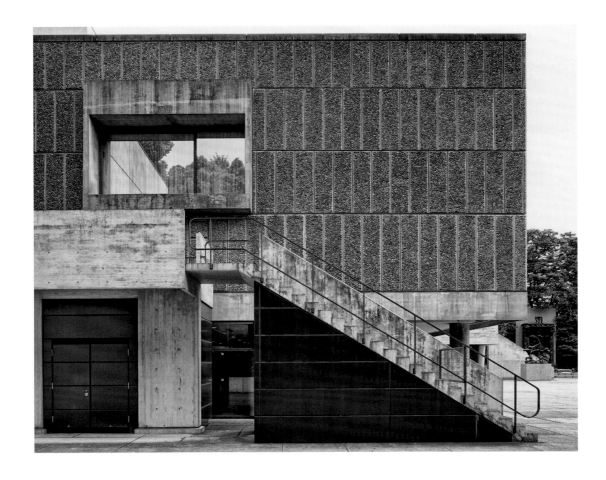

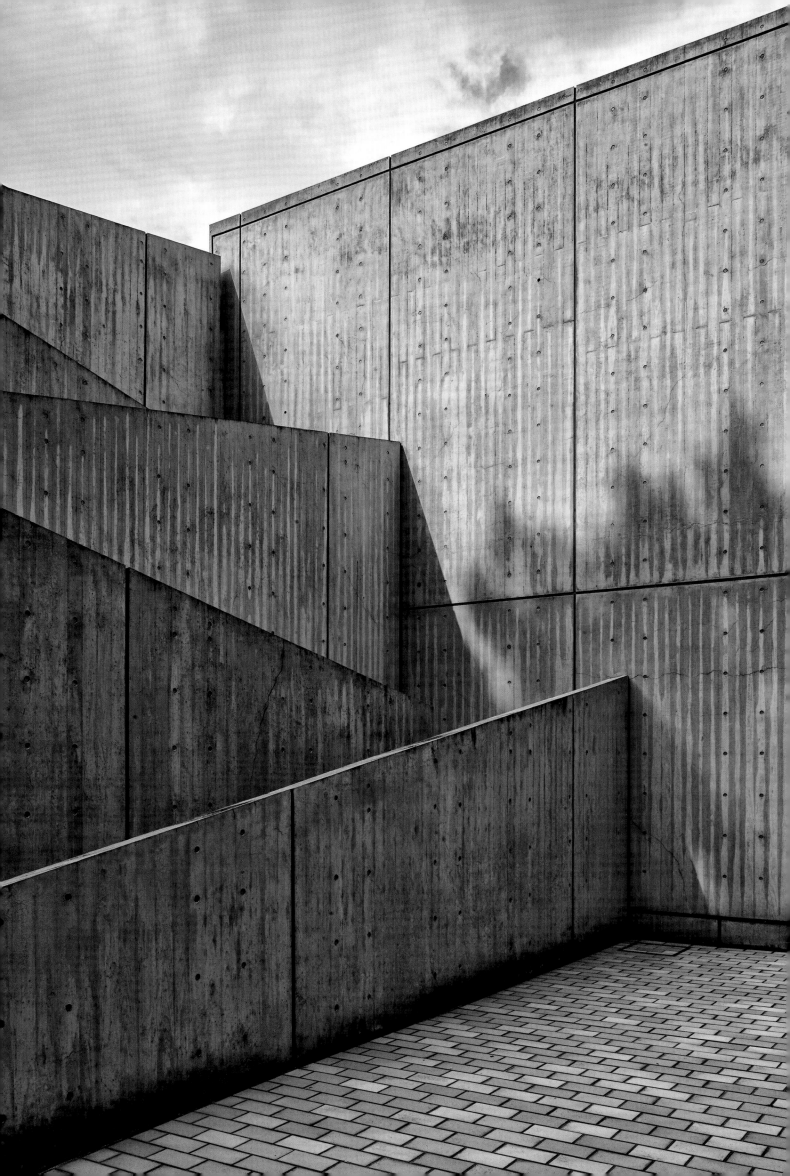

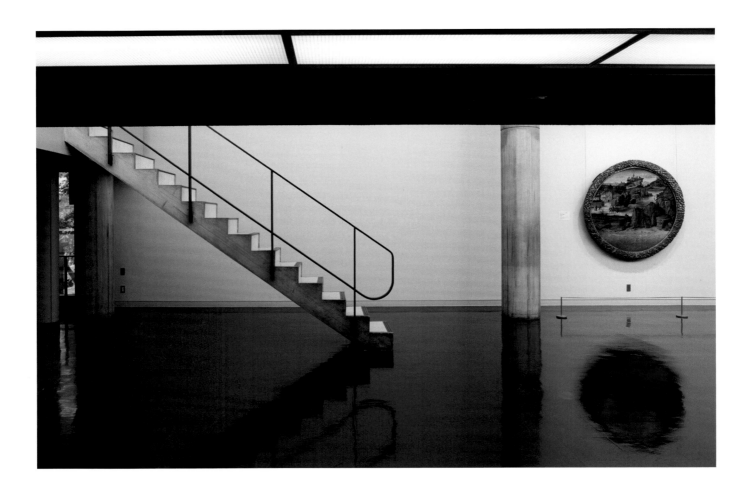

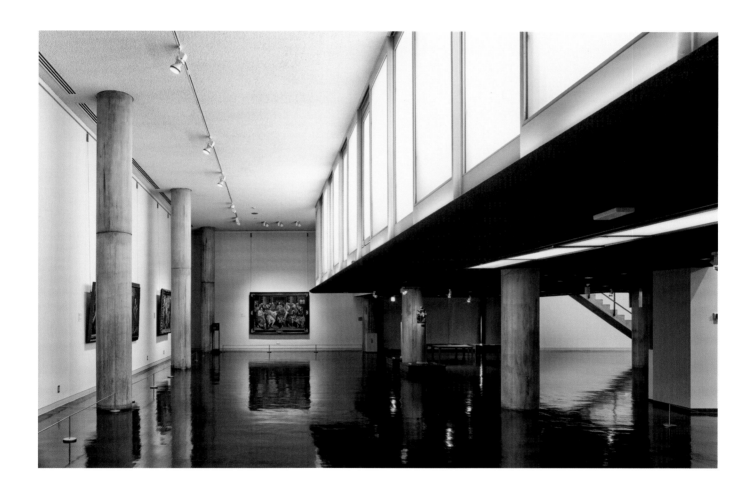

How to Photograph the Ineffable

DANIEL NAEGELE

Il faut toujours dire ce que l'on voit. Surtout il faut toujours, ce qui est plus difficile, voir ce que l'on voit.[1]

With photographs of his architecture, Le Corbusier could call into question the authority of perspectival space. The camera sees in perspective. The camera never lies. But what if the truth-telling image were a-perspectival? Can a photograph tell a truth about a space that cannot otherwise be known?

In 1956, Le Corbusier was commissioned to design the National Museum of Western Art in Tokyo. The museum realizes a pinwheel parti that Le Corbusier had been proposing for museum projects for over 25 years. Both a passage and a place, skylit from above but removed from all other 'edges' of the building, the central room – the two-storey 'spoke' of the pinwheel – begins the *promenade architecturale*. Le Corbusier proposed a photomural for this room, but it was never executed. The court was left quiet, yet includes a distant ramp, two columns illuminated from above, balconies, patterned tiles and a yellow-brown floor that holds a thin army of gesticulating Rodin sculptures.

Emden's photograph must capture both the room in its entirety and the sense of the ineffable that is the essence of the space. But how to photograph 'l'espace indicible'?

Emden's image is in colour. It divides the space into three horizontal realms. The upper is bluish: a ceiling emitting natural light through clouds of triangles. The lower portion is brownish, jagged, textured – the earth. The centre is mostly grey and projects and recedes as it works its way between the blue and brown.

The two columns are in the centre of the photograph, illuminated from above. True verticals, they intersect with the true horizontal floor. A Cartesian frame of reference is established. Their alignment suggests a perspectival space, drawing the viewer's eye to the left, to the deep, dark space of the photograph. This is in conflict with the photograph's other perspective, one that draws the viewer's eye to the right, to the highly illuminated long window beyond a balcony of a similar shape.

Emden's wondrous composition both massages and heightens this visual conflict. A dominant horizontal line moves the eye from the foreground in the far right across the balcony in the mid-ground right, to the line where the tile meets the distant wall. It moves the eye left, and then down into the wall. And then right, and down again. And again left, and to the wood floor of the lobby and the waiting army of Rodins. Looking right again to the balcony: though it recedes from the mid-ground into the depth of the hall, its top rail is not a diagonal line but assumes horizontality, parallel with the horizontal frame of the photograph.

Dual perspectives. Diagonals illustrated as horizontals. With an image of great accuracy and beauty, Emden harmonizes these visual conflicts while presenting us with the wonder of ineffable space.

1 'We must always say what we see. Above all, and this is more difficult, we must always see what we see'. Le Corbusier used this phrase by Charles Péguy as a 'motto' in several of his later books. It appears again and again.

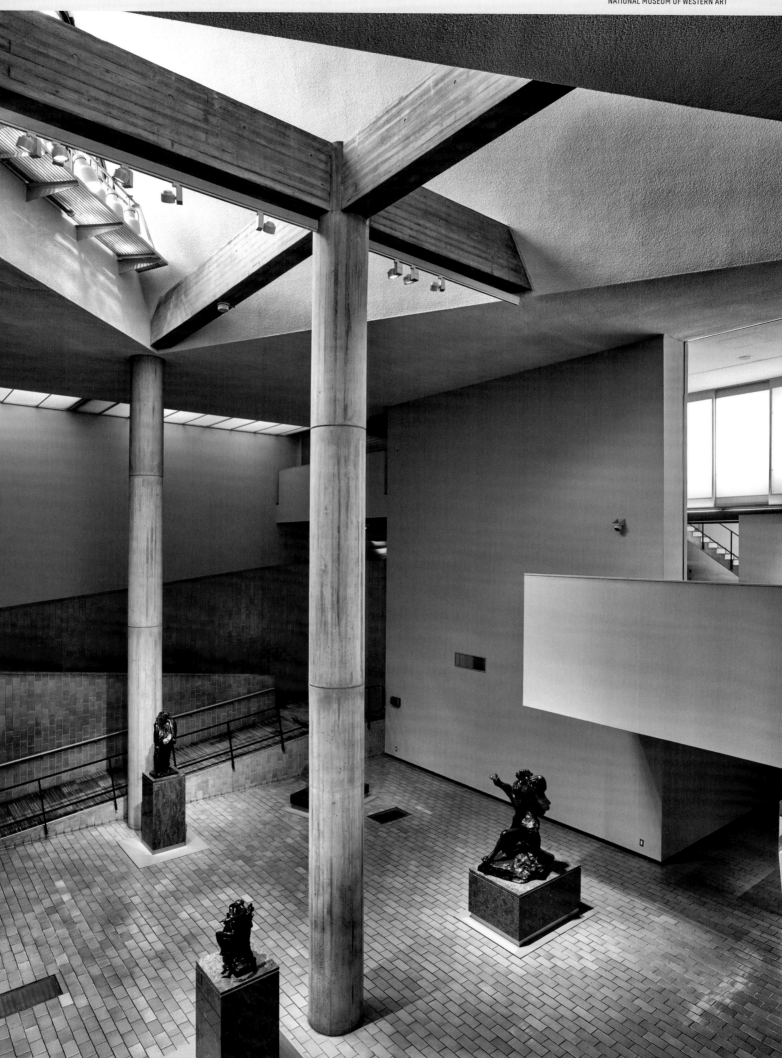

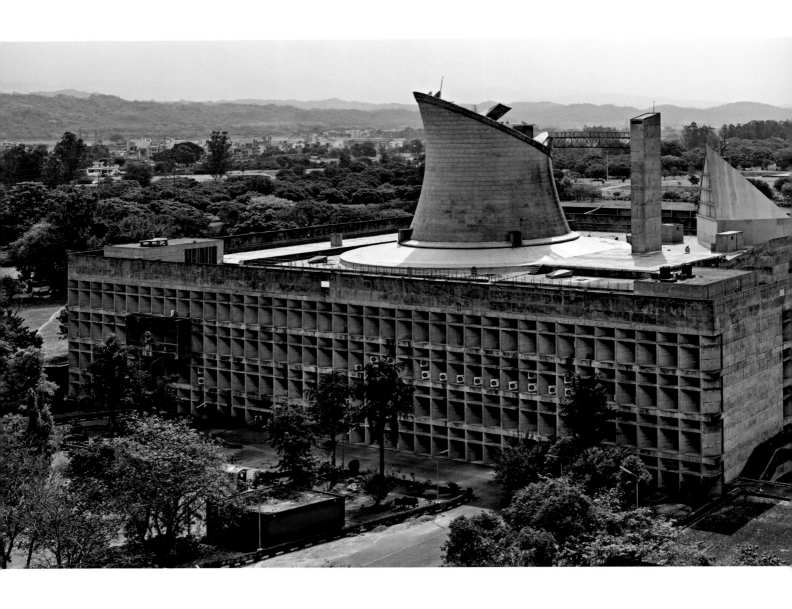

Palace of Assembly
Chandigarh, India, 1955

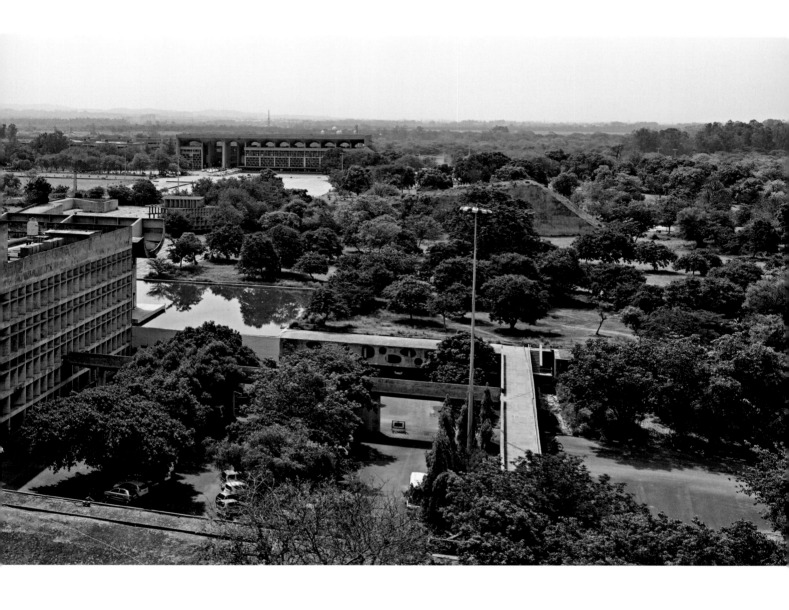

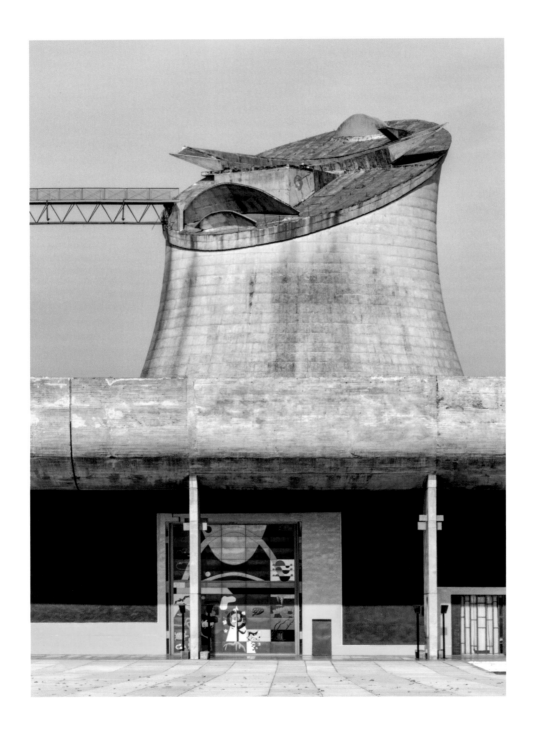

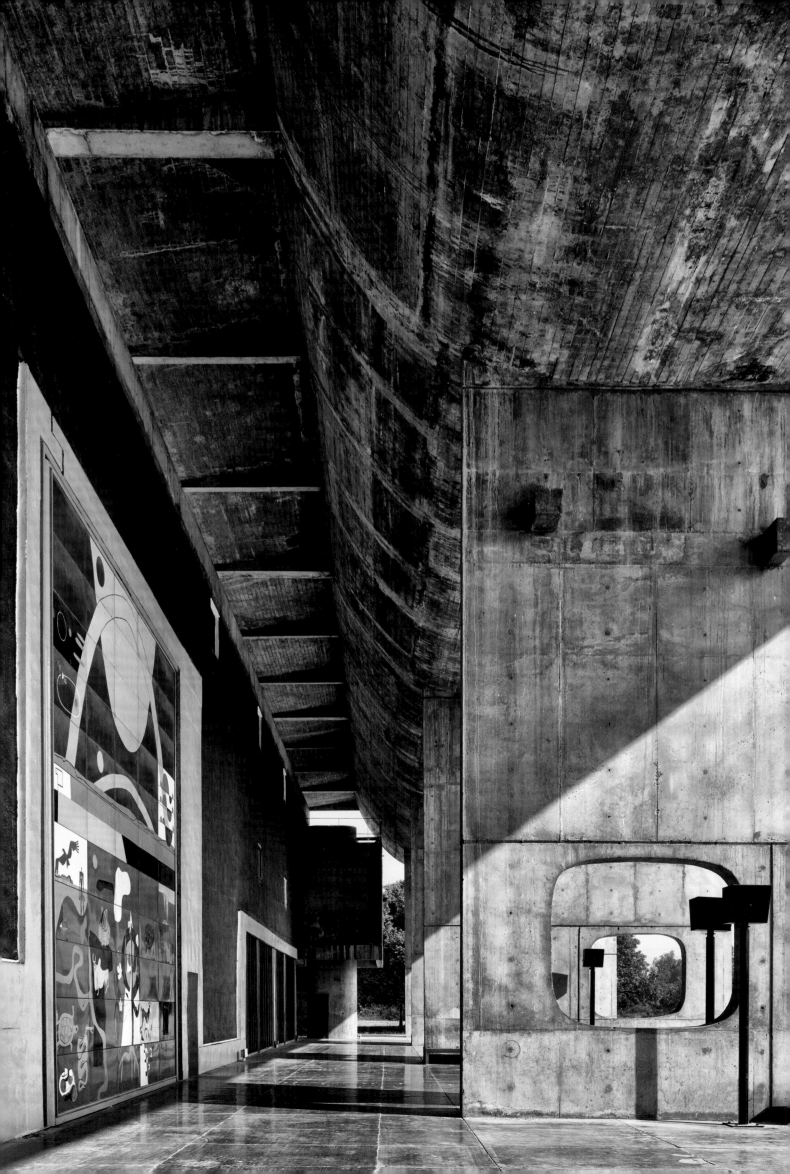

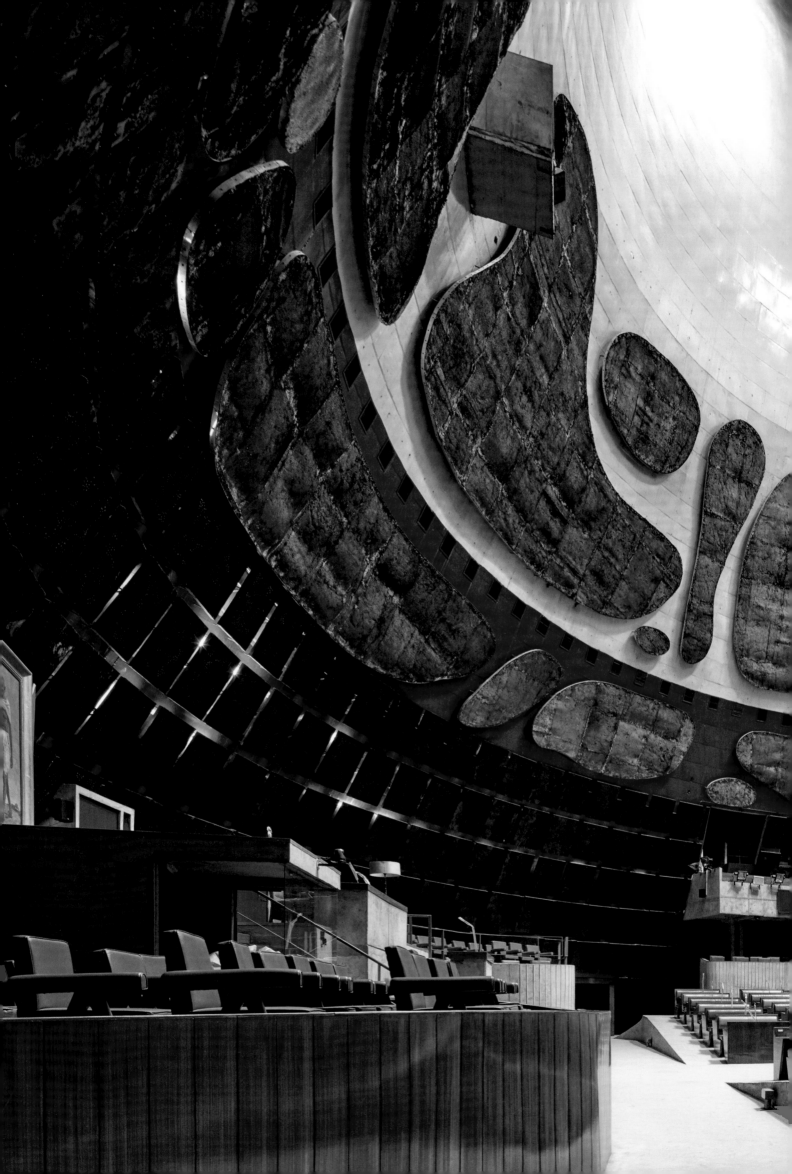

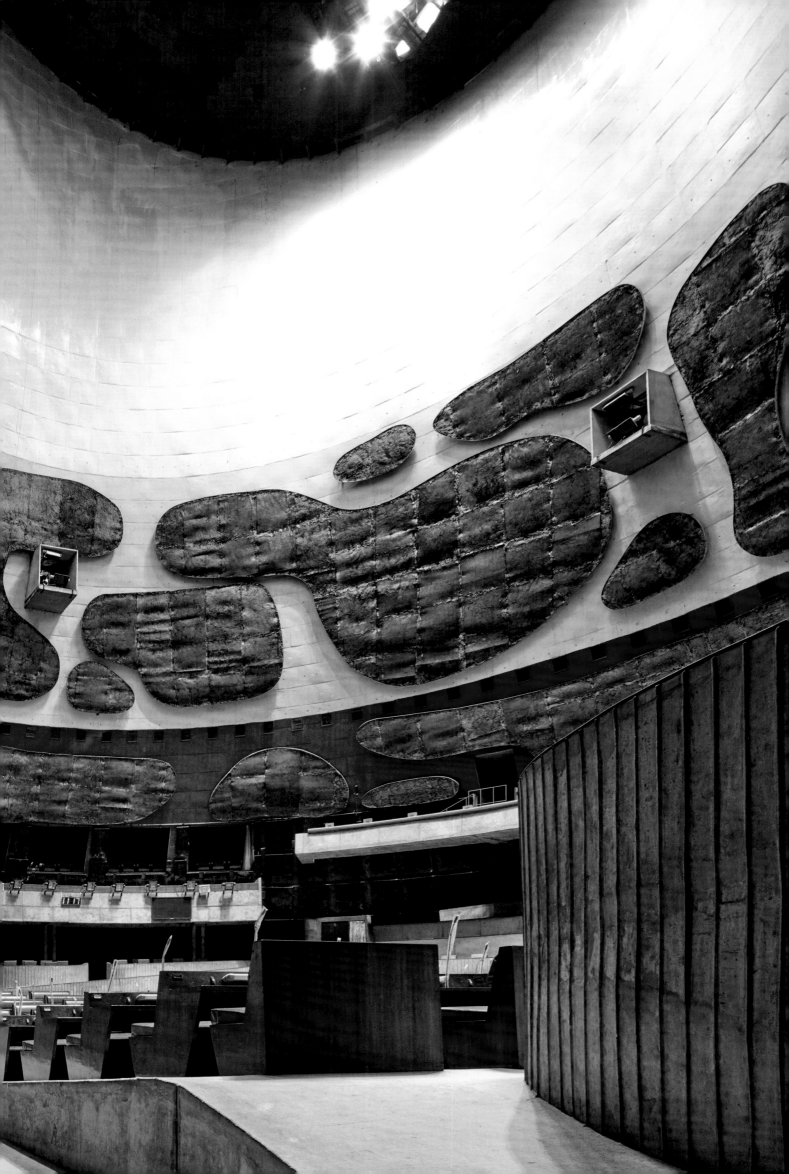

A-morph

GÜNKUT AKIN

When I chose this photograph, I had two associations right away: Michelangelo and Alexander Calder. Then I went and read *The Poem of the Right Angle*: the group of poems and lithographs Le Corbusier began in 1947 and was still working on in 1951 when he took up the design of Chandigarh. The amorphous holes seen at the right of the photograph are the reason I chose it. They continue beyond the frame of the picture as well. The monumental buildings at Chandigarh are full of them. The amorphous, as the word implies, has no form. These holes appear in particular on the huge facing wall behind the portico in the High Court, and on the Parliament building portico and inside it. One of them can be seen at the upper right of this photograph, in the background, on the piloti bearing the curvilinear canopy at the monumental entrance to the Parliament. The acoustic panels, which Le Corbusier called 'cloud-shaped', on top of the Parliament assembly hall are also amorphous. He drew these inside a plaster model large enough for him to insert his head and hand to draw the clouds directly onto the surface. Then they were enlarged and applied.[1]

Le Corbusier wrote *The Poem of the Right Angle* in response to the sarcastic criticism that found a Baroque quality to his works after 1950 and proposed he be given the Grand Prix de Rome.[2] For him the right angle was still the attitude of the subject standing up on top of the horizontal ground plane, firm on the ground, consciously drawing a rectilinear line out of chaos and reaching conclusions it applies. He ends the poem: 'It is a sign of consciousness. It is an answer and a guide, the fact, my answer, my choice.'[3] The architect's hand draws the grid plan of Chandigarh city for the hundred-square-kilometre plain at the foot of the Himalayas. Each city block is a rectangle of 800 by 1,200 metres. The pattern on the Parliament's side facade at the left of the photograph is the small scale of the orthogonal plane.

The amorphous has no shape because it is neither rectangular nor defined according to Euclidean geometry. Ellipses and circles follow rules. By contrast, these are purely decorative forms whose corners have been arbitrarily rounded. They have lost their objective definition, and thus their modernity. Le Corbusier likens them to the holes in Swiss cheese.[4] They are not like beautiful organic forms, which he calls 'objects of poetic reaction';[5] they are ordinary things. Indeed in the *Poem*, when Le Corbusier describes the non-rectilinear – which is to say, the chaotic – he lines up repulsive images: reptiles, worms wriggling in the mud, maggots feeding on corpses and so on.[6] So why did he use these amorphous forms?

Next to the Chandigarh Parliament's bulky boards, how lightweight the floating acoustic panels Alexander Calder made for the 1953 Caracas University Aula Magna. Don't I know it was his 'mobiles' that first introduced the amorphous forms that took over the world in the 1950s? But these forms, symbolized by kidney-shaped side tables, were 'new' things that distanced the nightmare of the Second World War, signifying joy in life, weightlessness and frivolity. Maybe the postmodern era began with these, while all were unaware.

Le Corbusier said in an interview broadcast on the BBC in 1959: 'I am a visual man, a man who works with his eyes and hands: working with forms takes me out of myself.'[7] He made many statements like that. His eyes never got enough of form. His use of amorphous forms at precisely that time was less because they were in fashion than because he let himself be carried away by the world of lawless form, not part of his repertoire before.

When I look back I always put Le Corbusier in the balance with Michelangelo. Looking at this photograph I immediately thought of the artist's last architectural work, the Porta Pia. The same *horror vacui*. In *Towards a New Architecture* Le Corbusier praises Michelangelo to the skies.[8] It is as if he is talking about himself. A wall of the High Court, sprayed with a cement gun, reminds him of Michelangelo's giant *Last Judgement* in the Sistine Chapel. The painting that expresses the most profound anxieties of being by forgoing perspective, the great achievement of the Renaissance. According to Le Corbusier, the Chandigarh wall is its 'second edition'.[9] If you keep on with creativity and craving form, this is what you get. There are too many forms in the photograph. Along with the amorphous holes, he even squeezed in a small balcony between the grid facade and the monumental canopy of the entrance.

1 R. Gargiani and A. Rosellini, *Le Corbusier, Béton Brut and Ineffable Space, 1940–1965: Surface Materials and Psychophysiology of Vision* (Lausanne, 2011), p. 293.
2 Le Corbusier, *Creation is a Patient Search* (New York, 1960), p. 192.
3 Le Corbusier, 'G.3 Outil', in *Le Poème de l'angle droit* (Paris, 1955).
4 Gargiani and Rosellini, *Le Corbusier*, p. 270.
5 Le Corbusier, 'Les Objets à réaction poétique', in Le Corbusier, *L'Atelier de la recherche patiente* (Paris, 1960), p. 209.
6 Le Corbusier, 'A.4 Milieu', in *Le Poème de l'angle droit* (Paris, 1955).
7 Le Corbusier, *Creation*, p. 300.
8 Le Corbusier, *Towards a New Architecture* [1923] (New York, 1986), pp. 164–72; see for Porta Pia p. 169.
9 Gargiani and Rosellini, *Le Corbusier*, p. 248.

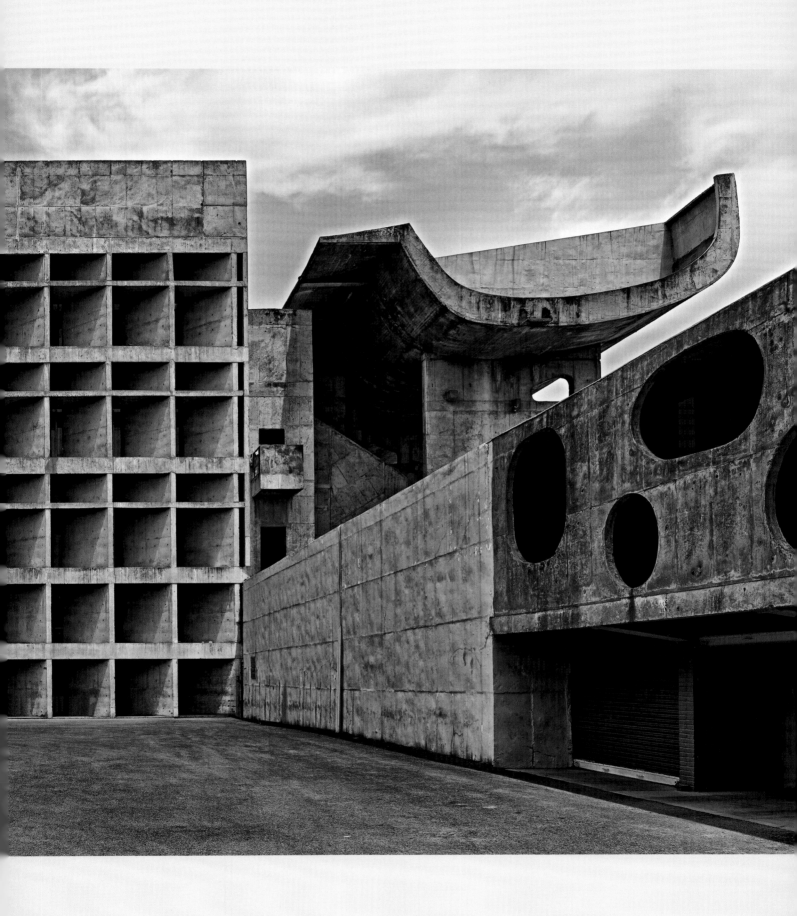

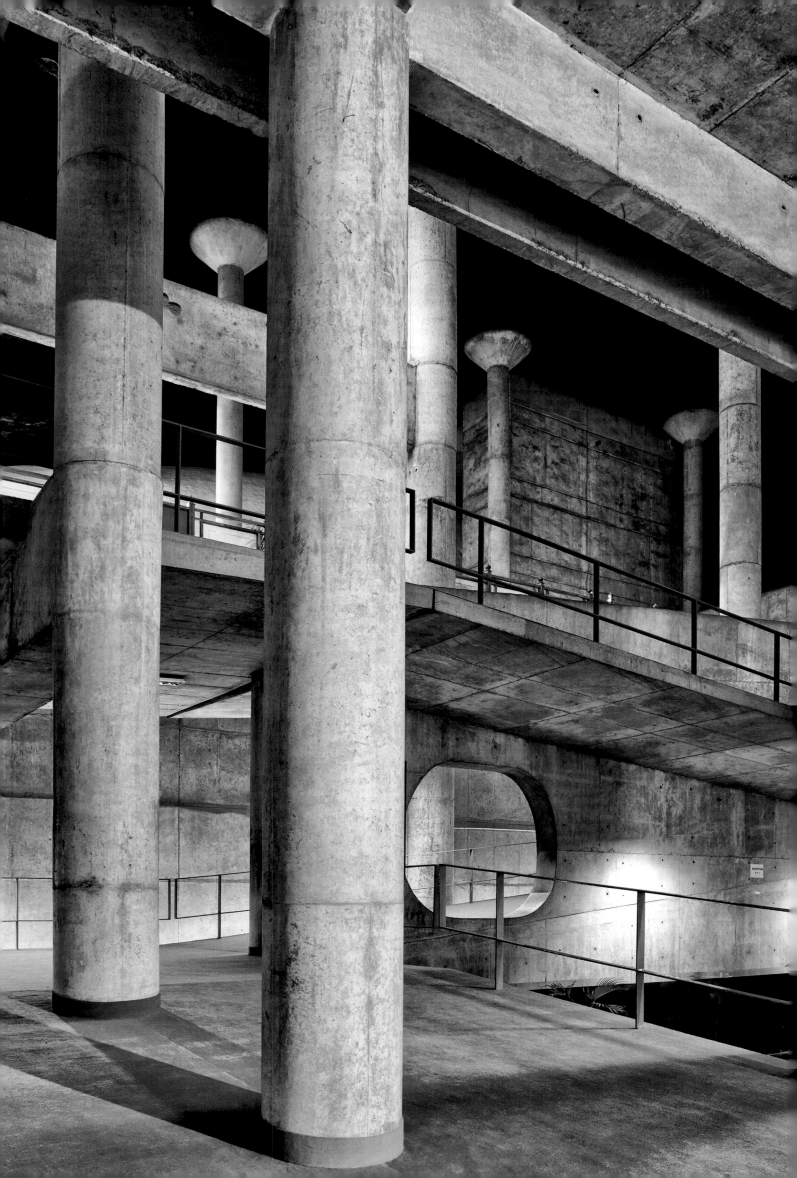

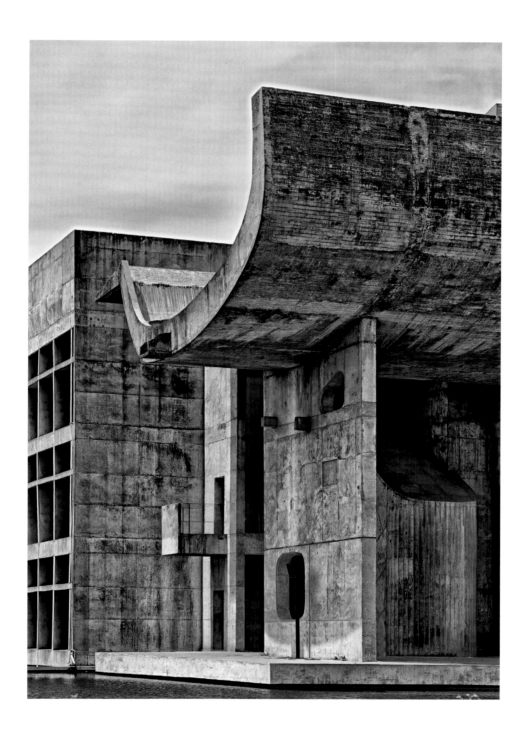

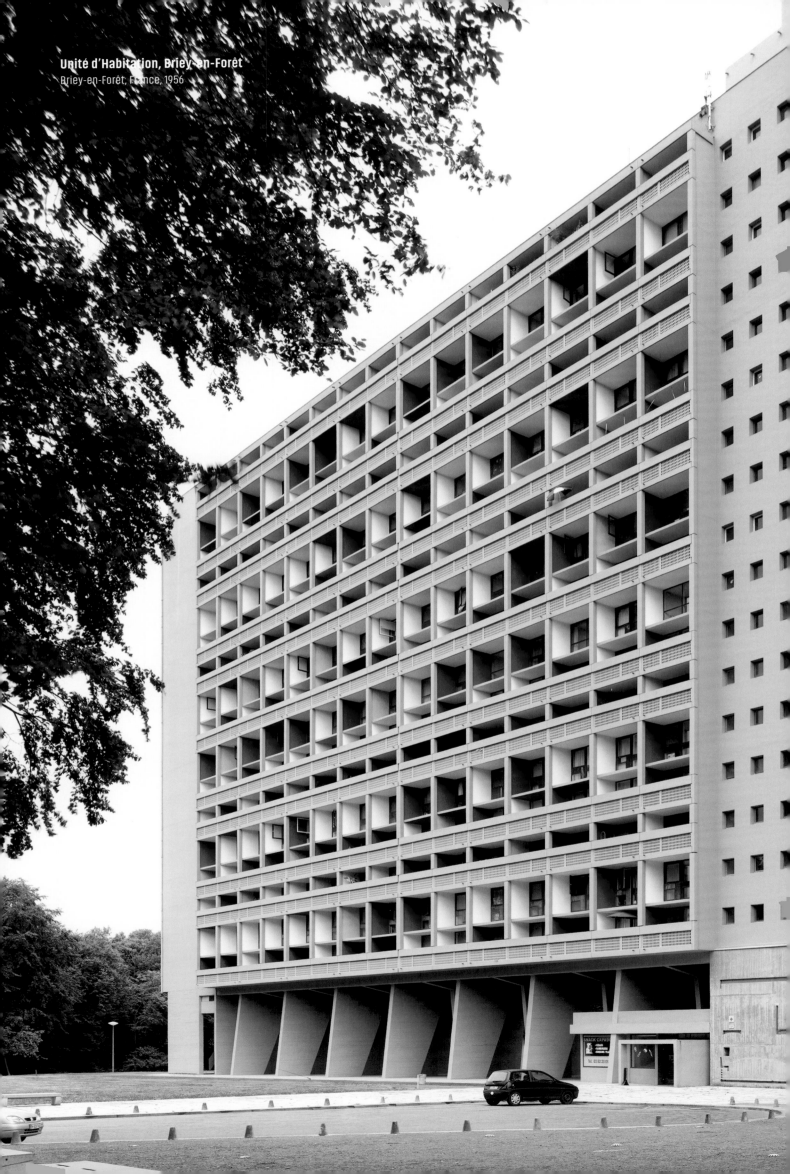

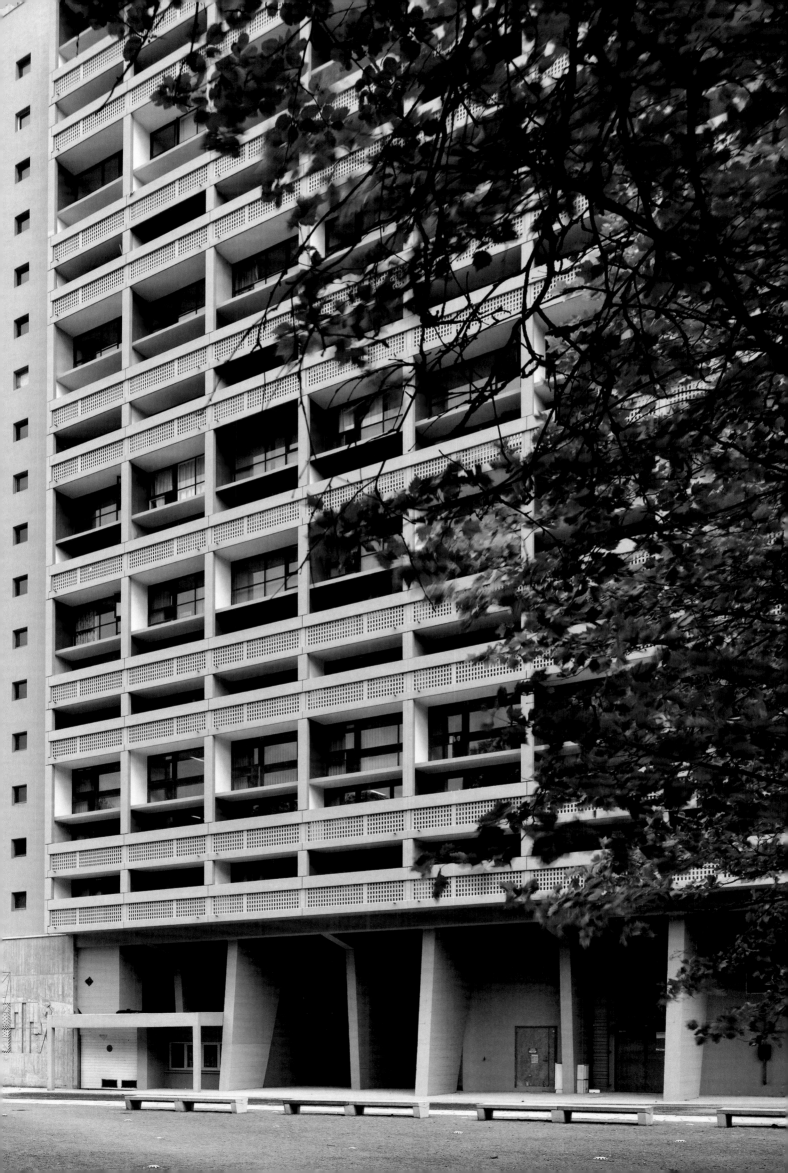

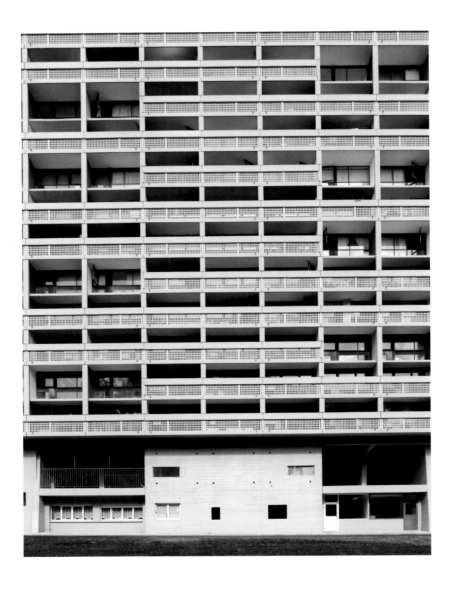

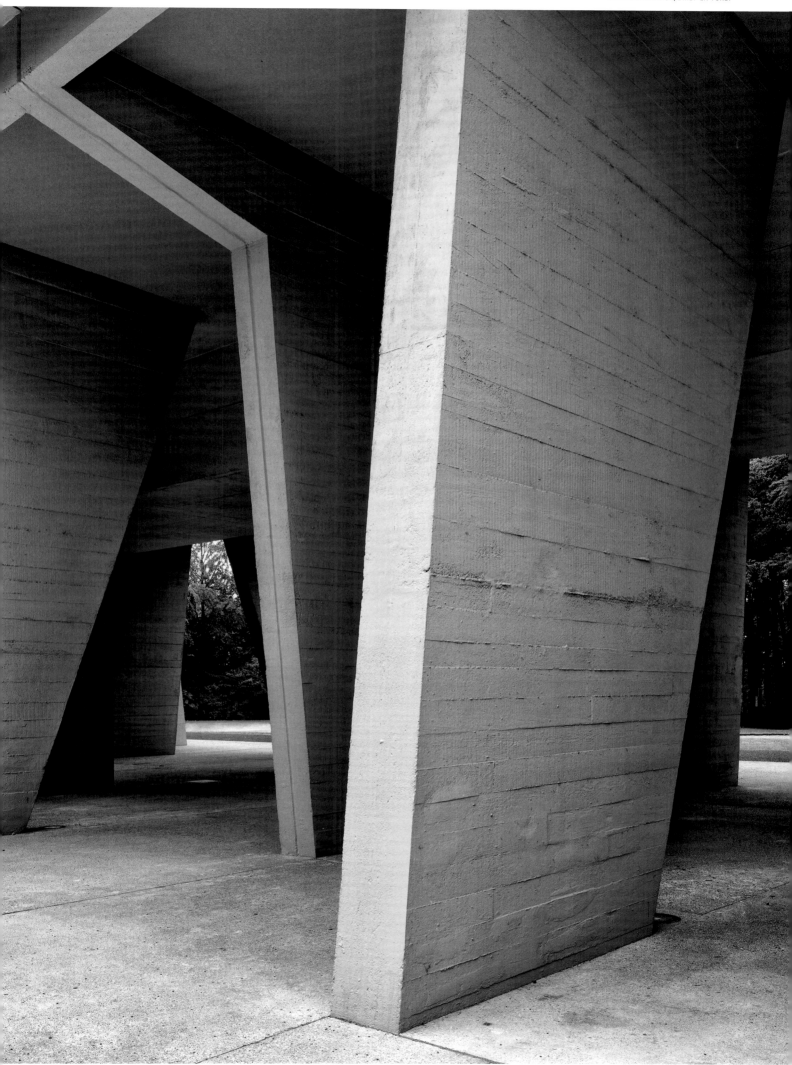

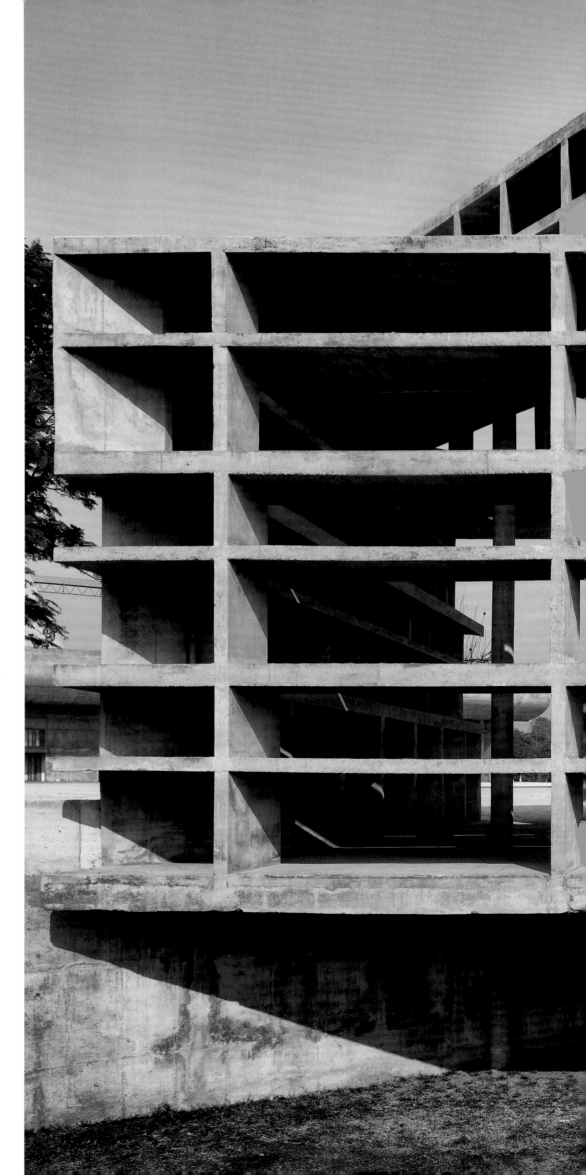

The Tower of Shadows
Chandigarh, India, 1957

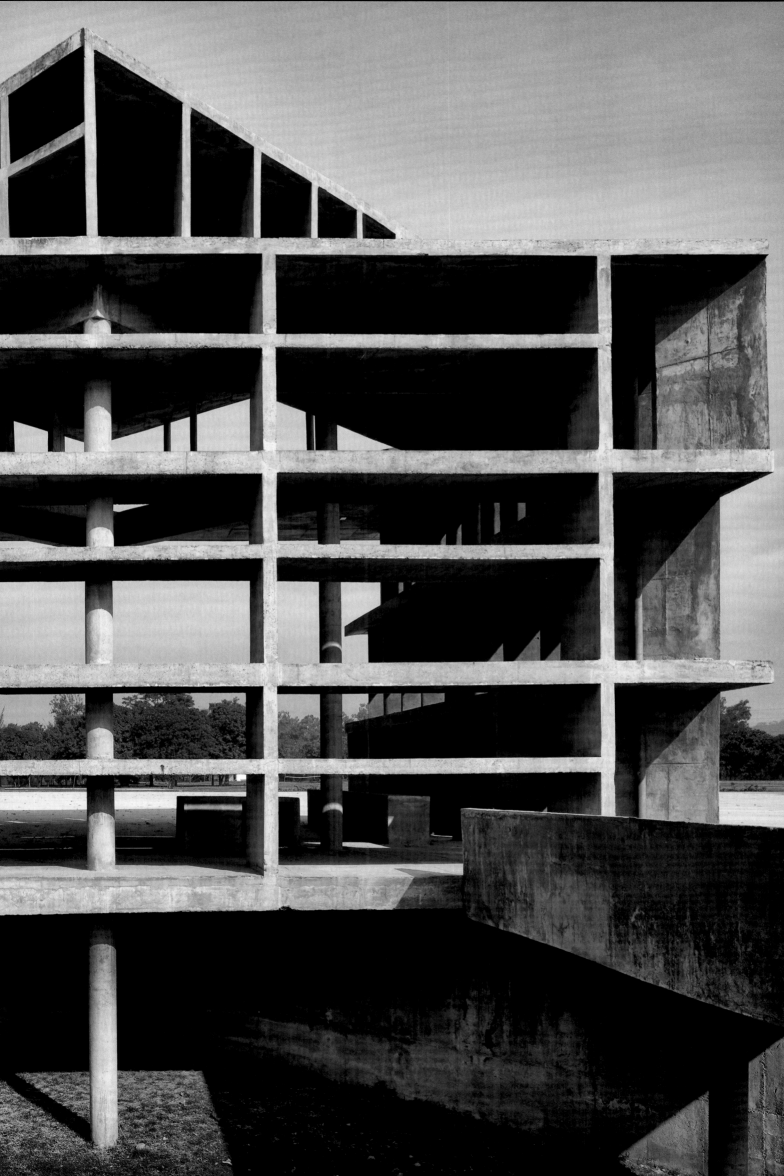

The 'Temple' of Shadows

REHA GÜNAY

The building is made up of a reinforced concrete skeleton and creates the impression of a pergola that provides shadow. It doesn't have a specific function. Le Corbusier defined the building as 'a very open hall, very high and shadowy'.

In the 1930s, Le Corbusier believed in heliotherapy and argued that the main facades of buildings should face the sun. When the Cité de Refuge (1929–33) became terribly hot during the summer months, he started researching the question of shadow. He worked on the brise-soleil that would be placed on the exteriors of his buildings according to the angle of the sun's rays. Fred Keck was working on the same topic in the USA around the same time, resulting in the idea of the 'solar house'. But in fact Frank Lloyd Wright had already used the brise-soleil, in 1909 in the Robie House. As for Le Corbusier, the brise-soleil he used along the long facades of the Unité d'Habitation face east and west. He explained it thus: 'The clock and the solar calendar brought to architecture the "brise-soleil" to be installed in front of the windows of modern buildings.' After this, he announced the brise-soleil as his invention.

However, the brise-soleil hastily prepared for Marseille wouldn't work in the Indian climate; more specific data was needed. It seems that Iannis Xenakis was the technician in this department. A Romanian-born Greek-French engineer, Xenakis is also famous in the field of electronic music. He drew the final solar diagram for the city of Chandigarh in 1957. Yet this was only done for show, as all the important buildings of Chandigarh had already been designed long before that date.

The Tower of Shadows is the only building in Chandigarh where the brise-soleil were applied in a totally correct way. The tower, with a plan close to a square, has its four facades facing exactly north, east, south and west. Brise-soleil were placed on all except the north. The building was designed to block any sunlight; hence its name, Tower of Shadows. The lantern-shaped roof, with no floors and with facades that are placed on top of the three-storey building at an oblique angle, represents the intercardinal directions. The brise-soleil, placed vertically, were constructed at different angles according to the direction of each facade. This way, sunlight was blocked in the early and late hours of the day. At other times, horizontal elements of differing depths obstructed the rays of the sun.

Public opinion holds and hopes that this building acted as a laboratory designed with the aim of testing sunlight control before the other buildings in Chandigarh were built, to be utilized for them. In fact, however, its design was realized in Le Corbusier's Paris

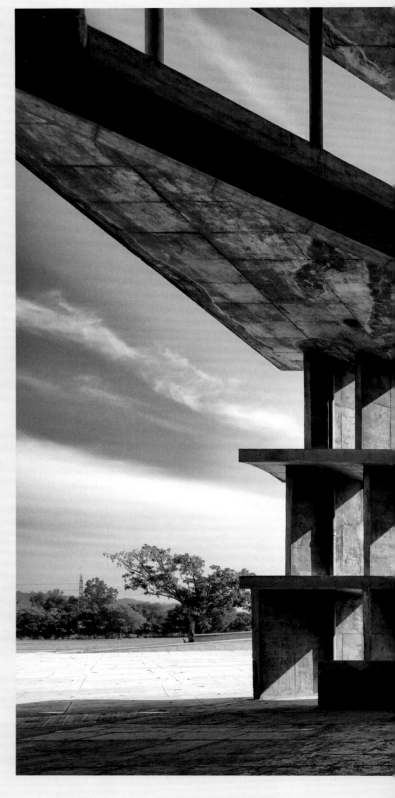

office between 1956 and 1965 and construction was completed in 1986.

In this way, Le Corbusier succeeded in taking control of the sun-rays. In addition, the architect proved his competence and talent by completely eliminating sunlight in the building's interior and gained the respect of the public. Le Corbusier's own phrases, such as 'the conquest of shadow and coolness', show that he saw this as a battle. Shadow won the battle, yet the reinforced concrete brise-soleil absorbed the heat of India's burning summers in such a way that during the night they massively emitted and spread it. Though shadow was achieved, the choice of material cast a cloud on the success.

We can consider this building as a monument

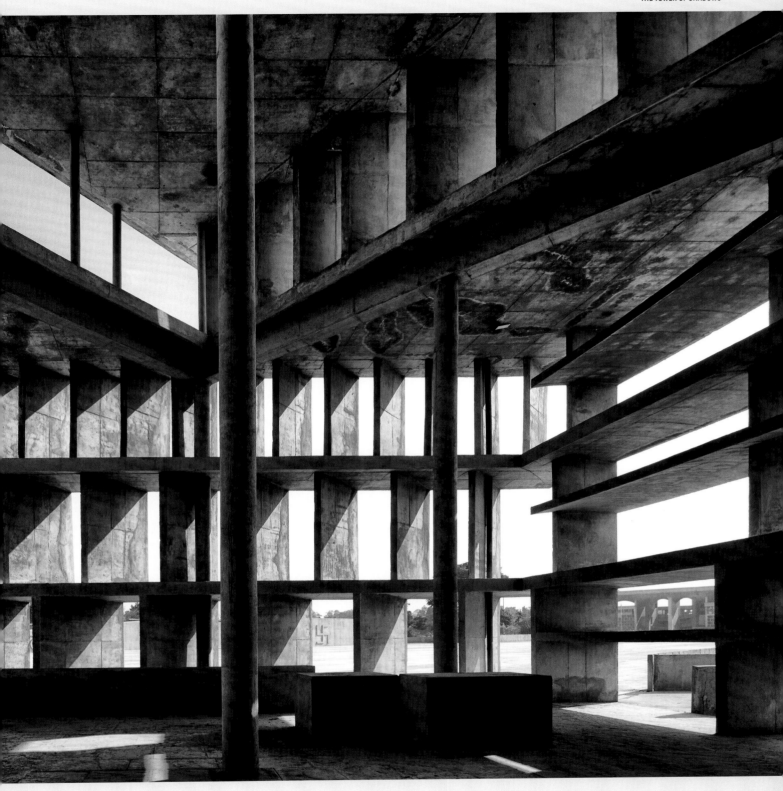

through which the architect realized his theories about sunlight control. It may be more proper to name it the Temple of Shadows.

By photographing this building, Cemal Emden reflects the actuality of Le Corbusier's definition of it as a very open, very high and shadowy hall. And what's more he seems to offer a critique, by documenting some of the rays of light that fall inside the space.

Barber, Daniel A., 'Le Corbusier, the Brise-soleil, and the Socio-climatic Project of Modern Architecture, 1929-1963', *Thresholds*, 40 (2012), pp. 21-32

Denzer, Anthony, *The Solar House: Pioneering Sustainable Design* (New York, 2013)

www.fondationlecorbusier.fr

Siret, Daniel, 'Le Corbusier Plans. 1950 – Studies in Sunlight – Tower of Shadows (Chandigarh)', in *Le Corbusier Plans*, DVD No. 11 (Paris, 2006)

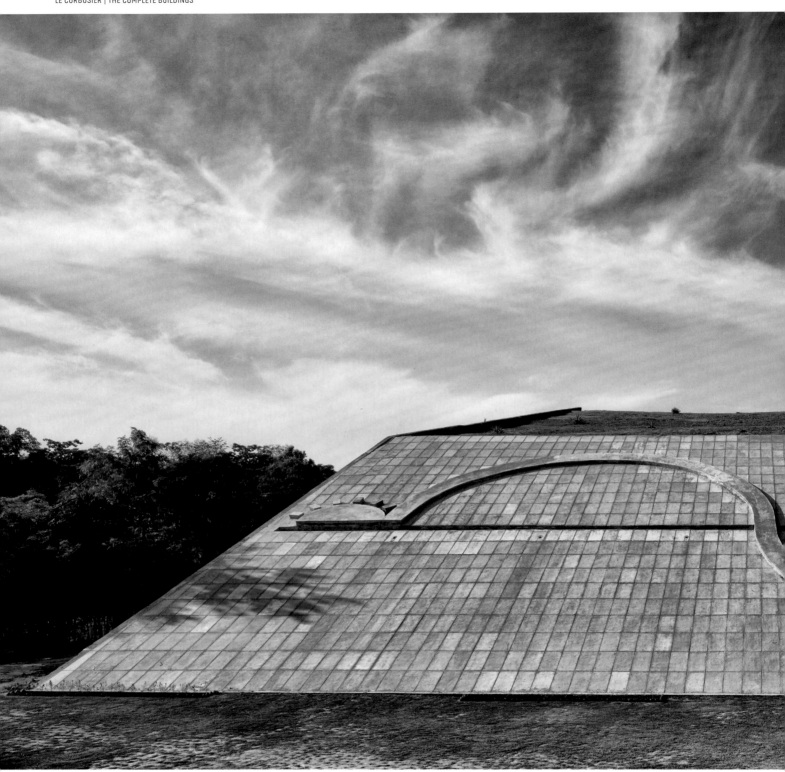

The Geometric Hill
Chandigarh, India, 1957

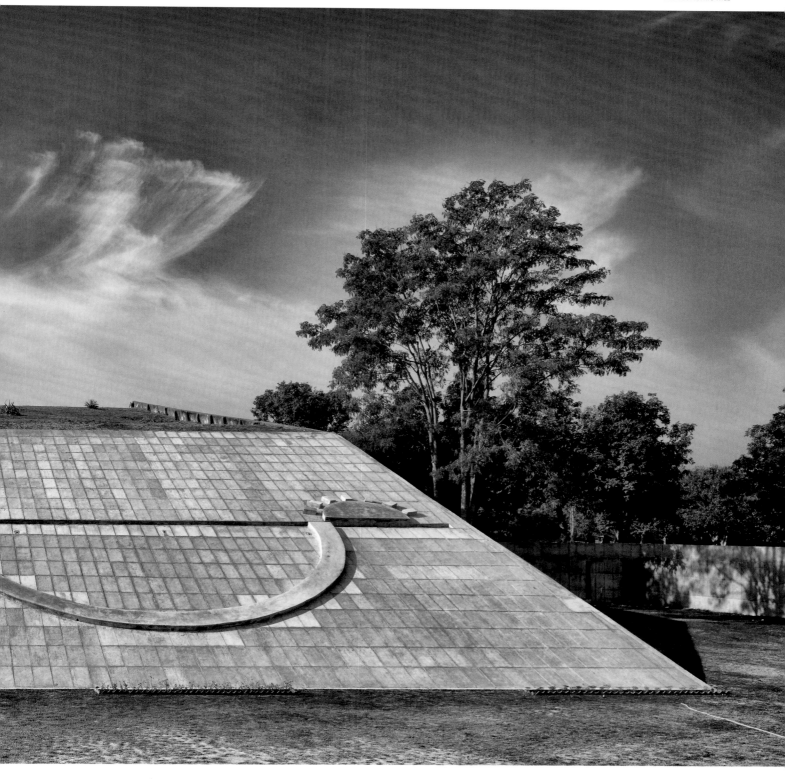

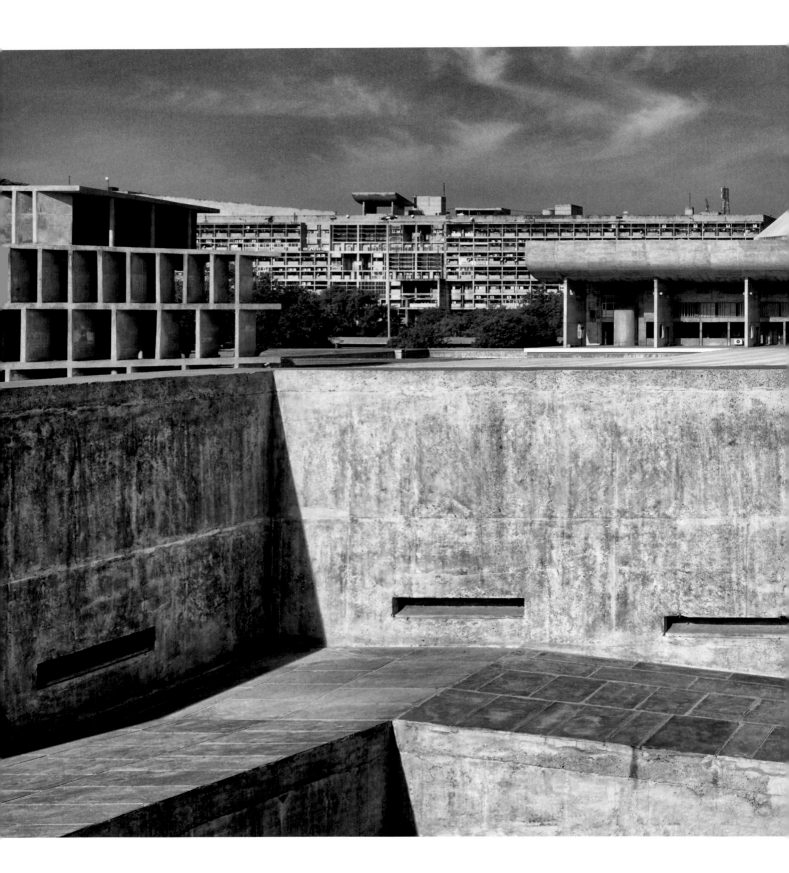

The Monument to the Martyr
Chandigarh, India, 1957

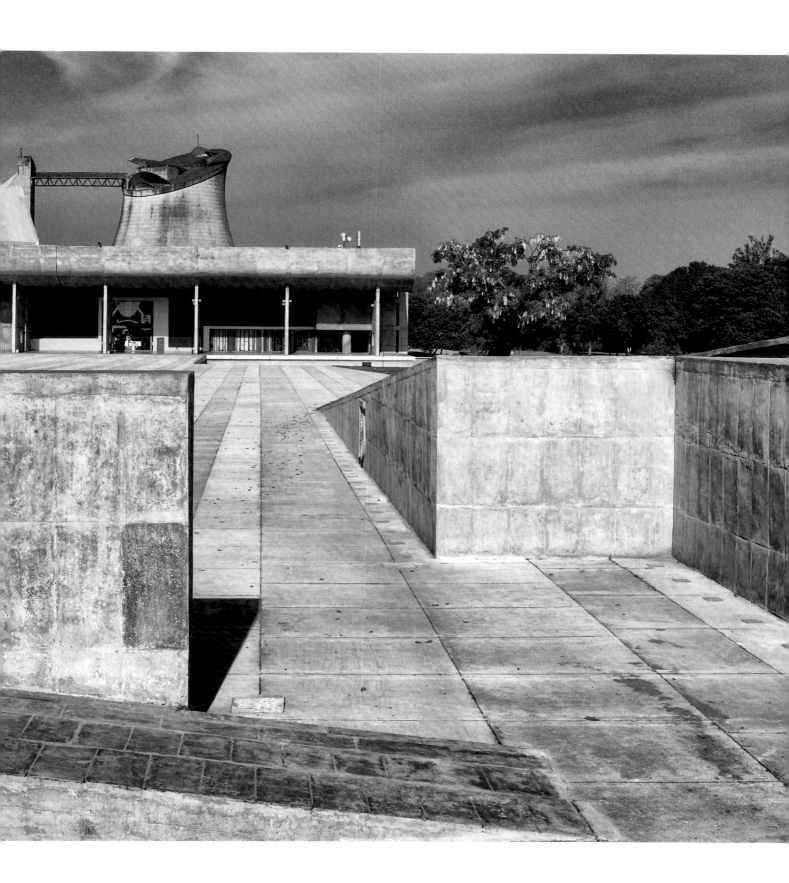

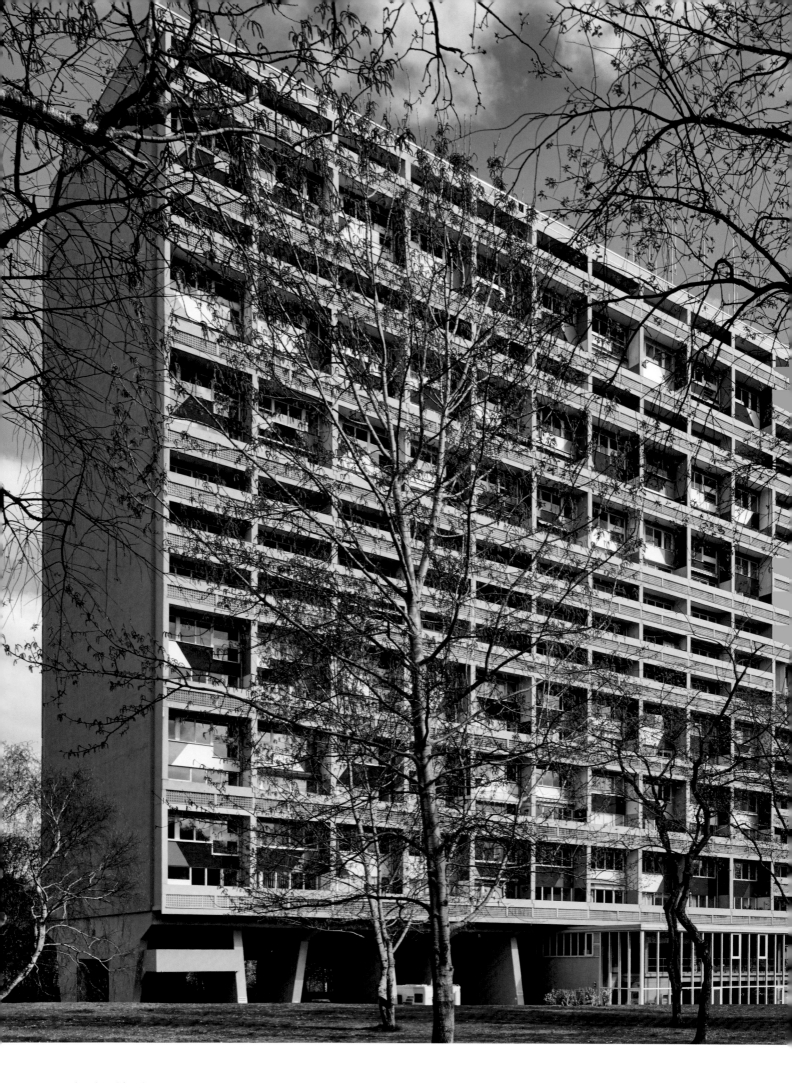

Unité d'Habitation, Berlin
Berlin, Germany, 1957

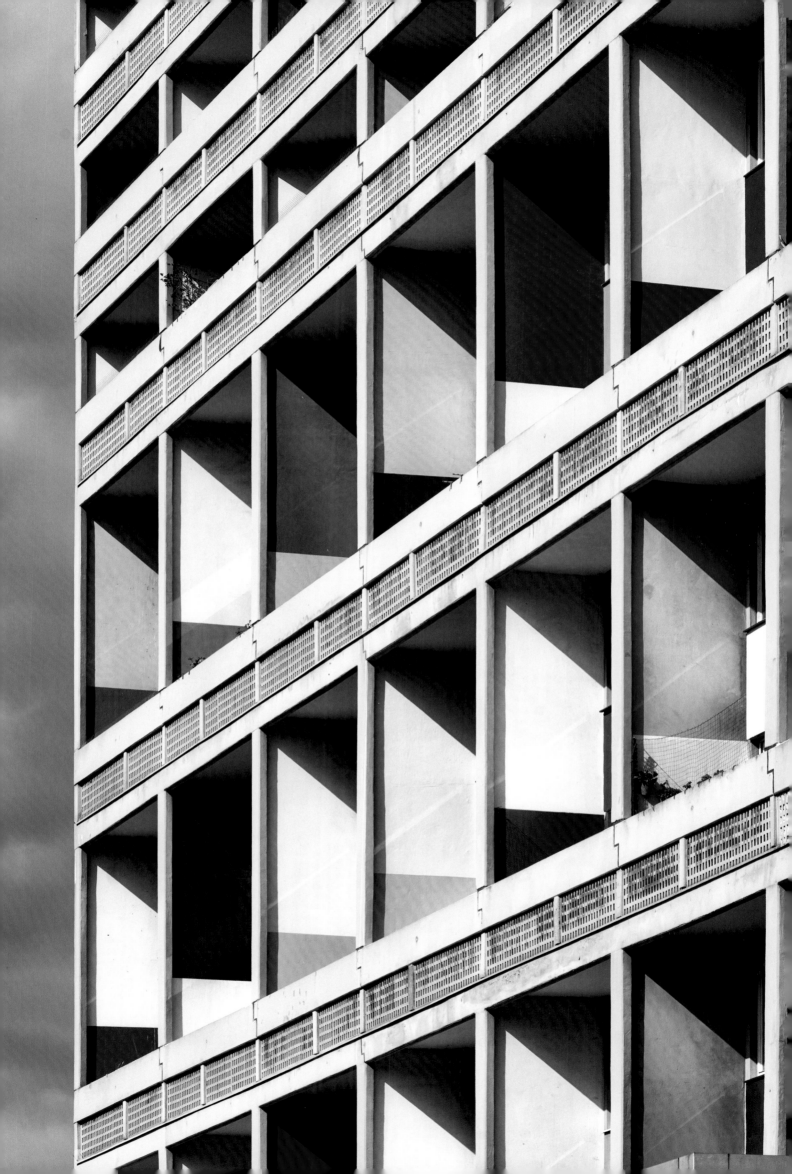

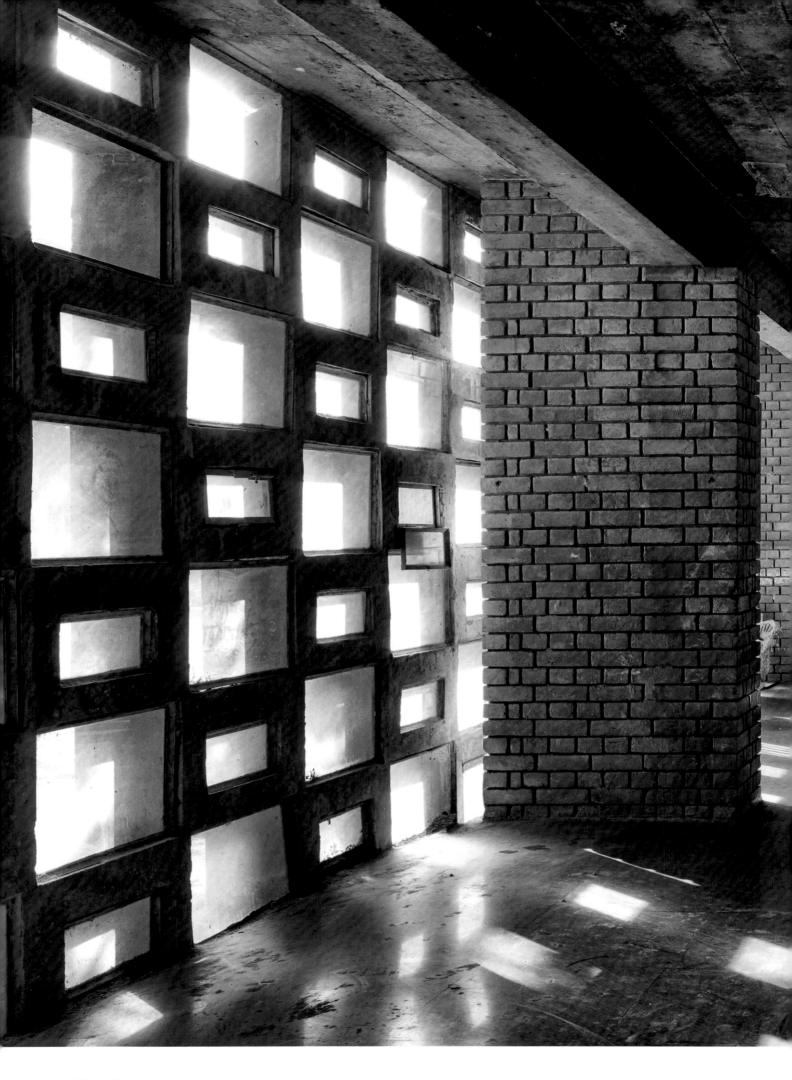

College of Art
Chandigarh, India, 1950–65

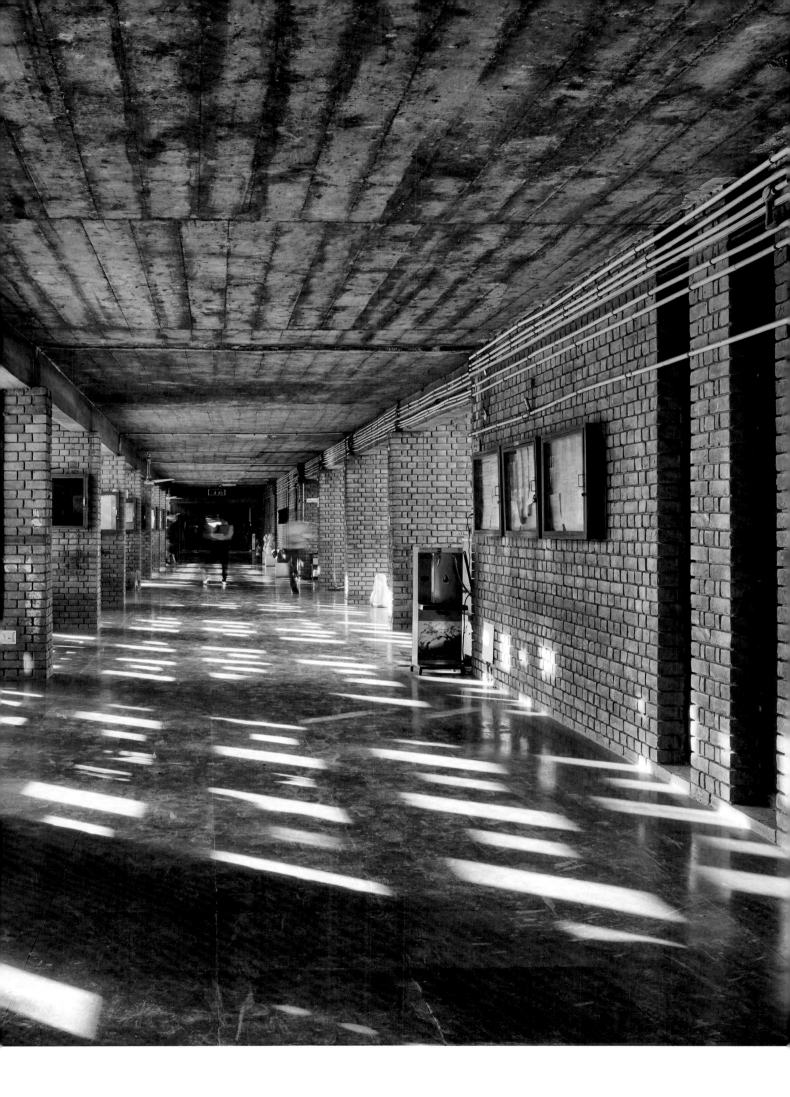

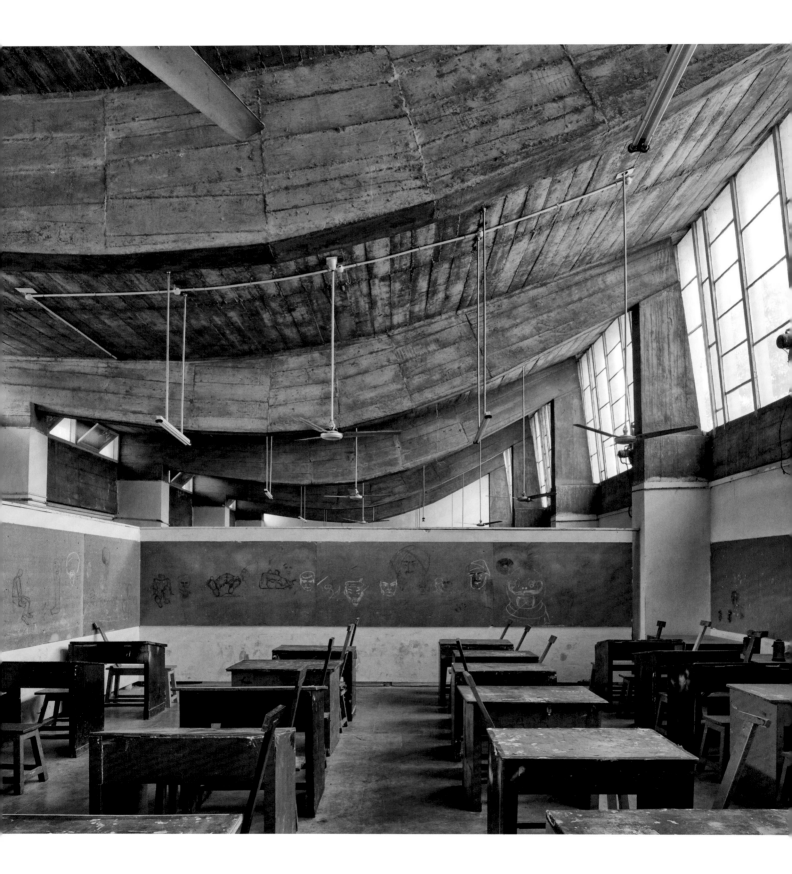

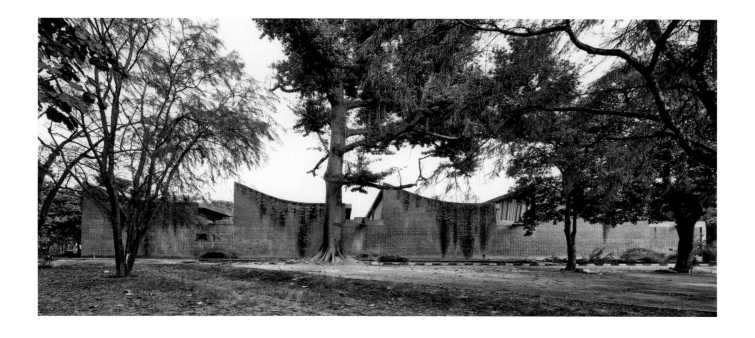

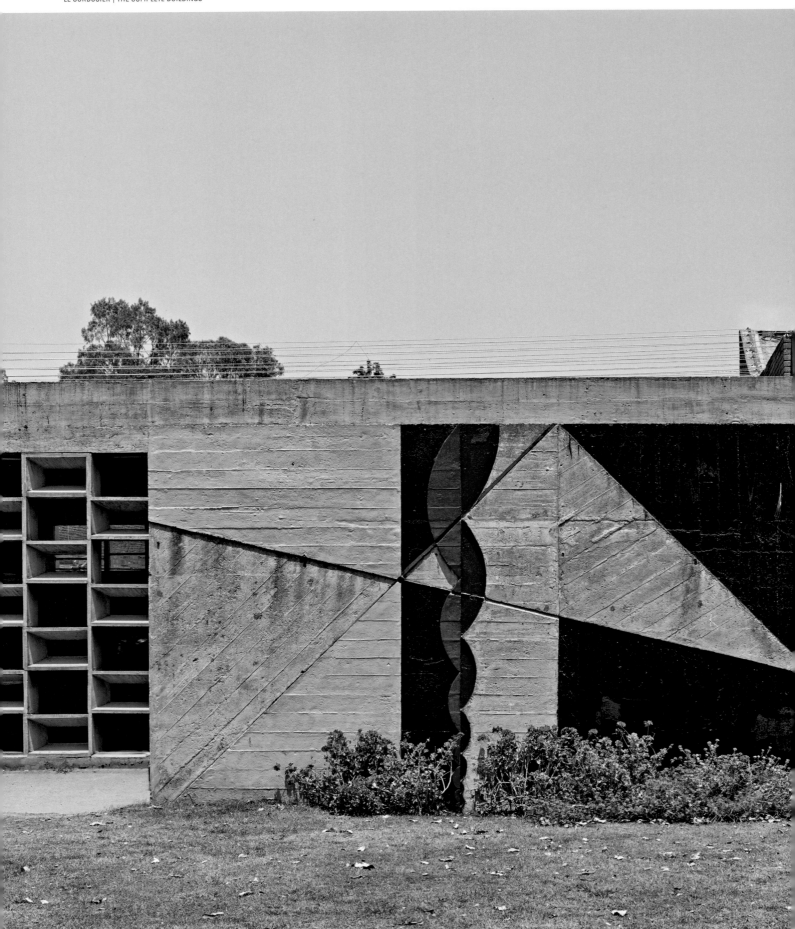

College of Architecture
Chandigarh, India, 1950–65

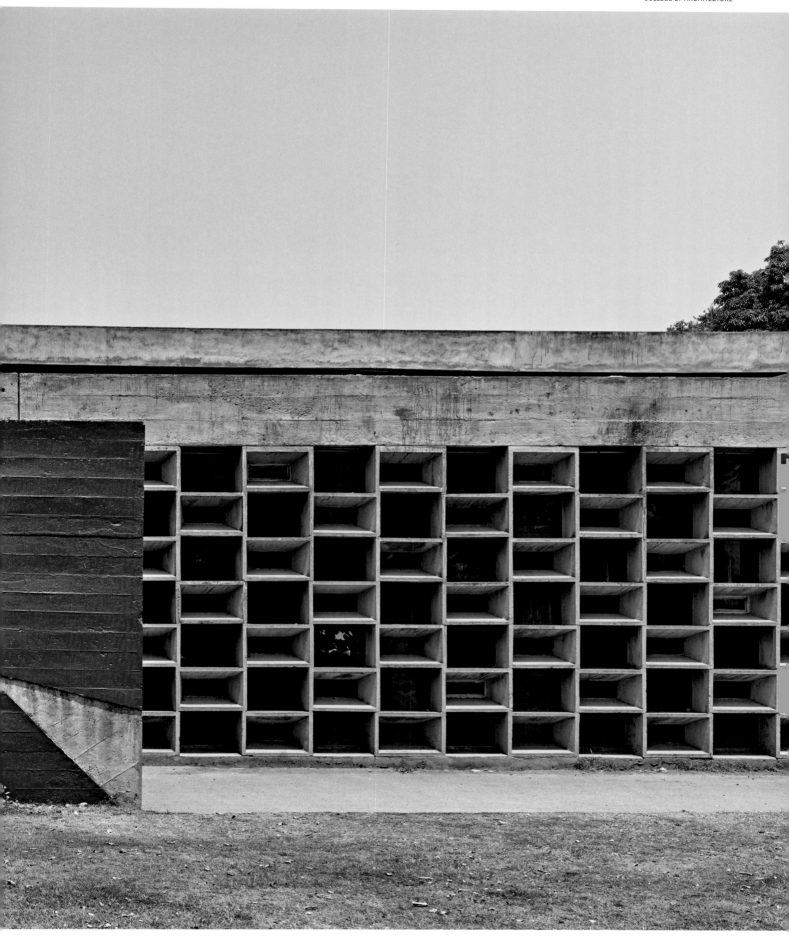

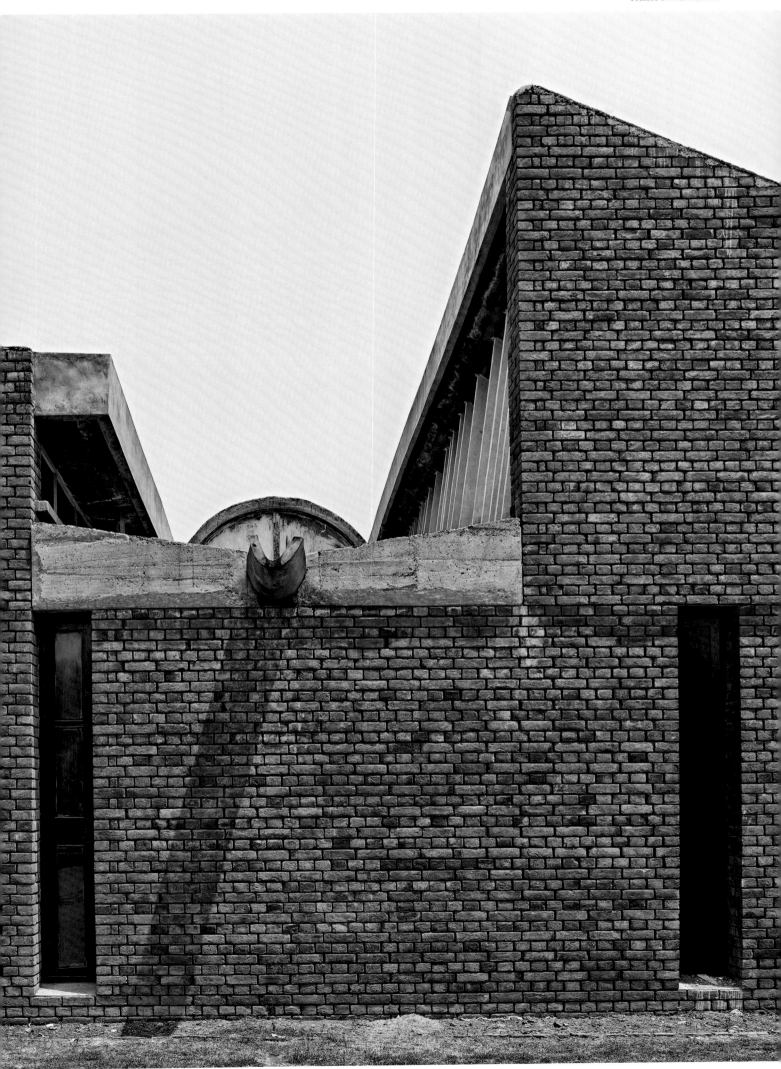

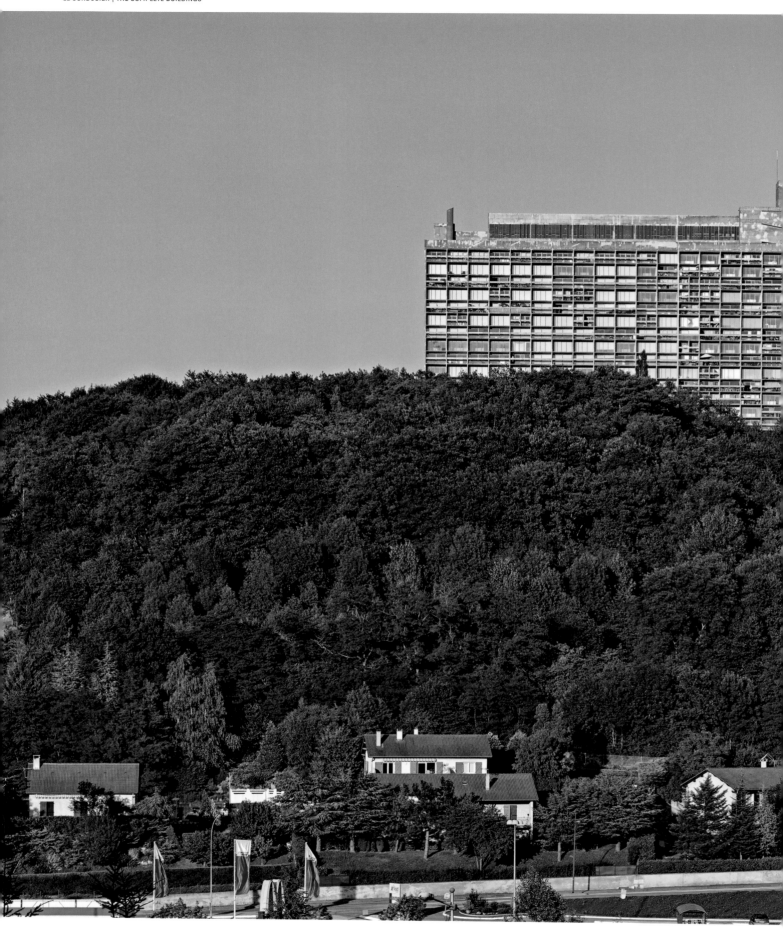

Unité d'Habitation, Firminy
Firminy, France, 1960

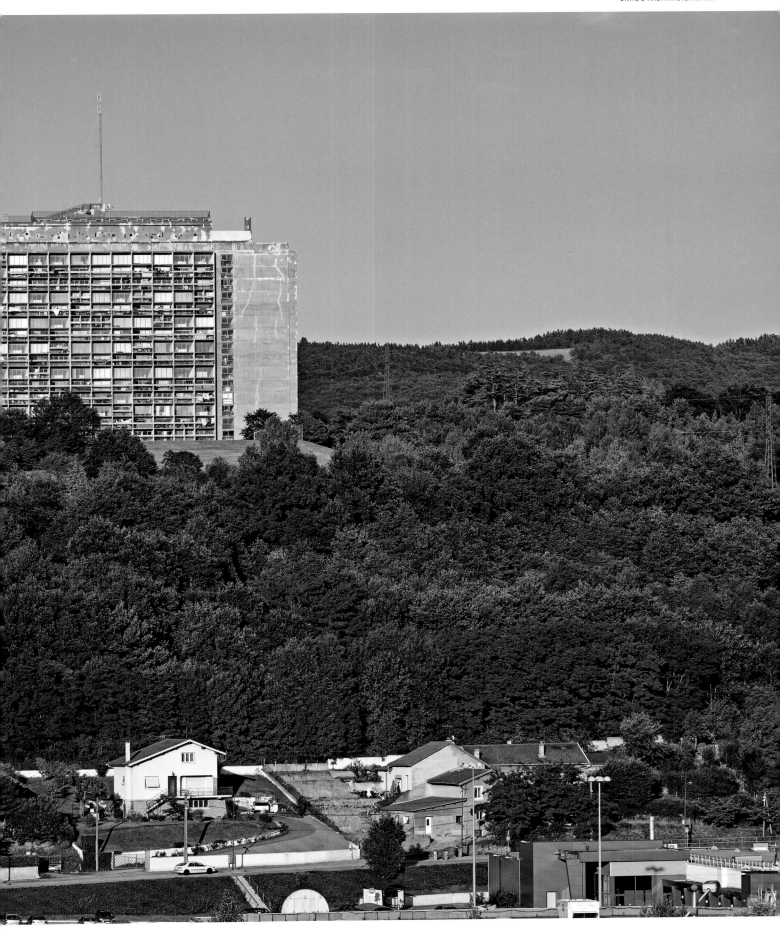

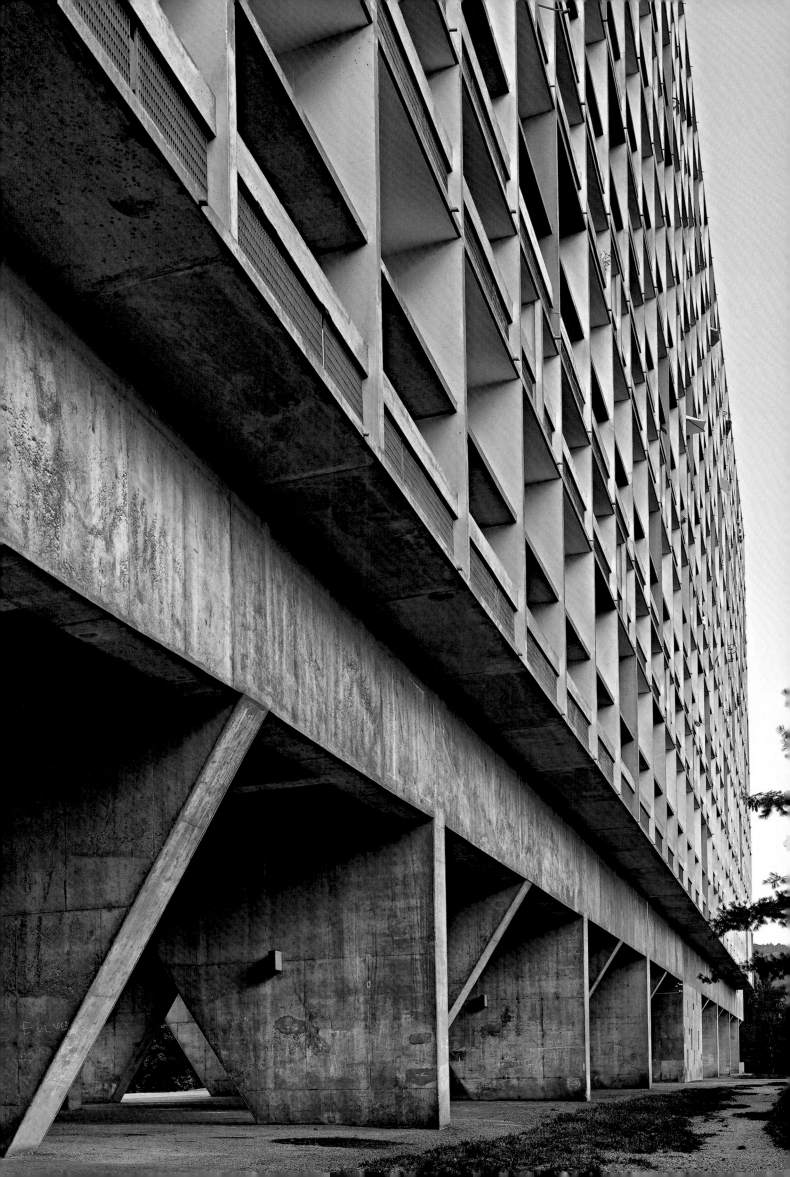

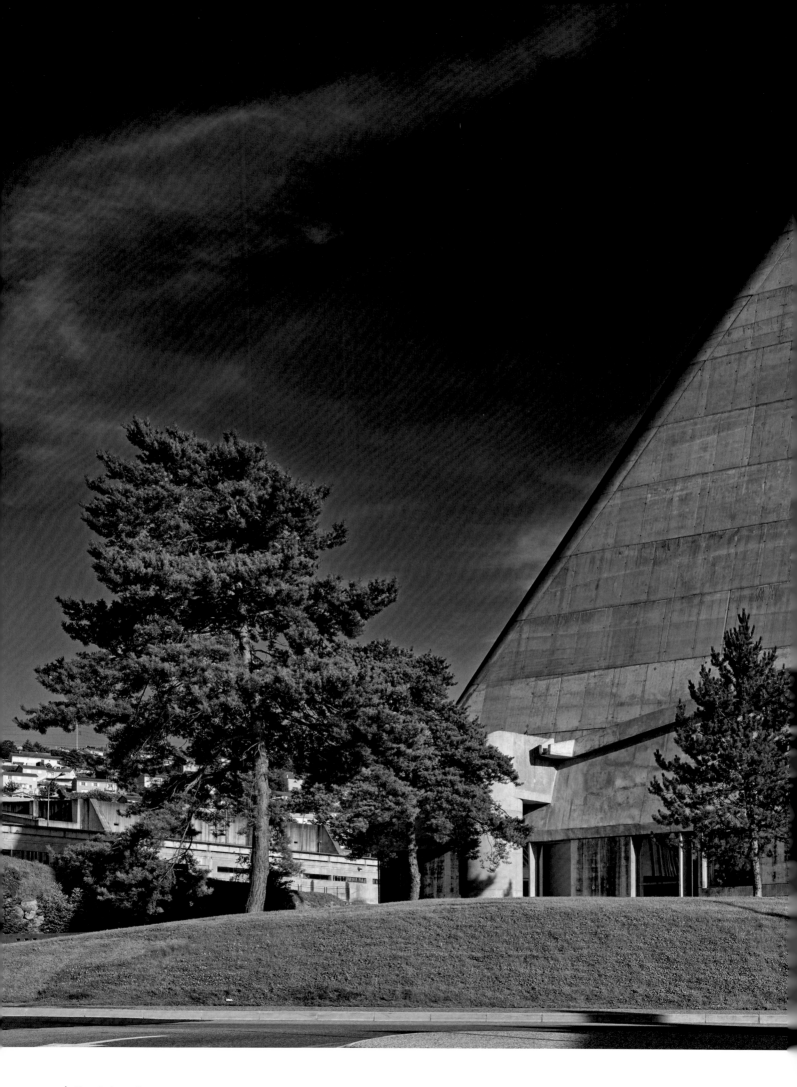

Église Saint-Pierre
Firminy, France, 1960–2006

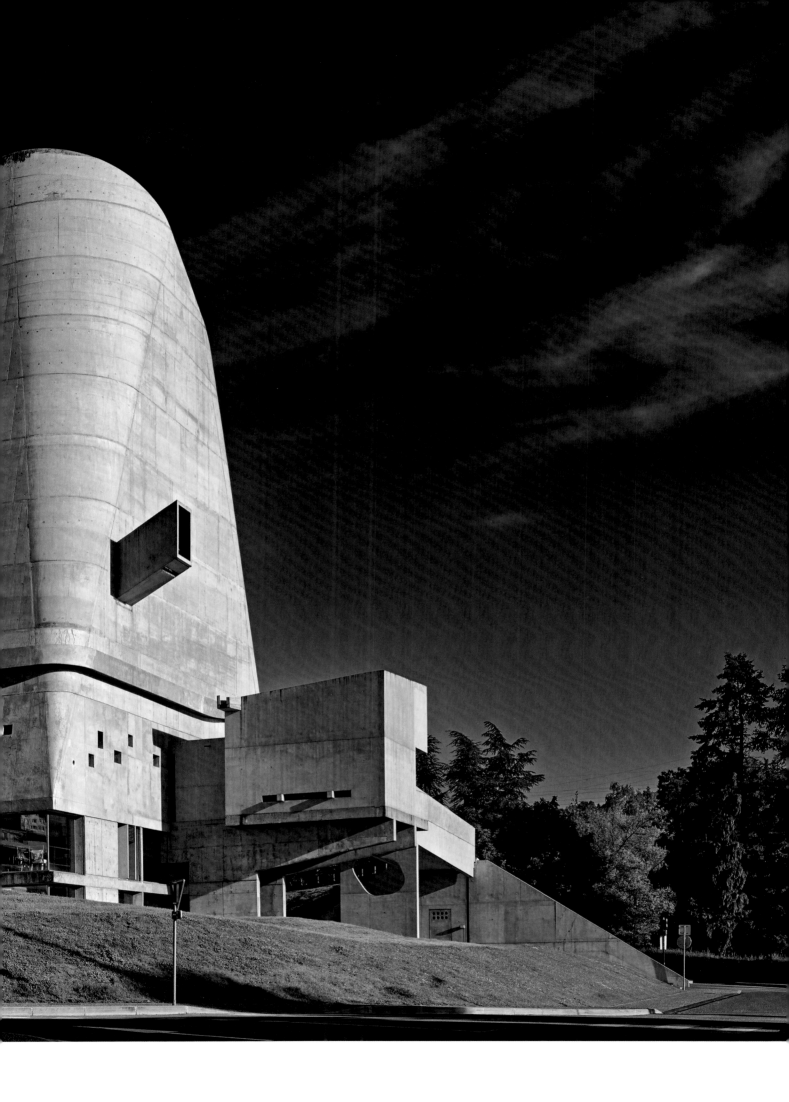

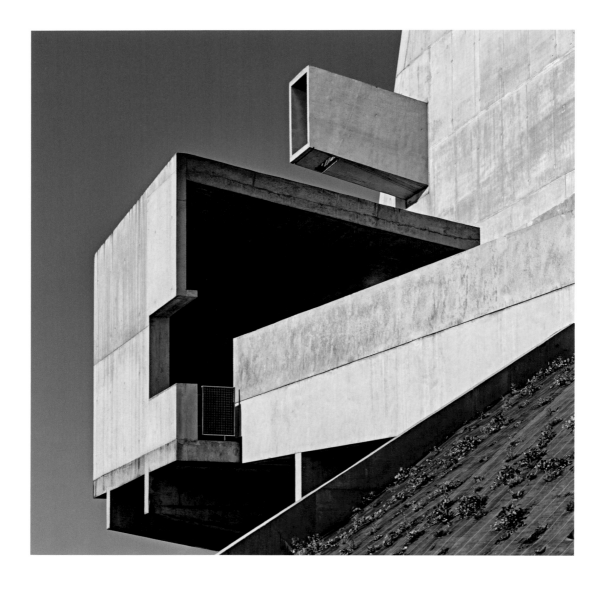

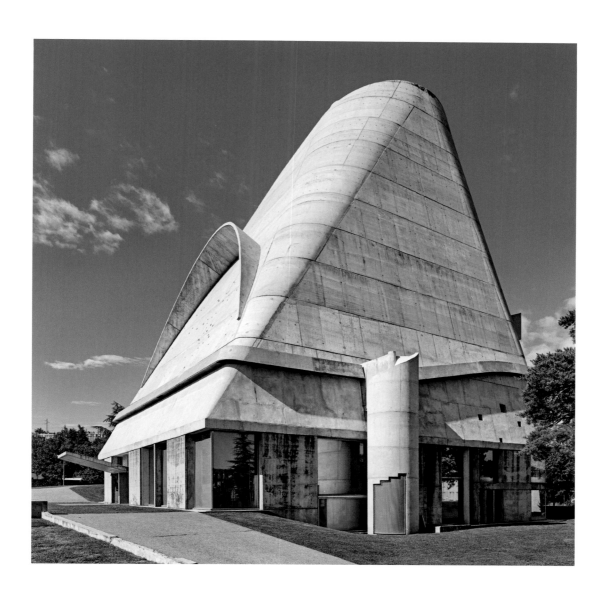

Building Images

TÜLAY ATAK

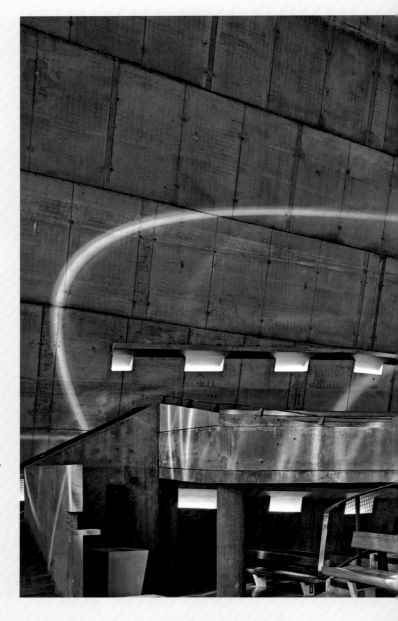

I t is usually the case that when a building is photographed, it enters the world of images. In the case of the Église Saint-Pierre de Firminy, however, one could argue that the building is already an image, and more specifically a photographic image. What makes a photograph is a perennial question with an uncertain answer: is it the photographer, the subject, the camera, the chemistry of the film, the relationships among elements inside the frame, or how the image relates to what is outside the frame? Considering the history of the camera, one could tentatively define a photographic image as one that light makes on a sensitized surface. And this is what brings the spaces of Église Saint-Pierre de Firminy close to photographic images.

For instance, the streaks of light in the photograph could have been produced when photographing the building or during the development process. Instead, the image we see captures an effect of the building. The Fresnel lenses inserted into the openings above the apse refract light and focus it as lines on the concrete surfaces of the interior. Due to the geometry of the building, which combines flat and curved surfaces, the lines bend and curve. While the lines do move slightly, they are always there during the morning hours. The result is well documented and the curvy lines of light are an iconic aspect of the building. What produces the lines is not even architecture, which, as a discipline, bridges abstract geometry and material tectonics; rather, they are created by a building component that operates like a filter on a camera. The special lenses produce the curvilinear lines that intersect the seams of the concrete formwork. They enable something that architecture does not traditionally do: to make images in space. One might say that they remind us that a building can make photographs – after all, there is architecture to a camera obscura.

The building of images is different from making images of buildings. Writing in 1955, five years before the designs for the Église Saint-Pierre de Firminy were initiated and 51 years before the building was completed, the architectural historian Reyner Banham suggested a theory of the image in architecture. He wrote that 'image' is an aesthetic category that provides an alternative to classical theories of beauty. Unlike an abstract quality that pleases, an image moves its observer and is caused by the thing itself.[1] One could propose a lineage of buildings that build images, a lineage that would certainly include framed views, but also examples like Pierre Chareau's Maison de Verre, which controls and filters the light. In the case of Église Saint-Pierre de Firminy, light, materialized through building components, makes the image. This definition of photographic images is perhaps limited in the context of the technical and historical aspects of photography, but in architecture, the result is refreshing. Architecture addresses light materially. It also ceases to be the subject of photography. Instead, the photograph captures and documents the images that the building produces.

1 Reyner Banham, 'The New Brutalism', *Architectural Review*, 118 (1955), pp. 354–61.

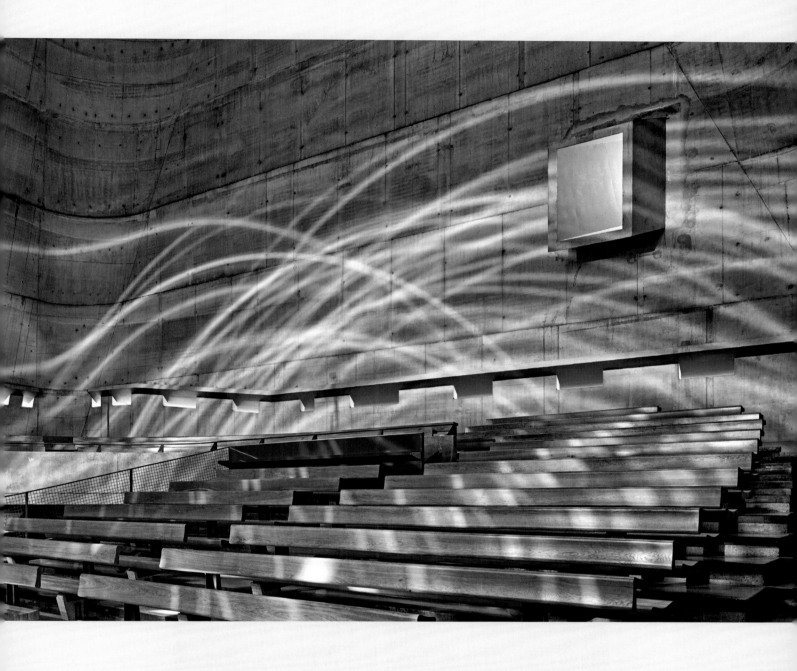

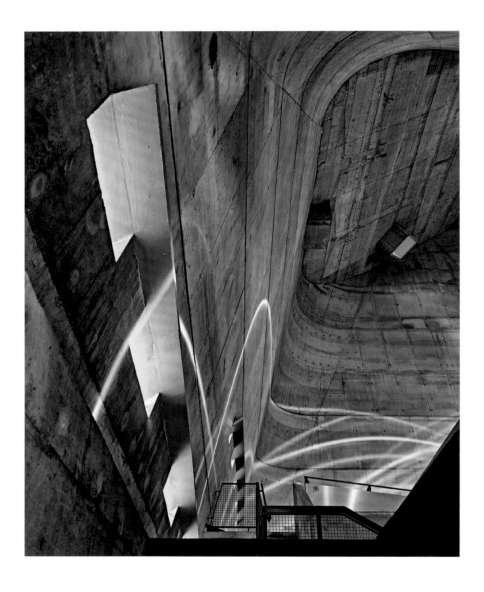

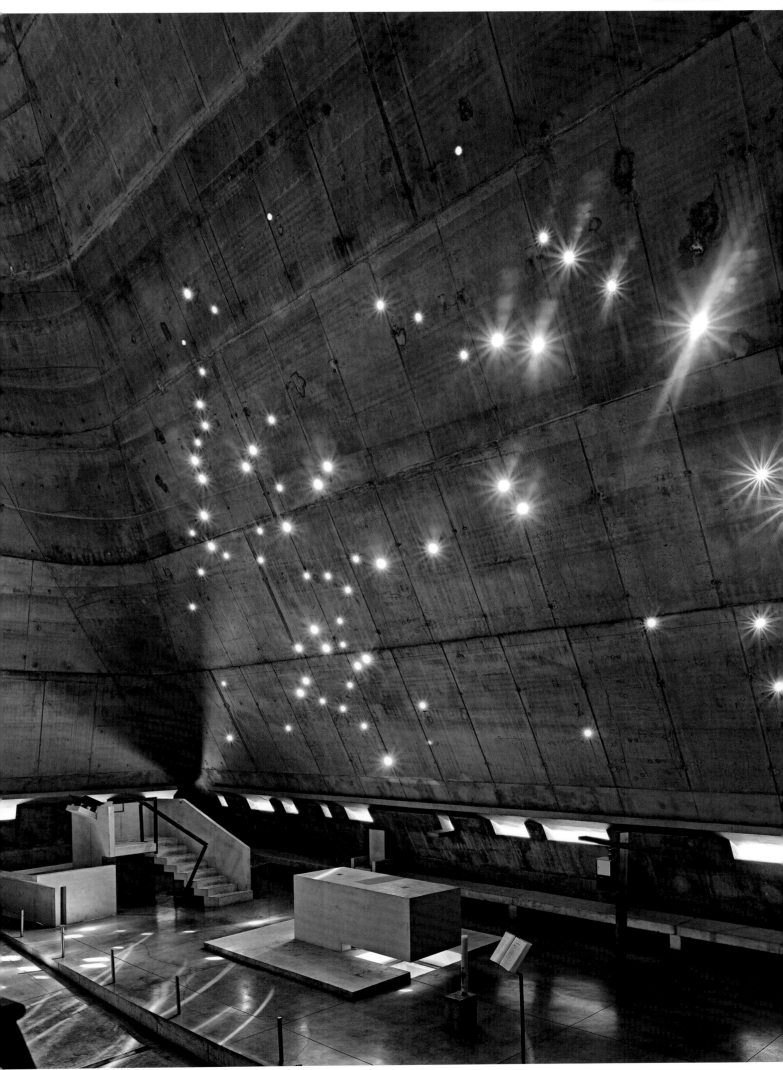

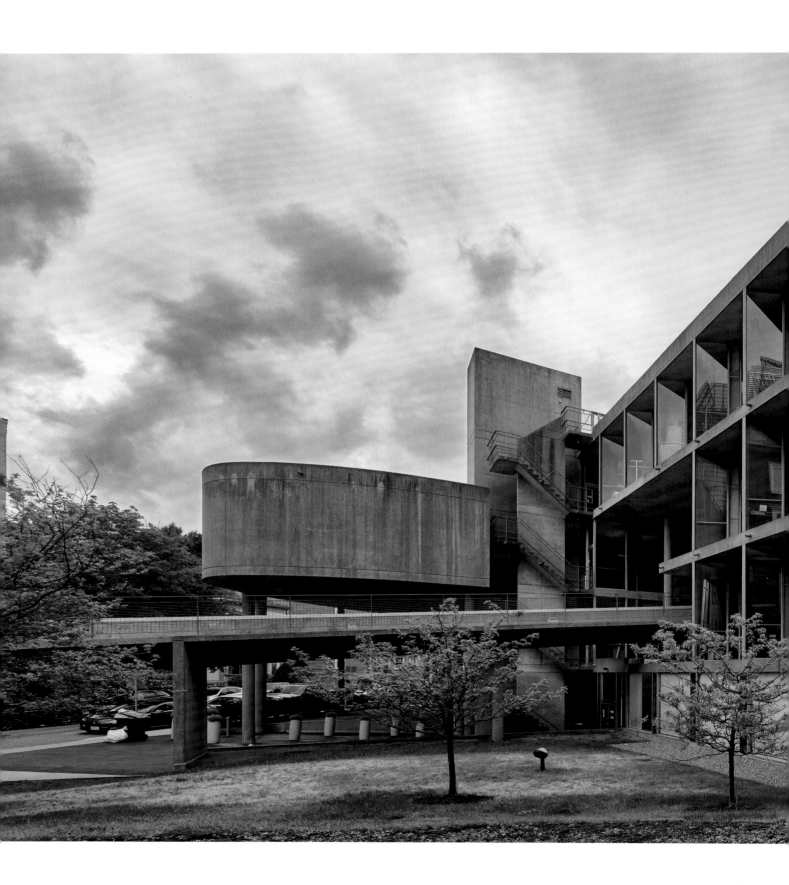

Carpenter Center for the Visual Arts
Cambridge, Massachusetts, USA, 1961

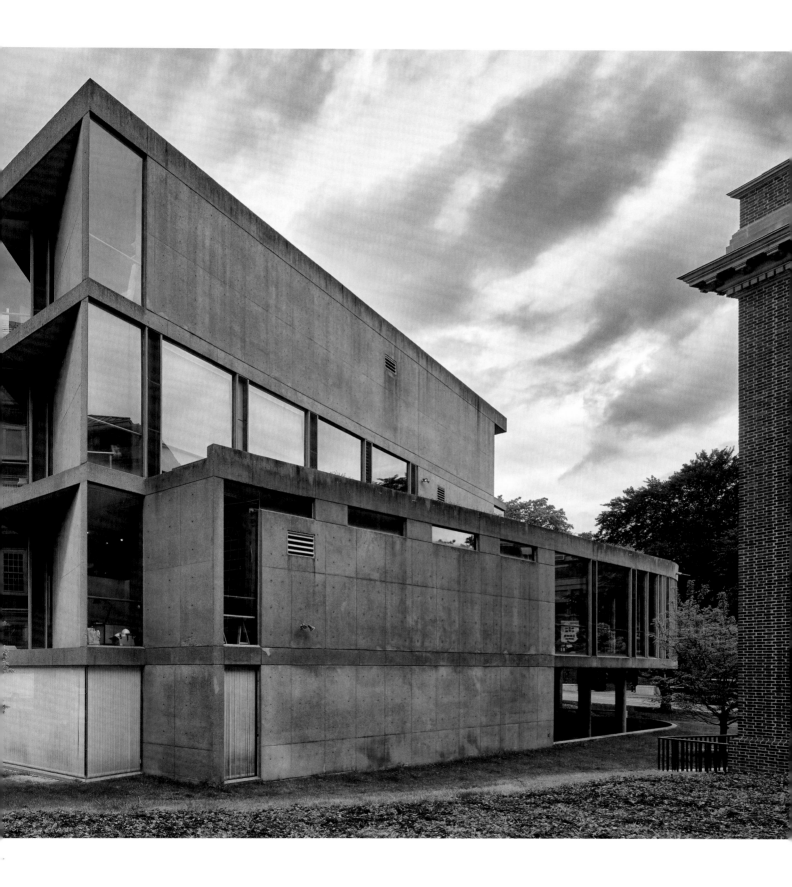

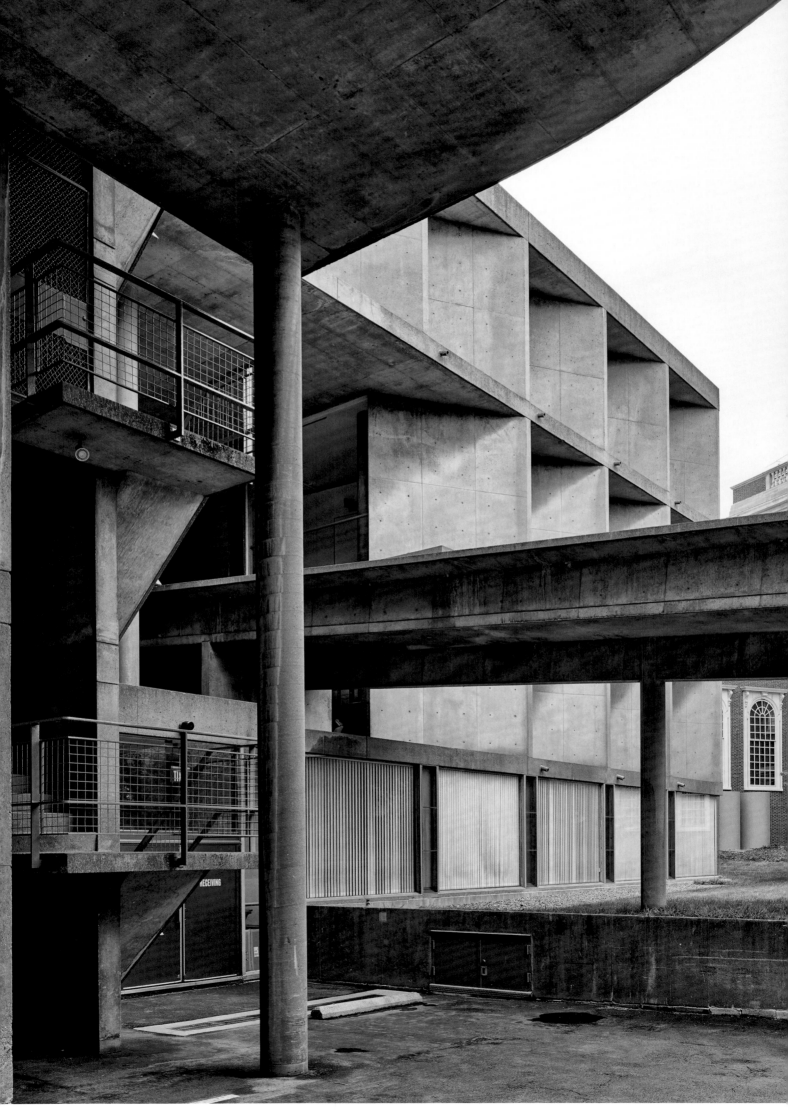

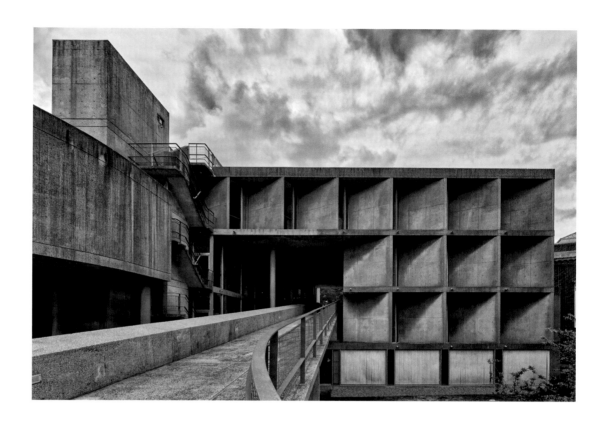

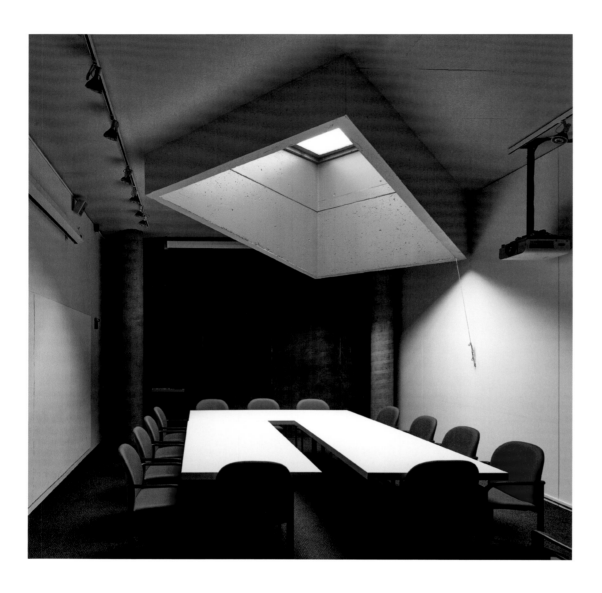

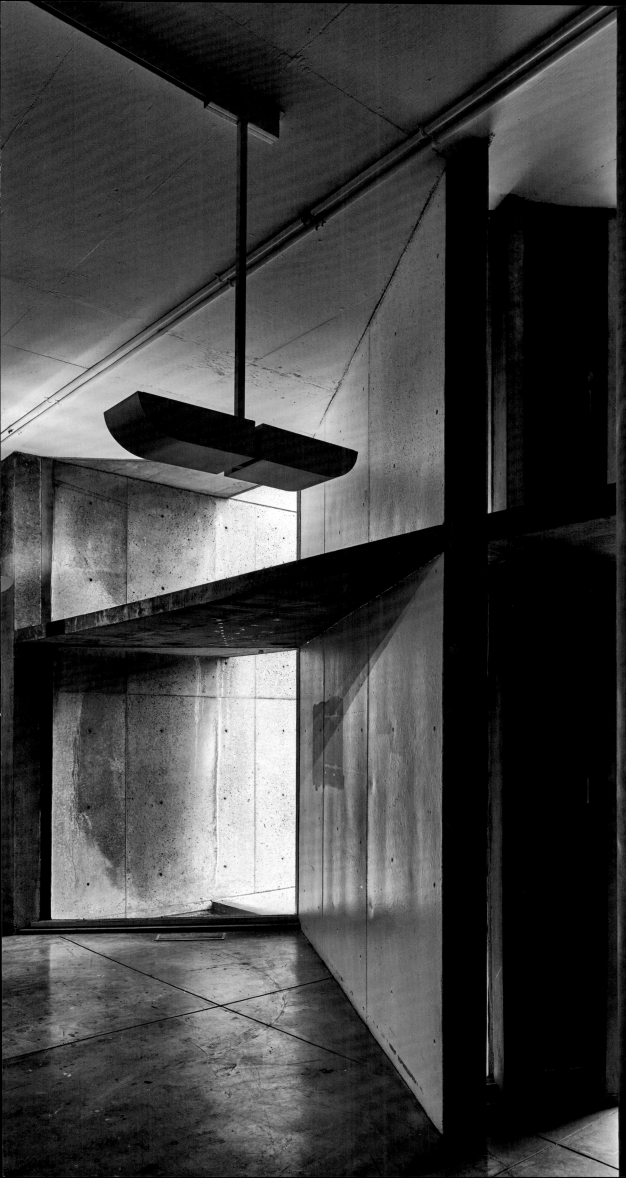

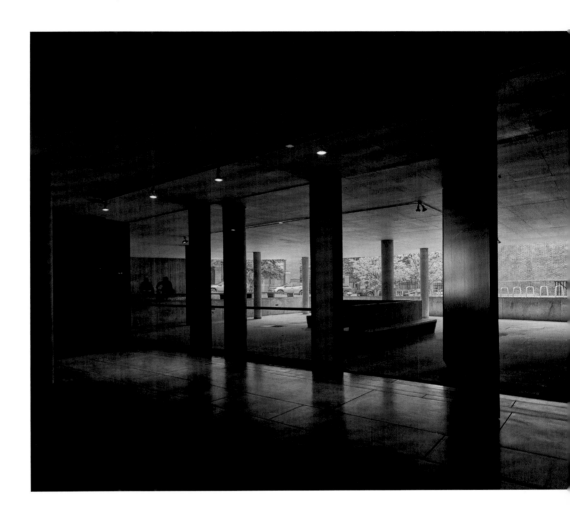

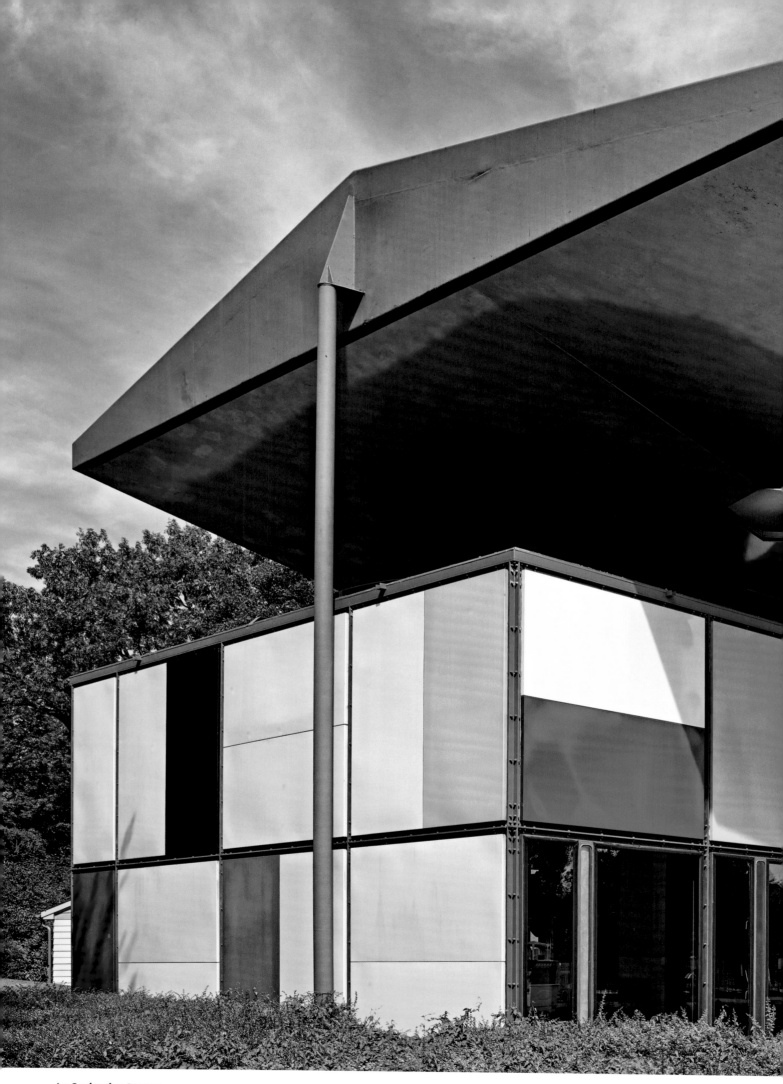

Le Corbusier Centre
Zurich, Switzerland, 1963

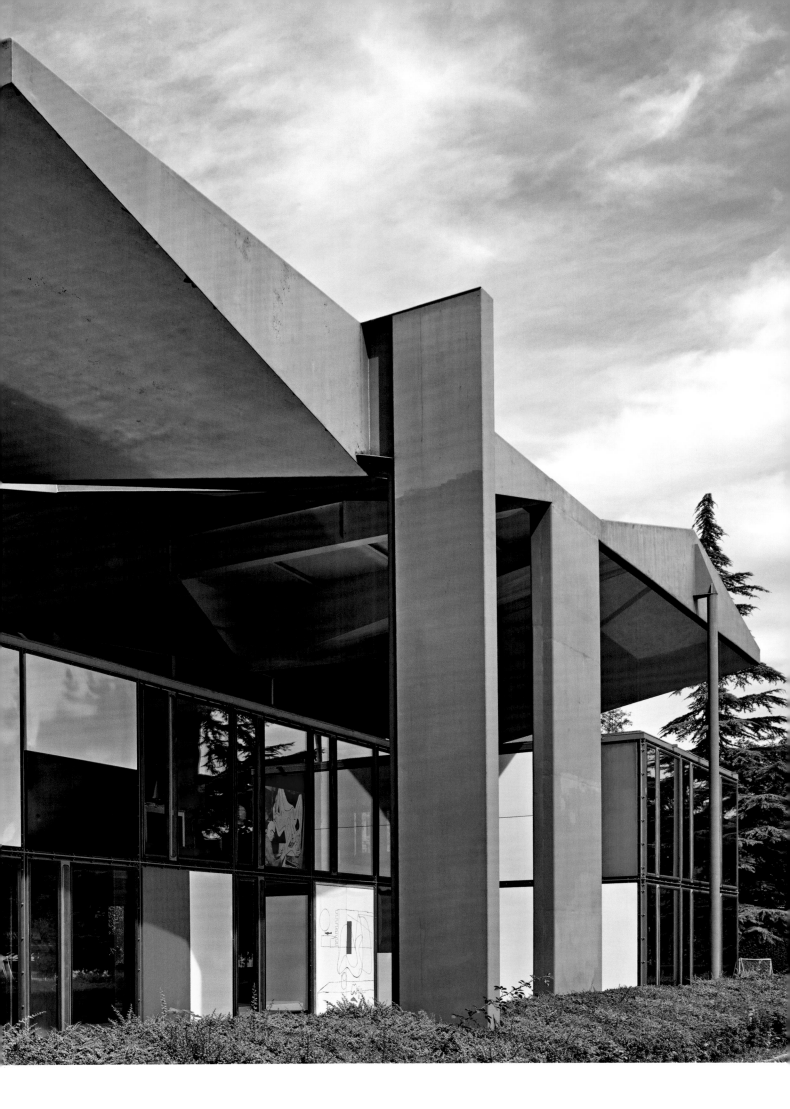

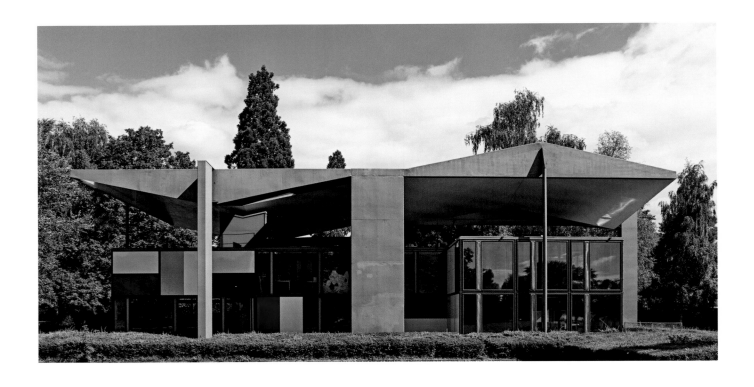

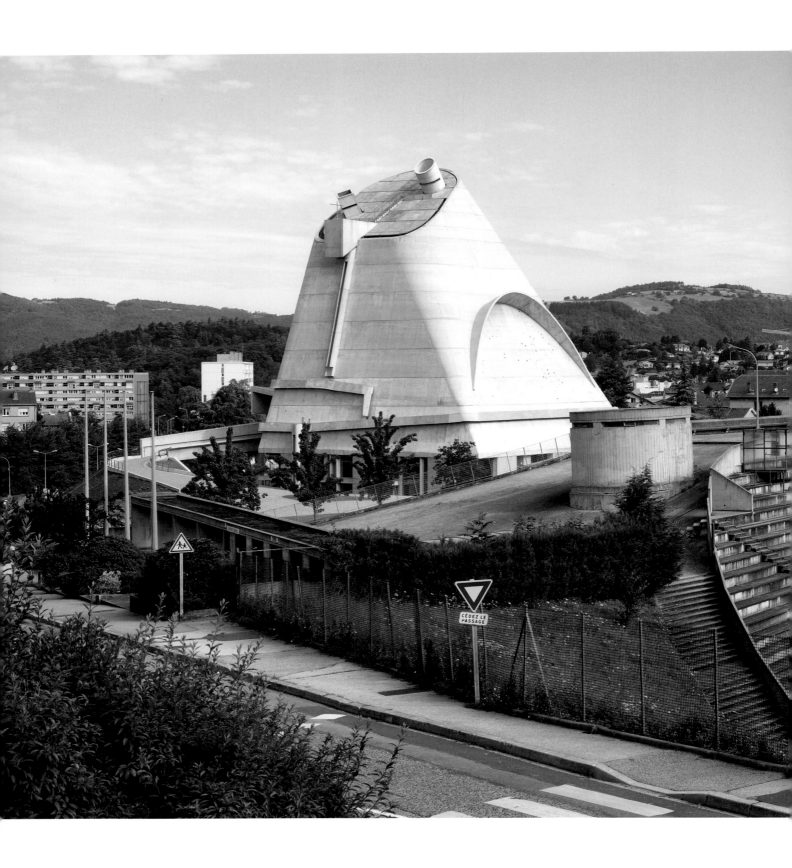

Stadium
Firminy, France, 1965

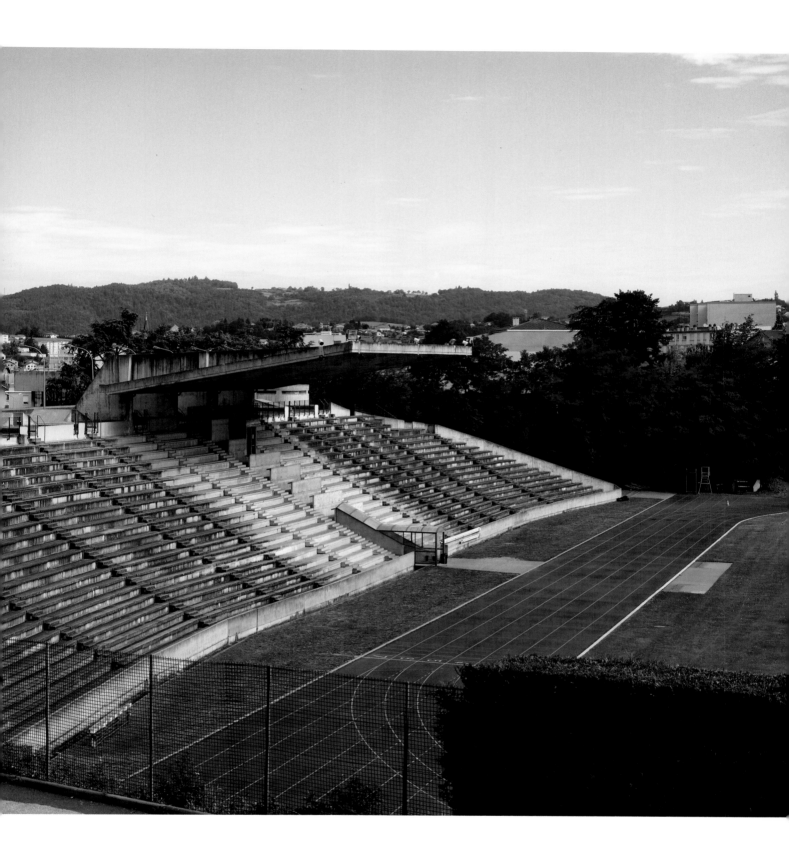

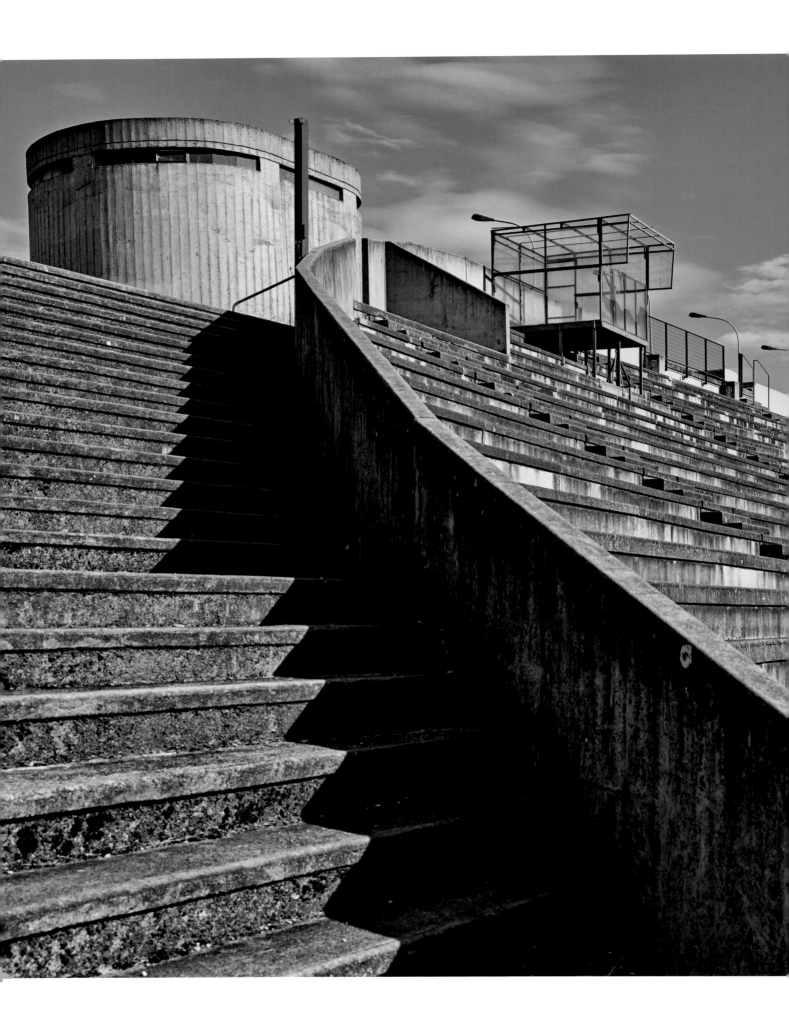

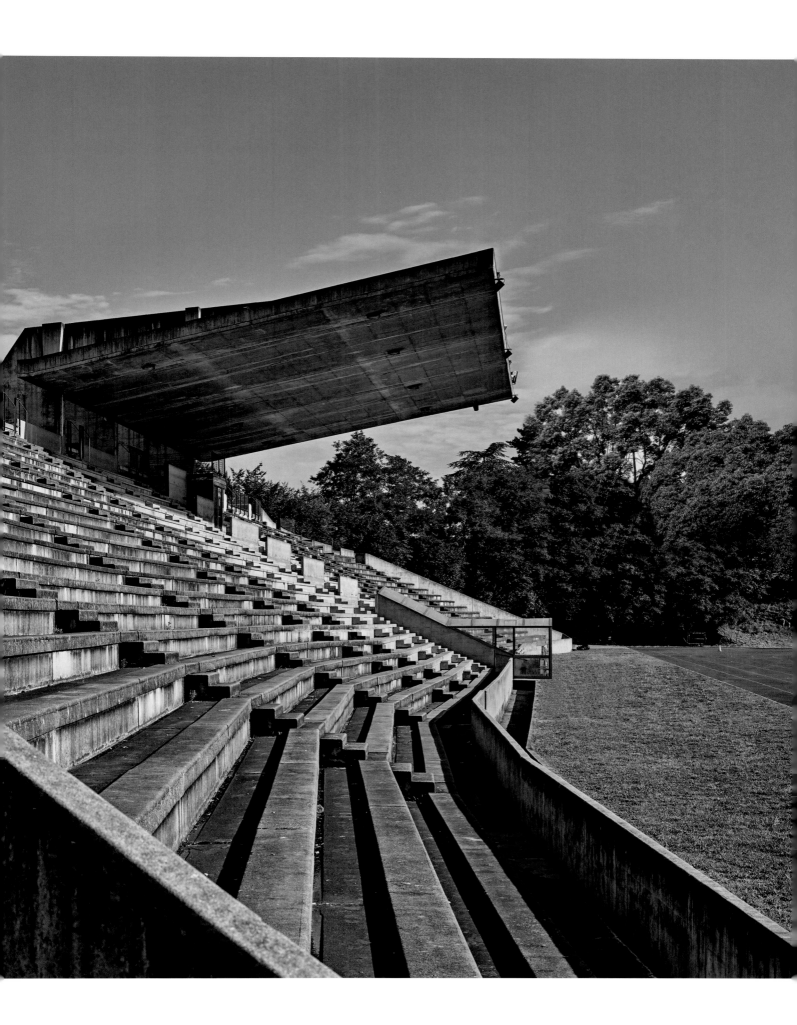

Catalogue of Buildings

Villa Fallet
La Chaux-de-Fonds, Switzerland, 1905

This is the first building the young Charles-Édouard Jeanneret (Le Corbusier) designed. He collaborated with a local architect named René Chapallaz during the construction of the villa, which was built in his home town in the Swiss Jura. Villa Fallet presents stylistic and decorative features abstracted from elements of the local flora – the pine trees in particular – with a design approach in line with the Arts and Crafts movement. *pp. 10-15*

Villa Jaquemet
La Chaux-de-Fonds, Switzerland, 1907

Designed for the relatives of the Fallet family, Villa Jacquemet displays Jeanneret's continuing effort to interpret his native chalet typology using the tools of contemporary craft styles. This building is plainer in terms of decorative features when compared to Villa Fallet. *pp. 16-19*

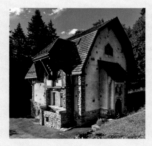

Villa Stotzer
La Chaux-de-Fonds, Switzerland, 1907

The third in the series, Villa Stotzer is situated close to the earlier two residences in Jeanneret's home town. It was designed with an approach similar to that which shaped Villa Fallet and Villa Jacquemet, yet certain differences in the facade treatment and roof form exist here and across the three edifices that represent the beginning of Le Corbusier's career as an architect. *pp. 20-23*

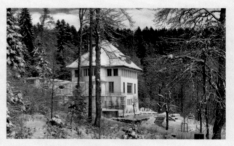

Villa Jeanneret-Perret
La Chaux-de-Fonds, Switzerland, 1912

As the name implies, Jeanneret designed this villa – which is also known as Maison Blanche – for his parents. The building marks a change in the young architect's style and reflects the influences of some formative experiences he recently had, such as his travels around Eastern Europe and the Mediterranean and the time he spent in Peter Behrens's office in Berlin. The plain, light-coloured facades, the simple roof with overhanging eaves and the horizontal strip of windows form a language that apparently diverges from the style of the first three houses he built in La Chaux-de-Fonds. *pp. 24-27*

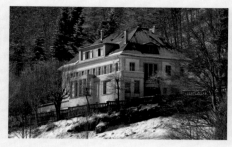

Villa Favre-Jacot
Le Locle, Switzerland, 1912

Jeanneret designed this large mansion for the founder of the Zenith watch company in the city of Le Locle, known as the centre of watchmaking in Switzerland. As in Villa Jeanneret-Perret, the architect is in search of a new architectural language freed from regional aspects in this building, and employs classic elements of the modernism that was emerging in Europe and America. *pp. 28-31*

Villa Schwob
La Chaux-de-Fonds, Switzerland, 1916

As Jeanneret was approaching the end of his La Chaux-de-Fonds period, he designed a unique villa that stands out among his works in his home town. Villa Schwob, again designed for a watchmaker, bears traces of influences similar to those in the previous two villas he designed, and is also named Villa Turque because of certain associations with Turkish houses. However, this villa is far more sophisticated in both stylistic and technical aspects as it reflects Jeanneret's ongoing experiments with systems of proportion and dimensioning, construction techniques with reinforced concrete, and heating and fireproofing systems. *pp. 32-35*

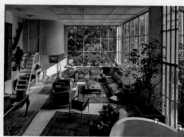

Atelier Ozenfant
Paris, France, 1922

Le Corbusier had already moved to Paris and started a partnership with his cousin Pierre Jeanneret when he designed the studio-house for his friend the painter Amédée Ozenfant. The building is shaped by the abstract language the architect was to perfect throughout his projects of the 1920s, known as his Purist period, and displays typical features like a simple prismatic mass, large openings on the facades and plain surfaces without decorative elements. The double-height studio space at the heart of the building has a special light that enters from the glazed exterior walls and the roof windows at once, creating a perfect atelier for a painter. *pp. 36-39*

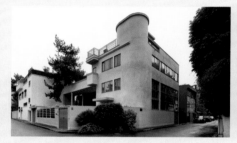

Villas Lipchitz-Miestchaninoff
Boulogne-sur-Seine, France, 1923

A second opportunity to work on the atelier-house typology appeared soon for Le Corbusier. Even though he initially designed this building as a cluster of three units for artists, the executed building housed the workspaces and residences of only two sculptors, Oscar Miestchaninoff and Jacques Lipchitz. The ground-floor studios and the garden provided spaces for sculpting and the residential quarters were placed on the upper floor. *pp. 40-43*

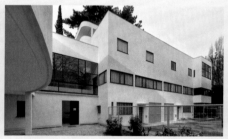

Maisons La Roche-Jeanneret
Paris, France, 1923-25

The L-shaped building placed at the end of a cul-de-sac in Paris which houses the Fondation Le Corbusier today was originally designed as a pair of attached houses; one for Le Corbusier's brother, Albert Jeanneret, and his wife, and the other for the young banker Raoul La Roche. This pair of houses can be considered as the first significant example of the series of Purist villas the architect designed in the 1920s. As well as his Five Points of Architecture, this building displays Le Corbusier's important concept of the *promenade architecturale*, specifically through the ramp inside the double-height gallery he designed for the exhibition of La Roche's painting collection. *pp. 44-49*

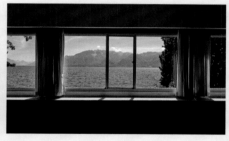

Villa Le Lac
Corseaux, Switzerland, 1923-24

The 'villa by the lake' is a small house Le Corbusier designed for his parents. It is a modest and functional modern dwelling that is in perfect harmony with its site right next to Lake Geneva, even though it was designed before the site was decided. Its horizontal mass and window opening on to the lakeside create a strong bond between the architectural space and the adjacent body of water. Originally a plain white box, the villa went through several alterations, including an upper-floor annex and the galvanized steel cladding on the north facade, which were made by Le Corbusier himself. The architect's mother lived in this house until after her 100th birthday. *pp. 50-53*

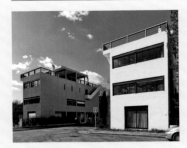

Quartier Moderne Frugès
Pessac, France, 1924

Le Corbusier received this housing commission from the industrialist Henry Frugès, who shared his passion and interest in building low-cost, standardized and mass-produced houses. In this project, the architect had the chance to experiment with his Dom-Ino scheme, based on a reinforced concrete frame, on a larger scale than in the individual villas. Another experiment he realized in Pessac was in polychromy, which would never leave his agenda throughout his career, though his colour palettes kept changing. *pp. 54-59*

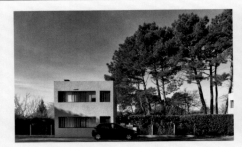

Maison et Cantine
Lège, France, 1924

This building is part of a small cluster of workers' houses Le Corbusier designed for Henry Frugès. The compound is formed of six units for families and one for a bachelor and a communal space – the *cantine*. This lesser-known group of houses at Lège is the predecessor of the Quartiers Moderne Frugès at Pessac. *pp. 60-61*

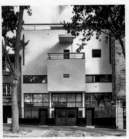

Maison Planeix
Paris, France, 1924

The small yet impressive Maison Planeix, designed for the funerary sculptor Antonin Planeix, is situated in a row, attached to the neighbouring buildings. Its almost perfectly symmetrical facade is beautifully proportioned and partitioned, resembling a classical villa. As in most of Le Corbusier's Purist houses, the ground floor is reserved for service spaces and circulation while the main living spaces are placed on an upper level, a *piano nobile* in the exact sense. There is an atelier for the artist on the topmost level, connected to the other main floors and the small garden at the back by an outdoor staircase. *pp. 62-67*

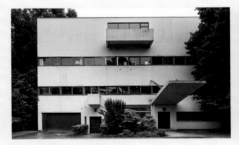

Villa Stein-de-Monzie
Garches (Vaucresson), France, 1926

Le Corbusier once more dealt with multiple clients willing to share a house in this project that he designed for the American couple Michael and Sarah Stein and the French woman Gabrielle de Monzie and her daughter. This house, which is also known as Les Terraces, is a seminal work of the architect's from the 1920s period as a result of its complex and original plan and facade configurations and the underlying system of proportions and the structural grid that regulate them. The house was original in its programmatic organization as well, and was used as a place for artistic and intellectual gatherings in addition to domestic activities, due to the profile of its owners. *pp. 68-71*

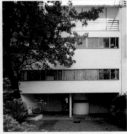

Maison Cook
Boulogne-sur-Seine, Paris, France, 1926

This four-storey prismatic house which Le Corbusier designed for the American artist William Cook displays an emblematic application of the Five Points, through its dynamically designed free plan and free facade, lined with strip windows; its emptied ground floor with the help of pilotis; and its roof garden opening up to the views of the surrounding landscape. The internal organization of the house was 'reversed', in Le Corbusier's words, by positioning the living quarters at the top, right underneath the terrace garden. The double-height living room has an enhanced level of three-dimensionality as a result of its fluid space, the sculptural forms and surfaces it houses and the openings on its exterior walls, placed at different heights. *pp. 72-73*

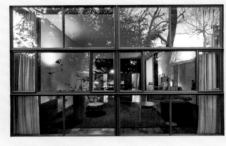

Maison Guiette
Antwerp, Belgium, 1926

Apart from his early work in his home town, Maison Guiette is the first commission Le Corbusier received outside France. It is built on a narrow and deep plot in Antwerp, which determined its specific proportions and differentiated it from the other prismatic multi-storey houses of the architect. The house is designed both as a house and a studio, and the living quarters are placed on the ground floor in connection with the garden at the back, in response to the demands of the client, the Belgian artist René Guiette. Distribution of the interior spaces and circulation are artfully expressed on the facades of the building by the use of balconies and openings of unusual sizes and positions. *pp. 74-79*

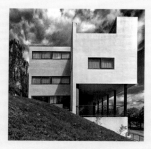

Houses of the Weissenhofsiedlung
Stuttgart, Germany, 1927

The two buildings Le Corbusier designed for the 1927 Stuttgart Deutscher Werkbund exhibition were his response to the question of modern dwelling and were displayed next to other significant architects of the time. This single-family house based on his Citrohan model, and the two-family residence located close to it, displayed both the potentials of the reinforced concrete frame and the Five Points derived from it, and a fresh interpretation of domestic life in modern times. Free and flexible plans, abundant use of open-air spaces and large openings that filled the interiors with light formed the basic components of this new way of living. *pp. 80-85*

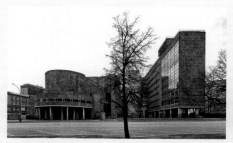

Centrosoyuz
Moscow, Russia, 1928

After a challenging sequence of competitions, Le Corbusier won this complex building commission in Moscow. Le Corbusier's scheme – which he formerly experimented with in the League of Nations project of 1927 – for the headquarters of the Soviet Centrosoyuz was a multifunctional cluster of buildings that housed offices and public enterprises such as auditoria, restaurants and clubs. The architect himself declared that the most important concept in the design of the complex was circulation, as he had to 'regulate crowds entering and leaving all at the same time'. So the diversely shaped and sized building masses that form the complex sit on or at times float above a continuous ground of circulation dotted with pilotis. *pp. 86-91*

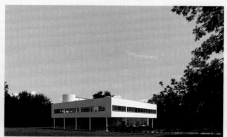

Villa Savoye et Loge du Jardinier
Poissy, France, 1928

There is no doubt that Villa Savoye is the most iconic work of Le Corbusier, not only among his Purist villas but also within his complete body of buildings. In fact, it is the aesthetically perfected embodiment of certain architectural ideas he had long been working on, such as the Five Points of Architecture, the *promenade architecturale* and a Purist language. His wealthy intellectual clients Pierre and Eugénie Savoye initially had faith in Le Corbusier's vision of modern living inside the sun-filled and airy interiors and terraces of the house, oriented towards different vistas of the surrounding pastoral landscape, even though they did not inhabit the house for very long, due to some technical problems. *pp. 92-101*

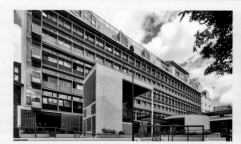

Armée du Salut, Cité de Refuge
Paris, France, 1929

As a result of his ongoing collaboration with the French Salvation Army, Le Corbusier designed a complex for the sheltering of the homeless and the needy, a perfect programme to work on the concept of the building as a complete social unit. The Cité had dining halls, service spaces and recreational facilities placed under or in front of the dominant block of dormitories, which would house men and women separately. A multi-layered system of circulation linked these different elements in the programme and formed a sequence of in-between spaces and vistas. Le Corbusier also worked on the problem of climate control in this building, through the section of the glass curtain wall and the use of mechanical systems. *pp. 102-107*

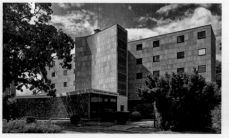

Pavillon Suisse
Paris, France, 1930

After the disappointment with the League of Nations competition in Geneva, Le Corbusier received a commission for a building that would serve as a dormitory and social centre for the Swiss students of the Cité Internationale Universitaire in Paris. He took advantage of this modest project on a tight budget to experiment with several architectural and structural ideas. Again, as he did in his earlier public buildings, he placed different programmes in separate masses and linked them with circulatory devices. The structure of the building also showed variety, creating hybrids of reinforced concrete and steel skeletal systems and masonry walls. The variety of surface materials and the degrees of transparency on different facades are other innovative aspects of this project. *pp. 108-13*

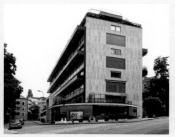

Immeuble Clarté
Geneva, Switzerland, 1930

This nine-storey apartment building in Geneva was based on the housing units Le Corbusier had been working on in his urban schemes. However, the end product differs from them structurally and materially as well as programmatically. Edmond Wanner, a Swiss metal manufacturer, commissioned the building and also undertook its construction based on a steel-frame structure. This structural system of prefabricated metal elements brought together by dry assembly techniques both provided variety and flexibility in the design of the apartments and defined the architectural language of the building, together with the large surfaces of glass fortified with double-glazing and mechanical devices for climate control. *pp. 114-17*

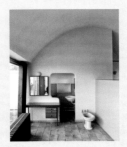

Immeuble Molitor / Appartement de Le Corbusier Paris, France, 1931–34

The building is another manifestation by Le Corbusier of an urban housing block, this time built with a reinforced concrete structure and as infill within the city fabric. The building houses flats of residential units, some of which are duplexes like his theoretical *immeubles-villas*, and Le Corbusier's own studio and house at the top, which he used throughout his lifetime. Le Corbusier worked on the curtain wall application with various forms of metal and glass in the design of the facade. His own apartment at the top displays the most variety in terms of spatial organization and use of materials, such as the exposed masonry wall, which signals his divergence from the Purist language. *pp. 118-21*

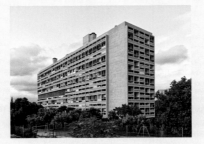

Unité d'Habitation, Marseille Marseille, France, 1945

The first built example of the Unité d'Habitation typology – Le Corbusier's ultimate model for modern collective living – is the one in Marseille. The huge prism, which sits on a hilltop in a beautiful landscape, is lifted off the ground by reinforced concrete pillars to allow pedestrian and vehicular traffic to pass beneath. It provides residences of differing types and sizes for 1,600 people and the numerous social and technical services necessary for a community of this size. The ingenious section of the block brings together interlocking duplex houses, services at certain floors and a roof terrace with sculptural forms. This ground-breaking project also displays Le Corbusier's studies on the Modulor – the proportioning system he developed – and Brutalism. *pp. 122-29*

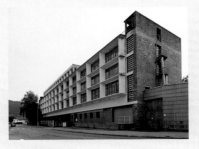

Usine Duval Saint-Dié-des-Vosges, France, 1946

Jean-Jacques Duval was one of the few true supporters of Le Corbusier's planning for Saint-Dié, which was never executed. His belief in the architect's vision opened the way for a new factory building on the site of a former family hosiery manufactory. Le Corbusier designed a building for Duval that housed a production line with vertical and horizontal axes and which complied with his 'green factory' concept. The linear volume of the building was lifted off the ground by pilotis and shaped by the grid of a reinforced concrete frame structure whose dimensions were set according to the Modulor, as were the secondary architectural elements on the facade. *pp. 130-33*

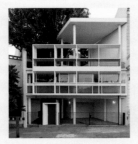

Maison Curutchet La Plata, Argentina, 1949

Le Corbusier had the chance to extend his individual house schemes to a totally different geographic and climatic context through the design of the house and office of the surgeon Pedro Domingo Curutchet. The building in La Plata, Argentina, was to be placed on a lot tightly framed on two sides by other buildings and overlooking a park in front. While the doctor's surgery and residence were separated by a small inner court, they were at once linked by elements including ramps, staircases, terraces and a unifying facade grid made up of brise-soleil. The outcome is a small yet complex building with an original spatial organization, in both plan and section. *pp. 134-39*

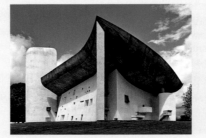

Chapelle Notre Dame du Haut Ronchamp, France, 1950–55

The impressive chapel at Ronchamp is situated at the end of a pilgrimage route, on a hilltop with views of the surrounding landscape on all sides. It is a sculptural mass formed of concave and convex surfaces of either *béton brut* or white plaster with a rough finish. The interior of the building has an equally plastic expression and fully represents Le Corbusier's notion of the 'ineffable space', which is mostly created by the form and the quality of light entering it. The perforations on the walls, the coloured glass windows and the slit under the reinforced concrete shell roof provide a constantly changing environment of luminosity inside the chapel, which is one of the architect's most poetic works. *pp. 140-49*

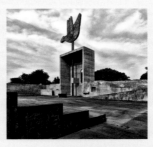

The Monument of the Open Hand Chandigarh, India, 1950–65

The open hand is a motif Le Corbusier had been working on since the late 1930s. Its final form is embodied in a monument placed at one end of a large public plaza in the Capitol Complex in Chandigarh. The 14-metre-high metal hand has been interpreted as a symbol of the peace and prosperity of humankind, the relationship of man with nature or 'man's noble creations', and takes its form from Le Corbusier's Modulor man. *pp. 150-51*

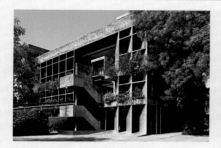

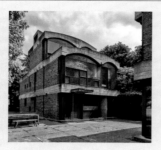

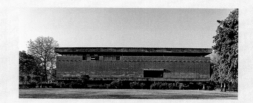

Mill Owners' Association
Ahmedabad, India, 1951

Le Corbusier's works in India, which are located in Ahmedabad and Chandigarh, constitute a significant part of his late career. The centre he designed for the association of cotton mill owners of Ahmedabad is one of his four built works in this city. The building, which includes an assembly hall and offices in addition to the social and recreational facilities of the association, acts as a visual and climatic device as well. Through its facade made up of brise-soleil and frames, and indeed its whole structure accommodating empty spaces and passages, the building provides shade, breeze and vistas of the surrounding landscape and river. *pp. 152-57*

Maisons Jaoul
Neuilly-sur-Seine, Paris, France, 1951

The two houses that were designed for the Jaoul family in a suburb of Paris are important representatives, in the category of domestic buildings, of the post-war Brutalist aesthetics Le Corbusier developed. The naked and rough use of materials such as concrete, bricks and tiles not only served to express a new architectural language but also complied with the tight budget of the project. The Jaoul houses also display Le Corbusier's interest in vernacular architecture, especially that of the Mediterranean – which had been visible in his works since the beginning of the 1930s – through the use of the Catalan vaults. *pp. 158-63*

Sanskar Kendra City Museum
Ahmedabad, India, 1951

The City Museum in Ahmedabad is another take on the idea of the museum of unlimited growth. As in the museum in Tokyo, this example is quite different from the ideal generic scheme Le Corbusier conceived, which is a simple square spiral and has the potential to grow outwards endlessly. This museum, commissioned by the mayor of Ahmedabad, is a square prism with defined limits that is lifted off the ground by a grid of pilotis, which create a shaded peripheral passage that leads to the central courtyard and into the building. *Béton brut* and local brick are the main materials that form the language of the prism, which provides a roof terrace as well. *pp. 164-67*

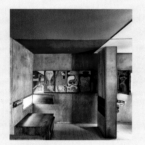

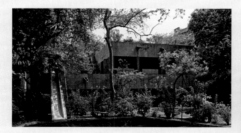

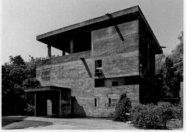

Le Cabanon
Roquebrune-Cap-Martin, France, 1951

Le Corbusier built himself the simplest possible building for his holiday home and studio in the South of France, on a cliff overlooking the Mediterranean. This minimal log cabin, which reminds one of Laugier's primitive hut, is dimensioned according to the Modulor and fits in a square of 3.66 × 3.66 metres. The interior is skillfully divided into the sub-spaces necessary for daily usage and work by the meticulous design and positioning of fixed furniture, partitions and window openings. Le Corbusier used the *cabanon* until the end of his life and died while swimming in the sea right below it, in 1965. *pp. 168-71*

Villa Sarabhai
Ahmedabad, India, 1951

Le Corbusier designed this house for Smt Manorama Sarabhai and her son, who came from a wealthy family of mill owners. The spatial organization of the building is based on a series of structural bays covered with Catalan vaults at the top, which both define the interior spaces and extend them towards the lush natural environment outside. The location's extreme climatic conditions, including high temperatures and levels of humidity and monsoon downpours, largely shaped the design of the house, from its positioning according to the prevailing winds to the incorporation of tools like the deep brise-soleil, the roof garden and the passages that allow air circulation. *pp. 172-75*

Villa Shodhan
Ahmedabad, India, 1951

The Shodhan house, the second domestic project Le Corbusier realized in Ahmedabad, has its origin in some previously worked on yet unbuilt projects for other clients and for slightly different contexts in the same city. Even though it has a more compact and modest layout than the Sarabhai house, Villa Shodhan displays a similar architectural language as its predecessor and a continuing concern with the control of climatic conditions. In both houses, the brise-soleil reaches such a depth and scale that it gains a spatial quality and becomes a natural extension of the interior space. The double and triple-height terraces on the upper floors, shaded by the monumental roof slab at the top, reminds one of Le Corbusier's villas from the 1920s. *pp. 176-79*

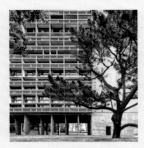

Unité d'Habitation, Rezé
Rezé, France, 1952

The second built example of the Unité d'Habitation type is at Rezé, in the west of France, and was initially designed to be inhabited by the workers from the port of nearby Nantes. This building and its apartments are slightly smaller than those in Marseille, and it has fewer social facilities due to the budget restrictions defined by the Habitations à Bon Marché, a low-cost housing scheme. The differences from the first Unité also include structural ones and those related to the use of materials and detailing, as Le Corbusier made certain revisions both for the sake of adapting the type to the new context and for general improvement. *pp. 180-85*

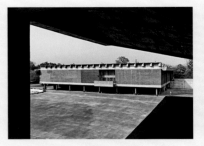

Museum and Art Gallery
Chandigarh, India, 1952

Similar to the museums Le Corbusier designed for Tokyo and Ahmedabad, the Museum in Chandigarh is a version of the museum of unlimited growth scheme. The building shares many features with its predecessor in Ahmedabad, such as its main prismatic body raised off the ground by pilotis, its entrance from below the prism and its internal courtyard. The organization of interior spaces rotating around a centre and the *promenade architecturale* provided by a ramp are also typical of Le Corbusier's exhibition buildings. The tectonic expression of the museum, based on the coupling of *béton brut* and local brickwork, and the striking colours applied indoors fit well into the architect's late-career portfolio. *pp. 186-91*

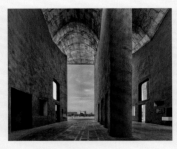

Palace of Justice
Chandigarh, India, 1952

The Palace of Justice (High Court) in Chandigarh is one of the three major state buildings in the Capitol Complex, the administrative sector of the city planned by Le Corbusier as the new capital of Punjab. The plan of the building is simple and straightforward, with an asymmetrically placed, semi-open foyer and a series of courtrooms accessed from the public space at the front. However, the effect of its grand volume, its facade swept with deep brise-soleil and the striking colours on its large surfaces give the Palace of Justice an impressive and monumental appearance. The unifying parasol roof, detached from the main body of the building, has both symbolic connotations and a functional role in climate control. *pp. 192-201*

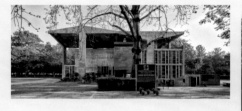

Architecture Museum
Chandigarh, India, 1952

Located near the Chandigarh Museum and Art Gallery, the Architecture Museum presents a form reminiscent of the Heidi Weber centre in Zurich. While the use of prismatic masses placed under a parasol canopy draws a strong resemblance between the two buildings, the difference in structural material – reinforced concrete in this case, instead of steel – creates an equally powerful distinction. The free-standing roof structure with the extensive shade it casts over the building beneath seems more appropriate to the Indian climate than Switzerland. *pp. 202-207*

Maison du Brésil
Paris, France, 1953

More than twenty years after the construction of the Pavillon Suisse in the Cité Internationale Universitaire, Le Corbusier had the opportunity to work on a very similar programme, for housing Brazilian students, on a site very close by. He collaborated with the Brazilian architect Lúcio Costa, who put forward the initial design ideas, which synthesized certain typically Corbusian principles with cultural elements. The Brazilian residence shares basic similarities with the Pavillon Suisse, such as the monumental block of dormitories raised on pilotis and the smaller masses of communal spaces linked to it, yet differs in the bold use of materials and colours, which reached their most striking expression in the unique entrance hall. *pp. 208-15*

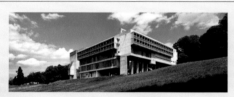

Couvent Sainte-Marie de La Tourette
Eveux, France, 1953

When Le Corbusier was asked to design a monastery for the Dominican Order on a sloped site in the midst of a forest near Lyon, he probably recalled the memories of the visits he paid in his youth to the monasteries of Ema, near Florence, and Mount Athos, Greece. His design, a complex grouped around a central courtyard, sits on the slope in an equally dramatic way as those historic compounds do. The monastery houses communal spaces, including study halls, a library, a refectory and a church, and individual cells for one hundred monks, which shape the two major facades with their balconies, also working as brise-soleil. Le Corbusier's collaboration with the musician-engineer Iannis Xenakis in this project left its mark on diverse aspects of the buildings. *pp. 216-23*

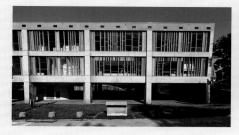

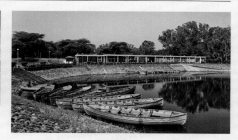

Maison de la Culture
Firminy, France, 1953

Le Corbusier designed four structures in Firminy, comprising a stadium, a church, a Unité d'Habitation and a cultural centre, the Maison de la Culture, which constituted the second major urban work of the architect after Chandigarh. The cultural centre, which rests to one side of the stadium, is constructed using a complex reinforced concrete structure that runs through the 112-metre-long building, below the suspended parabolic roof. An auditorium, theatre, halls for various performing arts and a bar form the main elements of the architectural programme of the centre, which stands as proof of Le Corbusier's never-ending experiments with structure and form. *pp. 224-27*

Palace of Ministries
Chandigarh, India, 1953

Another major building in the Capitol is the Secretariat that houses the secondary offices of the assembly. The unusual size and proportions of the 254-metre-long horizontal prism are in an original dialogue with the plain topography of its site and the mountains in the distance. A powerful pattern shapes the facade of the Secretariat, made out of 'diverse types of brise-soleil', in Le Corbusier's words, behind which elements of glazing and ventilation are placed. The sculptural masses of the ramps attached to the two main facades also help to break the monotony of the dominant pattern, which gets transformed at certain points due to the hierarchy of the offices behind them. *pp. 228-33*

Yacht Club
Chandigarh, India, 1953

Le Corbusier designed this building as a social facility for the boats navigating Sukhna Lake in Chandigarh. Its horizontal, low mass is placed by the edge of the water in a manner that avoids obstructing the vistas of the surrounding landscape. The spaces in the building are defined by a regular grid of columns around which walls and glazed separators are arranged in a semi-autonomous character, a scheme that echoes the 'free plan' principle in Le Corbusier's Five Points of Architecture. *pp. 234-35*

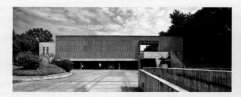

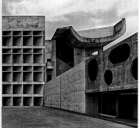

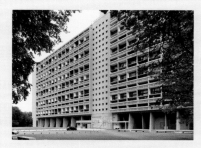

National Museum of Western Art
Tokyo, Japan, 1955

The museum in Tokyo is the first realized version of the idea of the museum of unlimited growth, which Le Corbusier had first formulated in the 1930s, and was originally built to display the paintings and sculptures by Western artists amassed by the collector Matsutaka Kojiro during a period in Paris. Le Corbusier incorporated his typical tools – pilotis, ramps and the courtyard – in the square plan of the museum, which resembled yet in fact differed remarkably from the spiral plan of his generic museum design. He completed the project with the help of two Japanese architects, Maekawa Kunio and Sakakura Junzo, who had previously worked at his Paris office. *pp. 236-45*

Palace of Assembly
Chandigarh, India, 1955

The parliament building is the third major element of the Chandigarh administrative sector, together with the Palace of Justice and the Palace of Ministries. This time the orthogonal prism is animated by the plastic qualities of its frontal porch and the central assembly hall, a reinforced concrete hyperbolic cone that pierces the building's upper surface. Le Corbusier explained that the form of the assembly hall – inspired by industrial cooling towers – works perfectly in terms of natural air conditioning, while for acoustics it is not ideal in terms of geometry. The pictorial work by Le Corbusier applied on the main door of the building displays the current forms and colour scale the architect was preoccupied by in that period. *pp. 246-55*

Unité d'Habitation, Briey-en-Forêt
Briey-en-Forêt, France, 1956

The third Unité was realized in Briey-en-Forêt, in northeastern France. The state commissioned and financed the building, and the budget was again very tight, as in Nantes. Owing to both financial restrictions and strict building regulations, this Unité also lacked the social facilities that existed in Marseille, and the apartments had to be even smaller than those in Nantes, to Le Corbusier's disappointment. *pp. 256-59*

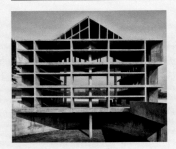

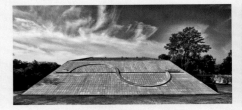

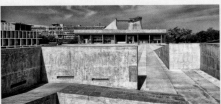

The Tower of Shadows
Chandigarh, India, 1957

The Tower of Shadows, Geometric Hill and Monument to the Martyr are symbolic structures placed inside the man-made landscape of the main plaza of the Capitol Complex in Chandigarh. They are located midway between the monumental buildings of the Palace of Justice and the Palace of Ministries and in a close relationship to one another. The Tower of Shadows, which stands at a 45-degree angle with respect to the axes of the Capitol Complex, is a hollow structure of reinforced concrete frames that casts deep shadows inside and out and allows the observation of the path of the sun. *pp. 260–63*

The Geometric Hill
Chandigarh, India, 1957

Next to the ramp that gives access to the Tower of Shadows lies the Geometric Hill, a substantial artificial mound of grass-covered soil with a relief of a solar diagram on its paved surface facing the plaza. *pp. 264–65*

The Monument to the Martyr
Chandigarh, India, 1957

The Monument to the Martyr, which stands across from the Tower of Shadows and Geometric Hill, is a rotating ramp that acts as a viewing deck for the entire plaza. The three monuments together create a landmark zone within the Capitol and provide distinct spatial experiences as well as diverse vistas of the nearby buildings. *pp. 266–67*

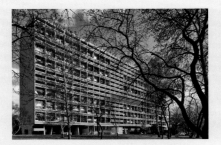

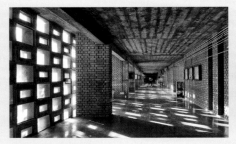

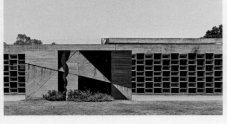

Unité d'Habitation, Berlin
Berlin, Germany, 1957

The Unité d'Habitation in Berlin is the only one outside France and was completed around the same time as that in Briey. This Unité sits on a beautiful site in the Olympic Park and is a satisfactory example of the type in terms of size and the balance of individual units and communal facilities. However, this time, Le Corbusier was not pleased with the 'aesthetic interpretation' of the building and found its material finishings too precise and polished for his taste. *pp. 268–71*

College of Art
Chandigarh, India, 1950–65

The two colleges Le Corbusier designed in Chandigarh for the study of art and architecture have very similar layouts, in the form of studios organized around courtyards, using a mat building logic open to growth in different directions. Both buildings are placed at an oblique angle to the city grid for the sake of orientation with respect to the sun and receiving northern light inside the studios. Daylight enters through the clerestory openings provided by the curved forms of the roofs of the single-storey studios, creating the characteristic elevations of the educational cells, thus giving an identity to a building that otherwise has a particularly modest appearance, with simple forms and facades finished with local brick masonry. *pp. 272–75*

College of Architecture
Chandigarh, India, 1950–65

This school initially had the same layout as the College of Art, but it is situated on a different spot to the north of the grid of Chandigarh. Le Corbusier's vision for the two schools incorporated possibilities for future expansion, and in time these were realized, so that the final plans of the buildings diverged from each other considerably. Today, even though the plan of the school of architecture is a bit different, the atmosphere and functioning of the studio and courtyard spaces of the two colleges are similar, both existing as untidy workspaces for their students. *pp. 276–79*

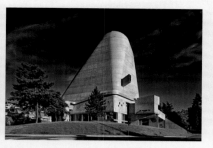

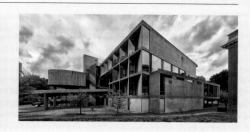

Unité d'Habitation, Firminy
Firminy, France, 1960

The final Unité d'Habitation of the five examples executed was built in Firminy, alongside the other three major projects Le Corbusier designed for the city. Le Corbusier initially proposed three Unités for Firminy, yet only one of them was built and the actual construction was completed in 1965, after the architect's death, under the supervision of his long-time assistant André Wogenscky. Even though the Unité of Firminy reflects restrictions in social facilities and apartment size similar to those in the previous three, it also displays Le Corbusier's continued experimentation and improvement in the use of materials and structural elements, such as the pilotis. *pp. 280-83*

Église Saint-Pierre
Firminy, France, 1960–2006

Saint-Pierre in Firminy is one of only three churches Le Corbusier designed, and the last among them to be completed. Its original form, a conical reinforced concrete shell that sits on a cubical base, has its origins in a chapel design Le Corbusier worked on in the late 1920s. The form is also associated with the cooling towers of power plants that Le Corbusier had come across during his recent travels. The grand interior volume is lit by a constantly changing diffusion of daylight entering through the different openings on the concrete shell and the circular perforations on its surface, which contain optical lenses. The church was completed more than 45 years after it was designed, for financial and political reasons. *pp. 284-91*

Carpenter Center for the Visual Arts
Cambridge, Massachusetts, USA, 1961

Le Corbusier's sole executed building in North America is a centre for Harvard University designed to be used for the production and exhibition of artworks by students and artists. The building accommodated lecture and study halls, studios and exhibition spaces and was completed in collaboration with two other architects, Guillermo Jullian de La Fuente and Josep Lluís Sert. A ramped passage acts as the main artery of the building and both links it to the streets on the opposite sides and regulates the distribution and connection of its spaces. Around the ramp, prismatic and circular masses are brought together in a compact composition whose surfaces are shaped by typically Corbusian tools, including the deep brise-soleil, patterns of vertical openings and glass bricks. *pp. 292-99*

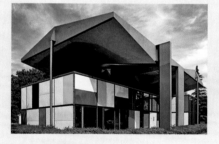

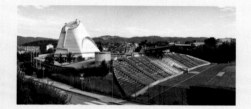

Le Corbusier Centre
Zurich, Switzerland, 1963

Originally named the Maison de l'Homme, the pavilion that stands in a park on the shores of Lake Zurich was completed in 1967, after Le Corbusier's death. The building was commissioned by Heidi Weber, a Swiss designer and art collector, with the intention of using it both as a house and an exhibition venue. Le Corbusier gladly worked on and solved the problem of bringing together the domestic and public programmes, although in time the latter dominated the use of the pavilion. The building is a unique composition of lightweight steel-frame prisms, which constitute the main body, and a parasol roof made of metal sheets folded in different directions, which provide shade for the terrace underneath. *pp. 300-303*

Stadium
Firminy, France, 1965

The stadium or sports arena Le Corbusier designed for Firminy is located between his Maison de la Culture and the Église Saint-Pierre. In fact, the architect's original intention was to place the cultural centre directly adjacent to the stadium's tiered seating to achieve an economy of design and construction. However, for bureaucratic reasons this was not possible and the arena's seating could not profit from the shade the cultural centre's overhanging mass would have provided. *pp. 304-307*

The other surviving buildings by Le Corbusier are listed here. These buildings were omitted from this publication either because of a lack of architectural value due to destruction or alteration or because they could not be photographed for privacy or security reasons.

Cinéma 'La Scala'
La Chaux-de-Fonds, Switzerland, 1916
Partially destroyed and altered

The cinema in his home town was the first public building commission Le Corbusier received. Since the plan scheme was more or less set from the beginning, he focused on the design of the facades, which are interpretations of neoclassical canonical forms abstracted in a modernist fashion. Today only the rear facade remains, as the original building was partially destroyed during a fire in 1971.

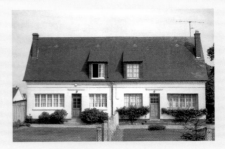

Cité Ouvrière
Saint-Nicolas d'Aliermont, France, 1917
Incomplete and altered

This project is one of the earliest examples of Le Corbusier's housing settlement schemes for workers. The architectural style of the two-storey houses presents a plain vernacular vocabulary, with steep pitched roofs and separate small windows, typical of Le Corbusier's pre-1920 period. Only one of the 46 houses in the project was actually built and it stands considerably altered in its present state.

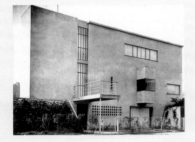

Villa Besnus
Vaucresson, France, 1922
Altered

The house – also known as Ker-Ka-Ré – that Le Corbusier designed for the Besnus family near Paris is an early example of his reinforced concrete residential buildings, with a minimalist form and expression. Both the plans and the facades of the two-storey prismatic mass are formed through the subtle composition of certain basic elements, organizing spaces and surfaces very economically. The building was altered by the addition of a pitched roof, and changes have been made on its facades as well.

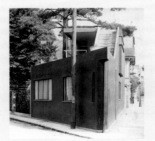

Maison Ternisien
Boulogne-sur-Seine, France, 1926
Extensively altered

Le Corbusier worked on artists' studio-residence programmes – such as the design he made for Mme and M. Ternisien – on many different occasions. The ground floor is divided into two main spaces that house a painting atelier and a music room, while the first floor accommodates the residential spaces and a roof terrace that extends over the triangular mass at the corner of the unusually shaped site. Approximately a decade after its completion the building was radically altered by the addition of four extra floors, designed by another architect.

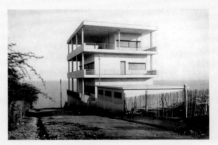

Villa Baizeau
Carthage, Tunisia, 1928
Not photographed for privacy reasons

Le Corbusier designed two alternative schemes for the house of the industrialist Lucien Baizeau in Carthage, the first of which he favoured for its originality and complexity. The first scheme applied principles from the Dom-Ino and Citrohan houses and had an innovative section with interlocking spaces that was assumed to generate air circulation throughout the building. The parasol roof would also help to control the climatic conditions of the North African coast. However, in response to the demands of the client, a second, more conventional design scheme was applied.

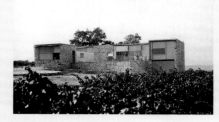

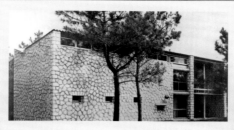

Villa Mandrot
Le Pradet, France, 1929
Not photographed for privacy reasons

The holiday house Le Corbusier designed for Hélène de Mandrot displays a shift away from the Purist aesthetics of his villas of the earlier decade. The load-bearing stone walls of the house make clear this shift in architectural language as well as the emerging interest of the architect in using local materials and craftsmanship. Yet certain architectural features of the building, such as the plan layout and the facade composition, remain faithful to the generic schemes Le Corbusier had worked on in his previous modern houses.

Villa 'Le Sextant'
Les Mathes, France, 1935
Not photographed for privacy reasons

The change in Le Corbusier's style is evident once more in Villa 'Le Sextant', another holiday home he designed using exposed stone masonry as a dominant architectural feature (as in Villa Mandrot). The house had to be built on an extremely tight budget and by a local contractor without the architect's supervision. These conditions determined the choice of materials and structural system: a combination of masonry walls and timber-frame skeleton. The outcome is a simple box that accommodates a modest house, wrapped around by an L-shaped veranda.

Stadium
Baghdad, Iraq, 1956
Not photographed for security reasons

In the mid-1950s Le Corbusier received an invitation to design a sports complex in Baghdad that would accommodate a stadium, a gymnasium and a pool. Owing to the turbulent economic and political conditions of the country, the design and construction processes extended over decades and surpassed the architect's lifetime. Construction was completed in 1980 and the sports complex functioned as planned until the early 2000s, when it was used for military purposes during the Iraq War. The stadium has lost some of its architectural value as a result of certain additions and decay.

Bâtiments de l'Écluse
Kembs-Niffer, France, 1960
Not photographed due to ongoing renovation work

Le Corbusier designed a watchtower and a customs building as complementary structures of the sluice at the junction of the Rhône and Rhine rivers. As the architect himself explained, these structures stand between architecture and engineering and form part of an infrastructure built to regulate a natural landscape. The designs of both buildings were inspired by and formed according to the movement and changes in level of the water in the sluiceway.

NOTES
The dates of buildings are given with reference to those provided by the Fondation Le Corbusier. Most dates refer to the year a project's design phase began.

SOURCES
Blake, Peter, *Le Corbusier: Architecture and Form* [1960] (London, 1963)
Boesiger, Willy, and Hans Girsberger, eds, *Le Corbusier*, 1910–65 (Basel, 1999)
Curtis, William J. R., *Le Corbusier: Ideas and Forms* (London, 2003)
Fondation Le Corbusier, www.fondationlecorbusier.fr
Frampton, Kenneth, *Le Corbusier* [2001] (London, 2015)
–, *Le Corbusier: Architect of the Twentieth Century* (New York, 2002)
Gans, Deborah, *The Le Corbusier Guide* [1987] (New York, 2006)
Prakash, Vikramaditya, *Chandigarh's Le Corbusier: The Struggle for Modernity in Postcolonial India* (Seattle, WA, 2002)

Front Cover
Palace of Justice, Chandigarh, India, 1952
Back Cover
Chapelle Notre Dame du Haut, Ronchamp, France, 1950–55
Frontispiece
Villa Savoye et Loge du Jardinier, Poissy, France, 1928

Prestel Publishing Ltd.
14–17 Wells Street
London W1T 3PD

Prestel Publishing
900 Broadway, Suite 603
New York, NY 10003

British Library Cataloguing-in-Publication Data: a catalogue record
for this book is available from the British Library

Photographs
Cemal Emden

Editor
Burcu Kütükçüoğlu

Editorial direction at Prestel
Lincoln Dexter

Translation
Nafiz Akşehirlioğlu (pp. 36, 62, 142, 186, 194, 218 and 262)
Victoria Holbrook (pp. 76 and 252)

Copy-editing
Aimee Selby

Acknowledgements
Sibel Bozdoğan
Edmond Charrière
Jean-Louis Cohen
İdil Erkol
Bénédicte Gandini
Ertun Hızıroğlu
Şule Tunca Malhan
Caroline Maniaque
Pelin Özgen
Kamil Özkartal
Michel Richard
Snehal Shah
Cem Sorguç
Han Tümertekin
Banu Uçak

Book design
Emre Çıkınoğlu

Pre-press
Spot Tasarım

Printing and binding
Mas Matbaacılık San. ve Tic. A.Ş.
Hamidiye Mahallesi, Soğuksu Caddesi No: 3
34408 Kağıthane-İstanbul
+90 212 294 10 00
book@masmat.com.tr
Certificate No: 12055

Printed in Istanbul
Printed on 130 gsm Garda Mas Ivory

ISBN 978-3-7913-8402-3

www.prestel.com